1979

STUDIES IN BRITISH ART

Frontispiece (over page) Francis Chantrey: Monument to Mrs Boulton, Great Tew, Oxfordshire.

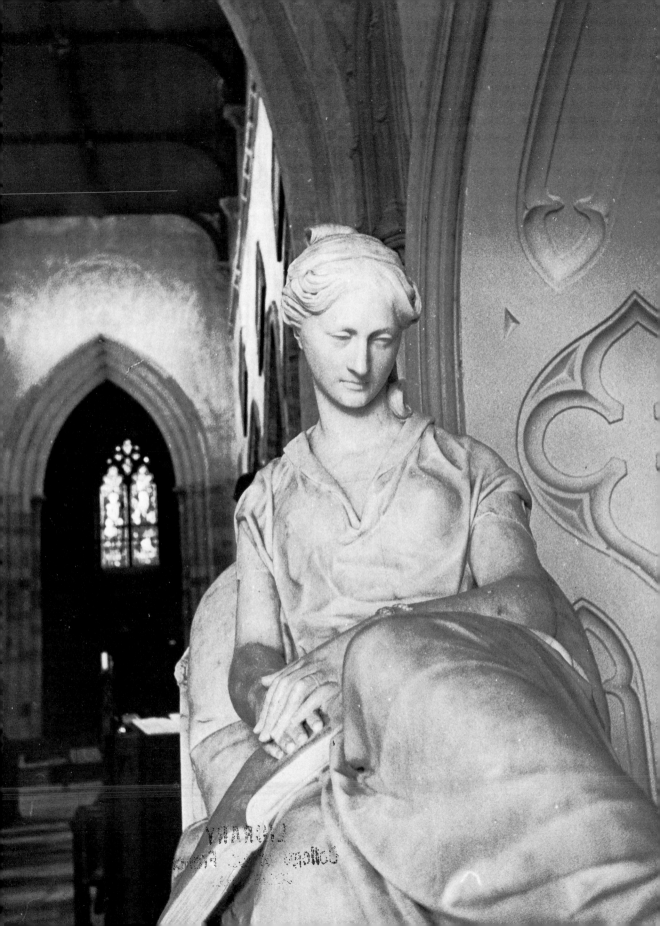

Church Monuments in Romantic England

NICHOLAS PENNY

Published for the Paul Mellon Centre for Studies in British Art
by
YALE UNIVERSITY PRESS
NEW HAVEN AND LONDON
1977

In Memoriam A.C.P.

Designed by John Nicoll and set in Monophoto Ehrhardt

Filmset and printed in Great Britain by
BAS Printers Limited, Wallop, Hampshire

Published in Great Britain, Europe, Africa, the Middle East, India and
South-East Asia by Yale University Press, Ltd., London.
Distributed in Latin America by Kaiman & Polon, Inc., New York
City; in Australasia by Book & Film Services, Artarmon, N.S.W.,
Australia; in Japan by Harper & Row, Publishers, Tokyo.

Library of Congress Cataloging in Publication Data
Penny, Nicholas, 1949–
Church monuments in Romantic England.

(Studies in British art)
Based on the author's thesis.
Bibliography: p.
Includes index.
1. Sepulchral monuments—England. 2. Sepulchral chapels—England.
3. Effigies—England. 4. Romanticism in art—England. I. Paul Mellon
Centre for Studies in British Art. II. Title. III. Series.
NB1860. P44 731'.76'0942 76–58912
ISBN 0–300–02075–9

Preface

ENGLISH sculpture of the period stretching roughly from 1780 to 1840 has been so neglected that in exploring it I have felt myself to be a pioneer. But in fact the few who have preceded me have already accomplished the most arduous tasks. I have had Rupert Gunnis's *Dictionary of British Sculptors* and Margaret Whinney's magisterial *Sculpture in Britain* to help me. Both the National Monuments Record and the Conway Library—thanks, in the latter case, largely to the energy of Benedict Read—now have excellent photographic records of this sculpture, and Professor Pevsner and the other authors of the 'Buildings of England' series seldom fail to list the relevant monuments. Without these works and institutions I would not have dreamt of undertaking this research. And without the stipend and travel grant which I received as Leverhulme Research Fellow in the History of Western Art at Clare Hall, Cambridge between 1973 and 1975, I would have only dreamt of undertaking it. That it has been published in this form is due to the generosity of the Mellon Centre.

I am deeply indebted to the late Margaret Whinney who gave me much advice and encouragement in the early stages of my research; and above all I am grateful to Michael Kitson of the Courtauld Institute who fostered the Ph.D. thesis upon which this book is based. In addition, I must thank Terence Hodgkinson, Francis Haskell, Benedict Read, David Udy, Homan Potterton, John Newman, Charles Saumarez-Smith, John Kenworthy-Browne, Alison Yarrington and my wife who have discussed sculpture with me, criticized my ideas, and either added to or challenged my facts.

Members of the Westmacott family helped greatly in my researches. John Physick kindly introduced me to drawings in the Victoria and Albert Museum. Professor Owen Chadwick gave me valuable hints on ecclesiological matters. Lady Lucas, Lord Fitzwilliam and the Duke of Rutland granted me permission to see commemorative sculpture not normally accessible to the

v

public. I am also greatly indebted to the kindness of vicars, vergers and estate agents too numerous to list, and to staff of many libraries, manuscript departments, and county record offices.

The bibliography consists of only a few fundamental sources for the study of sculpture in this period, together with some articles of my own, and these works are abbreviated in the notes to the text.

Families of sculptors can cause confusion. Sir Richard Westmacott will normally be referred to as Westmacott, his father as Westmacott the elder, his son as Westmacott the younger. The elder Bacon will normally be called Bacon, but his son, Bacon the younger. When monuments are located only by the name of a village, this means the parish church in that village and all churches are Anglican unless stated to be otherwise.

Contents

List of Plates

All photos are by the author unless otherwise stated, except Plates 16, 32, 34, 59, 95 and 112 which are photos made by the museums and libraries concerned.

ix

well, Chichester Cathedral. Photo F. H. Crossley.

71. Charles Rossi: Monument to Elizabeth, Countess of Pembroke and her son, Wilton, Wiltshire.

72. Richard Westmacott: Monument to Elizabeth Stanhope, Bristol Cathedral.

73. E. H. Baily: Monument to Eliza Mortimer, St Martin's, Exeter.

74. Christopher Cass (?): Monument to Jane and Edward Bray, Great Barrington, Gloucestershire.

75. Joseph Nollekens: Monument to Earl Spencer, Great Brington, Northamptonshire. Photo National Monuments Record.

76. James Paine the Younger: Monument to William Powell, Bristol Cathedral.

77. E. Boehm: Monument to Henrietta Montagu, Newton, Cambridgeshire. Photo Courtauld Institute.

78. Terence Farrell: Monument to the Countess de Grey, Flitton, Bedfordshire.

79. John Flaxman: Monument to I. H. Browne, Trinity College Antechapel, Cambridge. Photo Philip Gaskell.

80. E. H. Baily: Monument to Sarah Russell, St Mary's, Handsworth, Birmingham.

81. Agostino Carlini: Monument to Lady Milton, Milton Abbas, Dorset. Photo Derek Sherborn.

82. John Townsend the Third: Monument to the Countess of Pomfret, St Mary's, Oxford.

83. Edward Bingham: Monument to William and Susanna Gery, Peterborough Cathedral.

84. Richard Bentley: Monument to Galfridus Mann, Linton, Kent.

85. Thomas Rickman: Monument to Robert Whitworth, Buckden, Huntingdonshire. Photo James Austin.

86. John Carline the Younger: Monument to the Poore Family, Salisbury Cathedral. Photo National Monuments Record.

87. Thomas Banks: Monument to Penelope Boothby, Ashbourne, Derbyshire. Photo National Monuments Record.

88. Francis Chantrey: *The Sleeping Children*, Lichfield Cathedral. Photo National Monuments Record.

89. J. and T. Tyley: Monument to Georgina Worral, Bristol Cathedral.

90. Francis Chantrey: Monument to Lady Frederica Stanhope, Chevening, Kent. Photo National Monuments Record.

91. Richard Westmacott: Monument to Christopher Jeaffreson, Dullingham, Cambridgeshire. Photo Courtauld Institute.

92. E. H. Baily: Monument to Viscount Brome, Linton, Kent.

93. Richard Westmacott the Younger: Monument to the third Earl of Hardwicke, Wimpole, Cambridgeshire. Photo Courtauld Institute.

94. Richard Westmacott the Younger: Monument to Charlotte Egerton, Rostherne, Cheshire. Photo Courtauld Institute.

95. John Flaxman: Design for a Monument, British Museum.

96. Thomas and Mary Thornycroft: Monument to John Hamilton-Martin, Ledbury, Herefordshire.

97. John Bacon the Younger: Detail of Monument to Christina Medley, St Thomas's, Exeter.

98. Raffaelle Monti: Monument to Lady de Mauley, Hatherop, Gloucestershire.

99. Raffaelle Monti: Angel from the De Mauley Monument, Hatherop, Gloucestershire.

100. Detail of Monument to Jacob Bosanquet, Bath Abbey.

101. Monument to Fletcher Partis, Bath Abbey.

102. Monument to Dauntsey Hulme, Manchester Cathedral.

103. Richard Westmacott: Monument to Benjamin Kenton, Stepney Parish Church, London. Photo Courtauld Institute.

104. John Flaxman: Monument to William Bosanquet, Leyton, Essex. Photo Courtauld Institute.

105. John Bacon: Monument to Thomas Guy, Guy's Hospital Chapel, London. Photo A. F. Kersting.

106. John Bacon: Monument to John Howard, St Paul's Cathedral. Photo Warburg Institute.

107. John Bacon: Relief on the base of the Howard Monument, St Paul's Cathedral, London. Photo A. F. Kersting.

108. Richard Westmacott: Monument to Georgina Holland, Millbrook, Bedfordshire.

109. John Bacon: Monument to Sir William Jones, St Paul's Cathedral. Photo National Monuments Record.

110. John Flaxman: Monument to Sir William Jones, University College Chapel, Oxford. Photo A. F. Kersting.

111. John Flaxman: Monument to the Yarborough Family, Campsall, Yorkshire. Photo National Monuments Record.

112. John Flaxman: Design for the Yarborough Monument, British Museum.

113. Nicholas Read: Detail of the Monument to the Duchess of Northumberland, Westminster Abbey.

X

Introduction

MRS Beeton, considering how best to measure 'the rank which a people occupy in the grand scale', recommends us to consider the ways in which they 'reduce to order and surround with idealisms and graces the more material conditions of human existence'. She was thinking of dinner and of marriage. Yet what she says applies no less to ways of honouring the dead. The study of the commemorative sculpture of our recent ancestors, although considered as an eccentric antiquarian hobby, merits the respect accorded to the investigation of mourning in New Guinea or the art of embalming in ancient Egypt. Now that church monuments are so rarely erected it is surely time to enquire why they once were erected.

An obvious question, hardly ever asked, and certainly never answered, is why there are so many post-Renaissance church monuments in this country. Why is this—more than portrait painting, landscape painting or animal painting—a peculiarly British art form? Monuments are particularly abundant in village churches near great country houses, and these churches were perhaps more often important in the life of the landed nobility here than was the case on the continent. They are also abundant in town churches and cathedrals and it may be that the social status of the wealthy merchants in England was greater than it was abroad. More simply, church burial was far more common in England, and attempts to limit or prohibit burial in church vaults only arose in England during the second half of the period studied here, whereas there is a continuous history of such attempts in Italy and France. It will also be proposed in this book that commemorative sculpture provided an outlet for the imagery otherwise discouraged by protestantism. To pursue any of these partial explanations is of course to leave the field of art history. And this is certainly not a work of 'pure' art history.

There are many other questions which can be asked about church monuments. They should reveal much about how our civilization has thought

I

of death, or contrived not to think of it, how our ruling classes asserted the status and continuity of their families, and how our artists gave coherence and decorum to the stammerings of grief, strove to strengthen fading memories of the dead, and to support hopes for a future life. Moreover, there is much in this subject which should interest the economic, political and social historian, as well as the historians of religion and ideas. My intention here is to trace the evolution of certain conventions and themes, asking questions as I do so. But first I have included two chapters on the sculptor's profession and on the ways that monuments were commissioned, because some knowledge of these subjects is needed before the right questions can be asked.

This is not a comprehensive study; there are types of monument which are hardly mentioned; and, obviously, I have not visited every church in England (to say nothing of Wales, Scotland and Ireland). I am particularly conscious of my ignorance of South Wales, the lowlands of Scotland and both the south-west and north-east of England. My approach varies and is never systematic. And this needs no apology, for a systematic approach would only be necessary if the works of art were systematically produced.

It remains to explain why I have chosen to begin this study in the final decades of the eighteenth century and to end it in the mid-nineteenth century. In this period there was a measure of stylistic coherence—a consistent attachment to neo-classicism of one sort or another—and a certain iconographic coherence. Moreover there is a sharp decline in the number of monuments erected after the 1840s. Thereafter Bishops and great nobles repose upon tomb chests; we also find gothic revival tablets and brasses, medallion portraits set in alabaster surrounds, and regimental monuments; but there is not the range and variety studied here. After 1850 more and more people agreed that it was more suitable to erect a window or even a church to someone's memory, than to block a window by a large monument or to turn a church into a family mortuary chapel. Also with the opening of the new suburban garden cemeteries, burial in the church vaults became less essential for the upper-classes.

1. Materials and
Market Conditions

THE church monuments which are the subject of this book cost between £50 and £6000. They were luxuries of expensive imported materials made only for the wealthy few who wore Indian muslin, sat on chairs of West Indian mahogany and drank port and claret and hock. The material used for figure sculptures was white 'statuary' marble from Carrara, or, less commonly, Serravezza, in Tuscany. As a consequence of the French war it tripled in price at the end of the eighteenth century.[1] Also important, but subordinate, were veined white marble, a slightly grey-white marble (known as 'Sicilian' in England and as *Ravaccione* in Italy), and the blue-grey marble (known as 'dove' in England and as *bardiglio* in Italy). These also came from quarries in the same area of Tuscany. Black marble on the other hand, although it was imported from Italy, probably came more often from Belgium, and, sometimes, from Derbyshire or Ireland.

Many imposing monuments of the eighteenth century, among them Rysbrack's monuments to Stanhope and Newton and Roubiliac's Argyle monument in Westminster Abbey, include sarcophagi of black marble traversed by thin yellow veins. This is an Italian marble from Porto Venere known both as 'golden vein' and as 'portor'. In the mid-eighteenth-century there was a vogue for lavish breccia marbles—'plum-pudding-stones' or *arlecchine*, usually from Serravezza, and often including pink, pale green and mauve fragments. The pyramid ground in Nicholas Read's monument at Brightlingsea, Essex to Nicholas Magens is a good example of this (Plate 1). Sir Henry Cheere even used the brilliant orange and yellow breccia, Sicilian Jasper. But most highly favoured of all was the rich mustard or egg-yellow marble flecked with dark grey, quarried at Montarenti, near Siena.[2] It may be seen on the sarcophagus of J. F. Moore's monument in Bath Abbey commemorating William Baker (Plate 2).

3

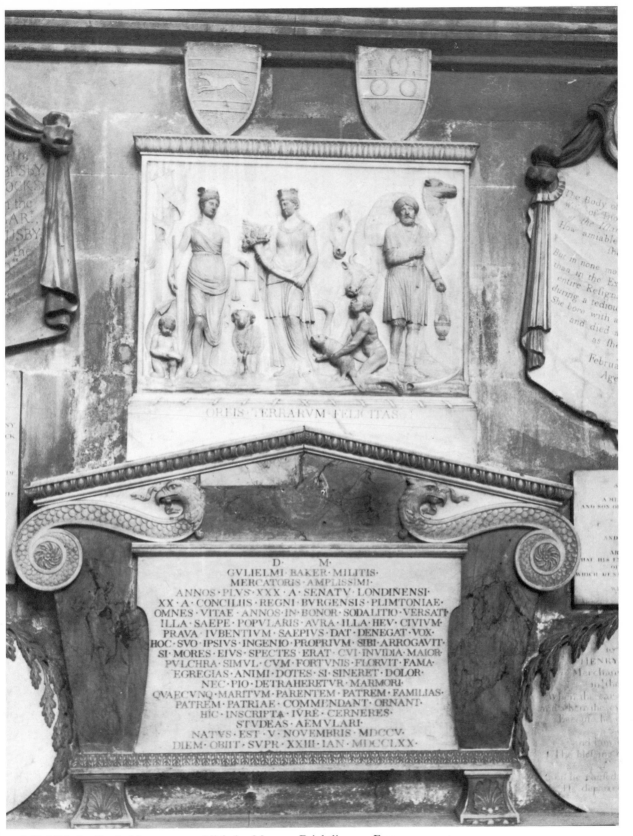

ORBIS TERRARVM FELICITAS

D M
GVLIELMI · BAKER · MILITIS ·
MERCATORIS · AMPLISSIMI ·
ANNOS · PLVS · XXX · A · SENATV · LONDINENSI ·
XX · A · CONCILIIS · REGNI · BVRGENSIS · PLIMTONIAE ·
OMNES · VITAE · ANNOS · IN · BONOR · SODALITIO · VERSATI ·
ILLA · SAEPE · POPVLARIS · AVRA · ILLA · HEV · CIVIVM ·
PRAVA · IVBENTIVM · SAEPIVS · DAT · DENEGAT · VOX ·
HOC · SVO · IPSIVS · INGENIO · PROPRIVM · SIBI · ARROGAVIT ·
SI · MORES · EIVS · SPECTES · ERAT · CVI · INVIDIA · MAIOR ·
PVLCHRA · SIMVL · CVM · FORTVNIS · FLORVIT · FAMA ·
EGREGIAS · ANIMI · DOTES · SI · SINERET · DOLOR ·
NEC · PIO · DETRAHERETVR · MARMORI ·
QVAECVNQ · MARITVM · PARENTEM · PATREM · FAMILIAS ·
PATREM · PATRIAE · COMMENDANT · ORNANT ·
HIC · INSCRIPTA · IVRE · CERNERES ·
STVDEAS · AEMVLARI ·
NATVS · EST · V · NOVEMBRIS · MDCCV ·
DIEM · OBIIT · SVPR · XXIII · IAN · MDCCLXX ·

1. (left) Nicholas Read: Monument to Nicholas Magens, Brightlingsea, Essex.
2. (above) John Francis Moore: Monument to William Baker, Bath Abbey.

As far as the monuments covered by this book are concerned, we are immediately struck by the disappearance, at the end of the eighteenth century, of these coloured marbles, and the preference for uniform black and white and for greys without veins. The iconography of Baily's monument in Newcastle Cathedral to Joseph Bainbridge, who died in 1823, is not different from that of Fisher of York's monument in Lichfield Cathedral to Stephen Simpson who died in 1784, but we know at once that Fisher's monument is the earlier work from its use of coloured marble, as much as from the refinement of the detailing (Plates 3 and 4). This change must reflect the neo-classical pursuit of purity. But coloured marbles often had antique associations—in fact were often literally neo-classical and obtained by cutting up antique fragments.

This was the case with the *africano* used with 'statuary', red oriental granite, *paragone* and 'golden vein', by Christopher Hewetson in his Provost Baldwin monument in Trinity College, Dublin,[3] and it may also have been the case with the exciting black and white marble used by Richard Hayward in his tablet in Westminster Abbey commemorating William Strode who died in 1786 (Plate 5). This seems to be *grande antique*—also called *bianco e nero*

6

3. (far left) John Fisher the Elder: Monument to Stephen Simpson, Lichfield Cathedral.
4. (left) E. H. Baily: Monument to Joseph Bainbridge, Newcastle Cathedral.

5. Richard Hayward: Monument to William Strode, Westminster Abbey.

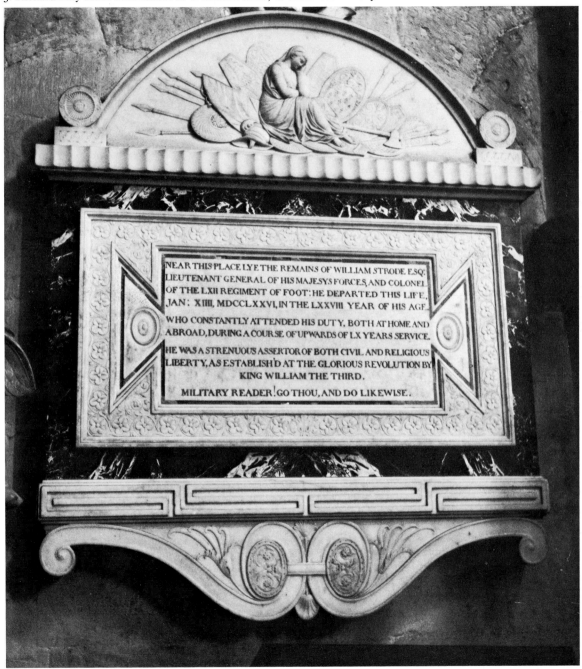

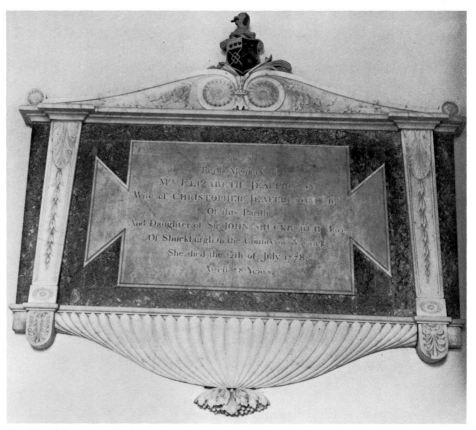

6. Richard Westmacott the Elder: Monument to Elizabeth Jeaffreson, Dullingham, Cambridgeshire.

antico—a marble much esteemed by the Romans who quarried it in the Pyrenees. The quarries were rediscovered and reopened in 1844, but when Hayward used the marble it was very rare. The veneer consists of two slices from the same block reversed and juxtaposed to form a symmetrical pattern. There is also a very thin band of pale green marble.

At Dullingham in Cambridgeshire Richard Westmacott the elder, in his tablet to Elizabeth Jeaffreson, who died in 1778, made his veneer from ten separate pieces of marble (Plate 6). But the 'figure' here was less distinct because his marble is a *lumachella*, a densely fossiliferous marble—a particularly pink specimen of *occhio di pavone pavonazzo*, a beautiful product of an obscure geological past which then possessed an additional glamour as a relic of the historical past, quarried by the Romans in Sagario in Asia Minor, and long buried in Classic soil.[4]

It must be significant that the disappearance of such marbles from English church monuments coincided with the French war and the consequent disruption of trade with the Roman *scalpellini*. But it is odd that such coloured marbles were not revived in monuments after the war, when English visitors

8

to Rome were avidly buying *tazze* and miniature obelisks made of *rosso antico*, *pavonazetto* and so on, together with tables inlaid with the complete spectrum of antique marbles, and—when they could afford them and Papal officials obliged—monoliths of *cipollino* or even oriental alabaster dredged from the Tiber. Shortly before the war Hewetson used red oriental granite for his Baldwin monument as did Richard Colt Hoare for the monument of his wife at Stourton, Wiltshire. Such materials did not catch on because they could not, for a while, be easily imported. Yet British granites—including Cornish red which was thought the equal of Egyptian red—were not employed instead, even though they were being energetically promoted at this date.[5] The war cannot have affected the supply of British marbles, yet they too fell out of favour for church monuments.

The shortage of statuary marble during the war became so serious that important works such as the Pitt statue in Cambridge and the Fox monument for Westminster Abbey were delayed; and, in the latter case Cornish granite (presumably a pale grey variety) was seriously proposed as a substitute.[6] It is hard to determine exactly when the vast range of native granites and marbles so gloriously orchestrated by Victorian architects were made available. Hutchin's *History of Dorset* of 1724 implies that Purbeck was no longer worked, but there are eighteenth-century ledger stones of this marble, perhaps reworked from medieval pieces. Pennant describes serpentine quarries in Anglesea in 1733 and by the 1810s George Bullock of Liverpool had developed the Mona marble quarries there.[7] On the other hand it seems that few of the most brilliant Devonshire marbles were exploited before the 1840s.[8] The first water-powered marble saws and polishers in Britain were those established by William Colles at Kilkenny in Ireland in 1733 to work black marble. The next were those established at Ashford in Derbyshire in 1748 by Henry Watson of Bakewell; and Derbyshire was certainly the most important centre for marble in Britain during the eighteenth century.[9] Watson's monument tells us that he was the 'first who formed into ornaments the *Flours* and other *Fossils* of this country.' The amethyst and amber flourspars were worked into vases and inlaid into chimneys and tabletops, but only make one appearance that I know of in a church monument.[10] The 'fossils' of the epitaph, however, are marbles and in Watson's own monument at Ashford (he died in 1786), and in many others nearby, especially at Bakewell, we find black Derbyshire marble tablets framed by grey and brown fossil marbles. More rarely, a green or orange brown marble is employed.[11] Also, in such tablets, alabaster is used.

Alabaster was perhaps the only native material to have enjoyed the esteem accorded to Italian marbles during the eighteenth century—as the alabaster columns of the halls of Holkham and Keddlestone testify; yet it was not employed in monuments further from the peak district than Derby or Sheffield and was never as popular as it had been in the late middle ages and would be again after 1850. Derbyshire marble and alabaster works flourished

in the early nineteenth century when steam-powered mills were introduced and new veins of marbles were discovered (including the magnificent 'duke's red', at first, and justly, entitled *anglo-rosso-antico*).[12] But local tablets are of standard white statuary, even when signed by firms such as Bradbury and Lomas of Bakewell, or Redfern of Ashford, who produced coloured marble table-tops and chimneys.

One British material, black slate, was extensively employed instead of black marble as the ground for statuary monuments. Compact limestones such as Malta stone and Roche Abbey stone, were sometimes used for figure sculpture. Mrs Coade's artificial stone enjoyed a certain popularity for tablets and tombstones.[13] But statuary marble remained the essential material. And if there were times when it was scarce and highly priced, then it was available in larger blocks—so that the old practice of fitting small pieces together was less common—and the marble was seldom disfigured by flaws or by grey stains and yellow veins as it had been so often early in the eighteenth century.[14]

Marble was not only needed for sculpture, but for table-tops, chimney-pieces, chimney-slips, kitchen-slabs and shop-counters. So there were hundreds of retailers outside London and the major ports. In and around towns such as Birmingham, Chester, Shrewsbury, Peterborough, Norwich, Cheltenham, Exeter or Derby one must expect many tablets to be the work of local firms; whilst tablets by Liverpool, Bristol, York and Bath sculptors will be found all over the country, and, indeed, in the West Indies. Nevertheless, if a sculptor aspired to excell as a figure sculptor, then he was almost certain to migrate either to London or to Rome.

The majority of leading English sculptors studied in Rome—Bacon and Chantrey are the notable exceptions—and a significant number virtually settled there: Hewetson and Deare are examples in the late eighteenth century; Gibson, R. J. Wyatt, Theed the younger, Gott, Campbell and Macdonald are examples in the first half of the nineteenth century. Marble and skilled labour and the cost of living were cheaper in Italy, and the numerous English visitors to Rome were almost obliged to visit the sculptors' studios, providing the sculptors with a steady trade in portrait busts and standard replicas of ideal heads. Also, wealthy philistines on holiday in a place where they felt it a duty to pay lip-service to culture, were far more likely to be tempted by a marble nymph than they were in London. But monuments were not sent from Italy as often as busts or ideal statues. Six or seven such monuments will be described in this book, but most important monuments were made in London.

Apart from the cost of marble, tools, and travelling to London (or Rome), the sculptor needed a large yard and studio. He also had to employ assistants—not only skilled carvers, but men to help move the massive weights. The studio also had to serve as a showroom and so it was desirable for it to be near the residential area of the metropolis where space was most

expensive. As was realised at the time, the painter's problems in starting his career were negligible beside these.[15] These initial expenses, combined with intense competition and a very limited market, made sculpture a risky business. Many sculptors—including some of the best known—either went bankrupt or were forced to write desperate begging letters to patrons or to apply to the Academy for help—Wilton, Angelini, Clarke, John Fisher of York, Westmacott the elder, Bubb, Rossi, Sebastian Gahagan, Pitts, Carew, Behnes, Baily and Lough among them.[16]

The profession tended to divide into a few great sculptors, most of whom were extremely prosperous, and minor sculptors who either worked for them or as superior stone-masons. Rossi's career illustrates the precarious nature of the middle ground. He was awarded a Royal Academy travelling scholarship in 1785 in order to study in Rome. On his return, his talents were quickly rewarded. He was made Sculptor to the Prince of Wales in 1797, Associate of the Academy in the following year and full member in 1802.[17] He obtained a greater share of the commissions given by Parliament for monuments to war heroes than any other sculptor except Westmacott, and he had contracts with the Coade stone factory which had helped Bacon to make a fortune. But, in spite of all this, the competition from Nollekens, the Bacons, Flaxman, Westmacott and Chantrey, combined no doubt with financial ineptitude, bad luck and the demands of a very large family, nearly drove him out of business.[18] In 1807 he was in despair. By 1816 he was considering becoming a journeyman to his junior, Westmacott, and also contemplating taking up a post as sculptor to the King of Haiti.[19] Whereas he had formerly supplemented his work on monuments with the production of architectural ornament (such as the cast gothic detail for Porden's Eaton Hall), work on artificial stone reliefs for the Custom's House and on the Carytids of St Pancras now became his main work.[20]

Had he worked as a journeyman for Westmacott, Rossi would not necessarily have lost all his independence. In Rome Benjamin Gibson and Benjamin Spence had a recognized importance in John Gibson's studio.[21] Even James Theakston who cut Chantrey's drapery also worked indenependently. And, although Goblet and Gahagan were exploited by Nollekens, Westmacott helped his assistant Carew, and Chantrey helped his assistants Francis and Weekes, to establish themselves.[22]

The most successful sculptors enjoyed very good relations with their patrons—Chantrey's friendship with Coke of Norfolk and Westmacott's with Lord Holland were particularly remarkable—but the protection of great patrons was most important for sculptors of the second rank. Thus Samuel Whitbread gave vital help to Garrard, as did the Duke of Rutland to Matthew Cotes Wyatt, the Earl of Egremont to Carew, Benjamin Gott to Joseph Gott, the Duke of Sussex to Francis, and Joseph Neeld to Baily.[23] Rossi never had help of this sort. In starting a career it was also an advantage to have the support of a senior literary figure. Chantrey was the protegé of Horne Tooke,

and Gibson of Roscoe. But usually a sculptor had connections with other sculptors, masons, plasterers, or, best of all, architects, which would be useful in starting a career.

Thomas Scheemakers, Bacon the younger, Sir Richard Westmacott, Westmacott the younger, Peter Hollins, Mary Thorneycroft and Theed the younger all had fathers who were sculptors. Wilton and E. G. Papworth were the sons of plasterers; whilst Flaxman was the son of a dealer in plaster casts. There were also many connections with wood carvers: John Steel was a woodcarver's son, Gibson was first apprenticed to a cabinet-maker, Chantrey was apprenticed to a frame-carver and Richard Westmacott was apprenticed, briefly, to his maternal grandfather, the joiner Robert Vardy, before he was sent to Italy.[24] William Pitts was the son of a Leicester silver chaser. R. J. Wyatt and Matthew Cotes Wyatt came from a family of architects and builders. James Paine was the son of an architect, and Rennie was related by marriage to Cockerell.

Professional association with architects was most important. John Thomas first worked for his brother, a minor architect, and then for Barry who eventually gave him charge over all the decorative carving of the new houses of parliament and so enabled him to establish one of the largest practices ever known in this country.[25] Perhaps the most remarkable case of such an association before Thomas was the informal alliance between Richard Westmacott and the Wyatt clan. His father, Westmacott the elder, executed chimney pieces for James Wyatt's houses and a number of monuments to his design (Plate 7), and a brother was in James Wyatt's office. When Westmacott was in Italy it was known that Wyatt was protecting his interests, and on his

7. Richard Westmacott the Elder: Monument to the tenth Earl of Pembroke, Wilton, Wiltshire.

return we find Westmacott working for the Office of Works boardroom, Fonthill, Ashridge, the Exchange at Liverpool, New College Oxford, Castle Coole, Dodington and Cobham—all places at which Wyatt was employed. There are a number of early monuments which Westmacott may well have executed at Wyatt's recommendation.[26] And when Westmacott collaborated it was almost always with the Wyatts—with Benjamin Dean Wyatt over the Duke of York's column, with Matthew Cotes Wyatt over the Nelson monument in Liverpool, with Wyattville over the colossal statue of George III at Windsor. In the case of the monument by Westmacott to Lord and Lady Penrhyn (Plate 138) we note that Samuel Wyatt had built both Penrhyn houses, Penrhyn Castle near Bangor and Winnington in Cheshire, whilst Benjamin, a brother of James and Samuel, had been Lord Penrhyn's agent.[27] In the case of the monument by Westmacott to the Earl of Bridgewater (Plate 141) we note that it is in a chapel by Wyattville near a house by James Wyatt for which Westmacott also produced decorative sculpture. In the case of the Pembroke monument at Wilton (Plate 8), we note that Westmacott's father had carved an earlier monument there to Wyatt's design (Plate 7) and that James Wyatt had altered the house, calling Westmacott in to arrange the sculpture gallery. In the case of the ambitious monument to Viscount Bulkeley who died in 1822, which Westmacott erected at Beaumaris, Anglesey, we may note that Bulkeley's seat, Baron Hill, had been rebuilt by Samuel Wyatt.

In order to survive in the middle ground between the great studios of Chantrey and Westmacott, and the mason's yards clustered around Hyde Park Corner and later Pimlico and what was then the New Road, a sculptor needed work of the sort that architects could best provide. Rossi's association with Smirke was important in this respect; so too was Wilton's with Chambers, and the talented Nicholl was in despair until taken up by Cockerell.[28] In addition, Wedgwood and Coade both offered some work to sculptors at the close of the eighteenth century. But in the subsequent period Coade's successors in the terracotta and artificial stone business (J. M. Blashfield, W. Croggan, Joseph Browne, Felix Austin and M. H. Blanchard) were not especially enterprising, and the only important opportunity for modellers was provided by silversmiths, in particular Rundell, Bridge and Rundell who employed Flaxman, Baily, Cundy, Pitts and the elder Theed. The manufacture of small bronzes did not flourish in this period as it did in Paris.[29] But London was noted for the quality of the paste impressions of gems made there and there were plenty of high quality plaster casts. Unfortunately, although the most popular bust sculptors supplemented their incomes by making plaster replicas, the copyright act of 1798 did not give adequate protection to the lesser sculptors who wished to establish a reputation through editions of plaster sculptor.[30]

Sculptors in the eighteenth century had often supported themselves by restoring antiques, but this practice was increasingly frowned upon after

8. Richard Westmacott: Monument to the eleventh Earl of Pembroke, Wilton, Wiltshire.

1800. Also, after the French wars, the English in Rome did not act as dealers in antiquities as Wilton, Nollekens, Deare, and Richard Westmacott had during the eighteenth century.[31] There were other peripheral, but rewarding types of work undertaken by sculptors, such as the arrangement of national and private collections of sculptures, the transport of collections from towns to country residences (or vice versa), and the casting of bronze copies; but this sort of work usually went to Westmacott and Chantrey, the men with the great studios and their own foundries.

The great sculptors—above all, Nollekens, Bacon the elder, Westmacott, Chantrey (and to a lesser extent Flaxman whose wealth never matched his reputation[32]) together with the two major British sculptors in Rome, Gibson and R. J. Wyatt—enjoyed a far higher status than their equivalents in the first half of the eighteenth century. Instead of being asked to copy or restore antiques they were more likely to be asked to create original works, for this was the period in which contemporary English gallery sculpture was first collected in any quantity by the aristocracy. The great sculptors were less likely to be treated as mere carvers by their patrons and it was much less common for them to be asked to carry out a monument to an architect's design, as had so often been the case in the eighteenth century.[33] Other artists were sometimes involved: Cipriani designed one of Nollekens's monuments, Stothard designed monuments and was supposed to have assisted Chantrey, and Ingres designed a monument to Lady Jane Montague, daughter of the fifth Duke of Manchester, which was never, alas, executed.[34] But by and large the inventor was the carver—or at least the modeller.

Once the sculptor had made his clay model and supervised the plaster model which was made from it, improved pointing machines made it easy for assistants to cut it out in rough from the marble. Pantographic pointing-machines enabled the model to be enlarged or reduced. Improved machinery, including steam-powered saws, facilitated the preliminary cutting.[35] Other gadgets which we know to have been employed were the 'camera oscura' for bust making, and 'Wollston's magnifying camera'.[36] What we do not know is whether the machines used for replicating carving which Cheverton and Jordan and Collas developed during the 1830s and 1840s were used for the monuments discussed here. Certainly Chantrey was interested in the machines of this sort which James Watt had been busy with during the early years of the century.[37] We will frequently have occasion to notice the duplication of figures and motifs, sometimes with no perceptible variations, but this did not amount to mass-production, which would have meant 'ready-made' monuments such as the Romans had, and such as were said to exist in post-Napoleonic Paris.[38] The cost of marble prohibited English sculptors from taking the risk of anticipating an order and even the smallest tablets were not complete for months and often years after they were ordered. Of course one could inspect sample sculpture in the Coade and Sealy artificial-stone showrooms in Lambeth, and they also published catalogues.[39] Also most

15

sculptors would have drawings ready to show a patron, in order to secure an order 'whilst the tear was still in the eye', and there is a set of drawings almost certainly used by the Bacons for this purpose which is now in the Victoria and Albert Museum. The customer was presented with a set of ideas, but this did not prevent him from having his own ideas carried out.

The enormous amount of business taken on by the great sculptors certainly led to a great deal of low quality work, which, although signed Westmacott or Flaxman, can only have been hastily designed by those men and can never have been touched by their chisel. Westmacott and Flaxman were certainly the worst offenders from this point of view—some of their designs are extraordinarily clumsy and many signed works deplorably executed— whereas Chantrey is more reliable, although often dull, and Bacon always contrived a cosmetic appeal and his early training in the ceramic industry made him partial to the idea of reproducing his designs.[40] Pressure of work also encouraged duplication and conformity to standard conventions, but this was balanced by the competition between the great sculptors which encouraged novel inventions or at least distinctive variations on these conventions. Similarly, the need to shine at the Royal Academy meant that sculptors would always be striving to produce some work of the best quality even when the quantity of inferior studio productions was mounting.[41] The best work was of course done for those who were prepared to pay—or, in rarer cases, for those who badgered the artist to provide it. And to the patrons and customers we must now turn.

2. Commissions
and Conventions

IN the south-west corner of the parish church of the remote Wiltshire village of Cliffe Pypard there is a surprisingly grand monument with three life-size white marble figures and a sarcophagus of yellow marble, a pale Siena, but selected to resemble the *giallo antico* of the Romans (Plate 9). Carpenter's tools are carved in panels which flank the inscription and a basket of tools appears on top of the sarcophagus in reference to the trade of the man commemorated—Thomas Spackman, a local boy who established himself as a master carpenter in London, where he was 'blessed by Providence, after many Years' Industry and Frugality'. Such ornamentation is not peculiar—similar tools will be found on the tablet at Blandford St Mary in Dorset erected to, and probably carved by, the mason architect and carver Francis Cartwright. But the Cliffe Pypard monument is also—above all—a monument to a philanthropist.

Spackman died on 13 October 1786 at Kimbolton. He had no children, but he provided for his widow and left a large portion of his fortune to his six nephews and nieces. In addition he had purchased £1000 of 3% Bank Consolidated Annuities which were to serve to keep this monument in order, to pay for a schoolmaster to teach the three R's to the children of the parish, and to provide bread for the poor. The details of this bequest were, at his behest, inscribed on the monument; and they also provide the chief subject of the sculpture, for, on either side of the sarcophagus, with fluttering drapery and exuberant curls, are a boy and a girl earnestly and contentedly reading and writing, whilst on top of the sarcophagus, with the active contraposto often given to the risen Christ,[1] is Spackman himself benevolently looking down on their progress, a childless man surveying the posthumous consequences of his charity.

Is Spackman portrayed as risen from the dead? And if so, how unusual was this? Were other philanthropists commemorated in this manner? These are

17

9. John Deval the Younger: Monument to Thomas Spackman, Cliffe Pypard, Wiltshire.

the sort of questions which I am concerned to answer in this book. But for the moment the reader must accept that this is in fact a highly original monument in its iconography, as well as being one of the finest, and last, examples of rococo figure carving in this country. The work is signed by John Devall, or Deval as he was also called, a man who succeeded his father, also John, as Master Mason to the Royal Palaces.[2] Deval signs no other monument, no other figure sculpture is ascribed to him, and, although he produced chimney pieces, he was not described as a sculptor, and he may only have supervised the carving. But to him, or his carver, must go the credit for the work's quality. What concerns us here is to whom we must give credit for the iconography.

The inscription suggests that Spackman ordered the monument himself, and from his will, drawn up in the spring of 1782, it is clear that he knew exactly what he wanted: a grave 'walled and arched with good sound brick thoroughly burnt', and, above it, or near it, 'as good and substantial a monument to my memory . . . with three carved figures of the best statuary marble to be set thereon as can be made' for the sum of £1000. He charged his executors to be sure that: 'the centre figure to represent myself in height size and likeness as near as the artist can make the same and that the other two be lesser figures and placed on each side by my own the one representing a school boy the other a school girl each holding a book in one hand and a pen in the other . . .' And he specified that there should be a 'device' on the monument showing 'a carpenter's broad axe and handsaw a square and a pair of compasses with a carpenter's basket full of other tools.' In addition he directed that: 'neat and substantial iron palisadoes fixed in a stone kirb be erected round the said monument to guard the same as good as can be made for fifty pounds over and above the said one thousand pounds.' These 'palisadoes' are no longer in place, but everything else is as Spackman directed.

Spackman appointed his steward, John Rogers, 'a carpenter of Great Tittlefield Street, Oxford Market, London' as his undertaker and directed him to see the monument properly executed 'according to the plan and drawing'. (In a codicil added a few months before his death Spackman also made Rogers an executor.[3]) The plan and drawing would probably have been provided by the sculptor, which suggests that Deval—whom Spackman would have known as a prominent figure among London builders—had been given the commission by 1782. The monument could very easily have been in place by the time Spackman died. The will does not prove that Spackman was responsible for the iconography, but it does show how deeply interested he was in every detail of it. It is a case in which the patron was certainly not simply a customer.

To order a magnificent monument to be erected to oneself was common practice before the eighteenth century, but rare in the late eighteenth century and very rare thereafter. People did continue to leave money for monuments

18

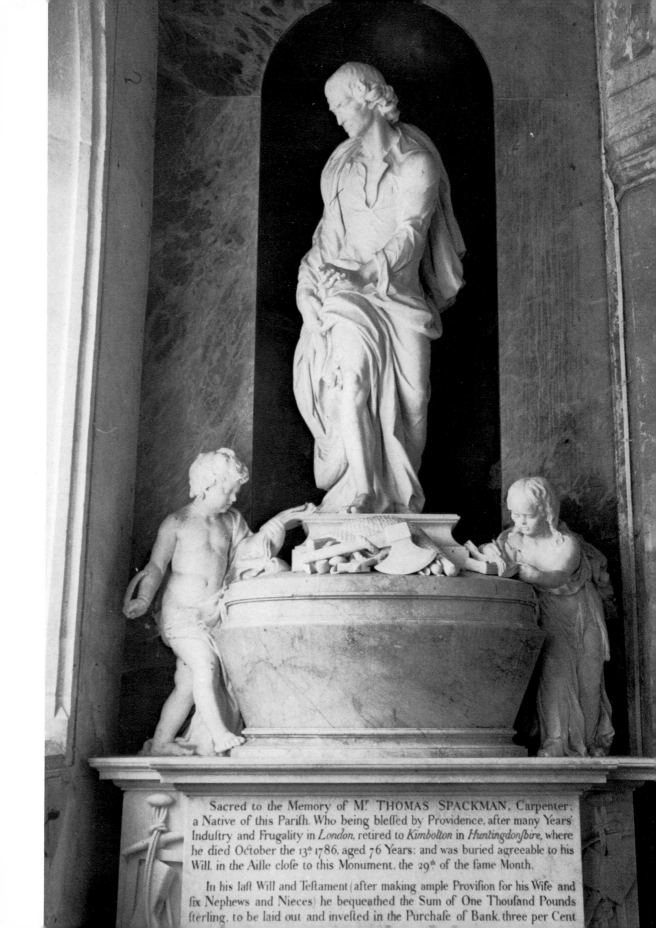

Sacred to the Memory of M.ʳ THOMAS SPACKMAN, Carpenter;
a Native of this Parilh. Who being blelfed by Providence, after many Years'
Indultry and Frugality in *London*, retired to *Kimbolton* in *Huntingdonſhire*, where
he died October the 13.ᵗʰ 1786, aged 76 Years: and was buried agreeable to his
Will. in the Ailfle cloſe to this Monument. the 29.ᵗʰ of the ſame Month.

In his laſt Will and Teſtament (after making ample Proviſion for his Wife and
ſix Nephews and Nieces) he bequeathed the Sum of One Thouſand Pounds
ſterling. to be laid out and inveſted in the Purchaſe of Bank. three per Cent

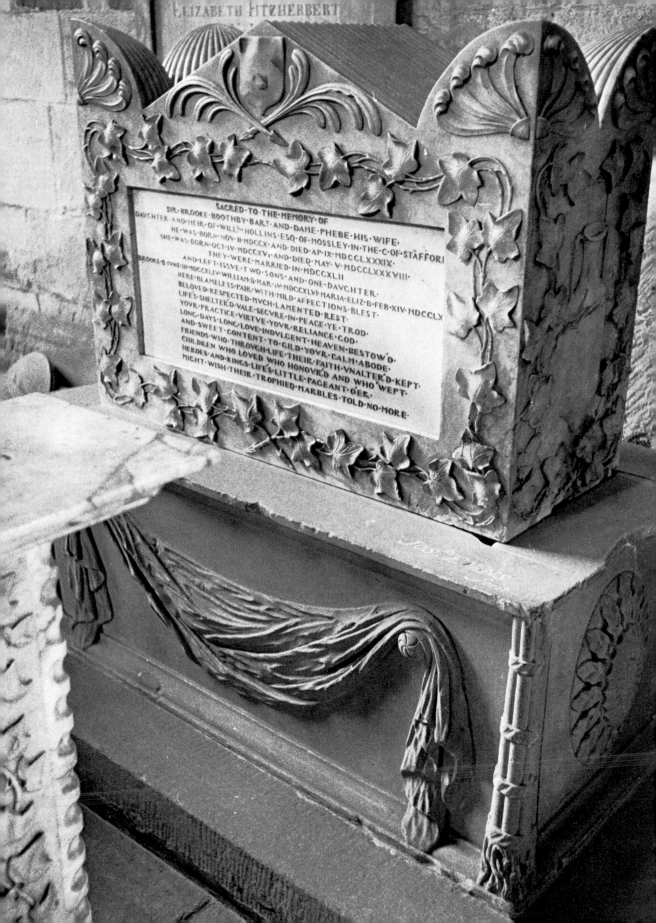

ELIZABETH FITZHERBERT

SACRED·TO·THE·MEMORY·OF
SIR·BROOKE·BOOTHBY·BART·AND·DAME·PHEBE·HIS·WIFE·
DAVGHTER·AND·HEIR·OF·WILL·HOLLINS·ESQ·OF·MOSSLEY·IN·THE·C·OF·STAFFORD
HE·WAS·BORN·NOV·II·MDCCX·AND·DIED·AP·IX·MDCCLXXXIX·
SHE·WAS·BORN·OCT·IV·MDCCXV·AND·DIED·MAY·V·MDCCLXXXVIII·
THEY·WERE·MARRIED·IN·MDCCXLII
AND·LEFT·ISSVE·TWO·SONS·AND·ONE·DAVGHTER·
BROOKE·B·IVNE·II·MDCCXLIV·WILLIAM·B·MAR·IV·MDCCXLVI·MARIA·ELIZ·B·FEB·XIV·MDCCLX
HERE·BLAMELESS·PAIR·WITH·MILD·AFFECTIONS·BLEST·
BELOVED·RESPECTED·MVCH·LAMENTED·REST·
LIFE'S·SHELTER'D·VALE·SECVRE·IN·PEACE·YE·TROD·
YOVR·PRACTICE·VIRTVE·YOVR·RELIANCE·GOD·
LONG·DAYS·LONG·LOVE·INDVLGENT·HEAVEN·BESTOW'D·
AND·SWEET·CONTENT·TO·GILD·YOVR·CALM·ABODE·
FRIENDS·WHO·THROVGH·LIFE·THEIR·FAITH·VNALTER'D·KEPT·
CHILDREN·WHO·LOVED·WHO·HONOVRD·AND·WHO·WEPT·
HEROES·AND·KINGS·LIFE'S·LITTLE·PAGEANT·O'ER·
MIGHT·WISH·THEIR·TROPHIED·MARBLES·TOLD·NO·MORE·

to their ancestors, parents, spouses and so on, but interest in the design of such monuments does not seem to have been as marked as when the matter was more personal. When a man orders his own monument, even if he is generally uninterested in the visual arts, he is likely to take an interest in its imagery. In other cases the men likely to take most interest were 'amateurs' of the visual arts. Among the upper classes there were many such, but they were still a minority, and for every gentleman with distinct ideas about the imagery of the monument he commissioned there were dozens with distinct ideas for the inscription. Several instances of highly original monuments commissioned by such 'amateurs' merit our special attention. Spackman's monument was an unusual one. So are those to which we must now turn.

In Ashbourne church, Derbyshire, Sir Brooke Boothby erected a monument to his mother and father who died in the Spring of 1788 and in the Spring of 1789 respectively. It is a block *stele*, with ears or acroteria, made of a local rusty alabaster and is decorated with ivy, and with *lachrymae* (antique tear vases) on the sides (Plate 10). The elementary form, together with its antique associations, and the *sans-serif* of the inscription on the inserted panel of white marble, mark this as an early instance of neo-classical sepulchral sculpture, comparable with the austere fluted sarcophagus at Wilton designed by James Wyatt for the tenth Earl of Pembroke who died in 1794 (Plate 7) and also repeated as a memorial to Thomas Gray at Stoke Poges, Buckinghamshire. The ivy is used as a simple emblem of clinging memory and as such it was a motif which continued in popularity throughout the nineteenth century, and is often found adorning Victorian headstones. By contrast the floral ornamentations of the rococo cartouche monuments earlier in the eighteenth century had tended to be purely decorative.[4]

This monument rests on a stone altar tomb, which is neither congruous in style nor in shape; but the prominent signature of Josh Evans is so placed on it that it must be taken to refer to the work above.[5] Evans was a provincial statuary who could not possibly have conceived of a monument of this originality. Boothby, on the other hand, was particularly interested in plants and a co-founder, with Erasmus Darwin, of the Lichfield Botanical Society. He was also a friend of artists such as Wright of Derby, Fuseli and Banks, and he was responsible for erecting, in the same church, a monument to his daughter which is one of the most original sculptures of the eighteenth century (and a work to which we will attend in a later chapter). The invention here is surely Boothby's.

Boothby was an ardent follower of Rousseau and one of his friends was the eccentric Lord George Simon Harcourt who refused to be addressed as 'my Lord' and removed the coronets on his carriage doors. Harcourt, however, changed his views in 1784, giving away his Brutus ring and going to Court. By the time of his death in 1809 he was remembered as an 'inflexible observer of every rule of courtly etiquette', remarkably proud of his ancient French lineage. (Nevertheless, he bequeathed a miniature of Rousseau to Boothby in

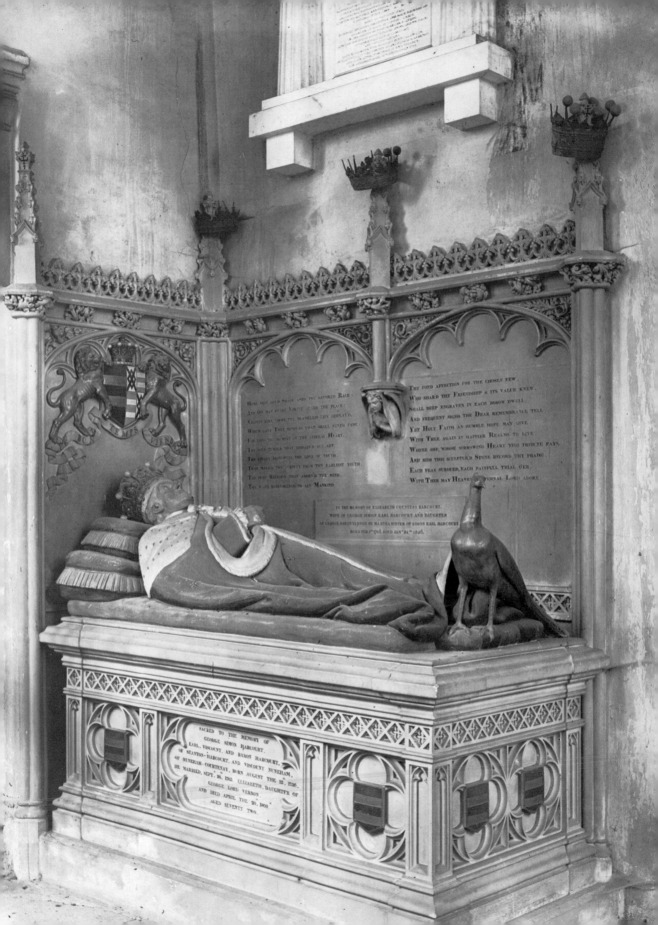

his will.) Harcourt was a friend of William Mason and of Horace Walpole, a keen patron of the arts and an important innovator in garden design;[6] and one would suppose that this, combined with romantic conservatism, accounts for the fact that he is commemorated at Stanton Harcourt, Oxfordshire, by one of the most precocious examples of the gothic revival in tomb-sculpture— a recumbent effigy on a tomb-chest, carved out of free-stone, correctly imitating a rather poor style of gothic, even deliberately stiff in the pose of the figure, and—what is most extraordinary—polychrome (Plate 11). We may deduce from the way that the epitaph to Harcourt's wife is added that the monument was erected before the summer of 1826 when she died. There is no evidence as to who commissioned the work or as to who carved it amongst the uncatalogued Harcourt papers in the Bodleian Library, and in his will Harcourt merely requested that he be interred with his ancestors and that the expenses of his funeral 'be not greater than decency requires'.[7] The tomb looks like the work of a local mason with some experience in imitating gothic for the purpose of restoration, but such a man would not have proposed so novel a type of monument. The idea must have come from some antiquary in Harcourt's family or circle of friends—and here too the originality is an 'amateur's'.

The Greek and gothic revivals are as evident in church monuments as they are in architecture, but the 'Jacobean' and the Italian Renaissance revivals are not generally important for monuments, nor is the rococo revival in interior decoration. Nevertheless, there is a pair of eccentric monuments in the de Grey mortuary chapel at Flitton, Bedfordshire which revive, and unwittingly parody, the rococo style of the early eighteenth century. The most remarkable is a cartouche, capped with a coronet, and furnished with grey marble curtains in which a flying putto is entangled (Plate 12). It commemorates

11. (left) Monument to Lord Harcourt, Stanton Harcourt, Oxfordshire.
12. (right) W. T. Kelsey: Monument to Lady Grantham, Flitton, Bedfordshire.

23

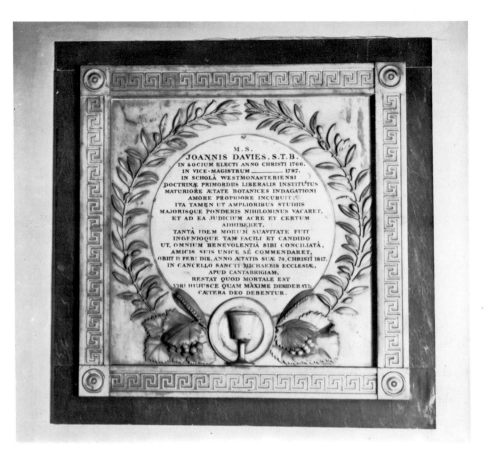

M.S.
JOANNIS DAVIES, S.T.B.
IN SOCIUM ELECTI ANNO CHRISTI 1766.
IN VICE-MAGISTRUM _____ 1797.
IN SCHOLÂ WESTMONASTERIENSI
DOCTRINÆ PRIMORDIIS LIBERALIS INSTITUTUS
MATURIORE ÆTATE BOTANICES INDAGATIONI
AMORE PROPRIORE INCUBUIT;
ITA TAMEN UT AMPLIORIBUS STUDIIS
MAJORISQUE PONDERIS NIHILOMINUS VACARET,
ET AD EA JUDICIUM ACRE ET CERTUM
ADHIBERET.
TANTÂ IDEM MORUM SUAVITATE FUIT
INGENIOQUE TAM FACILI ET CANDIDO
UT, OMNIUM BENEVOLENTIÂ SIBI CONCILIATÂ,
AMICIS SUIS UNICE SE COMMENDARET,
OBIIT I? FEBR? DIE, ANNO ÆTATIS SUÆ 74, CHRISTI 1817.
IN CANCELLO SANCTI MICHAELIS ECCLESIÆ,
APUD CANTABRIGIAM,
RESTAT QUOD MORTALE EST
VIRI HUJUSCE QUAM MÂXIME DESIDERATI;
CÆTERA DEO DEBENTUR.

Baroness Grantham, the mother of Thomas Philip, second Earl de Grey and third Lord Grantham, who commissioned the work, and who was also rebuilding Wrest Park in the style of Louis XV at this period.[8] The monument is signed by W. T. Kelsey of Brompton whose other works are standard tablets lacking any imagination; so the invention here was surely entirely Lord de Grey's.

For an 'amateur' to instruct W. T. Kelsey of Brompton, Joseph Evans of Derby, or a local Oxfordshire mason is one thing, but to instruct a leading sculptor is likely to be a more complicated matter for which documentary evidence is more desirable. Such evidence exists for a tablet by Flaxman to the Reverend John Davies in the vestry off the ante-chapel of Trinity College, Cambridge (Plate 13). Davies was Junior Bursar at Trinity from 1782 until 1790, and Vice Master from 1797 until 1806; he was also University librarian from 1783 until his death in 1817. Two of his friends John Hawkins, a traveller, antiquarian and horticulturalist, and Thomas Kerrich, an antiquarian and amateur artist, supervised Flaxman's designs. The former had studied at Trinity and had a son in residence there at this date, whilst Kerrich had served as Davies's deputy in the library and succeeded him as librarian.[9]

13. (left) John Flaxman:
Monument to John Davies,
Trinity College Antechapel,
Cambridge.
14. (right) John Flaxman:
Monuments to Elizabeth
Ellis the elder and younger,
St George's, Esher, Surrey.

Kerrich and Hawkins seem to have asked Flaxman for a sketch early in
1823. In the former year Flaxman had erected a double monument in St
George's Church, Esher, Surrey to Elizabeth Ellis who died in 1803 and to
her daughter, also Elizabeth, who was 'cut off' in 1820.[10] The younger
woman is commemorated by a tablet placed on top of the larger and rather
ungainly monument to her mother (Plate 14). It incorporates a garland of
lilies (with copper stamens) joined by a rose. The lilies are a simple emblem,
like the ivy of remembrance, but particularly proper for a young maiden.
Flaxman, however, was a busy man and thought that he would present the
same wreath to an aged academic; and his first idea for the Davies monument
was very similar to the Ellis tablet, only with a chalice and a patera at the
bottom, together with a lyre. Kerrich thought lillies and roses 'too common'
for a botanist and the lyre unsuited to a man who was 'hardly a poet'.[11] On 7
March 1823 Flaxman wrote to Hawkins reporting Kerrich's views (which
Hawkins shared) and including a new sketch, retaining the chalice and patera,
which both men had commended 'as particularly indicative of the Sacred
Offices of the clerical character', and adding emblems of the eucharist—'a
small sprig of vine on each side, with an ear of corn grouped with each',
carefully designed to unite the chalice and patera with a garland, not of

flowers, but of olive—'the emblem of peace as well as every liberal attainment and beneficial pursuit.'[12] Kerrich reported the unanimous approval of the Master and Fellows of Trinity.[13]

The final design, with its chaste conjunction of Christian and Greek imagery, is highly characteristic of Flaxman, yet it cannot be said to have been wholly his idea. Moreover, Hawkins, as well as Flaxman, must be given credit for the naturalism of the carving—and in particular for the pleasing irregularities of the olive garland. He insisted on supplying the sculptor with a particular specimen of olive which he sent to him pressed in a folio volume in November 1823.[14] Hawkins was something of an authority on olives, vines and corn[15]—all the plants which are carved here—and Flaxman would have been conscious that his patron's exacting standards were not merely confined to the iconography.

So far I have stressed the active part played by the patron in determining the appearance of a monument. Very often, however, we must suspect a dialogue between patron and artist but simply do not know what form it took. An earlier monument by Flaxman in Bath Abbey is a case in point. It commemorates John Sibthorp (Plate 15).

John Sibthorp succeeded his father, Humphrey, as Sherardian Professor of Botany at Oxford University, attaining, however, greater eminence as a founder of the Linnaean Society and by travelling, in spite of the perils of pirates, perfidious mule guides, plagues and hostile pashas, in search of the flora of Greece, Cyprus and the Levant. His enterprise was partially motivated by a desire to check the Natural History of the Ancients (he hoped of course to endorse the validity of their observations) and also to investigate the degree to which ancient knowledge and nomenclature had survived in the lore of shepherds and monks. He investigated fishes and birds, grottoes, shrines, old inscriptions and all curious local customs (such as the way that Cypriot girls stained their eye-lids) as well as flowers. He made three journeys before his early death, in 1796, aged thirty-eight, as a consequence of a chill caught on a visit to Nicopolis.[16]

Flaxman casts the deceased in the role of a Greek traveller wearing sandals, a short cloak (or *chlamys*), and a hat (*petasus*) slung on his back, inspired perhaps by an attic relief such as the grave *lekythos* of Hegemon now in the Fitzwilliam Museum (Plate 16), but then in the possession of Sibthorp's friend, J. Spencer Smith.[17] The monument is a very early case of a consciously severe Greek revival relief: the carving is crisp (the *acroteria* almost appear to have been snipped out of stiff card) and the frame is unmoulded. In the pediment there is a garland of *Sibthorpia Europea*, the Cornish Moneywort, a little creeper named by Linnaeus after Sibthorp's father.[18] But the important flowers are those which Sibthorp carries. Are these simply the botanical specimens with which the traveller returned to his homeland, or are we also to see him as a pilgrim carried now by Charon to 'the other side' still dwelling on earth's beauties? If the botanist's peregrinations

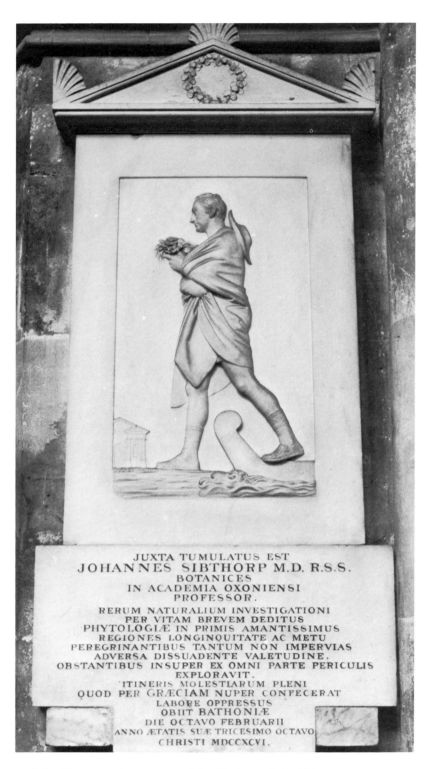

JUXTA TUMULATUS EST
JOHANNES SIBTHORP M.D. R.S.S.
BOTANICES
IN ACADEMIA OXONIENSI
PROFESSOR.

RERUM NATURALIUM INVESTIGATIONI
PER VITAM BREVEM DEDITUS
PHYTOLOGIÆ IN PRIMIS AMANTISSIMUS
REGIONES LONGINQUITATE AC METU
PEREGRINANTIBUS TANTUM NON IMPERVIAS
ADVERSA DISSUADENTE VALETUDINE.
OBSTANTIBUS INSUPER EX OMNI PARTE PERICULIS
EXPLORAVIT.
ITINERIS MOLESTIARUM PLENI
QUOD PER GRÆCIAM NUPER CONFECERAT
LABORE OPPRESSUS
OBIIT BATHONIÆ
DIE OCTAVO FEBRUARII
ANNO ÆTATIS SUÆ TRICESIMO OCTAVO
CHRISTI MDCCXCVI.

15. John Flaxman: Monument to John Sibthorp, Bath Abbey.

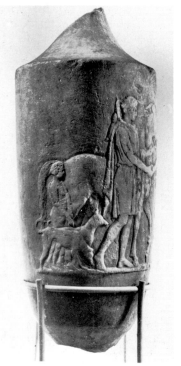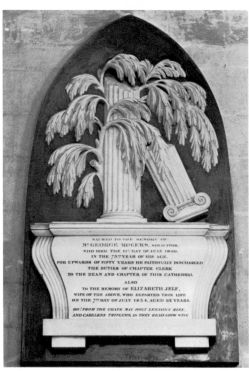

are here seen as emblematic of man's journey through life, then we have a man's profession providing a religious metaphor—a rare and sophisticated equivalent to the watchmaker's epitaph which informs us that he is 'wound up in hopes of being taken in hand by his maker', or to the engine-driver's elegy which commences:

> My engine now is cold and still,
> No water does my boiler fill.[19]

The payments for this monument were made between 1799 and 1802 by Thomas Platt of Brunswick Square, London, one of Sibthorp's three executors, but Platt was not carrying out any wish expressed in Sibthorp's will.[20] Most probably the idea that there should be a monument and that Flaxman should be employed came from another executor—someone we have already met with—John Hawkins. Hawkins was a friend and kinsman by marriage, a travelling companion of Sibthorp and a fellow member of the Ottoman Club.[21] He was keenly interested in the arts and a member of the Dilletanti.[22] He had helped Flaxman during the sculptor's Roman residence in the 1780s; Flaxman had arranged for the import of Hawkins's antiquities, some of which he also restored; and the two men kept in touch through a common friend, the poet Hayley.[23] Bearing in mind how large a part Hawkins played in supervising the monument to Davies, one must also wonder whether some credit for the originality of this monument should not also go to him.

16. (far left) Grave relief of Hegemon, Fitzwilliam Museum, Cambridge.
17. (left) T. Tyley: Monument to George Rogers, Bristol Cathedral.
18. (right) Thomas King: Monument to Robert Walsh, Bath Abbey.

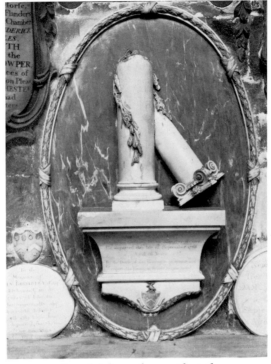

There are of course a great many cases in which we know that the person who commissioned the monument cannot have taken an active part in devising the imagery, because the imagery had already been employed many times elsewhere. In fact this was most commonly the case: sculpture as original as the Sibthorp monument, or as any of the other monuments considered so far in this chapter is exceptional. And it is time we turned to popular conventions, and to customers rather than patrons.

An emblem which enjoyed great popularity was that of the broken column. By 1850 this was a cliché in cemeteries and in mourning jewellery. It had long been used by second-rate London statuaries such as Manning[24] and had become popular with provincial firms such as the Tyleys of Bristol who sign the tablet in Bristol Cathedral to a chapter clerk, George Rogers, who died 12 July 1840 (Plate 17). During the seventeenth century and most of the eighteenth century the broken column sometimes appeared in monuments as an attribute of Fortitude or Constancy.[25] It was first employed prominently and by itself in the monument in Bath Abbey erected by Thomas King of Bath to the memory of Lieutenant Colonel Robert Walsh who died 12 September 1788.[26] Here we see a broken ionic column, clad with yew, placed against an oval ground of streaked grey marble (Plate 18). This epitaph gives a clue as to the emblem's meaning: 'By the death of this gentleman an ancient and respectable family in Ireland became extinct', and Richard Warner in his *History of Bath* of 1801 considered it as the monument 'most remarkable for happiness of design' in the entire Abbey—the broken column designating

29

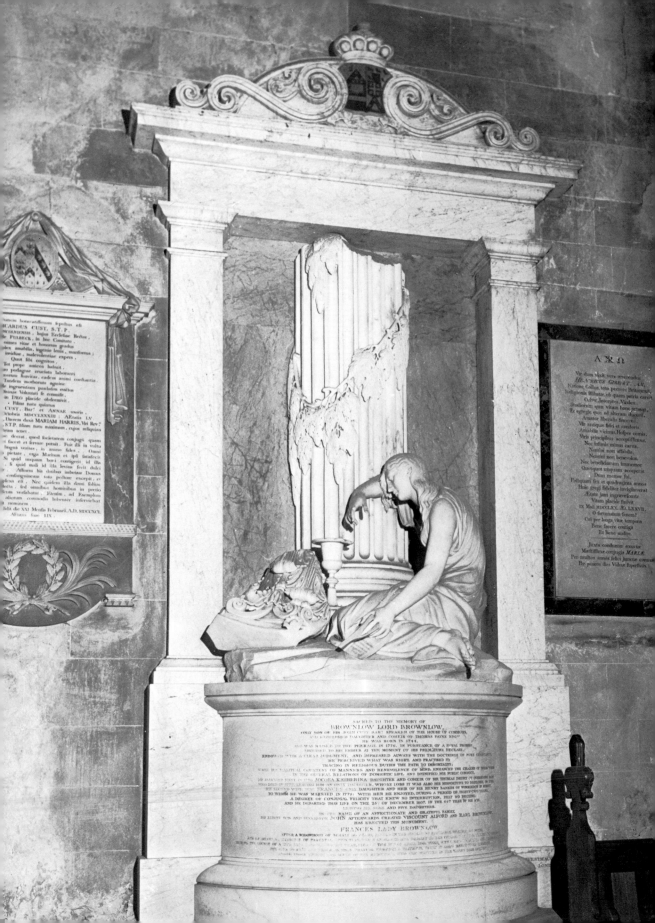

19. (left) Richard Westmacott: Monument to the first Lord Brownlow, Belton, Lincolnshire.
20. (right) Tombstone in Handsworth Churchyard, Birmingham.

'the line of descent being overturned'. Leading sculptors took up the theme, adding a mourning figure—Flaxman did so, for instance, in a monument to William Miles, a West India merchant, who died in 1803, a monument erected by Miles's son at Ledbury, Herefordshire. By that date the column's meaning must have been interpreted very loosely—for Miles did not die childless (nor was his life cut off in its prime, for he died aged seventy-five). Westmacott also used the idea a number of times[27]—the best example perhaps being the monument in the chancel at Belton, Lincolnshire, to the first Lord Brownlow who died in 1807. Here a life-sized, female mourner leans against the fluted shaft of a column, a Bible in her hand, a chalice and the shattered corinthian capital by her side (Plate 19).

Whatever light might be shed by documents on the reasons for earlier cases of the prominent uses of this emblem they are unlikely to be of much assistance in assessing why it proved so popular. For sentimental appeal it was perhaps only equalled by the motif of the cut or broken flower. This is not uncommon in Victorian headstones—there is a fine example in the churchyard of St Mary's, Handsworth (Plate 20)—and the Tyleys of Bristol again provide an instance in Bristol Cathedral of its popularity with provincial sculptors (Plate 21). The broken lily in the panel on the left stands for Frances Lamb who died aged thirteen in 1840: the two broken buds on the right for her two younger brothers who died in the same year.[28] The earliest occurrence of the motif that has come to my notice is the broken lily on the marble urn at Harefield, Middlesex, commemorating Diana Ball who died

31

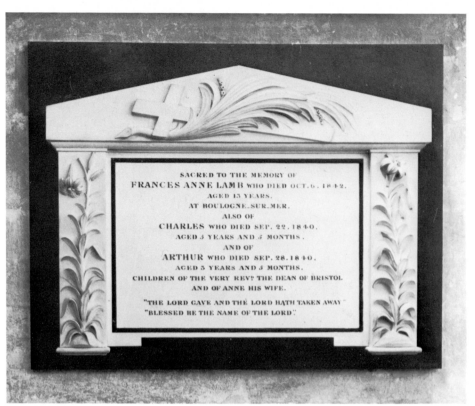

SACRED TO THE MEMORY OF
FRANCES ANNE LAMB WHO DIED OCT. 6. 1842.
AGED 13 YEARS.
AT BOULOGNE-SUR-MER.
ALSO OF
CHARLES WHO DIED SEP. 22. 1840.
AGED 3 YEARS AND 3 MONTHS.
AND OF
ARTHUR WHO DIED SEP. 28. 1840.
AGED 3 YEARS AND 3 MONTHS.
CHILDREN OF THE VERY REV? THE DEAN OF BRISTOL.
AND OF ANNE HIS WIFE.

"THE LORD GAVE AND THE LORD HATH TAKEN AWAY"
"BLESSED BE THE NAME OF THE LORD".

21. (above) J. and T. Tyley: Monument to the Lamb children, Bristol Cathedral.
22. (right) Richard Westmacott: Monument to Mrs Eardley Wilmot, Berkswell, Warwickshire.

aged eighteen on 23 February 1765. There are several other late eighteenth-century monuments which use the motif.[29] But it was popularized by Westmacott, usually in monuments to children, maidens or young wives 'cut off in the flower of their youth'.[30] The relief panels of roses and sickles on either side of his large relief monument at Berkswell, Warwickshire to Mrs Wilmot who died in 1818 (Plate 22) are typical—and, incidentally, probably the source for the Handsworth headstone. Another example is the darkened tablet in St Philip's, Birmingham to Beatrix Outram, wife of the rector (Plate 23). Brought up in Cambridge where her uncle, Thomas Postlethwaite, was Master of Trinity, she died in Birmingham, aged thirty, in 1810. A 'tender plant', according to the inscription, she 'droop'd and died' when removed from the 'fost'ring gales that breath on Cam's fair margin'—which explains the unhappy rose at the bottom of the tablet. 'But time will be, sweet plant! a gale divine shall thee revive'—hence the rose bud in a glory at the top of the tablet. The verse inscription was no doubt written by the Reverend Outram and it prompted the imagery Westmacott used, but then this was at most an original variation on a hackneyed theme; and, besides, the theme was not original in verse.[31]

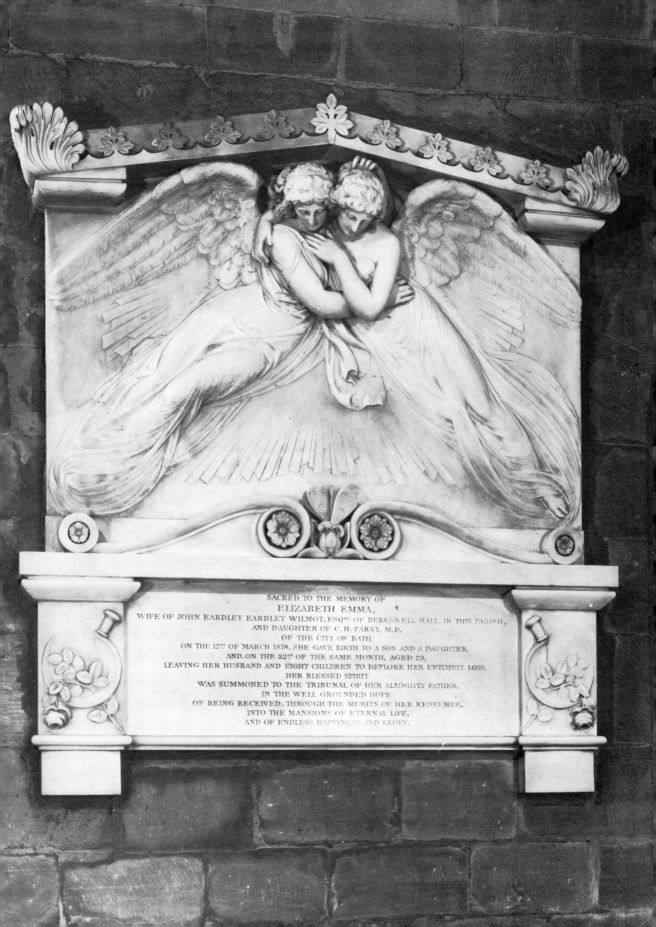

SACRED TO THE MEMORY OF
ELIZABETH EMMA,
WIFE OF JOHN EARDLEY EARDLEY-WILMOT, ESQ.ᴿᴱ OF BERKSWELL HALL, IN THIS PARISH,
AND DAUGHTER OF C. H. PARRY, M.D.
OF THE CITY OF BATH.
ON THE 12ᵀᴴ OF MARCH 1818, SHE GAVE BIRTH TO A SON AND A DAUGHTER,
AND, ON THE 22ᴺᴰ OF THE SAME MONTH, AGED 29,
LEAVING HER HUSBAND AND EIGHT CHILDREN TO DEPLORE HER UNTIMELY LOSS,
HER BLESSED SPIRIT
WAS SUMMONED TO THE TRIBUNAL OF HER ALMIGHTY FATHER,
IN THE WELL GROUNDED HOPE
OF BEING RECEIVED, THROUGH THE MERITS OF HER REDEEMER,
INTO THE MANSIONS OF ETERNAL LIFE,
AND OF ENDLESS HAPPINESS AND GLORY.

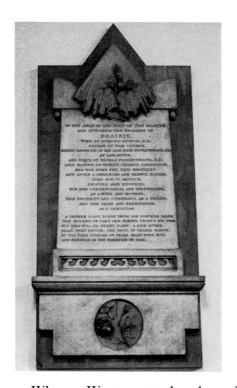 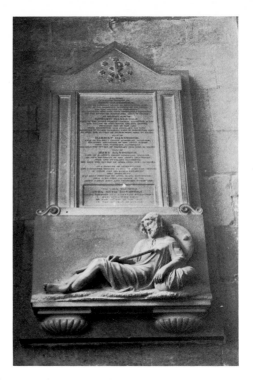

Whereas Westmacott played a major part in popularizing broken columns and cut flowers, there were some popular conventions which he seems to have first introduced. One example, related to the cut flower, is the motif of an angel reaping, looking up for divine sanction with sickle poised.[32] Westmacott was also interested in the metaphor of life as a journey and of the deceased as a weary pilgrim. There are at least four monuments in which he carved a relief of a reclining traveller, holding a staff and wearing a pilgrim's hat. The monument to various members of the Daddridge family erected in Malvern Priory in the late 1830s is a good example[33] (Plate 24). At Stradsett in Norfolk, on the monument to Thomas Bagge who died 3 June 1827 he included two round reliefs, one of poppies, the emblem of sleep, and the other a still-life of the pilgrim's equipment. But best of all is the life-size high-relief monument at Belton to Caroline, Countess Brownlow who completed 'her earthly pilgrimage' in 1824. Westmacott does not risk ridicule by showing her wearing the equipment, but portrays her seated, resting her arm on a Bible and holding a lily and a rose, with the staff and the hat with St James's cockle-shell beside her bare feet (Plate 25). It has been suggested that Flaxman wished to employ this metaphor in his Sibthorp monument, but Westmacott is much more explicit. Westmacott's source may have been painted portraits of ladies as pilgrims (Francis Wheatley, for instance, signed one in 1790), or literature.

In discussing conventions in church monuments it is helpful to seek for the expression of a similar sensibility in the literature of the period. In an essay

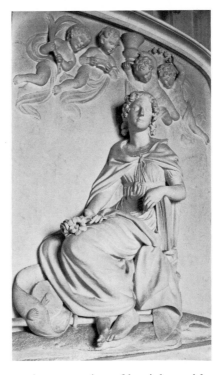

written in 1810 Wordsworth discussed the ancient practice of burial outside the city walls, by the side of country roads, and reflected on how the epitaphs there appealed directly to the traveller's situation and surroundings with metaphors of beauty faded like a flower, of greatness struck down like a tree by lightning, of life as a journey, and of death as the pilgrim's rest. It is no doubt a coincidence that Westmacott used the emblem of the shattered tree in his monument at Wilton, Wiltshire to the eleventh Earl of Pembroke (Plate 8)[34], but it is appropriate because emblems such as the shattered tree, or the broken column, the cut flower or the resting pilgrim all share a homely simplicity—an appeal to common experience, an echo of a common figure of speech or well-known phrase in the Bible. They avoid being erudite 'epigrammatical conceits', in Flaxman's words; and what they all risk is triteness, the risk Wordsworth and his followers were also taking in their verse. A discipline of Wordsworth's whose work is particularly pertinent in this connection is William Lisle Bowles. We might compare the theme of his 'Epitaph on John Harding', inscribed on a grave in Bremhill Churchyard, with a Westmacott relief:

> Lay down thy pilgrim staff upon this heap,
> And till the morning of redemption sleep,
> Old wayfarer of earth! From youth to age,
> Long, but not weary, was thy pilgrimage,
> Thy Christian pilgrimage . . .[35]

35

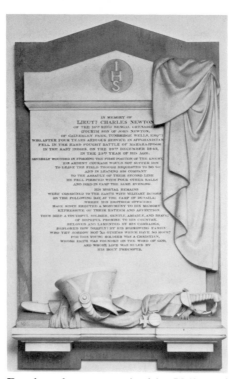

26. Richard Westmacott the Younger:
Monument to Lieutenant Charles Newton,
Holy Trinity, Tunbridge Wells, Kent.

Bowles also wrote, in his *Villagers' Verse Book* poems employing simple images from everyday rural life which could be learnt by heart by the children who attended sunday school (held, in summer, on the parsonage lawn), and one of these, 'The Mower', may be compared with Westmacott's reliefs of reaping angels.[36]

Some of the most popular conventions in commemorative sculpture were military ones. The use of the antique trophy—a triumphant 'glory' composed of the heaped up arms of hypothetical conquered enemies (Plate 5)—gave way in the nineteenth century to a far less pompous convention in which a few touching personal relics (also, it is true, evidence of rank) were arranged in an informal still-life. Westmacott the younger's monument in Holy Trinity, Tunbridge Wells, Kent, to Lieutenant Charles Newton of the Bengal Grenadiers, who died 29 November 1843, aged twenty-three, is one of hundreds of examples (Plate 26). It is not poetry that we should turn to find a parallel for this, but to accounts of officers' funerals which suggest that a display of sword, sash, helmet and medals as shown on Westmacott's relief was common on top of the coffin.[37] The custom remains and when Field Marshal Montgomery was buried on 1 April 1976 his coffin was adorned with his beret and ceremonial sword, close-up photographs of which were carried by the front-pages of the next day's newspapers.

The reader has now sampled the variety of approaches which will be taken in the chapters which follow. In the case of some original monuments an investigation of that particular commission may be undertaken. In the case of

36

conventions an effort will be made to relate them to themes which can be found in contemporary literature, and, sometimes, practice. The former procedure is the safest. But it is not, by itself, enough. This is immediately clear when one asks how these church monuments can help us to measure the depth of Christian faith in this period.

The slightest aquaintance with English literature will convince one of the confidence and indeed excitement with which seventeenth and early eighteenth-century poets contemplated the Christian 'future state'. Yet the greatest elegy by an English romantic poet—Shelley's *Adonais*—makes no reference whatever to Christianity (although Christ is coupled with Cain as a type of the outcast poet and prophet). And later Tennyson's *In Memoriam* gives expression to a perplexed, tentative and highly personal faith which the poet clearly does not assume that we share. Amongst the European intelligentsia during the eighteenth century scepticism was not uncommon and had been, in some circles, fashionable: and, during the romantic period, the authority of the Christian Church was further threatened by the enquiries of textual critics and geologists, whilst belief in the resurrection of the body grew more and more difficult to reconcile with the premises of natural science.[38] There were some who wished to announce their scepticism after death. John Baskerville, type-founder, printer and japan manufacturer was buried in 1775, according to his wishes, in a tomb in his grounds boldly inscribed with a notice that he was 'inurn'd' in unconsecrated ground, and with this wish: 'May the example contribute to emancipate thy mind from the idle fears of *Superstition* and the wicked arts of Priesthood'.[39] Lord Byron wished to be buried with his dog Boatswain in the unconsecrated vault which he constructed for that beloved animal at Newstead (Plate 27).[40] But these were eccentric cases. And, as I have already pointed out, at this date relatively few people commissioned their own monument.

The third Earl of Egremont, who became, in his old age, a great patron of British painting and sculpture, was unconventional enough to live openly with his mistress, but his position in society was such that he could not afford to give any publicity to the scepticism which he had adopted in his youth from the French *philosophes* so favoured in the circle of Fox and the Prince of Wales.[41] In private letters he remained a 'scoffer', calling the Society for the Propagation of Christian Knowledge a 'hypocritical rabble' and the Church 'the house of fraud'[42]; and he reflected thus on what Christian imagery was suitable for sculpture:

Our God Almighty has a good deal of the majesty of Jupiter & something of his morals, but his progeny is too beggarly for sculpture. I have often thought of the Holy Ghost & believe something very beautiful poetical & airy might be made of him, but where is the sculptor bold enough to undertake him. The very thought would make Flaxman's hair stand on end . . .[43]

27. Monument to Lord Byron's dog Boatswain, Newstead, Nottinghamshire.

In spite of this, services were held in the chapel at Petworth, and at Christmas Egremont received the sacrament (in 1819 he expressed a hope that it would 'do some good hereafter' since it had thoroughly chilled his fingers).[44] He was given a Christian burial and is commemorated in Petworth Church (which he restored) with a statue by E. H. Baily. The statue shows him seated in a contemplative attitude. The same convention was used for a number of bishops.

It is most unlikely that many monuments reflect in any direct way a decline in the religious faith of those for whom, or by whom, they were erected. Looked at in a more general way, however, certain of the conventions which will be discussed in this book may reflect the diminished, or at least diluted, force of the Christian faith in the imagination of the educated classes. The portrayal of the deceased as someone who is 'asleep' can be related to a reluctance to face—as a Christian should—the prospect of bodily corruption. And the tendency to concentrate upon the grief of those who kneel by the deathbed, or by urns or tombs, suggests not the soul's survival, but the survival in the memory of friends and relatives—the only form of afterlife accepted by Ugo Foscolo in his great romantic poem, *I Sepolchri*, and the best consolation that many mourners today can muster.[45]

However, this is only one side of the picture, for the age of romanticism was also an age of religious revival. In England the Evangelical movement, which men like Egremont so detested and, later on, the High Church revival were to make the Victorian age a profoundly religious one—so much so in fact that those who criticized and abandoned the Church often appear religious in their 'honest doubt', at least when contrasted with the scepticism of the 'Enlightenment'. Much sepulchral sculpture of the early nineteenth century reflects the new found piety of the upper classes, as will appear again and again in this book. And if the straightforward acceptance of the afterlife was no longer common, then a romantic fascination with the 'unknown' led to a considerable increase of interest in the spiritual world, 'beyond the shadow of our night', and this is certainly reflected in Church monuments from 1800 onwards. It is impossible to discuss precisely, and hard to discuss fairly, changes in religious attitude when so much that was not deliberately concealed was only revealed unconsciously. But the attempt is worth making and the reader will no doubt add his own reflections to those which will be cautiously advanced later in this book.

3. Dynastic Pride
and Domestic Sentiment

CHURCH monuments require church walls, but churches have seldom been designed for monuments and have suffered greatly as a consequence. Bath Abbey has virtually no wall space left uncovered by them (Plate 28)—in the words of an anonymous epigram:

> These walls, adorned with monument and bust,
> Show how Bath waters serve to lay the dust.

And the columns were once covered by monuments as well. In Westminster Abbey, windows were bricked up to accommodate more monuments, and there, as elsewhere, old monuments were removed to make room for new. The first monuments were permitted in St Paul's in the 1790s. By the time Wordsworth wrote his forty-fifth Ecclesiastical Sonnet in 1821 it was

> Filled with mementos, satiate with its part
> Of grateful England's overflowing Dead.

The fact that monuments—even those erected by some 'rich quondam tradesman'—were so 'huge great' that they seriously encroached upon the congregation's space was lamented by Weever in the early seventeenth century.[1] And in the early eighteenth century we may follow the dispute between Kneller's widow and Alexander Pope over the way that her projected monument to her husband and herself was intended to replace Pope's monument to his father—a dispute which is immortalized in Pope's lines:

> One day I mean to Fill Sir Godfry's tomb,
> If for my body all this Church has room.
> Down with more Monuments! More room! (She cryd)
> For I am very large, and very wide.[2]

We know how much the possession of pews was debated and it seems that

40

28. Bath Abbey, the North Aisle.

similar contention over wall-space for monuments was not uncommon. But the greatest damage to the architecture of English churches was done by the great families with whom no one in the parish could quarrel—least of all the parson, whose living was in their patronage.

The entire chancel at Warkton in Northamptonshire is devoted to four gigantic monuments to the Montagues, with the consequence that it is almost impossible to be more than peripherally conscious of the altar. The two large monuments to the Duttons to left and right of the altar at Sherborne in Gloucestershire have a similar effect and other families were no less industrious in converting whole churches into their mortuary chapels. The Harcourt family, having filled Stanton Harcourt with monuments, moved to Nuneham Courtenay in the 1860s. The Ancasters so overcrowded Edenham Church in Lincolnshire that their descendants had to be accommodated in neighbouring Swinstead.

As a rule, when a church is filled with monuments to a single family, the biggest or the earliest will be found in the chancel. This was not only the most prestigious area of the building, but to place a monument there was a way of making it clear that one owned the living—for the chancel was the responsibility of the tithe-owner rather than of the tithe-payer.

More frequently than taking over an entire church a great family would keep to one transept or large side chapel which could serve as a pew for the living as well as a vault for the dead. Some very powerful families built wings

41

onto the side of the church, which had the advantage that they could be enlarged as more dead branches of the family tree accumulated. Of these, the de Grey chapel at Flitton in Bedfordshire, is especially large—almost as large as the church to which it is attached. Of the eighteen monuments which it contains, only four could be described as small and some are ten feet wide. I am calling these wings chapels, but there is little to encourage one to pray inside them.

A well documented case of a family enlarging a church to accommodate more monuments can be followed in the Bridgewater family papers. Soon after the seventh Earl's death in 1823, a special chapel was built by Wyattville south of the chancel in Little Gaddesden church, Hertfordshire; and in this Westmacott's relief monument to the Earl (Plate 140) was erected as the 'altar-piece'. At about the same date the eighth Earl, living in Paris, added a codicil to his will, leaving money for a column to the 'Canal Duke', for an obelisk to his parents, and for a church monument for himself.[3] After his death in 1829 it was clear that his monument would not be a modest one (£4000 had been left to pay for it) and Clarke, the Bridgewater agent notified the executors that a new chapel would have to be built. Jenks, the rector, then objected to any more space being made for the dead Bridgewaters unless more space was also made for his flock. Behind Jenks was the seventh Earl's widow who strongly objected to the late Earl having a more splendid monument than 'any of his ancestors had'. It was not until the Spring of 1831 that the disputes died down and Westmacott was approached to design a relief monument of the birds, fishes, beasts, flowers and rocks which the Earl wished to be studied in the Bridgewater Treatises. This was complete by that December and now hangs, poorly lit, at the entrance to the seventh Earl's chapel.[4] Such family rivalry was no doubt common enough: such problems with space were very common.

In mortuary chapels, such as that at Little Gaddesden, the family could keep together without mixing with anyone of a lower station: on the last day it would be possible for the whole clan to ascend together (quarrelling in the case of the Bridgewaters about precedence at the gates of Heaven); and with this occasion in mind coronets were often placed on top of the coffins. In their concern for sepulchral status the English upper classes appear to have almost approached the Pharaohs. After the coffin of the fifth Duke of Bedford had been taken in procession from Woburn to Chenies (a groom leading the Duke's favourite horse behind the mourning coaches), and the burial service had been held, the vault was left open for inspection for a few days. 'It then contained fifty-one members of the family, two of them embalmed in upright coffins. The coffin of the famous Lord William Russell was surrounded by iron bars, to prevent any too jealous admirers from extracting portions of the exterior.'[5]

All efforts were made to transport those who died abroad back to their proper vaults. The dead Earl of Bristol was disguised as an antique statue

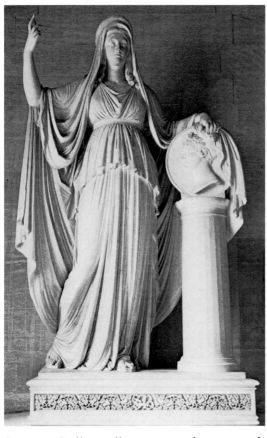

29. Antonio Canova: Monument to Lady Brownlow, Belton, Lincolnshire.

because Italian sailors were reluctant to include corpses with their cargo.[6] Less superstitious English sailors were known to drink the spirits in which Anglo-Indian corpses were preserved.[7]

Dynastic pride must have been the chief motive behind the creation of exclusive repositories for a single family's monuments (and dead), but sometimes the family was aware that a monument required a separate setting, harmonious in style and also private and solemn, as at Wetherall in Cumberland, Ilam in Staffordshire, and Handsworth, near Birmingham, where special chapels were constructed for Nollekens's monument to Mrs Howard, for Chantrey's monument to David Pike Watts, and for Chantrey's monument to James Watt. These chapels were sufficiently detached from the church. But this was not always the case. At Belton in Lincolnshire a gothic chapel was added to the Church in 1816 by Wyattville[8] because there was no space left in the chancel for Canova's monument to Lady Brownlow, who had died two years before (Plate 29). Subsequent monuments—that to the next Lady Brownlow by Westmacott (Plate 26) and that to the first Earl by Marochetti—were carefully related to Canova's sculpture, but the chapel soon became too crowded, and it was always insufficiently removed from the rest of the very crowded church.

43

During this period Quatremère de Quincy eloquently compared the effect of pictures competing for attention in a gallery with social gatherings 'where beauty herself is on the fidget to excite admiration rather than to inspire love', and asserted that the true lover of the arts 'requires the silence of solitude to enable him to concentrate himself in the enjoyment of an only object.'[9] Mausolea were in the eighteenth century often created to provide just such a proper setting for the bereaved patron to visit, far from the busy world and the distractions of the village church.

For my purpose here a mausoleum is defined as a completely isolated building, distinct from a mortuary chapel or 'dormitory' which is attached to a church,[10] and also as a building large enough to stand in.[11] There are a number of difficult cases, such as Smirke's building at Markham Clinton, Nottinghamshire, for the Duke of Newcastle, which is really a mausoleum incorporating a church rather than a church with a mortuary chapel attached; but the category is generally easy to recognise. The first example, in Western Europe, since antiquity, was Hawksmore's mausoleum in the ground of Castle Howard, which was finally completed in 1742. It was followed by five or six examples in Britain in the 1750s and 1760s, and then in the last decades of the eighteenth century there commenced the great age of mausolea, when dozens were erected and hundreds of designs produced, and when one of the leading architects, Sir John Soane, would have been quite content to design nothing else.[12]

The neo-classical architect's interest in archaeology must have promoted the appeal of mausolea, not only because it underlined the importance of such buildings in the antique—and, in particular, the Roman—world, but also because of the romantic excitement with dim, top-lit, semi-subterranean spaces which this archaeology fostered, and which the prints of Piranesi did so much to encourage. Moreover, grand designs for a mausoleum, or a 'valhalla', or a cenotaph provided architects with an excellent opportunity to make an imposing display at an academy exhibition. Such buildings, since no one lived or worked in them, could be sublime without inconvenience. In this respect the mausoleum resembled the museum, the other favourite building type of this period. Beckford had in fact projected a combined mausoleum and art gallery at Fonthill and Soane's work at Dulwich really does serve this dual purpose, almost as if to make the point clear to historians.

The patrons would not, of course, have been oblivious to the appeal of the sublime, but the original impetus for them to pay for these designs to be carried out probably came, above all, from dynastic pride, spurred on by the fact that church vaults were everywhere filling up. In some cases, one should rather say that they paid for these designs to commence being carried out, for a number of the finest mausolea were either never completed or never used.

This is true, for example, of the long destroyed castellated mausoleum, with compendious catacombs and a chapel, erected on a hill at Highlands, Essex in 1756 by the banker, Sir Charles Raymond, which was never used

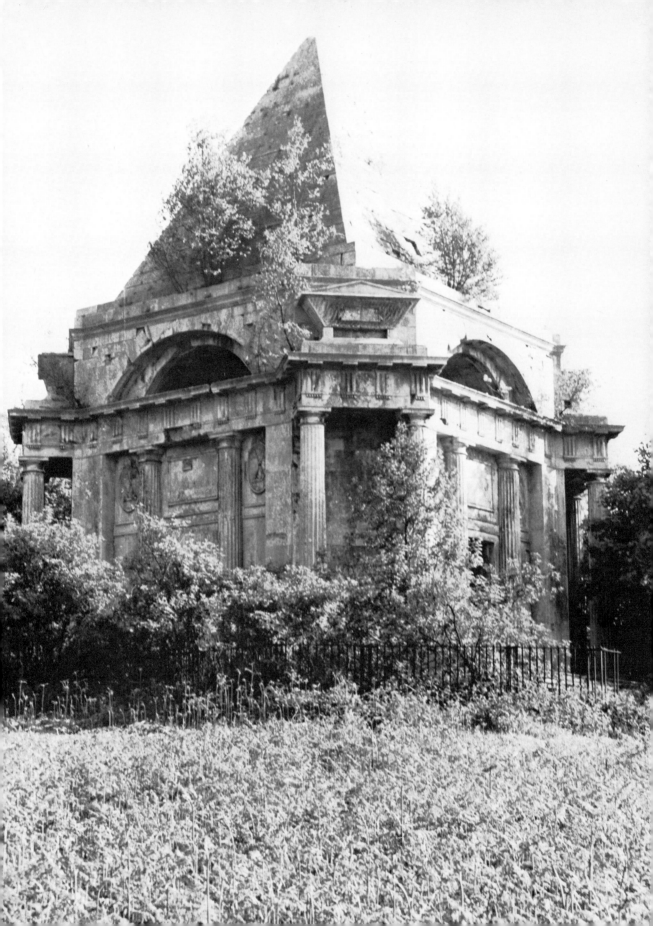

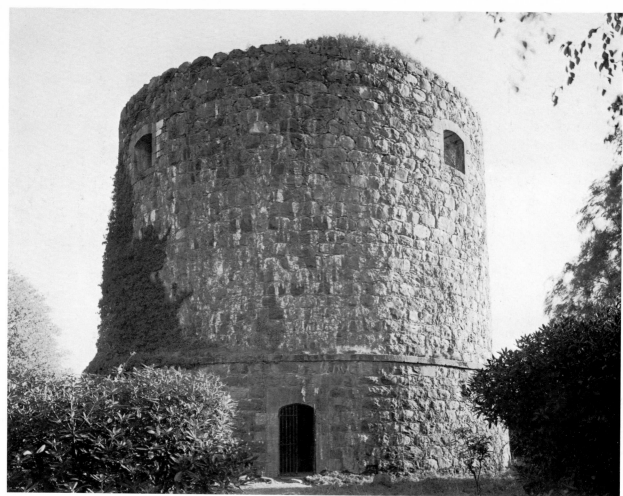

31. The Mausoleum, Glynllifon, North Wales.

because the Bishop refused to consecrate it. The superb mausoleum (inspired by a building in Poussin's *Ordination*) which James Wyatt designed in 1783 for the third Earl of Darnley and which is now falling to pieces in the grounds of Cobham Hall, Kent was also never used, perhaps because it was not quite complete at the time of the third Earl's death (Plate 30).[13] The impregnable drum of granite blocks which stands in Glynllifon Park, Caernarvonshire (Plate 31), represents the first stage of a mausoleum commenced by the second Lord Newborough in 1826, but never completed by his successor who diverted the funds to the rebuilding of his house.[14] It was probably designed to rival the mausoleum of Cecilia Metella, the so called 'Capo di Bove' visited by all grand tourists and the subject of many lines in the fourth canto of Byron's *Childe Harold*.

Only a few mausolea, even of the completed examples, contain any ambitious commemorative sculpture, although there is a fine urn in the Constable mausoleum at Halsham and ornamental sarcophagi in Adam's

46

Bowood mausoleum in Wiltshire and in the Nash mausoleum at Farningham in Kent.[15] Four remarkable exceptions which do contain important monuments are the Dartrey mausoleum in Co. Monaghan, Eire; the Pelham mausoleum in Brocklesby Park at Great Limber, Lincolnshire; the Rutland mausoleum in the grounds of Belvoir Castle, Leicestershire; and the Rockingham mausoleum at Wentworth Woodhouse in the West Riding of Yorkshire. The sculpture is not generally of a type which one would expect in a building dedicated to dynastic pride. Indeed the first three of these mausolea are above all shrines to the memory of a beloved wife.

The first of these mausolea is in Ireland where members of the ruling class seldom had parish churches near their houses and did not share their religion with their tenants. Consequently, when a great monument was commissioned there often seems to have been considerable perplexity as to what would constitute a proper site for it.[16] Obviously a mausoleum was the answer to this problem—provided, that is, that one could afford to have one as well as a monument.

Sir Thomas Dawson commissioned a monument to Lady Anne Dawson, his wife, the daughter of the Earl of Pomfret, soon after her death on 1 March 1769, at the age of thirty-six. The sculptor he chose was Joseph Wilton who had already worked in Ireland in collaboration with Chambers for Lord Charlemont. The *Hibernian Journal* informs us that the monument had arrived in Ireland in the days preceding 19 August 1774 and by the time it reached Dartrey a 'temple' had been erected on an island in the park (now a state forest). This building is based on a design by James Wyatt dated 1770 and now in the National Library of Ireland—1770 was the year in which Dawson was created Baron Dartrey. We do not know what Wyatt was paid, but he can hardly have given much time to such a feeble elevation (Plate 32). It is not known how extensive the vaults were, but the Dartrey family cannot have continued to use them for long, and the building must have been allowed

32. James Wyatt: Elevation of the Dartrey Mausoleum, The National Library of Ireland.

47

to fall into decay a long time ago. It is in every way a complete contrast to the monument inside (Plate 33).[17]

Wilton's monument to Lady Dawson is unquestionably his masterpiece. It is quite as ambitious as the approximately contemporary monument, also by Wilton, to General Wolfe in Westminster Abbey, and it is similarly dramatic, yet incomparably more successful both because it is in the round and because it is in a setting designed for it—with a dark ground and top lighting. Lord Dartrey and his son Richard are shown approaching Lady Dawson's urn at the moment when they are met by a descending angel bringing assurances of the deceased's place in heaven. Whereas the soldiers in the Wolfe monument seem to take the angel's arrival rather for granted, Lord Dartrey and his son are startled and at the same time deeply interested, and this is as evident in their stance as in their faces—for the forward stride of Lord Dartrey is checked by his son's arm thrown in fear across his waist and by his own involuntary gesture of hand pressed against chest. The drapery is as complex and as baroque as in any of Wilton's high-reliefs, but it does not distract the eye from the narrative, but rather enhances it by creating a sense of arrested movement and by creating an emphatic and exciting chiaroscuro. If this monument was by an Italian and in a church in Rome, it would be one of the best known of all eighteenth-century sculptures. Instead, it is almost unheard of and has been vandalized. Toes and fingers and the angel's forearm had been knocked off and signatures had been scribbled on the urn when the Irish Georgian Society intervened in 1960. They cleaned the marble, waterproofed the temple and padlocked the door.

Fortunately, a finished drawing for the monument survives in the Victoria and Albert Museum which shows what was almost certainly the intended position of the angel's broken fore-arm[18] (Plate 34). This pose is the same as that used by Wilton in his monument to the Earl and Countess of Mountrath erected in Westminster Abbey in 1771.

There are, however, some small changes which are worth noting between the drawing for the Lady Dawson monument and the remaining marble. The colour scheme for the base and pedestal is changed—although the same colours—'white and veined', 'dove', and 'statuary'—are employed. The arrangement of the arms on the urn is altered. More importantly the angel is increased in size in relation to the urn so that he assumes a more authoritative presence. The boy's pose is made far more arresting and the father is made into a stronger and more stable figure—his drapery arranged less in simple segmental curves, but hanging with greater weight and catching on the step. Also, and not surprisingly, the drawing does not include the lengthy epitaph composed by the blue-stocking, Mrs Carter, which informs us that Lady Dawson, 'being possessed of all the external advantages which contribute to form a shining distinction on earth, nevertheless constantly practiced in their sublimest excellence, all those evangelical duties which improve and adorn the soul for heaven.'

48

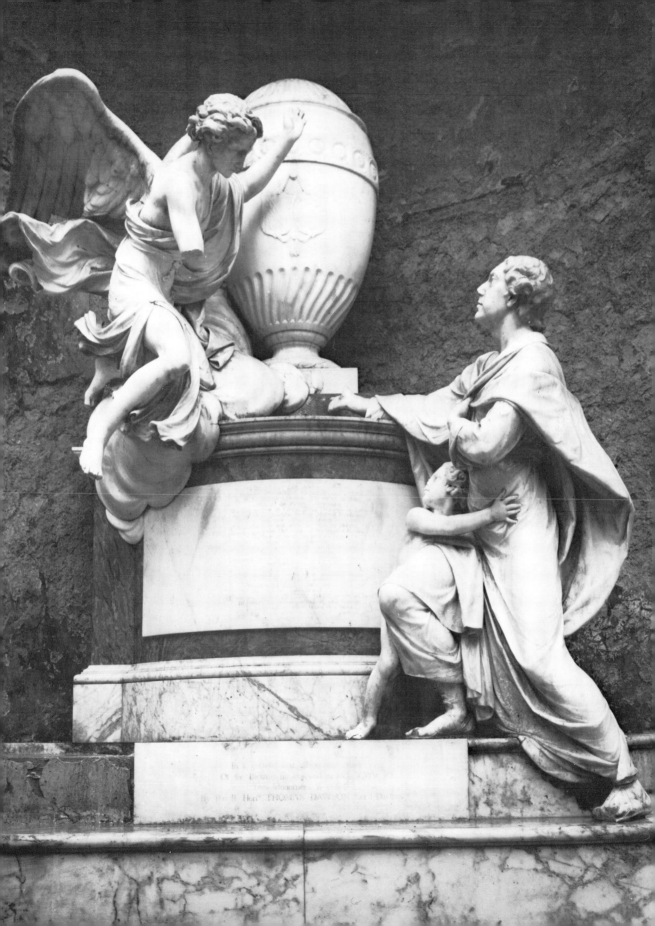

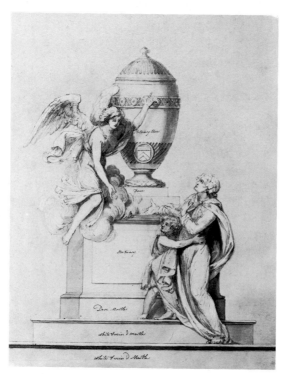

34. (left) Joseph Wilton: Design for the Monument to Lady Anne Dawson, Victoria and Albert Museum.

35. (right) Joseph Nollekens: Monument to Mrs Pelham, The Brocklesby Mausoleum, Great Limber, Lincolnshire.

The next mausoleum which we must visit was also erected to a young wife. Sophia, daughter and heiress of George Aufrère of Chelsea had been married to Charles Pelham of Brocklesly Park, Lincolnshire, for sixteen years when she died in 1786, at the age of thirty-three, of a 'brain fever'. Pelham erected the mausoleum primarily to commemorate his wife, but he may also have considered the building to be an appropriate dynastic gesture for a new peer. It is true that he only became Lord Yarborough when the building was complete but he may have been aware that the honour was on its way.

The commission for the monument went to Nollekens who had then just superseded Wilton as fashionable sculptor and who had already been much patronized by Pelham. Nollekens's statue of *Venus Chiding Cupid* of 1778 and his seated *Mercury* of 1783 (now both in the Usher Art Gallery, Lincoln) were in the Brocklesby Collection and Nollekens's bust of Mrs Pelham belongs probably to a slightly earlier period.[19] According to J. T. Smith, Pelham had bought antique sculpture from Nollekens during Nollekens's residence in Rome and thereafter they remained friends, Nollekens always receiving 'most liberal and immediate payment' for his work and an annual present of venison as well.[20]

In his monument to Mrs Pelham, Nollekens perhaps took as his starting point the traditional antique formula for the virtuous wife, draped, veiled and with her left hand on her chin. The veil has, however, become a fashionable scarf and he has also animated the statue with the lively serpentine movement of the bust. Mrs Pelham leans against a tree trunk with her legs crossed (Plate

50

36. Brocklesby Park, A View of the Mausoleum.

35), and, like Nollekens's statue of William Denison at Ossington (Plate 133), she must be considered as a marble equivalent to one of the pensive figures in communion with nature who appear so often in the portrait paintings of that period, and in particular in England in the portraits of Nollekens's friend, Gainsborough. The mausoleum itself is placed on the site of 'an ancient tumulus of Roman sepulture' and is studiously neo-classical in style. It is secluded in a most lovely landscape at the edge of the Brocklesby estate, just before the wood that borders the village of Great Limber. Pelham would have ridden across an open sweep of parkland and then up the mound, climbing between a screen of beech and a circle of dark cedars, now full-grown, which are said to have arrived from Italy with the marble for the building. Half-way up the mound the mausoleum appears, slightly to the right, half-cut off by the branches, its dome crowning the swelling of the hill (Plate 36).

Memorials of one sort or another had long been an important feature of the English landscape gardens and continental theorists at the end of the century gave our countrymen special credit for their perception of the consolation which nature could afford the mourner. Mausolea came to be seen as typical garden buildings, although where exactly in the garden they should be placed was much debated.[21] The greatest poem of this period on the commemoration of the dead, Ugo Foscolo's *I Sepolchri*, criticizes burial in church vaults, grotesque gothic and pompous baroque monuments in churches, and the new ruthlessly utilitarian cemetries opened in Italy by the Austrians and French, and holds up as an ideal, a memorial in a landscape, shaded by trees:

> E di fiori odorata arbore amica
> Le ceneri di molli ombre consoli

Inspired by Ercole Silva's *Dell' Arte dei Giardini Inglesi* of 1801, Foscolo felt that this ideal was realized in England, and perhaps also in English rural graveyards such as Gray's; and the central image of his poem (lines 130–6) was of English maidens mourning in such a setting. In France we have at the same date, J. B. Legouvé's *La Sepulture* and Chateaubriand's imitation of Gray: *Les Tombeaux Champetres*.[22] In England Wordsworth described the appeal of rural burial, and in the last paragraph of Bulwer Lytton's *The Disowned*, published in 1829, but set in the late eighteenth century, the narrator describes the tomb of his hero Mordaunt thus:

> his will had directed that he should sleep not in the vaults of his haughty line—and his last dwelling place is surrounded by a green and pleasant spot. The trees shadow it like a temple; and a silver, though fitful brook wails with a constant, yet not ungrateful dirge, at the foot of the hill on which the tomb is placed.

This way of thinking led, first on the continent and then in England, to the creation of landscaped suburban cemetaries.[23] What is important for our purpose here is that Pelham, like Mordaunt, created a last dwelling place surrounded by a 'green and pleasant spot', but he made it serve also as the vaults of his 'haughty line'.

Pelham's mausoleum is the work of James Wyatt, as was the Dartrey mausoleum, but unlike the Irish building this may claim to be his masterpiece, and we are not surprised that he chose the designs for it as his diploma piece. The detail is everywhere of the highest quality—the antique altars which connect the railings around the fosse, the frieze of skulls, *paterae* and swags of roses, sunflowers and poppies, and the sarcophagi, s-fluted in imitation of that of Caecilia Metella in the Farnese Palace. The sarcophagi are placed in the four niches of the massive cella wall and correspond to the monuments within. The circular lantern above the shallow copper dome is also s-fluted and the theme is taken up inside by the pedestal of the statue of Sophia, and underlines the sinuous pose of the figure. It is clear that both the

sculpture and the architecture, which was complete in 1794,[24] were designed together, and it is hard to know which to admire most. From the centre of the coffered dome, light falls through glass painted by Francis Eginton with 'cherubim adoring the Supreme',[25] and tints the marble golden, whilst light entering from the door adds clarity to the profile view of the figure, white against the Derbyshire alabaster columns, golden brown traversed by dark rusty red (Plate 37). The floor, like the floor of the mausoleum at Castle Howard, and like Wyatt's entrance hall at Dodington, of the same period, is inlaid with brass and coloured marble. The pattern radiates from the pedestal. No expense can have been spared, although Farington was exaggerating when he wrote that £20,000 was lavished on the building.[26]

The statue of Mrs Pelham is not the only monument in the mausoleum. Behind her there is a monument to Field-Marshal Sir William Pelham, one of Queen Elizabeth's best soldiers, and the founder of the dynasty; to her right there is a monument to Charles Pelham, Pelham's great uncle who bequeathed the estate and his name to Pelham in 1763; and to her left a monument to Pelham's father, Francis Anderson of Manby, who died in 1758. These are grand affairs with a rather vague iconography, rich pyramid grounds of red, green, grey and orange marbles, and figures carved with none of Nollekens's genius.[27] The remains of Pelham's great uncle and his father, together with those of Mrs Pelham and her parents, were transferred to the vault, so only the monument to Sir William is a cenotaph.

In many ways the quieter mood of Nollekens's monument when compared with Wilton's to Lady Dawson is typical of the general purging of baroque tendencies in English sculpture that took place gradually in the last decades of the eighteenth century. But Nollekens did also handle the theme of the angel descending to greet a mortal, in his monument to Mrs Howard, and also in his relief monument of 1805 to Jane, the first wife of Thomas Coke of Norfolk, in Tittleshall Church. Mrs Coke, who died, aged forty-seven in 1800, is portrayed leaning on a column in an elegant twisted pose similar to that of Mrs Pelham, but with an open Bible.[28] Nollekens apparently used Coke's daughter, Lady Andover, as a model so we must assume that Coke wished to remember his wife as she was when he had first known her. The cloud-born angel ascends to Mrs Coke, daintily indicating her celestial destiny, whilst a putto, seated at her feet, indicates her husband's enduring love by holding aloft a flaming heart (Plate 38). J. T. Smith thought that this cost about £2000,[29] although it was executed by the sculptor's chief assistant, Goblet. This gives one some idea of how much Pelham must have paid for the free-standing statue of his wife. The beautiful and fluent lines uniting the figures seem inhibited by the relief space, so that one wishes that the work had been realized in the round; but even had it been so realized it would have lacked the drama which Wilton gave this theme in his great group in the Dartrey mausoleum. The relief is almost impossible to appreciate in Tittleshall Church, where the lighting is entirely unsuitable. The problems involved in

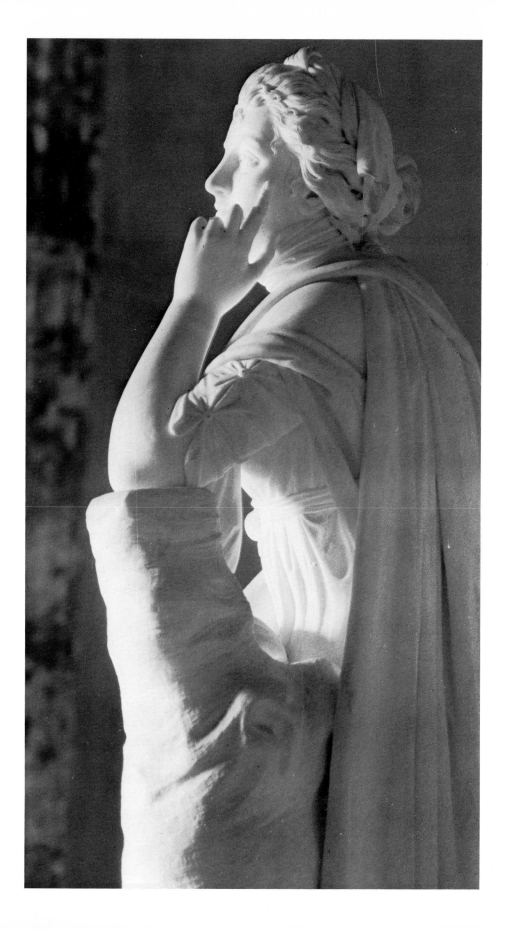

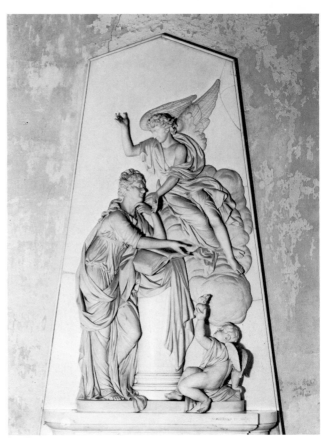

38. Joseph Nollekens: Monument to Mrs Coke, Tittleshall, Norfolk.

exhibiting grand monuments to advantage in parish churches must have been a major factor encouraging men like Lord Dartrey and Charles Pelham to build their mausolea.

The next mausoleum which we have to consider is the one erected in the grounds of Belvoir Castle, Leicestershire, to commemorate the Duchess of Rutland who died on 29 November 1825. Like the other two mausolea we have examined this is a shrine to a beloved wife. But it is quite different in architectural style. The Duke of Rutland's friends urged him to employ the 'Grecian' style, but the Duke, who was still rebuilding the Castle in the Norman style, to the designs of the Duchess and their chaplain, the Rev John Thoroton, chose this style for the mausoleum as well. Thoroton designed the building, employing genuine prototypes where possible,[30] but 'Messrs Wyatt' also helped. James Wyatt had started rebuilding the castle before the fire of 1816, and his son, Matthew Cotes Wyatt, assisted by his brother Benjamin Dean Wyatt, was employed to provide Louis XV interiors for the castle.[31] Also by Matthew Cotes Wyatt was the monument to the Duchess in the mausoleum. He had started work on this as early as January 1826. The foundation stone of the mausoleum was laid on 1 March 1826, and the completed building was consecrated on 28 November 1828.[32]

39. Matthew Cotes Wyatt:
Monument to the Duchess of
Rutland, The Mausoleum,
Belvoir Castle, Leicestershire.

The landscaped setting is as romantic as that at Brocklesby: a laurel avenue leads to a paved path which was originally flanked with yews and firs (recently uprooted and replaced by cherry trees). These must have contrasted dramatically with the light stone of the mausoleum. The gates open to reveal arch after arch of zig-zag and billet mouldings which frame the vision of the Duchess ascending to Heaven, her arms outstretched to greet the four children who predeceased her (Plate 39). Light falls on her from above through yellow glass and from concealed embrasures on either side through violet and blue, yellow and orange glass, with an effect which, on a bright day, will surprise even eyes accustomed to tricks of electric lighting. Pevsner was reminded of the baroque of the Asam brothers. However, the design is planar, the drapery surprisingly unagitated, and the low altar tomb, from which the Duchess rises, is adorned with the cardinal and theological virtues, figures which are far from baroque in style and set between stumpy Norman columns.[33]

In spite of the number of important sculptural commissions that went to him, Matthew Cotes Wyatt, lacked any sort of professional training. He was more practised as a decorative painter than as a sculptor, and he was perhaps most successful as a stage designer. He was a master of dazzling effects which

57

seldom survive much scrutiny—here, for instance, it is very quickly obvious how he has supported the Duchess in her flight—and one is not surprised that he preferred well-puffed studio shows to the competition of the Royal Academy exhibition.[34] His success was largely due to his father and to his friendship with a few noblemen, most notably the Duke of Rutland. As an old Etonian Wyatt was quite at home as guest of the Duke's at Belvoir. He helped the Duke with his ballooning,[35] provided some of the decor (incorporating genuine rococo *boiseries*) and decorative painting (a clumsy parody of Rubens) in the Castle, and carved a fictive table-cloth and napkin out of marble for a side-board in the dining room. But his chief work in the Castle was a life-size statue of the Duchess for the 'Elizabeth Saloon'. This room, named after the Duchess, was contemporary with the mausoleum, and, although positively festive in character, it too is commemorative. Whereas there is no dynastic reference in the decoration of the mausoleum (except perhaps for the armorial boss in the vault above one's head when one enters), there are, in the 'Elizabeth Saloon', medallion portraits of the Rutland family carried aloft by putti.

The allegorical painting of the 'Elizabeth Saloon' is said to allude to the Duchess's liaison with the Duke of York, who, before the mausoleum was complete, came to pay his respects to her remains. According to Greville he never recovered from a chill caught on his visit to the Rutland vaults in Bottesford Church,[36] and this may explain why the Belvoir mausoleum has a central heating system. Although the sculpture in the mausoleum is exclusively devoted to the Duchess, it was not only her coffin, but the entire contents of the old Bottesford vaults which were transferred to the mausoleum. We have already noted the family remains which were moved into the Pelham mausoleum, and it seems that in general the English nobility wished to affirm a relationship with their ancestors. There were a few exceptions: the Constables, for instance, left behind the coffin of one black sheep who had squandered the family money on racing whippets when the other coffins were moved, in 1802, from the vaults of Halsham Church to the new mausoleum.[37] But one does not find any mausolea erected to distinguish one branch of a family from another—although that was to be the motive for the creation, later in the nineteenth century, of the royal mausolea at Dreux, by Louis-Philippe, and at Frogmore, by Queen Victoria.

Matthew Cotes Wyatt's son, James, apparently inherited his father's taste for the theatrical, for he is responsible for a design for a monument to 'Bigam Sombroo' in 1838 which is now in the drawings collection of the Royal Institute of British Architects. Besides this the Rutland mausoleum looks tame. Allegorical figures adapted from Bernini are placed in a crinkle-crankle gothic chapel: angels ascend above the altar. Derek Linstrum has identified 'Bigam Sombroo' as the Begum Sombre, a dancing girl called Zerbonissa who married a German mercenary who was given the principality of Sirdhana by the Emperor of Delhi. When she died in 1836 she left nearly half a million

pounds to her husband's bastard, David Ochterlony Dyce, who took the name Sombre and came to England.[38] We know that he visited Chantrey in June of 1836 and ordered a monument from him for £5000.[39] No doubt he went to Wyatt when he heard of Chantrey's death. Nothing seems to have come of the monument, however, for Sombre, who secured a wife from the English nobility and a seat in Parliament, was charged with bribery, deprived of his seat, and, a few years later, was put under restraint as a lunatic.

The commemorative sculpture in the Dartrey, Pelham and Rutland mausolea are of an extravagance, relative to the many more modest monuments which are the main subject of this book which prompts the reflection that they are the domestic equivalents to the devotional sculpture which the Anglican Church would not permit. We have no marble Madonnas ascending to a cherub-laden heaven in our churches, but we do have the Duchess of Rutland—and Princess Charlotte at Windsor, also by Wyatt, and, earlier, Flaxman's Mrs Morley in Gloucester Cathedral, and many other ladies on a smaller scale and in lower relief, all of whom might easily be mistaken for ascending Madonnas by an archaeologist of the future. (Indeed, neither the Duchess of Rutland nor Princess Charlotte are identified by epitaphs.)

We have no sculptures of the Blessed expiring in ecstasy—like Bernini's Ludovica Albertoni in Rome—but in Croft Church, in the North Riding of Yorkshire, there is a monument by Thomas Banks to Cornelia Milbanke (a member of the family which Byron so disturbed) who died in 1785 (Plate 40). The frame is neatly neo-classical but the figure of Mrs Milbanke is far less so. She expires with a vision of two cherubs floating before her, which are, however, not palm-bearing emissaries of the Almighty, but her two dead children 'cherub forms' 'expanding' to her sight, we read in the epitaph, which describes those children that survive as 'connubial pledges of a Saint above'. That the substitution of real children for cherubs was by no means odd in this period is suggested by West's painting of the *Apotheosis of Prince Octavius*, commissioned by George III in 1783 and exhibited at the Academy in the following year.[40] Flaxman shows Mrs Bosanquet's children in this way in his death-bed relief to that lady at Llantilio Cresseny, Monmouthshire.[41] This domestic adaption of religious imagery was not, however, only characteristic of Protestants. Dyce Sombre was a Catholic convert and Minardi in the mid-nineteenth century painted the daughter of the Earl of Shrewsbury, the sister of Princess Doria, with her children, 'mounting through parting clouds to Heaven'.[42] Nevertheless, it is striking that, whereas the cult of Saints was widely frowned upon by Anglicans, it seems to have been accepted to refer to one's wife as one. And it is surely appropriate that Canova's monument to Lady Brownlow (Plate 29) is based on a statue of the Catholic Religion. In the protestant and English monument the portrait of a beloved wife replaces a crucifix, the tablets of the law and a relief of Saints Peter and Paul.

40. Thomas Banks: Monument to Cornelia Milbanke, Croft, Yorkshire.

There were perhaps more altar-pieces in Anglican churches in the early nineteenth century than is commonly realized. Constable painted several; West painted a number; Samuel Wale a great many. Four out of the five main Anglican churches in Manchester in 1816 had altar-pieces.[43] All the same no sculptures of the Madonna and Child were erected in English churches in this period. Instead there are sculptures of women nursing their children,

60

such as Chantrey's monument to Lady Stanhope at Chevening, Kent (Plate 90) or Westmacott's 'Homeless Traveller' (Plate 140). Westmacott's monument to the seventh Earl of Bridgewater at Little Gaddesden (Plate 141) appears at first to represent the Rest of the Flight into Egypt, and Pevsner describes the similar monument at Wilton as a Holy Family (Plate 8).[44] Shortly after the failure of the scheme to decorate St Paul's with murals of Biblical stories, those same stories were successfully adapted for monuments by Flaxman. In general, it may be said that there was not the shortage of devotional art in Georgian England that some historians, seeking for Christian art, have supposed. It may not have been an age in which churches were built or decorated with notable gusto, but there were remarkable shrines to beloved wives. There were also temples to political heroes.

The final mausoleum which we must visit is the Rockingham mausoleum, in the park of Wentworth Woodhouse in the West Riding of Yorkshire, erected by Earl Fitzwilliam, the nephew and heir of the second Marquis of Rockingham. Land subsidence threatened the building earlier this century and it is now bound together by iron and the crowning tempietto bricked up, yet it remains one of the most imposing, as well as one of the largest, park ornaments in England (Plate 41). Carr of York was the architect and his first

41. John Carr: The Rockingham Mausoleum, Wentworth Woodhouse, Yorkshire.

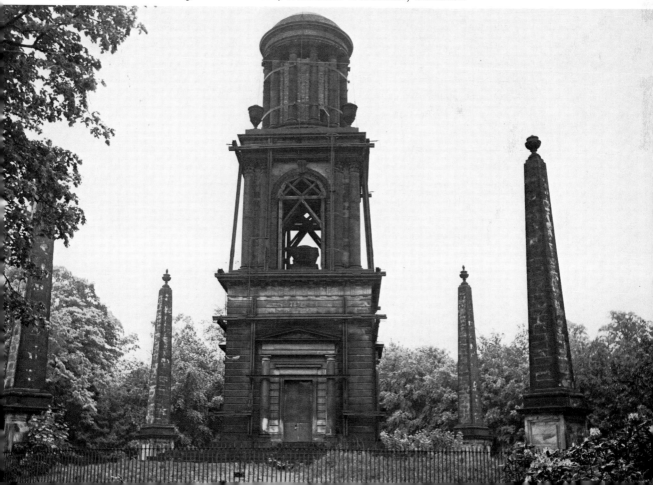

ideas for the building (dated 1783, the year after Rockingham's death) were even bolder. He wanted to crown the building with an obelisk like those which now surround the building.[45] Work on the mausoleum commenced in 1785 and it was complete in 1791, except for the obelisks which were erected in the following year. It cost £3,208.3s.4½d,[46] exclusive of sculpture and the architect's fees. Carr was paid annually as the estate architect, working on the house and stables at the same time.[47] He had also served Rockingham, and was devoted to the Rockingham interest in politics.[48]

Inside the mausoleum, half-concealed by wooden props and with his hand broken off by vandals, stands Nollekens's statue of Rockingham (Plate 42): his arm eloquently raised, his sensitive features captured the moment before speech. His peer's robes are rendered with precision and the textures of silk and fur are carefully discriminated, yet the details are subordinate to a graceful but vital design. The work is not dated, but Carr reported that Nollekens was modelling the figure in April 1788.[49] In commissioning Nollekens Fitzwilliam was employing one of Rockingham's favourite artists. (The four goddesses by Nollekens which now adorn Wentworth Woodhouse, were originally executed in the 1770s for Rockingham's house in Grosvenor Square.[50])

I have called this building a mausoleum. It looks like one and even displays a sarcophagus on the second register of the elevation. It was, also, from the start, called a mausoleum. But Rockingham was buried in York Minster where Fisher of York was to have erected a monument to him,[51] and Fitzwilliam was buried with both his wives in the Fitzwilliam vault at Marholm near his Peterborough seat of Milton. So this is, strictly, a cenotaph. And the emphasis is not dynastic: Rockingham is not surrounded by his ancestors, but by busts of his friends and political allies, Keppel, Fox, Sir George Savile, Frederick Montagu, the Duke of Portland, Burke, John Lee and Lord John Cavendish, arranged in pairs on pedestals (supplied by Fisher of York) between the windows. The busts are by Nollekens, save for that of Burke which is unsigned, that of Keppel which is signed by Ceracchi, and those of Cavendish and Portland which are signed by Bacon and dated 1793.

The Rockingham mausoleum was in fact a temple of political friendship, the model for the Temple of Liberty at Woburn where busts of the friends of Fox surround a bust of their hero.[52] The temple at Wentworth was erected by Fitzwilliam as an act of piety towards his uncle and his circle who had formed the nucleus of the Whig opposition to the American wars and to the influence of the Crown—'that set of men from whose union alone the country can be saved', as Fox put it,[53] The long inscription on two sides of the pedestal is by Burke. It stresses Rockingham's ability to hold the opposition together, and reminds his successors 'who daily behold this monument' that it was 'not built to entertain the eye, but to instruct the mind'. It concludes with three words in capitals: 'REMEMBER. RESEMBLE. PERSEVERE.' Ironically, by the time that the last busts were in place, Burke and Fox had quarrelled over the

CHARLES WATSON WENTWORTH,
MARQUIS OF ROCKINGHAM, EARL OF MALTON,
VISCOUNT HIGHAM OF HIGHAM FERRERS,
BARON OF ROCKINGHAM, MALTON, WATH, AND
HAROWDEN AND BARONET IN GREAT BRITAIN,
EARL AND BARON OF MALTON IN THE
KINGDOM OF IRELAND, LORD LIEUTENANT AND
CUSTOS ROTULORUM OF THE WEST RIDING
OF YORKSHIRE, CITY OF YORK, AND COUNTY
OF THE SAME, CUSTOS ROTULORUM OF THE
NORTH RIDING, AND VICE ADMIRAL OF THE
MARITIME PARTS THEREOF, HIGH STEWARD
OF KINGSTON UPON HULL, KNIGHT OF THE
GARTER, AND FIRST COMMISSIONER OF THE
BOARD OF TREASURY.
BORN MAY 24TH 1730, DIED JULY 1ST 1782.

42. Joseph
Nollekens:
Monument to the
Marquis of
Rockingham, The
Rockingham
Mausoleum.

French Revolution, and soon afterwards Fitzwilliam broke with Portland, who recalled him as Lord Lieutenant of Ireland.[54]

The Rockingham mausoleum is less domestic and less private than the other mausolea examined in this chapter, but it is not dynastic. And in spite of the dynastic motivation behind the creation of exclusive vaults the sculpture in mausolea follows the general trend of monuments in this country from the 1780s onwards. The finest monuments were erected either to women or children, or to public heroes, rather than to major male representatives of a noble family, and made their appeal more to sentiment than to family pride.

43. Giovanni Guelfi: Monument to James Craggs, Westminster Abbey.

4. Devotional Attitudes and a Feminine Heaven

AT the beginning of the eighteenth century the two most popular types of grand monument in England showed men either standing or reclining. Both types retained their popularity until about 1765, and were not entirely outmoded in 1780. At first, the standing men strut and swagger in Roman armour, but after the monument to James Craggs was erected in Westminster Abbey in the late 1720s (Plate 43) they tend to be relatively sober in attitude. Craggs, who was Secretary of State at the time of the South Sea Bubble, leans with his elbow against a giant urn and has his legs crossed. The pose is at once self-confident and informal, dignified and relaxed, like the best poetry of Pope—who supervised the execution of the monument by Giovanni Guelfi (to Gibbs's designs) and who supplied the epitaph.[1] A splendid succession of monuments by Scheemakers, Roubiliac and Cheere make use of this pose: one of the later examples is Nollekens's statue at Ossington, Nottinghamshire, to Robert Denison who died in 1763 (Plate 44). The attitude was often pensive, but it is not associated with grief or prayer, and it was not confined to church monuments—it was also used by Rysbrack for his statue of the Duke of Somerset erected in the Cambridge University Senate House in 1756 (Plate 45), and was popular in portraits by Hudson, Reynolds and Gainsborough.

The still more popular reclining effigies of the same period are usually even less easily reconciled with religious feeling. They will be dealt with at greater length in the following chapter. Here we may observe that although such effigies in the sixteenth and early seventeenth century were often deep in pious thoughts, they often appear in the late seventeenth and in the eighteenth century to be greatly concerned with their own importance. Even when they read they tend to seem excessively conscious of themselves, and they often appear to be acknowledging the bows of visitors at a *levée*. The grandiloquence which the example of Craggs seems to have banished from

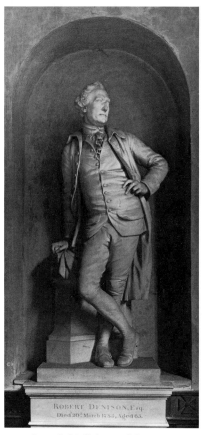

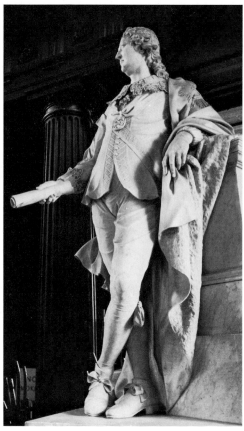

44. Joseph Nollekens: Monument to
Robert Denison, Ossington,
Nottinghamshire.

45. Michael Rysbrack: The Duke of
Somerset, The Senate House, Cambridge
University.

the standing figures often survives here. The hand which is not outspread
upon the chest, grips a baton, indicates the medallion bust of a wife or is held
open as if acknowledging applause. Good examples of this pose in the late
eighteenth century are J. F. Moore's monument to Earl Ferrers in Ettington
Church, Warwickshire and the monument by Wilton to the first Earl of
Mexborough at Methley in the West Riding of Yorkshire.

In general, then, a concern to portray the deceased in a pious or devotional
posture is not particularly conspicuous in grand monuments erected in
England during the first two-thirds of the eighteenth century. Such a
concern was, however, frequently displayed later, and particularly from
about 1820 onwards.

Kneeling figures first appear in English monuments as supplements to full-
length recumbent effigies—rows of diminutive mourning relatives who
replace virtues around the tomb-chests in the late sixteenth century. Larger
figures kneeling at prayer stools—husband opposite wife, and often with

66

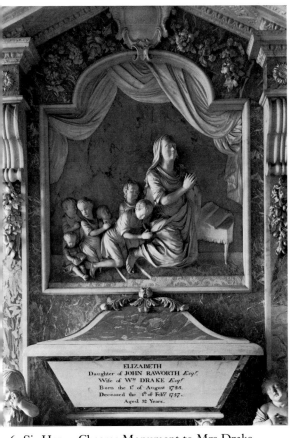

46. Sir Henry Cheere: Monument to Mrs Drake,
Amersham, Buckinghamshire.

47. Thomas Banks: Monument to the second Earl of
Hardwicke, Flitton, Bedfordshire.

symmetrical rows of sexually segregated offspring tapering off behind each
parent, are extremely common in early seventeenth-century wall monu-
ments. Life-size figures also pray at the foot, or side, or head of recumbent or
reclining effigies at that date. But after the Restoration and during the
eighteenth century it is far harder to find examples of kneeling figures. There
are a few exceptions; for instance, a Queen Anne version of the Jacobean
praying family may be seen at Chisleden, Wiltshire, in the monument to
Edward Melish. But the most notable exception is the monument by Sir
Henry Cheere at Amersham Buckinghamshire, commemorating Mrs Drake,
who died in 1757. She is shown with her six children, five of whom kneel
with her (Plate 46).

When kneeling figures do appear at the end of the eighteenth century they
are not praying, but mourning over an urn. Women who are portrayed
actually weeping beside an urn can sit—as in Banks's monument to the
second Earl of Hardwicke who died in 1790, which is at Flitton, Bedfordshire

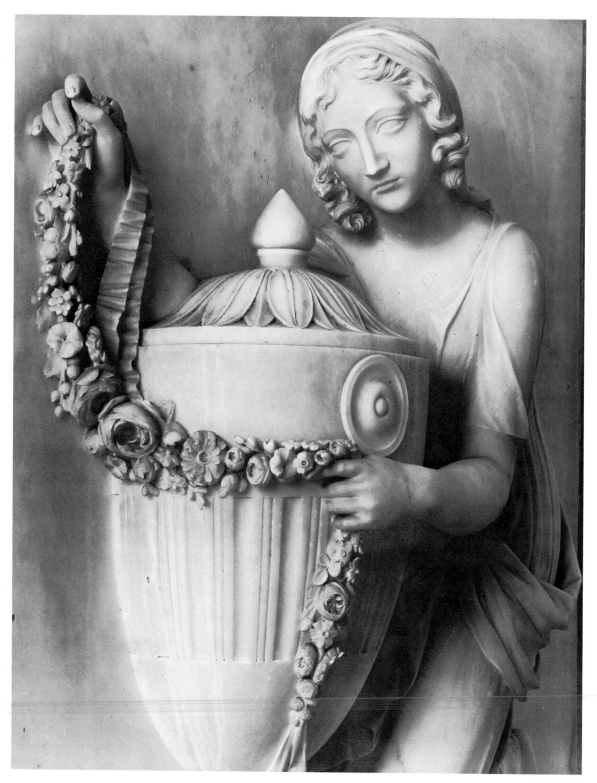

(Plate 47); but when they place a garland upon the urn it is more convenient for the sculptor if they stand (as in many of Bacon's works) or kneel, as in Banks's other monument to the same Earl of Hardwicke at Wimpole, Cambridgeshire (Plate 48).[2] Such a kneeling figure is devotional—but in a sense which Rousseau would have appreciated more than Saint Paul. I have carefully called this a kneeling figure because it is hardly ever possible to be sure whether it is intended as an idealized widow or female relative, or as an allegorical female.[3] The problem is no different with nineteenth-century treatments of this theme. We may deduce from the epitaph of Chantrey's monument to Arabella, Duchess of Dorset, at Withyham, Sussex, that the kneeling mourners are her bereft daughters,[4] but who is the young woman, also carved by Chantrey, who kneels by the urn of Sarah Whinyates in St Werburgh, Derby.[5] We might suppose that the woman kneeling in yet another Chantrey monument, that to Admiral Sir Richard Hussey Bickerton in Bath Abbey (Plate 49), was his widow. Yet a guide-book informs us that 'it

48. (far left) Thomas Banks: Detail of Monument to the second Earl of Hardwicke, Wimpole, Cambridgeshire.
49. (left) Francis Chantrey: Monument to Sir Richard Bickerton, Bath Abbey.

50. (left) Richard Westmacott: Monument to Robert Myddleton Biddulph, Ledbury, Herefordshire.
51. (right) Francis Chantrey: Monument to Lady Saint Vincent, Caverswall, Staffordshire.

might be either Fame or Sorrow.'[6] Similarly, the figure kneeling in distress in the monument by Westmacott at Ledbury, Herefordshire, would seem to be Charlotte Myddleton Biddulph (Plate 50). She erected the monument to her husband, Robert Myddleton Biddulph of Chirk, who died 30 August 1814, and her two sons and her daughter are portrayed in relief panels on either side of the figure. However, the same figure, was used by Westmacott at Belton (Plate 19) where it is more easily interpreted as a personification of Faith.

Chantrey, whilst continuing the convention of the woman kneeling by an urn, also commenced, or rather revived, a convention for portraying the deceased at prayer. Perhaps the first of these was his monument to Martha, Lady St Vincent, at Caverswall, Staffordshire, erected in 1818, two years after her death.[7] This monument is placed on the north side of the chancel and is slightly turned towards the congregation. It is excellently framed, and the white marble admirably enhanced, by the grey ground of a large seventeenth-century monument behind it (Plate 51). In spite of the way the figure is turned, one is not encouraged to think of this as a public statue. She is not displaying her feelings to us; rather, we have glimpsed her 'true', her private self. The hands are not formally held together, but crossed on the breast, the dress is simple, her coronet is carelessly propped behind her, only just visible from a frontal view, and a tassel is caught under the prayer cushion. This is quite different from the fully conscious negligence of the crossed leg and unbuttoned shirt favoured in much mid-eighteenth-century portrait sculpture. But is this a portrait? It cannot be a portrait of the Countess when

71

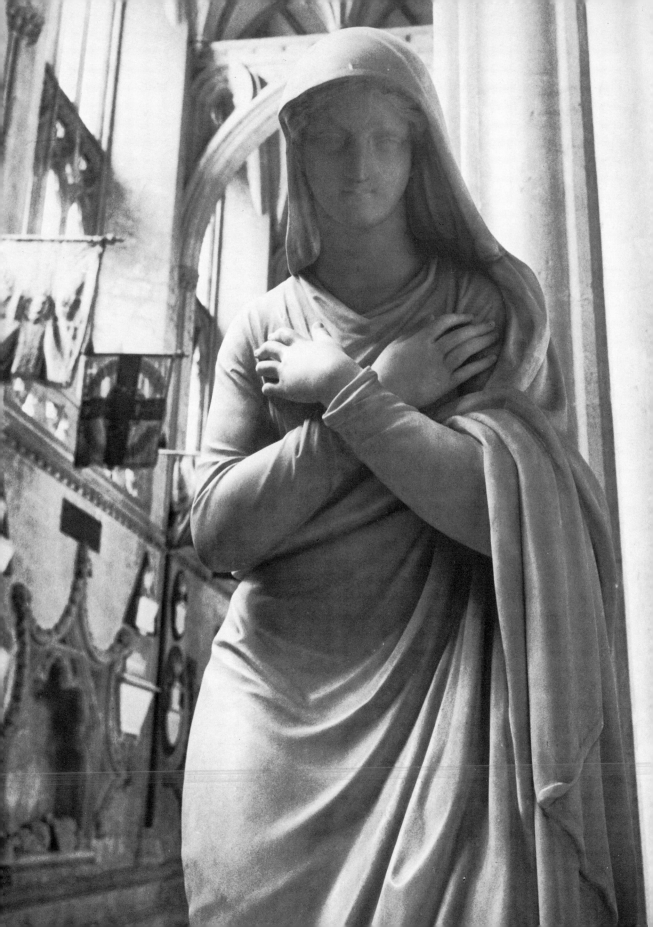

52. (left) E. H. Baily:
Detail of Monument
to Harriet Middleton,
Bristol Cathedral.
53. (right) E. H. Baily:
Monument to Bishop
Pelham, Buckden,
Huntingdonshire.

she died, for she was then well over fifty. It must be a portrait of her in her youth—and it must be idealized because the same figure was also used by Chantrey in other monuments.[8]

Other sculptors employed the kneeling posture. Ternouth's monument to Charlotte Bulkeley at Beaumaris, Anglesey, is a notable case and there are also two excellent high-relief monuments of women at prayer desks by Westmacott.[9] The kneeling posture was also popular on the continent. Bartolini's kneeling girl—*La Fiducia in Deo*—completed in marble in 1835 and purchased by Donna Rosa Poldi-Pezzoli, was an immensely popular work. Bartolini also used the praying posture in his monument to Queen Hortense of 1845, now in the Musée Napoléon, Arenenberg.[10] His pupil Pampaloni had caused a sensation in 1827 with a sculpture of a praying boy, part of a sepulchral group, subsequently reproduced in isolation at least twice in marble, and countless times in plaster.[11] Pradier's *Praying Girl* was also much duplicated, but in bronze not plaster.[12] The first isolated figure of a praying child that I have seen in a British nineteenth-century monument is E. H. Baily's high-relief tablet in the church of Llanbadarn Fawr, a suburb of Aberystwyth, to Matthew Davies Williams, who died, aged four, in 1833. Baily, however, chiefly carved kneeling women—indeed, in those of his works which I have seen, his men are never portrayed in this attitude (his Bishop Jebb erected in 1836 in Limerick Cathedral, for example, is shown seated).

The first of Baily's kneeling women was probably the monument in Bristol Cathedral to Harriet Middleton who died on 13 May 1826 (Plate 52). Another, also in profile and high-relief serves as the monument at Buckden in Huntingdonshire to Bishop Pelham who died in 1827 (Plate 53). A third monument, at Ardington in Berkshire, commemorates Mrs Vernon, who

died in 1830. All three figures are virtually the same, and not very different from Chantrey's, save that they are less lively and perhaps more ideal. However, the Bristol and Ardington monuments represent the deceased, whilst the Buckden monument must represent the deceased's bereft widow or at least a mourner. Thus monuments for men and women can be equally feminine. Later in the century, for example, in Theed's monument to John Williams, dated 1851, in Gresford, Denbighshire, the kneeling woman could well be an angel or an allegory of Faith. However beautiful and however touching, the feminine kneelers after those by Chantrey do not recapture the frisson which his work gives one—the almost embarrassing feeling that one is witnessing the private expression of pious innocence.

This type of kneeling figure popularized by Chantrey was, it must be stressed, new. Figures shown kneeling at their prayers had been very rare in the eighteenth century. One is bound to enquire whether there was any change in life as well as art. There is no reason to suppose that Fielding intended us to think of Squire Allworthy in *Tom Jones* as out of the ordinary because he spent some minutes on his knees every night.[13] We may be sure that Anglicans knelt to take Communion (although that was not then a frequent act, even with the pious) and Defoe mentions how dissenters were obliged to do so by law in the early part of the century.[14] Couples knelt at the marriage service (Lord Byron was anxious to have a comfortable cushion). George III knelt at important services—although the fact that Fanny Burney made a special note of this may be significant.[15] However, that it was considered odd in the early part of the nineteenth century for the gentry to kneel is strongly suggested by a number of sources. Jane Austen's younger brother, Admiral Francis Austen, when a young man, was spoken of as '*the officer who kneeled at Church*'—a custom, J. E. Austen-Leigh noted in the second half of the century, 'which now happily would not be thought peculiar'.[16] When the mother of the Reverend Leonard Shelford and her sisters knelt to say their prayers and repeated the responses aloud, the congregation 'broke into a titter'.[17] Most significant of all is the fact that as late as the 1840s, Queen Victoria (whose education as a child had been supervised by a panel of Bishops and who had been encouraged by Melbourne to be entirely conventional) was astonished that Lady Lyttleton, the governess to the Princess Royal, insisted that the child said her prayers kneeling. Albert told the governess that he thought such habits had been abolished by the Reformation.[18] (But the Queen had certainly knelt to receive the Sacrament at her coronation in 1838, at least to judge from George Baxter's colour print of 1841.)

The characteristic attitude of standing figures in the mid-eighteenth century was equally appropriate for a statue outside a church. This remains true of many of the standing figures erected in churches in the early nineteenth century, by both Westmacott and, in particular, by Chantrey.[19] However, a number of Chantrey's male figures are shown in a specifically

55. (left) John Gibson: Monument to Bishop Van Mildert, Durham Cathedral.
56. (right) Francis Chantrey: Monument to Bishop Heber, St Paul's Cathedral.

religious attitude, either reclining upon their deathbeds, or kneeling.

Chantrey's kneeling figures seem to be, without exception, women or bishops. However, the last monument which Chantrey erected to a bishop— that to Bishop Bathurst in Norwich Cathedral[20]—shows the figure seated (Plate 54). Did this old-fashioned Whig dislike the new fashion of kneeling? Gibson's monument to the Tory Bishop of Durham, Van Mildert (Plate 55) of the same date also shows a seated figure. It is interesting that both these men are also shown wearing their wigs, whereas most of the kneeling bishops, as we shall see, do not. According to Professor Chadwick, George IV had refused Bishop Carr of Chichester permission to remove his wig in 1824, but William IV invited Bishop Blomfield to remove his during one very hot summer at Brighton, and by 1832 the majority had apparently removed their wigs— Howley, the Archbishop of Canterbury, being an exception.[21] In spite of these seated bishops, the kneeling posture can be called the characteristic attitude for an episcopal monument between 1820 and 1845, just as between 1845 and 1885 the characteristic attitude was recumbent, and this was entirely due to Chantrey.

Chantrey's first works of this type were his monuments to Bishop North in Winchester Cathedral and to Bishop Stuart in Armagh Cathedral, both of whom are shown kneeling in profile. These were erected in 1825 and 1826. Then came his monument to Bishop Heber—or, rather, his monuments, for there are three of them by him. Soon after Heber's death at Trichinopoly in India on 3 April 1826, there were meetings in Madras and in Calcutta and in the following year in Oxford and London, to open subscriptions for monuments to him. All these commissions were given to Chantrey and are meticulously documented in an appendix to Amelia Heber's *Life*, and, of course, in Chantrey's own ledger. The last of the three was that which was erected in the crypt of St Paul's in London, in 1835; it was the largest and

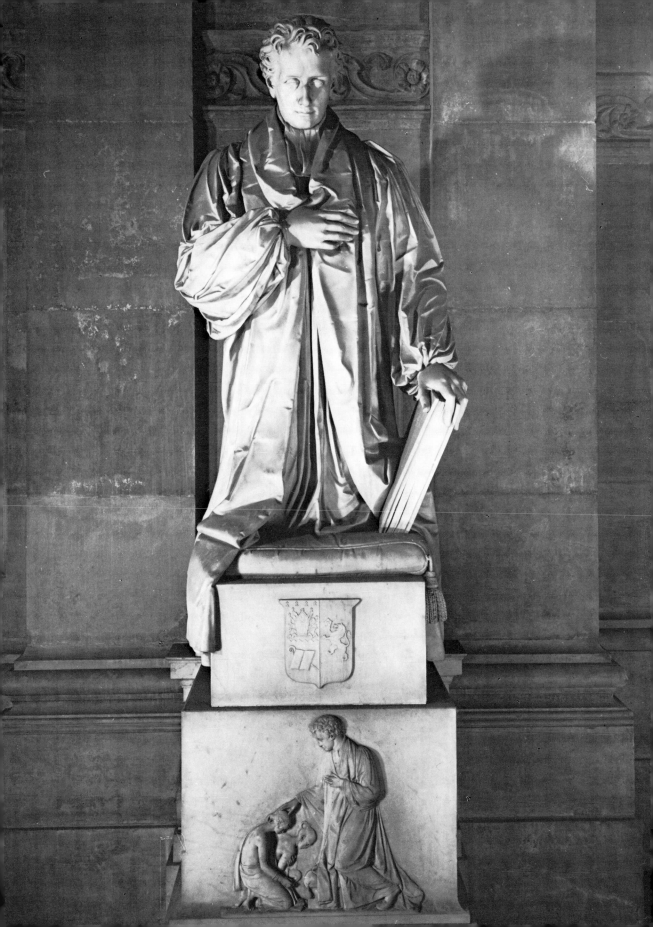

recapitulates the earlier works (Plate 56). Like the monument erected in Calcutta (first in St John's and later transferred to St Paul's), it shows the bishop 'kneeling on a pedestal, with one hand on his bosom and the other resting on the Bible', whilst the relief on the pedestal, showing the bishop blessing converted natives, repeats Chantrey's first monument to Heber, erected in St George's Chapel, Madras.[22]

Another free-standing statue of a bishop in a devotional attitude is Chantrey's monument in Lichfield Cathedral to Bishop Ryder who died in 1836, which was exhibited at the Royal Academy in 1841 (Plate 57). In contrast to Heber, Ryder's concentration appears to be directed inwards. The hands are held together, with the result that the sleeves puff out sideways, making the figure heavier. Heber's pose is the happier one, and, not surprisingly, the one Chantrey used in his profile, relief monuments to other bishops.[23] A preliminary clay sketch in the Victoria and Albert Museum is

the most spontaneous, but not the strongest, of his versions of the pose.[24]

Although many bishops were later to be portrayed in a recumbent attitude, evidence of the enduring popularity of the kneeling posture is not hard to find. In Cardington Church, Bedfordshire, for example, there is a high relief monument to Samuel Whitbread the younger and his wife, Elizabeth the daughter of Earl Grey, erected after the death of the latter in 1846 at the age of eighty-one. Since she is shown together with her husband she is necessarily portrayed as a young woman, for he had committed suicide in 1815 (Plate 58). It is unfortunate that the Church was reconstructed so that the light falls on the backs of the figures, for the whole design demands that it should fall on them from above and in front, as the metaphorical light for which men pray. The faces are tilted forward with the intention that their thoughtful features will be enhanced by shadow. As it is, the whole front of each figure is in shadow.

Mrs Whitbread's hands are joined in prayer and at the same time she leans affectionately on her husband's shoulders. His hands are joined, but in the same relaxed, downward pointing way that Bishop Ryder's were.[25] The heavy draperies, the bold modelling, and also the sentiment mark this as the work of an artist profoundly influenced by Chantrey. It is, in fact, the masterpiece of Weekes—Chantrey's chief assistant. Other examples of kneeling figures can be found in England throughout the nineteenth and even in the twentieth century.

On the continent the most important of all male figures at prayer is certainly the statue of Pope Clement XIII on Canova's monument unveiled in St Peter's in 1792—a remarkable rejection of rhetorical papal poses, familiar, if only in line engravings, to British sculptors and perhaps an influence on the developments outlined above. The kneeling pose also enjoyed considerable popularity in France where, however, it was part of a revival of sixteenth and seventeenth-century iconography, which was not the case here.[26]

At this point in this study it is important to remind ourselves of the return to favour during the last decades of the eighteenth century of death-bed scenes in English church monuments. At first there are usually allegorical accompaniments: Death who advances with his dart upon Mrs Nightingale; the Muse of Science who supports Provost Baldwin; Faith who supports Mrs Howard and guides Samuel Whitbread's eyes to Heaven, and who, with Hope and Charity, stands by the bedside of Mrs Petrie. Flaxman in his monument of 1798 to Lady Shuckburgh—Evelyn at Shuckburgh, Warwickshire, showed a very much more naturalistic scene, including a girl clutching desperately at her dying mother. Instead of an allegorical figure he included an angel.[27] Flaxman's monument was to prove highly influential and Gibson's monument to Mrs Byrom at Daresbury, Cheshire, a plaster model of which is in the Royal Academy (Plate 59) is perhaps inspired by it. Sarah Byrom died 2 February 1833, probably in childbed. Her hand is about to fall from her child, her eyes are fixed on the angel who has entered the chamber and indicates her removal to heaven.

In 1812 Chantrey confirmed the reputation he had made with his portrait busts by exhibiting, in Spring Gardens, a death bed group which was even more naturalistic either than Flaxman's earlier or than Gibson's later monument, and which dispensed with the angel. This was the monument to Marianne Johnes, the daughter of 'Johnes of Hafod', the cultured patron of Banks. It showed husband and wife beside the couch upon which their daughter lies dying.[28] This great work was, unfortunately, destroyed by a fire at Hafod Church in 1932 and, although an old photograph survives (Plate 60), we may better experience the impact which the sculpture made by looking at Chantrey's other versions of the same theme. There is a death-bed relief to Sir Simon Taylor at Edington in Wiltshire, and three to women who died in childbed,[29] and, above all, there is the great free-standing life-size monument to David Pike Watts at Ilam, Staffordshire (Plate 61).

59. John Gibson: Plaster Model for the Monument to Mrs Byrom, Royal Academy of Arts, London.

Watts's only surviving child, Mrs Jesse Watts Russell, had already commissioned a series of busts from Chantrey to adorn Ilam Hall which she and her husband were rebuilding to the designs of John Shaw, when she ordered, in 1816, first a tombstone for her father in St John's Wood Chapel, Paddington and then the monument for Ilam Church.[30] For the monument she paid £6,090 (including the cost of conveyance and erection). The work was completed on 30 July 1827, and all paid for by May 1829.[31] To receive it she erected an octagonal Gothic mortuary chapel attached to the Church, and Chantrey made the base of the monument congruous in style. The arms in the panels of this base are repeated in the bosses of the chapel's vault. The vault

81

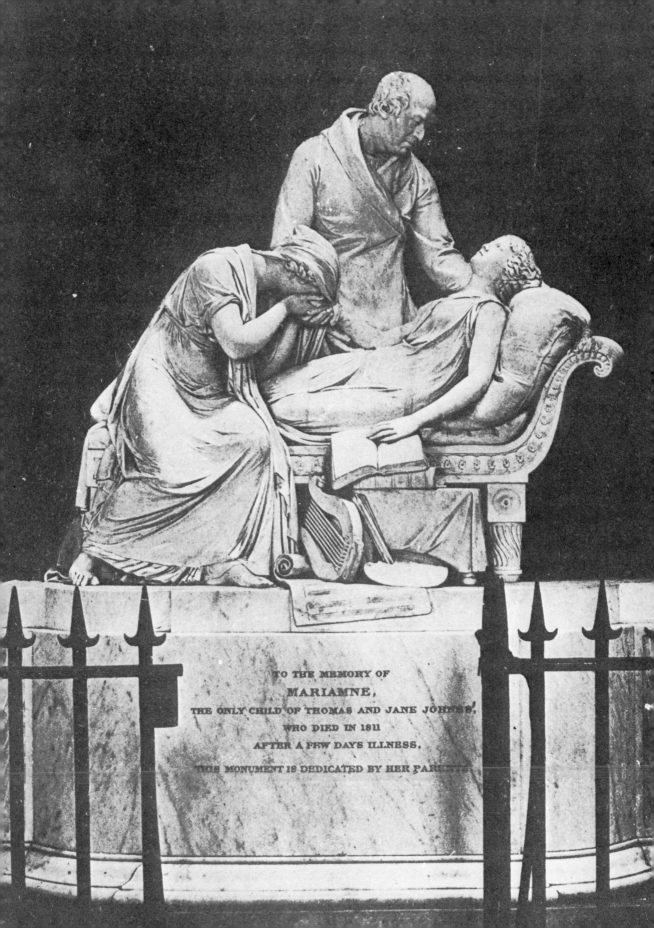

TO THE MEMORY OF
MARIAMNE,
THE ONLY CHILD OF THOMAS AND JANE JOHNES,
WHO DIED IN 1811
AFTER A FEW DAYS ILLNESS.

THIS MONUMENT IS DEDICATED BY HER PAR....

springs from corbel angels with hands alternately crossed or joined in prayer who look down at the white tableau-vivant of the good Christian's death.

An exceptionally full obituary of Watts was published in *The Gentleman's Magazine*.[32] He was befriended by Benjamin Kenton, the Vintner (whose 'Good Samaritan' monument will be noticed elsewhere in this book) and fell in love with Kenton's daughter. Kenton did not approve and the daughter 'declined' fatally. The repentant Kenton then made Watts his adopted son and left to him his business and his fortune. Watts, thereafter, dedicated himself to good works. He was a patron of Christ's Hospital, of the Institution of Sunday Schools and of the Central National School in Baldwin's Gardens. He married a Miss Morrison of Durham who gave birth to two sons and a daughter, but the sons died young and so the daughter and her four children became his heirs: 'During his last illness he was assiduously attended by his son-in-law and his daughter, and although his deathbed was visited by bodily pain, yet it was rendered a blessed and instructive scene, for it was truly the death of the righteous.'[33] This is the 'blessed and instructive scene' Chantrey illustrates. Watts leans up from his couch, resigned to the will of God, but concerned for the spiritual welfare of the family he leaves: one hand touches the text 'Thy Will be Done', while he blesses his daughter with the other. The daughter is a kneeling figure similar to Chantrey's single figures of this type. Three children are also present. It is highly likely that they would have been taken to the dying man's bedside—and not only so that he could see them for the last time.

The great Evangelical Henry Venn (Rector of Yelling and Chaplain to the Earl of Buckley) recommended in his *Complete Duty of Man*—a popular devotional handbook of the period—that visits to the 'bedside of a departing Saint' should be made an essential part of a child's education.[34] In Mrs Sherwood's *History of the Fairchild Family*[35] children are exposed to the deaths of both saints and sinners (to say nothing of decomposing gibbeted corpses) from a very early age and at every possible opportunity. After reading such literature it is gratifying to observe Chantrey's superior knowledge of childhood psychology. The youngest child is frightened, whilst the other two, even when seen from the chapel entry, reveal by 'their attitudes and above all the tilt of their heads . . . the curiosity of children towards illness rather than grief'.[36] Such unconsciousness of the real nature of what they witness makes the work more poignant, as well as more naturalistic.

Just as the kneeling Mrs Russell in this group invites comparison with Chantrey's other kneeling figures, so also Watts himself, sitting up on his deathbed, invites comparison with Chantrey's other reclining figures. These figures are entirely purged of the heroic or pompous attitudes of the eighteenth century. Good men await their death with pious resignation, good women with dreamy expectation. The first of these reclining men is the first Earl of Malmesbury whose monument is in Salisbury Cathedral, a work commissioned in February 1822 for £600, but which eventually cost

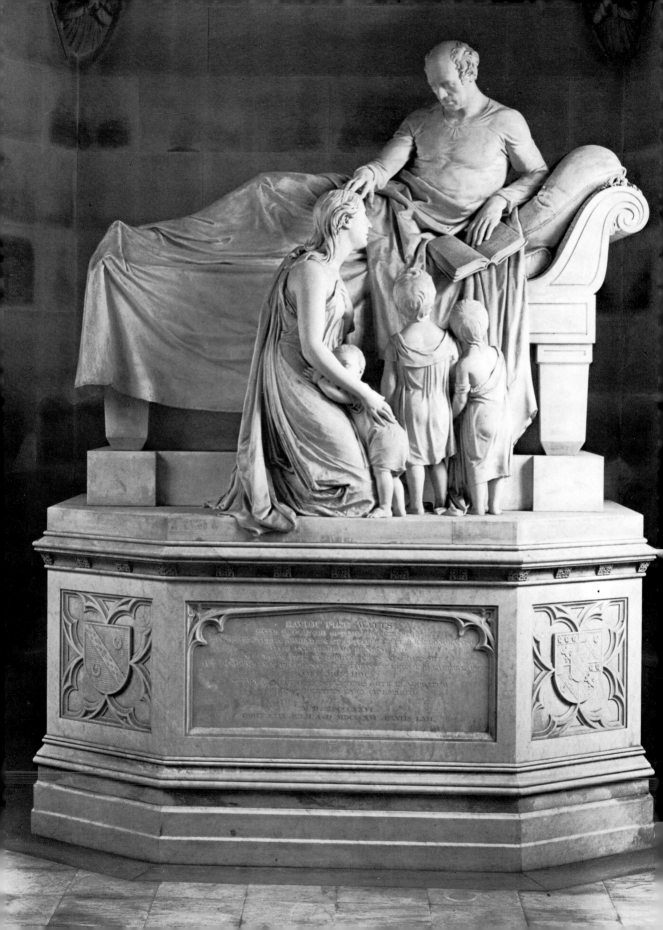

£843.12s.10d. because of the gothic frame added at the request of Hans Sloane[37] (Plate 62). The Earl seems about to discourse upon the text which he had been reading and intellectual energy animates the man's whole figure in spite of its reclining and relaxed position and the heavy drapery with which he is covered. This is chiefly conveyed through the upturning of the right hand, the slightly stiff twist of the neck, and the wonderfully sensitive modelling of the head. The text itself is made the climax of a compact still-life into which the Earl's coronet is tucked—half-hidden like Lady St Vincent's.

It comes as no surprise to discover that Chantrey repeated the idea of the Malmesbury monument at least twice.[38] It was not, however, a type which was very popular with other sculptors, although Benjamin Gott used it on two occasions.[39] Charles Smith's monument, carved out of freestone at Whalley in Yorkshire, commemorating the Rev. Thomas Whitaker, who died in 1822, is rather different. It is hard to believe that Whitaker, who rests his elbow on a pile of books and scrutinizes his flock with disapproval, is on his death-bed.[40]

The first of Chantrey's monuments to feature a reclining woman was also one of his most celebrated works—the monument to Elizabeth Digby in

61. (left) Francis Chantrey: Monument to David Pike Watts, Ilam, Staffordshire.
62. (below) Francis Chantrey: Monument to the Earl of Malmesbury, Salisbury Cathedral.

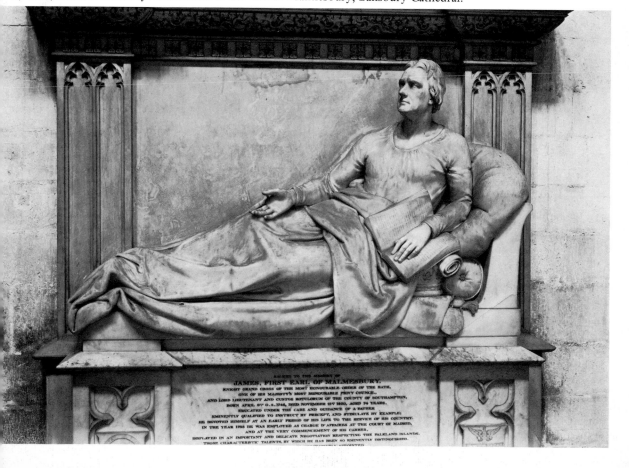

SACRED TO THE MEMORY OF
JAMES, FIRST EARL OF MALMESBURY,
KNIGHT GRAND CROSS OF THE MOST HONOURABLE ORDER OF THE BATH,
ONE OF HIS MAJESTY'S MOST HONOURABLE PRIVY COUNCIL,
AND LORD LIEUTENANT AND CUSTOS ROTULORUM OF THE COUNTY OF SOUTHAMPTON,
BORN APRIL 9th O.S. 1746, DIED NOVEMBER 27th 1820, AGED 74 YEARS,
EDUCATED UNDER THE CARE AND GUIDANCE OF A FATHER
EMINENTLY QUALIFIED TO INSTRUCT BY PRECEPT, AND STIMULATE BY EXAMPLE;
HE DEVOTED HIMSELF AT AN EARLY PERIOD OF HIS LIFE TO THE SERVICE OF HIS COUNTRY.
AND AT THE VERY COMMENCEMENT OF HIS CAREER,
IN THE YEAR 1768 HE WAS EMPLOYED AS CHARGE D'AFFAIRES AT THE COURT OF MADRID,
DISPLAYED IN AN IMPORTANT AND DELICATE NEGOTIATION RESPECTING THE FALKLAND ISLANDS,
THOSE CHARACTERISTIC TALENTS, BY WHICH HE HAS BEEN SO EMINENTLY DISTINGUISHED.

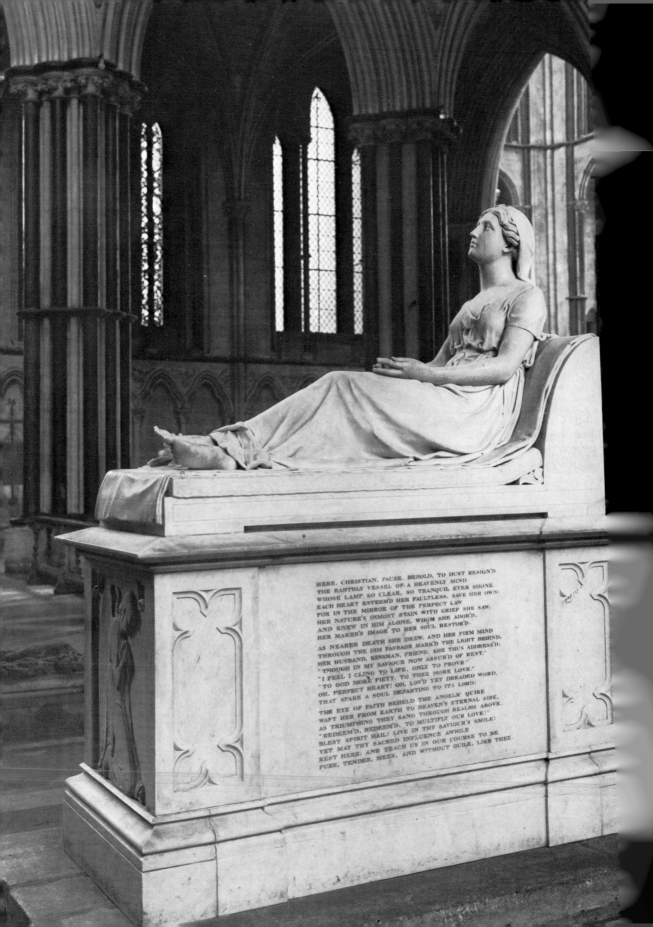

HERE, CHRISTIAN, PAUSE, BEHOLD, TO DUST RESIGN'D
THE EARTHLY VESSEL OF A HEAVENLY MIND
WHOSE LAMP SO CLEAR, SO TRANQUIL EVER SHONE
EACH HEART ESTEEM'D HER FAULTLESS, SAVE HER OWN:
FOR IN THE MIRROR OF THE PERFECT LAW
HER NATURE'S INMOST STAIN WITH GRIEF SHE SAW,
AND KNEW IN HIM ALONE, WHOM SHE ADOR'D,
HER MAKER'S IMAGE TO HER SOUL RESTOR'D.

AS NEARER DEATH SHE DREW, AND HER FIRM MIND
THROUGH THE DIM PASSAGE MARK'D THE LIGHT BEHIND,
HER HUSBAND, KINSMAN, FRIEND, SHE THUS ADDRESS'D:
"THOUGH IN MY SAVIOUR NOW ASSUR'D OF REST."
"I FEEL I CLING TO LIFE, ONLY TO PROVE"
"TO GOD MORE PIETY, TO THEE MORE LOVE."
OH, PERFECT HEART! TO THEE THAT DREADED WORD,
THAT SPAKE A SOUL DEPARTING TO ITS LORD:

THE EYE OF FAITH BEHELD THE ANGELIC QUIRE
WAFT HER FROM EARTH TO HEAVEN'S ETERNAL SIRE,
AS TRIUMPHING THEY SANG THROUGH REALMS ABOVE,
"REDEEM'D, REDEEM'D, TO MULTIPLY OUR LOVE!"
BLEST SPIRIT HAIL! LIVE IN THY SAVIOUR'S SMILE!
YET MAY THY SACRED INFLUENCE AWHILE
REST HERE; AND TEACH US IN OUR COURSE TO BE
PURE, TENDER, MEEK, AND WITHOUT GUILE, LIKE THEE.

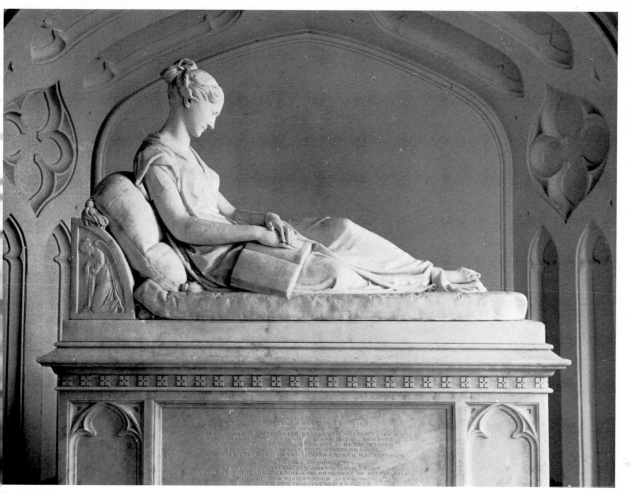

63. (left) Francis Chantrey: Monument to Elizabeth Digby, Worcester Cathedral.
64. (above) Francis Chantrey: Monument to Mrs Boulton, Great Tew, Oxfordshire.

Worcester Cathedral, known as 'Resignation' and illustrated under that title, alongside ideal sculptures intended for galleries, in the series of engravings published in 1832 as *Illustrations of Modern Sculpture*.[41] William Digby commissioned the work in 1823. It was complete in the autumn of 1825[42] (Plate 63).

A similar idea was used by Chantrey in his monument to Mrs Boulton at Great Tew in Oxfordshire, commissioned in 1830 and completed in 1834 for £1,500[43] (*Frontispiece* and Plate 64). The Boultons lived in North Birmingham (near their Soho works) and would probably have passed through Worcester on their way to their country house at Great Tew.

A difference between the two works is that Mrs Boulton is placed in a niche and, although free standing, is intended to be viewed from one side. She also looks down and holds a book, whereas Mrs Digby has her hands half-joined in prayer and looks up. The cushion between Mrs Boulton and the head of her couch corrects to some degree the one awkward feature of the Digby

87

monument—the lack of support for the back. But both figures are endowed with a similar sentiment.

The meaning of the Digby monument is elaborated by the poem on the tomb-chest. The first stanza opens with an excuse for the sculptor's idealization:

> Here, Christian, Pause, behold, to dust resign'd
> The Earthly vessel of a heavenly mind.

The second stanza explains her heaven-directed look:

> As nearer death she drew, and her firm mind
> Through the dim passage mark'd the light behind,
> Her husband, kinsman, friend, she thus address'd:
> "Though in my Saviour now assur'd of rest",
> "I feel I cling to life, only to prove"
> "To God, more piety, to thee more love".

In the third and final stanza we learn that:

> The eye of faith beheld the angelic quire
> Waft her from Earth to heaven's eternal sire.

This, however, was a scene which Chantrey, unlike many of his contemporaries, was little disposed to portray. There are, however, kneeling angels at the head and at the end of the tomb-chest.

The importance attached to deathbed scenes by many edifying writers in England during this period has already been touched upon. No doubt an even greater importance had been attached to this in former periods—in seventeenth-century Italy, for example, the Society of the Good Death actively encouraged people to rehearse for their own death—nevertheless it was remarkable, and it was not confined to the Evangelicals, as one might assume.

John Warton's great but forgotten work *Death-bed Scenes and Pastoral Conversations*, a three volume work which went through a number of editions during the 1820s and 1830s, is clearly High-Church (in the pre-Tractarian sense).[44] For the most part in this book the parishioner is on his death-bed, at least by the end of the 'conversation', and this adds a certain urgency to the narrative (as well as giving the parson a strong debating advantage). What is important for us is the fact that the actual death is often described as a sort of *tableau-vivant*, sometimes horrific, sometimes blissful, often 'trying' and always 'interesting'.[45] Although this book was apparently intended primarily to provide models of pastoral strategy for the use of inexperienced parsons, it enjoyed a far wider success. Remarking on this, the sons of 'Warton', who edited the book, wrote in the second edition: 'All men know that they have this last scene to act, very many are desirous of knowing how they may act it well; and they hope to acquire that momentous information from the study of

65. Peter Hollins: Monument to Sophia Thompson, Malvern Priory.

this book. It is our hearty wish that such a hope may not be in vain.'[46] Chantrey, although apparently not a particularly pious man—and one whose conversation was 'sadly larded with profane expletives'[47]—also, in his way, aspired to give models of a saintly ending.

There are many other monuments in this period with reclining female figures awaiting their death. In Italy one thinks of Bartolini's Monument in Santa Croce to Princess Czartoryski who died in 1837 and who is shown propped up on her daybed. But no English work of this period has quite that type of realism. A distinguished example by the Midlands' sculptor, Hollins, was erected in 1841 in Malvern Priory.[48] This commemorates Sophia Thompson who died on 2 February 1838 (Plates 65 and 66). She is a much less passive figure than Chantrey's and turns as if suddenly surprised by a sound or a light, her hair tumbling down her back as she does so. The text 'Ever so Come Lord Jesus' (Rev. 22:20) is written below. The idea is closer to

89

66. Peter Hollins: Monument to Sophia Thompson, Malvern Priory.

Roubiliac's Bishop Hough monument in Worcester Cathedral, a reclining figure who looks up to Heaven with astonished ecstasy (and, incidentally, an exception to the generalizations made about eighteenth-century reclining figures at the start of this chapter), than it is to anything by Chantrey. Unusual in the sculpture of this period is the note of genuine dramatic suspense conveyed by the slightly apprehensive pressure of her right hand on the pillow and by the raised left hand (half-draped, like that of Roubilliac's unforgettably urgent Eloquence in the Abbey). Hollins's figure is also more matronly than are Chantrey's, although Mrs Thompson died aged forty, which is two years younger than Chantrey's Mrs Digby.

Mrs Thompson's attitude is best explained as visionary or prescient: she has sensed or seen her coming end—or, in the words of the poem on Mrs Digby's monument:

> The eye of faith beheld the angelic quire
> Waft her from Earth to heaven's eternal sire

67. (left) Richard Westmacott: Monument to the Duchess of Newcastle, Markham Clinton (now Clumber Chapel), Nottinghamshire.

A similar idea had been used by Banks in his monument to Cornelia Milbanke at Croft, Yorkshire (a work discussed already in this book) where the dying woman has a vision of her dead children as angels came to greet her. Another and more comparable case is Westmacott's monument to Georgiana, Duchess of Newcastle, originally in the mausoleum-church at Markham Clinton, but recently moved to the chapel at Clumber, not far away and also in Nottinghamshire. The Duchess died on 27 September 1822, having been delivered of twins, a boy and a girl, the latter of whom was still-born and the former of whom died on 7 October. The monument was probably not complete in 1832.[49] The reclining woman, her children sleeping beside her, turns to see an angel who comes to beckon her away. The angel is in very low relief on a sort of screen behind the Duchess (Plate 67).

Hollins, himself, makes this theme quite explicit in his monument at Weston, Staffordshire, to Georgina, Countess of Bradford, who died in 1842 (Plate 68). The reclining woman is here portrayed in high relief. Unlike Mrs

91

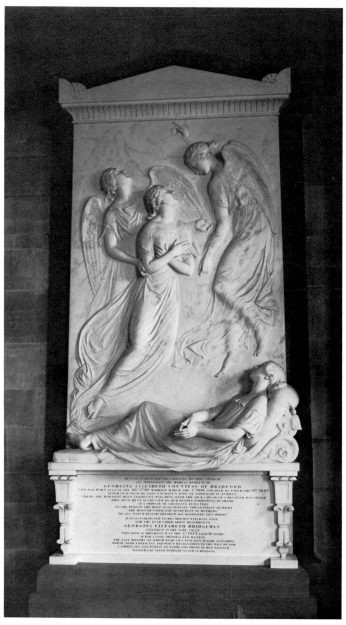

68. Peter Hollins:
Monument to
Georgina, Countess
of Bradford, Weston,
Staffordshire.

Thompson she is asleep, but upon a very similar couch and pillow to those used at Malvern Priory (and above a tomb-chest decorated with the same very peculiar ornament). The Countess is visited by a dream, and in it she sees not an angelic visitor but two angels lifting and conducting her spirit to 'heaven's eternal sire'. The vision here is in lower relief than the reclining woman, but the contrast is not perhaps sufficient to indicate, as it does in the case of Westmacott's work, two separate levels of reality. In this respect, the monuments by Joseph Edwards to Mrs White at Berechurch in Essex (Plate

69. Joseph
Edwards:
Monument to
Charlotte White,
Berechurch, Essex.

69) and to Mrs Hutton at North Otterington in the North Riding of Yorkshire
(women who died in 1845 and 1844 respectively) are more successful. There
the angels of which the reclining woman dreams are very faintly delineated in
a relief which is nowhere more than half-an-inch high. There may well be
other monuments of this type which have escaped my notice; indeed *The
Spectator* in 1834, criticizing a marble monument by Sievier shown at the
Suffolk Street gallery, declared that the idea of representing body and soul by
two figures was 'bad as well as hackneyed'.[50]

COME THOU BLESSED

SACRED TO THE MEMORY OF
AGNES SARAH HARRIET,
DAUGHTER OF HENRY CROMWELL ESQ: CAPTAIN R.N.
AND MARY HIS WIFE.
WHO DIED ON THE 30TH DAY OF NOVEMBER 1797
IN THE 18TH YEAR OF HER AGE.

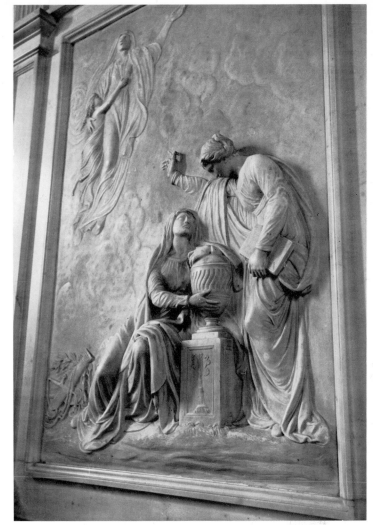

70. (left) John Flaxman: Monument to Agnes Cromwell, Chichester Cathedral.
71. (right) Charles Rossi: Monument to Elizabeth, Countess of Pembroke and her son, Wilton, Wiltshire.

It has become necessary to consider the theme of the ascending spirit as well as that of the reclining woman. Flaxman's low-relief monument in Chichester Cathedral to 'Agnes Sarah Harriet, daughter of Henry Cromwell, Esq., Captn. R.N. and Mary his wife' who died, aged eighteen, on 30 November 1797, shows the girl's spirit floating heavenwards with an escort of angels arranged gracefully in a reversed s, and, inspired, as were the nymphs of Banks, by the elegantly hysterical females who adorn the sides of the marble vases of antiquity (Plate 70). The monument was completed by the winter of 1798, but Flaxman was still awaiting Captain Cromwell's instructions as to the epitaph in November 1799.[51] It is possible that Flaxman's work came after Rossi's smaller low-relief monument at Wilton, Wiltshire, to Elizabeth, the first wife of the eleventh Earl of Pembroke who died in 1793 and her son George, who died in 1795, which shows a mourning woman consoled by the vision of their spirits taking flight (Plate 71). However, Flaxman's relief was certainly better known and was to prove an extraordinarily influential work, imitated by every major British sculptor of

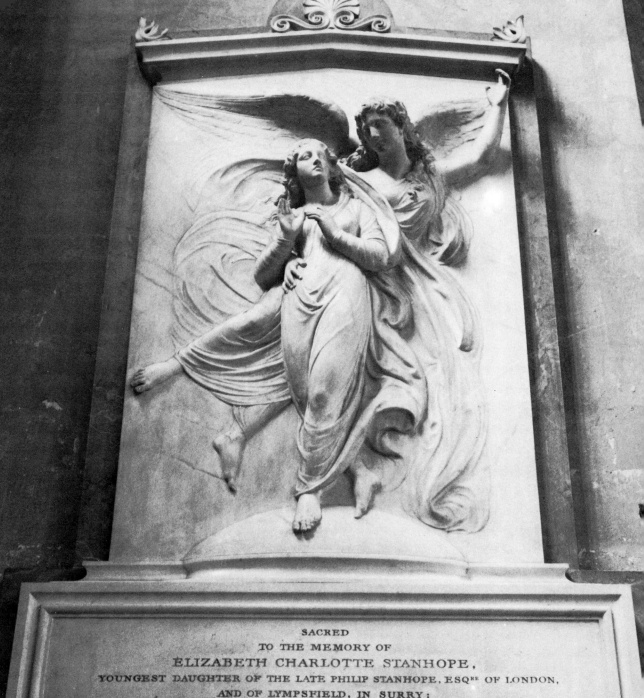

SACRED
TO THE MEMORY OF
ELIZABETH CHARLOTTE STANHOPE,
YOUNGEST DAUGHTER OF THE LATE PHILIP STANHOPE, ESQ.RE OF LONDON,
AND OF LYMPSFIELD, IN SURRY:
WHO DEPARTED THIS LIFE 13.TH JUNE 1816, AT THE HOTWELLS.
BORN OCTOBER 13.TH 1798.

72, (left) Richard Westmacott:
Monument to Elizabeth Stanhope,
Bristol Cathedral.
73. (right) E. H. Baily: Monument to
Eliza Mortimer, St Martin's, Exeter.

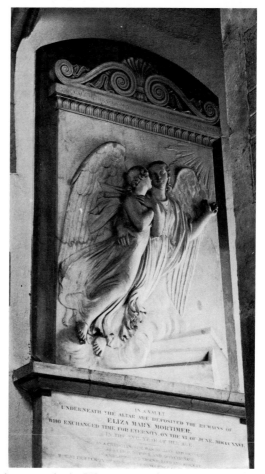

the following half-century. A good example is Westmacott's monument to Elizabeth Stanhope who died in 1816, which is in Bristol Cathedral (Plate 72); another is Baily's monument to Eliza Mortimer who died in 1826 which is in St Martin's, Exeter (Plate 73). There are many other examples both in Britain and on the Continent.[52] And Matthew Cotes Wyatt's monuments to Princess Charlotte and to the Duchess of Rutland represent ambitious adaptations of the idea.

Two general points can be made about this type of monument. Firstly, it is usually the flight of the soul that is portrayed and rarely the resurrection of the body. This is quite explicit in the case of Princess Charlotte, since her corpse remains below; and it seems implied in most of the low relief monuments by the attempt to make the floating forms so incorporeal. There are a number of exceptions to this, however, such as Cramphorn's monument to Mrs Cumberbatch who died in 1818 which is in Paddington Parish Church and the Baily monument in St Martin's, Exeter, where the figure has clearly burst out of a grave. Secondly, it is invariably women, or women with their children, who are shown ascending to heaven in this way.

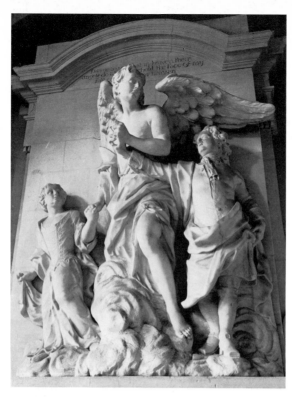

74. (left) Christopher Cass (?):
Monument to Jane and Edward
Bray, Great Barrington,
Gloucestershire.
75. (right) Joseph Nollekens:
Monument to Earl Spencer, Great
Brington, Northamptonshire.

In the eighteenth century, before Flaxman's Cromwell monument, figures
in monuments did sometimes rise up. They did so in some 'Resurrection'
headstones; in the charming monument perhaps by Christopher Cass at
Great Barrington in Gloucestershire, where the Bray children, in their
Sunday best, are led across the clouds by an angel (Plate 74); in Roubiliac's
monuments to General Hargrave, Lord Petre and Mrs Myddleton; in the
destroyed top section of Read's monument to Admiral Tyrrell; perhaps in the
monument to Spackman at Cliffe Pypard, Wiltshire discussed earlier; also in
Flaxman's own early monument to Mrs Morley in Gloucester Cathedral.[53]
But the theme was not a common one. When it did occur we can be sure that it
was the Resurrection that was referred to. Also, it was no more common for
women than for men.

The relative rarity of the ascending soul or resurrected body in the
eighteenth as distinct from the seventeenth or nineteenth century must not
encourage us to suppose that the subject was one in which men then took little
interest. Elegies in the early eighteenth century describe the soul's flight in
vivid pictorial detail. But sculptors generally referred to immortality by
means of the conceit of the medallion portrait, first popularized in the mid-
seventeenth-century Italy by Bernini. The passage of the spirit from this life
to eternity was portrayed metaphorically by an angel or a cherub or a skeleton
carrying a medallion portrait aloft, and by a medallion tied or about to be tied
to an obelisk or pyramid (the emblem of eternity).[54] Although a baroque
conceit, it still appealed in the late eighteenth century. Nollekens used it
several times, perhaps most beautifully in the monument at Great Brington,

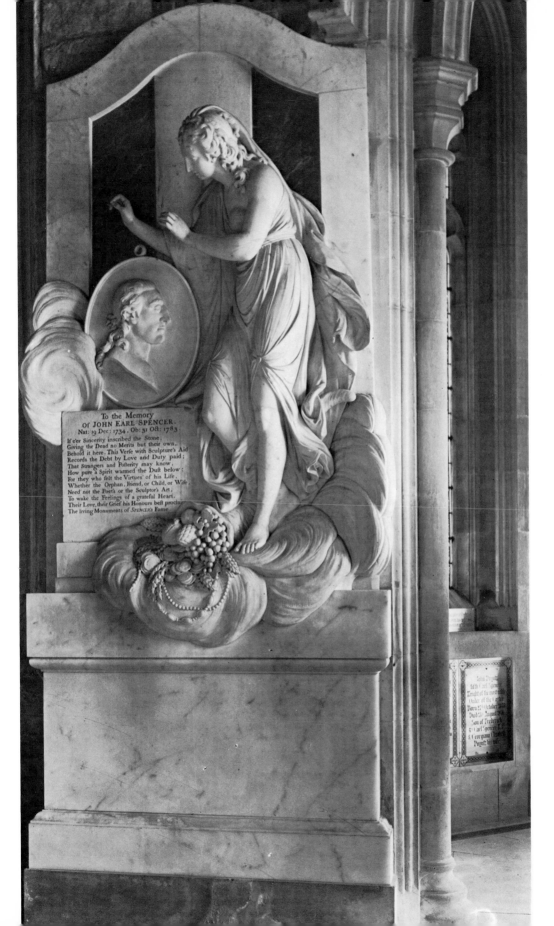

To the Memory
Of JOHN EARL SPENCER.
Nat: 19 Dec: 1734 . Ob: 31 Oct: 1783

If e'er Sincerity inscribed the Stone,
Giving the Dead no Merits but their own,
Behold it here. This Verse with Sculpture's Aid
Records the Debt by Love and Duty paid;
That Strangers and Posterity may know,
How pure a Spirit warmed the Dust below:
For they who felt the Virtues of his Life,
Whether the Orphan, Friend, or Child, or Wife,
Need not the Poet's or the Sculptor's Art,
To wake the Feelings of a grateful Heart.
Their Love, their Grief his Honours best proclaim,
The living Monuments of SPENCER'S Fame.

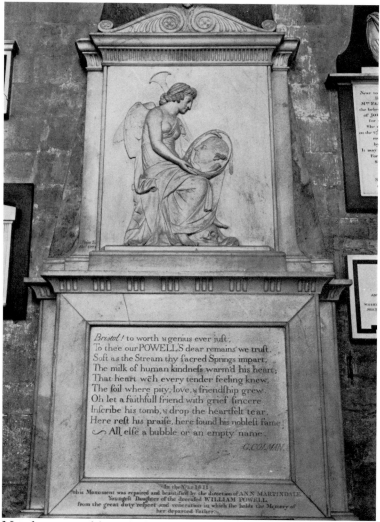

Northamptonshire, designed by Cipriani, in which an allegorical female, perhaps Abundance, ties up the medallion portrait of John, Earl Spencer, who died in 1783 (Plate 75). Far from being rejected by neo-classicists, Canova indicated the immortal prospects of Lady Brownlow's spirit by the same conceit. Faith holds her medallion portrait and points to heaven with her other hand (Plate 29). And James Paine the younger in his monument in Bristol Cathedral to William Powell—a work which is signed 1771 but which anticipates the relief style of continental neo-classicism by a whole quarter century—has the medallion of the deceased cradled by Fame or Immortality (Plate 76). Nevertheless, after 1800, it was quite exceptional for a British sculptor to favour this convention, although simple medallion portraits, sometimes placed against a pyramid-shaped ground, did remain popular.[55]

It is not enough, surely, to explain this change simply on the grounds that there was a reaction against what Flaxman called 'epigrammatical conceits'.

76. (left) James Paine the Younger: Monument to William Powell, Bristol Cathedral.
77. (right) E. Boehm: Monument to Henrietta Montagu, Newton, Cambridgeshire.

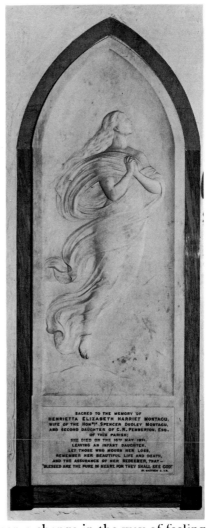

One is bound to concede that there had been a change in the way of feeling about the after-life, even though there had been no official revision of dogma concerning it. It is as if something more literal was required for the idea to command the bereaved patron's imagination: the winged baby carrying aloft a medallion portrait was too metaphorical. The convention initiated by the Agnes Cromwell monument was to lead a representation of the 'spirit-world' in relief that is so low that it resembles, in its faintness, spiritualist 'photographs' of spectres. Extreme cases of this are Matthew Noble's monument to Mrs Van den Bempde Johnstone who died in 1853 which is at Hackness, in the East Riding of Yorkshire; Boehm's monument to Mrs Henrietta Montagu who died in 1871, which is at Newton in Cambridgeshire (Plate 77); and Terence Farrell's monument to Henrietta Frances, Countess de Grey who died in 1848 at Flitton, Bedfordshire (Plate 78). This last work, which is unfortunately greatly damaged,[56] is one of the most remarkable

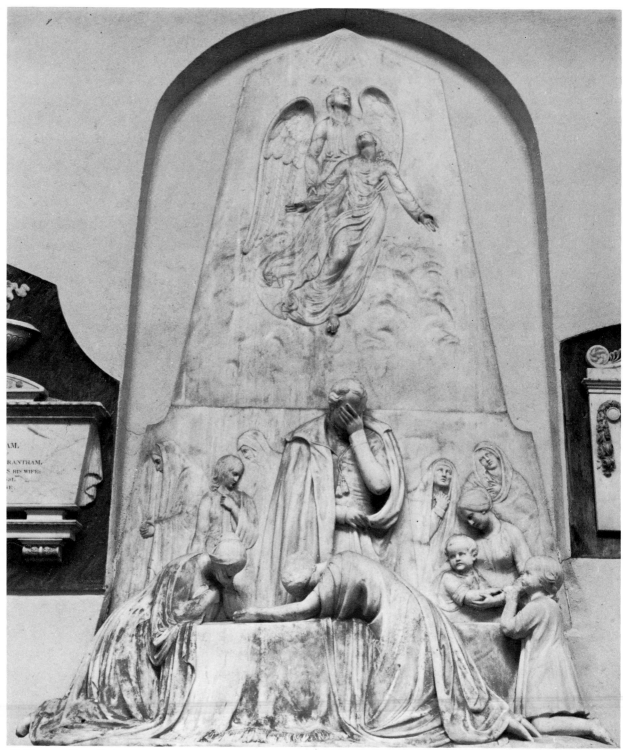

78. Terence Farrell: Monument to the Countess de Grey, Flitton, Bedfordshire.

cases of the domestic adoption of Roman Catholic iconography, which was discussed at the end of the last chapter; but at the same time it incorporates new elements of realism. The Earl stands, cold and grief-stricken, before his wife's draped coffin. The rest of his family are also in the foreground, but behind them flits a chorus of distressed female figures, who may be intended to represent subordinate mourners, but who certainly look as if they belong as much 'beyond the veil' as does the angel above, conducting the Countess's soul, as if she was the ascending Madonna.

To mention spiritualism in connection with these works is natural, considering that 'the presence amongst us of departed spirits' was then felt by a good many churchmen to play a central role in the work of 'a most minutely superintending Providence'.[57] Earlier in the century, long before the fad for table-tapping, the idea of closer intercommunion between this world and the spirit-world was also present to a less intense degree in the revived belief in guardian angels. Many people asked, optimistically, the question phrased thus by Mrs Hemans in her poem, *The Question of Angels*:

> But may ye not, unseen, around us hover,
> With gentle promptings and sweet influence yet,
> Though the fresh glory of those days be over,
> When, 'midst the palm-trees, man your footsteps met.'[58]

Guardian angels were originally a Counter Reformation cult which Protestants, for a long time, regarded with abhorrence. Luther and Calvin, indeed, had both condemned it.[59] However, the idea of departed souls interceding 'like guardian angels' was not uncommon in the eighteenth century.[60] The general idea of angels having 'charge over us' derived from the psalms and was of course quite respectable. However, the Swedenborgians, both within and outside the Church of England, revived the Counter Reformation cult and it seems gradually to have been accepted, perhaps because the idea was interpreted in a loose romantic way rather than dogmatically. As will be suggested in a later chapter, Flaxman, himself a Swedenborgian, probably first introduced guardian angels into English church monuments. His most influential portrayal of angels seems to have been his small relief monument to Isaac Hawkins Browne in the ante Chapel of Trinity College, Cambridge (Plate 79).

Browne had died in 1760 but the monument was commissioned in 1804, completed in July 1806, a year after it was exhibited at the Royal Academy, and it cost £160.[61] Browne was author of the Latin poem 'De Animi Immortalitate',[62] and this may have been a factor in the invention of the theme—'Angels strewing flowers on the tomb of a deceased poet', as it was described in the Academy Catalogue. Flaxman's pupil, Baily, in his monument to Peter Denys, Lady Charlotte Denys and Charlotte Denys (the second of whom died latest, in 1835) which is at Easton Neston, Northamptonshire shows a very similar group of three angels floating above

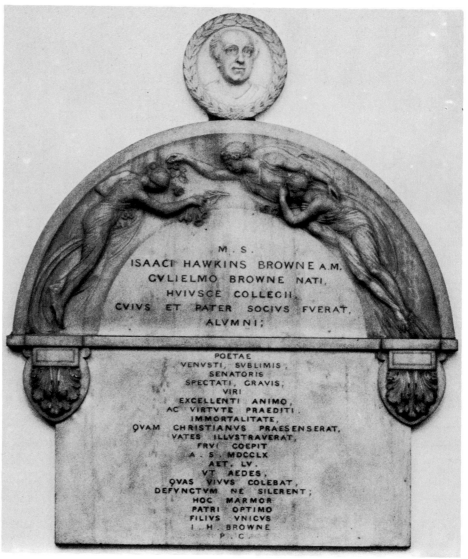

M . S .

ISAACI HAWKINS BROWNE A.M.
GVLIELMO BROWNE NATI,
HVIVSCE COLLEGII,
CVIVS ET PATER SOCIVS FVERAT,
ALVMNI;

POETAE
VENVSTI, SVBLIMIS;
SENATORIS
SPECTATI, GRAVIS;
VIRI
EXCELLENTI ANIMO,
AC VIRTVTE PRAEDITI.
IMMORTALITATE,
QVAM CHRISTIANVS PRAESENSERAT,
VATES ILLVSTRAVERAT,
FRVI COEPIT
A . S . MDCCLX
AET. LV.
VT AEDES,
QVAS VIVVS COLEBAT,
DEFVNCTVM NE SILERENT;
HOC MARMOR
PATRI OPTIMO
FILIVS VNICVS
I . H . BROWNE
P . C .

79. John Flaxman: Monument to I. H. Browne, Trinity College Antechapel, Cambridge.

the tombs of their late charges as if waiting to comfort any mourners who might come there to pray. The same angels appear also in his later monuments to Elizabeth Sparrow who died in 1841 which is at Colwich, Staffordshire, to Sarah Russell who died in 1842 which is at St Mary's, Handsworth, Birmingham (Plate 80); and in his earlier monument to Hannah Gostling who died in 1828, which is at Egham, Surrey. Flaxman's angels were different in style to the conventional cherubim, and the rarer full-size angels of earlier eighteenth century monuments, but it would be hard to prove that they represented a different class of angels. However, Baily did explicitly

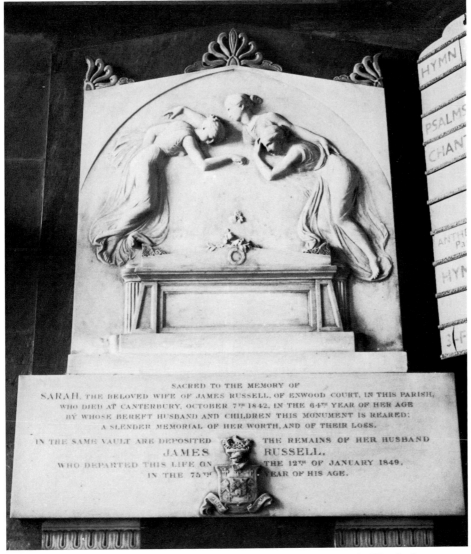

SACRED TO THE MEMORY OF
SARAH, THE BELOVED WIFE OF JAMES RUSSELL, OF ENWOOD COURT, IN THIS PARISH,
WHO DIED AT CANTERBURY, OCTOBER 7ᵀᴴ 1842, IN THE 64ᵀᴴ YEAR OF HER AGE
BY WHOSE BEREFT HUSBAND AND CHILDREN THIS MONUMENT IS REARED;
A SLENDER MEMORIAL OF HER WORTH, AND OF THEIR LOSS.

IN THE SAME VAULT ARE DEPOSITED THE REMAINS OF HER HUSBAND
JAMES RUSSELL,
WHO DEPARTED THIS LIFE ON THE 12ᵀᴴ OF JANUARY 1849,
IN THE 75ᵀᴴ YEAR OF HIS AGE.

80. E. H. Baily: Monument to Sarah Russell, St Mary's, Handsworth, Birmingham.

identify his angels—essentially the same angels as Flaxman's—as 'Guardian Angels' in his Academy Catalogue description of his monument to 'Lady Charlotte Dennis' of 1838.[63]

Richard Westmacott also employed this theme in a series of monuments. But his angels have wings[64] and are more boldly and sensuously conceived. A pair of them cling together, like two of Canova's three graces, forming an arch over the sarcophagus of the deceased, upon which they look down. Westmacott exhibited a relief entitled 'He shall give his angels charge over thee', at the Royal Academy in 1818.[65] This probably served as the

monument erected at Berkswell, Warwickshire, to Mrs Eardley Wilmot who died in that year (Plate 22). This is much the most elaborate of Westmacott's monuments of this type. The rich cresting of the pediment, the side panels with reliefs of cut roses and the butterfly (emblem of the soul) between the volutes are not details which reappear in Westmacott's subsequent versions.[66]

Were it not for the fact that these reliefs are church monuments, one might be tempted to consider them as illustrations to Moore's *Loves of the Angels*, or Byron's *Heaven and Earth*, or Lamartine's *Chute d'un ange*, the three popular poems of this period which took as a subject the old heresy that angels once experienced earthly passions.

Richard Westmacott the younger's guardian angels are more effete,[67] as are those carved by Behnes who hover pointing, with one hand, to heaven. The deceased is, we infer, 'on high'.[68] The idea derives, of course, from the angels who sit by the sepulchre from which Christ arose. The image haunted the imaginations of many men of this period:

—When by a good man's grave I muse alone,
Methinks an angel sits upon the stone;
Like those of old, on that thrice hallowed night,
Who sate and watched in raiment heavenly-bright;
And, with a voice inspiring joy not fear,
Says, pointing upward, that he is not here,
That he is risen![69]

Thus Samuel Rogers in *Human Life*—the poem which first used the phrase 'not dead—but gone before'. And thirty years later David Copperfield after the death of his child-wife is consoled by a memory of Agnes with her hand upraised 'like a sacred presence in my lonely house'.[70]

These changes in the conventions of English church monuments between the eighteenth and nineteenth centuries reflect a desire to feel closer to the spiritual world. Perhaps this was a consequence of a decreasing capacity to take that world for granted. Joseph Priestley's *Disquisitions Relating to Matter and Spirit*, published in 1777, shows how hard even the most pious thinkers often found it to accept the idea of an independent immaterial soul. Thereafter sculptors seem to have tried hard to help people accept the idea.

These changes in convention also reflect a new, or at least a newly focussed, attitude to women. There are praying figures of men to match those of women, but they are almost all of Bishops, whereas it was an attitude appropriate for all women. And whereas the praying men are vigorously characterized, the women are idealized, their individual identity, like that of angels being of less importance. Angels, although officially bisexual or asexual, had tended to be portrayed either as feminine or effeminate adults or as little boys, but in the nineteenth century the boys are far less common. Above all, whereas medallion portraits of both men and women had been

hoisted up to Heaven in the eighteenth century, only female souls are shown ascending in the early nineteenth century. Men, it may be objected, were not suitably dressed for celestial ascent. But then why do we think of female dress as more angelic? The early nineteenth century saw an astonishing increase in the idealization of women and in the literature of that period it was not uncommon for the wife or daughter to be described by men as

> A guardian-angel o'er his life presiding,
> Doubling his pleasures, and his cares dividing;
> Winning him back, when mingling in the throng,
> Back from the world we love, alas, too long.[71]

Society permitted women, or at least Ladies, to ascend to Heaven on monuments, just as it let them pass first through sublunary doorways. It was part of a practice, declining now but still very evident, which is best described as a form of 'chivalry', and through which women are compensated for the lack of freedom and the strictly prescribed social roles which derive from the importance of motherhood. Thus, women who cannot become professional painters may excel as amateur sketchers; thus women who are discouraged from the exercise of either ratiocinative or muscular powers are encouraged to cultivate their sensibility; and thus women who are barred from most forms of earthly privilege (including the privilege of becoming priests) are granted great prospects of heavenly crowns.

5. Marble Beds
and Gothic Monuments

THE most typically English church monuments are perhaps the smaller varieties: the brass, the Jacobean 'demi-figure' and 'kneeler', the baroque cartouche, the neat architecturally-framed tablet, the medallion, the bust. This is because there are many more monuments in English churches than in continental ones, and there was much more competition for wall-space. Something of this congestion has already been described in an earlier chapter, and obviously the problem was aggravated by large monuments, for as Wren observed, the very rich could always 'shoulder out' everyone else by erecting 'figures lying on marble beds' rather than more modest busts.[1] Nevertheless, 'figures lying on marble beds', which had been the most common form of church monument in the Middle Ages, never lost their popularity and were, indeed, much favoured during the 1850s and 1860s when there was a sharp decline in the number of smaller church monuments.

Amongst those effigies on marble beds a distinction should be made between figures lying on their backs, and figures either propped up on one elbow ('as if they had died o'the toothache'[2]) or sitting up. The former are described in this book as recumbent and the latter as reclining effigies. Reclining effigies, like seated, kneeling, standing, and equestrian effigies, were, for the most part, a Renaissance innovation, and arrived in Rome (perhaps coming from Spain) shortly after 1500 in Sansovino's Tombs in S. Maria del Popolo.[3] The posture, in a great many cases, derives from Roman river-gods and also from the vigilant feasters of much Etruscan and some Roman tomb sculpture. There was a good practical reason for the posture as well. If a recumbent effigy is placed on a high wall-tomb it is likely to be invisible. Gothic sculptors often tilted the effigy sideways—an uncomfortable solution which surely shows the strength of their inhibitions against 'animating' the effigy. A reclining effigy solves this problem with complete success.

On a double tomb, which is either fixed to a wall or placed against one, the recumbent effigies must be raised on different levels (which tends to look absurd), or one will block the other from view. If, however, one figure remains recumbent, but the other, behind, reclines, then the problem is solved. And this was a common way in which the new reclining effigy was employed in English church monuments in the early seventeenth century. The solution had an additional attraction in that one figure could be alive and mourn the other's death, which was appropriate then since husbands commonly made the death of their wife the occasion for commissioning a monument for both of them. (When both effigies do remain recumbent one sometimes notices that one has open and the other closed eyes to show who was alive when the effigies were carved.)[4]

During the course of the seventeenth century in England, the recumbent effigy, which had been perhaps as popular as the reclining effigy during the first two decades, steadily declined in favour. After the Civil War it also faced competition from the standing effigy especially favoured by martial Englishmen who wished to be remembered in Roman armour. There are very few notable late seventeenth-century recumbent effigies—the best are probably those by William Stanton in Great Mitton, Yorkshire, which date from the very last years of the century. These commemorate members of the Shireburn family: Catholics who perhaps retained a strong sense of tradition.[5] During the first three quarters of the eighteenth century, although reclining effigies continued in popularity, there are very few recumbent ones of any importance,[6] and little respect was given to such old ones as had survived. Stow's complaint in his *Survey of London* of 1720 that an effigy of one of the Veres was well carved, but still 'in the old gothic taste, flat on his back, and of no consequence'[7] was typical.

In 1775 Lady Milton died and, probably by the end of the decade, a monument for her and her husband had been executed by the Genoese emigré Agostino Carlini and erected in Milton Abbas Church, Dorset (Plate 81). This is a free-standing altar tomb, but it is intended to be seen from one side and the visibility of the figures from afar was obviously considered. Consequently, the sculptor revived the typically early seventeenth-century idea of having one figure recumbent and one reclining. This is the last major tomb which follows that pattern. Lord Milton contemplates his dead wife: conjugal grief was, of course, a strong theme in sculpture of the late eighteenth century—although it was usually expressed in other forms (above all, the figure weeping over an urn). In placing Lady Milton flat on her back the artist, or the patron, was certainly reviving an old style. What we cannot be sure about is whether this would have been thought of as necessarily in 'the gothic taste'. There is nothing gothic about Carlini's conception of the figure, but the ornament on the tomb-chest is certainly gothic—albeit of a charmingly flimsy and unscholarly type. The tombchest was designed by Robert Adam in the year of Lady Milton's death.[8] Lord Milton seems to have

109

81. Agostino Carlini: Monument to Lady Milton, Milton Abbas, Dorset.

82. (right) John Townesend the Younger: Monument to the Countess of Pomfret, St Mary's, Oxford.

83. (far right) Edward Bingham: Monument to William and Susanna Gery, Peterborough Cathedral.

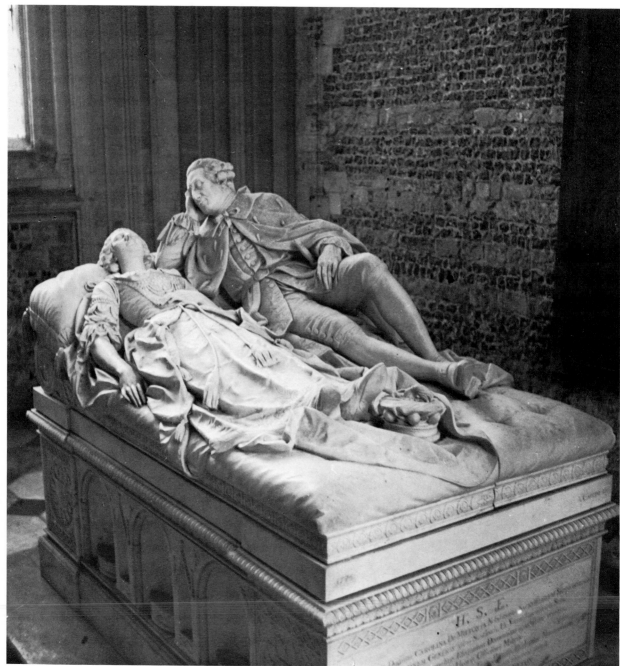

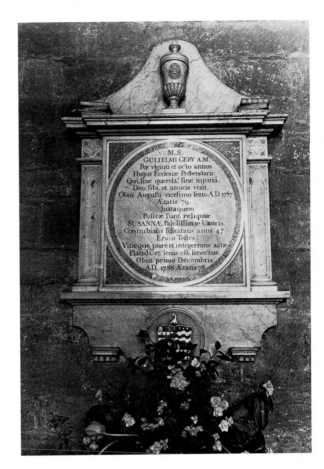

been a very whole-hearted goth, for he bullied that dedicated classicist Sir William Chambers to work in this style when he rebuilt Milton Abbas to match the remains of the Abbey.[9]

The question of how gothic this monument was intended to be becomes important when one realizes that although gothic ornament was used in late eighteenth-century monuments there were none, unless this counts as an exception, which came at all close to what was the usual type of gothic monument: that is the tomb-chest with a recumbent effigy. The way that the gothic tended to be used is well illustrated by the monument by John Townesend the third in St Mary's, Oxford, to Henrietta Luisa Fermor, Countess of Pomfret, who died in 1762, where gothic ornament is mingled with rococo and the largest ogee arch terminates in an urn finial (Plate 82). A later and more discreet case of this incorporation of Gothic ornament into an essentially ungothic form occurs in the side panels of the tablet to William Gery and his wife who died in 1787 and 1788 which is in Peterborough Cathedral and the work of Edward Bingham, a local mason (Plate 83). Similarly mixed in style is the extraordinary miniature wooden monument made for Ellen Devis and now in the Harris Art Gallery, Preston.[10]

Horace Walpole carefully studied the canopies of gothic tombs in Westminster Abbey, but only in order to copy them as chimney-pieces in Strawberry Hill. He also concerned himself with the preservation of gothic monuments of the type Stow abused (in particular, he intervened when the tomb of Aymer de Valence was threatened with removal to make room for Wolfe's monument).[11] But the statue of his mother which he placed in the south aisle of Henry VII's chapel is modelled on a statue of a Roman matron. In July 1773 William Mason consulted him about his design for the monument to Dr Dealtry executed by Fisher of York and to be seen in York Minster. Mason feared that to have Hygeia weeping by an urn might be considered too 'heathenish', but Walpole replied that the design was classic 'as I like those things should be'. When he commissioned Bentley to design a monument in 1757, erected in the following year in Linton Church, Kent, to Galfridus the brother of Horace Mann, who died in 1756, it took the form of a marble urn beneath a crocketed arch (Plate 84).[12]

The gothic ornament used by Flaxman at the very end of the eighteenth century and in the early decades of the nineteenth century was more accurate, and he sometimes introduced a figure, such as the angel on the Quantock

84. Richard Bentley: Monument to Galfridus Mann, Linton, Kent.

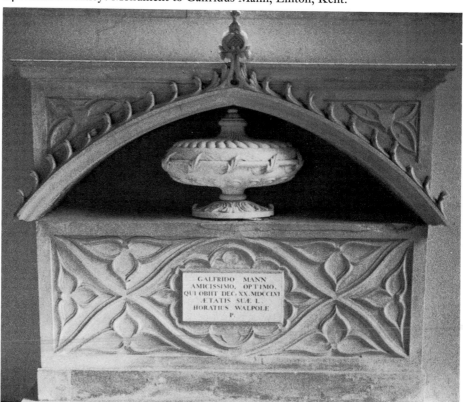

monument in Chichester Cathedral, which clearly reveals a close study of medieval figure sculpture—sculpture which Flaxman admired at a time when most artists considered it to be childish.[13] But there were still no unequivocally gothic monuments with recumbent effigies, with the single entirely isolated case of the Harcourt monument discussed in the second chapter of this book (Plate 11).

It might be argued that an antiquary like Walpole would have erected monuments like Harcourt's had Galfridus Mann been worthy of something so grand in size. However, Walpole is quoted by Gough as calling the recumbent posture 'a tasteless attitude',[14] so he must have admired the canopy, not the effigy of Aymer de Valence's tomb. Moreover, it is important to realize that, although gothic typography was used for solemn effects (such as the word 'deceased' on sale catalogues), and although the gothic could sometimes be revered for its association with 'British Worthies', it was not yet a sacred style, and the Middle Ages were still a part of the 'Dark Ages' and not yet the 'Age of Faith'. The ruins of abbeys, both genuine and simulated, were cherished for their picturesque appeal, also for the shudder that they could inspire in the inhabitants of a 'politer age', and as glorious reminders 'that the abodes of tyranny and superstitions', the dwellings of the 'sable band' were derelict.[15] Significant accounts of tombs are rarer in literature than are accounts of abbeys. But in Keats's *Eve of Saint Agnes* of 1819 there is a memorable passage on the 'sculptur'd dead' who

> . . . seem to freeze
> Emprison'd in black, purgatorial rails.[16]

They are seen as the relics of a chilly, remote and monkish age. Keats himself would surely have preferred to have been commemorated with a Grecian urn.

By Keats's time there had been a considerable advance in gothic scholarship, and what Britton and Rickman were doing for buildings—taking topographical notes, making detailed drawings and classifying types—others were doing for tombs. Richard Gough's vast volumes, *The Sepulchral Monuments in Great Britain*, appeared between 1786 and 1796, its appearance roughly coinciding with the creation in Paris of the Musée des Monuments Français.[17] If Gough's illustrations were often inadequate then the diligent Charles Alfred Stothard, the son of Thomas Stothard, made up for this with his *Monumental Effigies of Great Britain*[18]—a set of beautiful and precise etchings. His enthusiasm for detail would have pleased John Ruskin—one finds him, for example, turning the effigy of Richard Beauchamp onto its front to see if the back was carved. And he devoted whole days to scraping white-wash off alabaster. Unfortunately he was killed in 1821 when endeavouring to trace a stained glass window in Devon. He fell off his ladder and hit his head on a monument—'receiving his death-blow from one of those very effigies from which, through his talents, he will receive a sublunary immortality', as his editor, Alfred Kempe, phrased it in the Introduction to

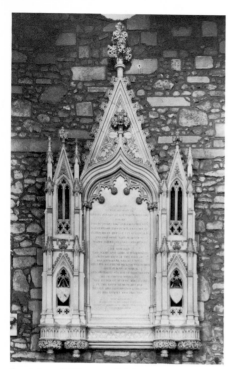

85. (above) Thomas Rickman:
Monument to Robert Whitworth,
Buckden, Huntingdonshire.

86. (right) John Carline the Younger:
Monument to the Poore Family, Salisbury
Cathedral.

the book published in 1832.[19] This edition has an entertaining frontispiece
etched by Stothard from a drawing by his father showing History trampling
on Time and tugging a fragment of a statue from him, whilst putti carry a
chain-mailed effigy heavenwards in triumph. Blore's *Monumental Remains* of
1826 shows how popular the study of these tombs was becoming,[20] and yet it
was not until the 1840s that they were imitated. Rickman, for instance, was
responsible for the design of the monument at Buckden, Huntingdonshire, to
Robert Whitworth, who died in 1831. It is a pretty, gothic triptych, with coats
of arms, originally painted—accurate enough as a piece of architectural
ornament, but still quite unlike any genuine gothic memorial[21] (Plate 85).
Apart from the Stanton Harcourt monument the only exception to this rule is
the canopied tomb-chest without an effigy in Salisbury Cathedral designed by
the Reverend Hugh Owen, carved by the Carlines of Shrewsbury, and
erected in 1817 (Plate 86).[22] This appears at first to commemorate Edward
and Rachel Poore who died in 1780 and 1771 respectively, but it also
commemorates the whole family, the male line of which ended in the two sons
of this couple. The epitaph makes it clear that the Poores could be traced back
in a direct line to Philip Poore of Amesbury, brother of Richard, founder of

114

Salisbury Cathedral. Surely the accuracy of the gothic was considered appropriate for this reason. An equally advanced example in France was the monument to Abelard and Eloise reconstructed in 1817 in the Père la Chaise cemetery by M. Godde.[23]

We return to the monument in Milton Abbas Church with an enhanced sense of the patron's possible pioneering intention. The next major monument to revive the recumbent effigy, however, was certainly not gothic in inspiration. Banks's monument in Ashbourne Church, Derbyshire, to Penelope Boothby (who died aged six in 1791), which was exhibited at the Royal Academy in 1793, where it was wept over by Queen Charlotte and the royal princesses,[24] is neo-classical in all its detail: the fluting of the tomb-chest, the acroteria and the stylized honeysuckle within the acroteria (Plate 87). In fact one may even wonder whether Banks did not know of one of the few recumbent effigies of antiquity.[25]

An interesting contemporary account of the impact made by 'Penelope' comes in the *British Tourist* by Dr Mavor who instructs his reader to dwell on details such as a 'ribbon sash, the knot twisted forward as it were by the restlessness of pain, and the two ends spread out in the same direction with the frock[26], in the same way that he proceeds to teach the reader the correct responses to waterfalls and ruined abbeys. It may be asked, whether the monument was not designed with the sentimental traveller half in mind. It is adorned with Latin, French, English and Italian texts, all reading like quotations (but, if so, extremely obscure) and these must have been carefully transcribed into hundreds of traveller's note-books.[27]

If it seems surprising that so private a work should have been half-intended for such public admiration, one might consider the way that people who retired to the privacy of remote cottages in this period nevertheless expected the 'World' to come and pay homage to the rustic neatness of their abode.[28] And, besides, Sir Brooke Boothby, Penelope's father, who commissioned this work, was also the author of a slim volume dedicated to her memory and entitled simply *Sorrows* in which he abandoned himself to grief in elegies which have in the author's own words, 'small pretensions to poetical merit', but are 'the expression of real feelings'.[29]

We know that Boothby was constantly in Banks's studio as the sculptor worked at the marble;[30] we know that they were friends from the twelfth sonnet in *Sorrows* which praises Banks's 'classick chisel'; and we know that they shared dangerously Republican opinions. The simplicity of the girl's dress, the emphasis on her innocence, accords closely with the ideas of Rousseau, whose works Boothby holds in his portrait by Wright of Derby, and it seems fair to credit Boothby with some of the originality of this work—the first notable monument to a child erected in eighteenth-century England—as also with the originality of the monument which he erected to his parents which was discussed earlier in this book. The sixteenth sonnet in *Sorrows* provides a clue as to Boothby's originality as a patron, for it is

addressed to Fuseli and describes a painting in which he portrayed (at Boothby's behest) an angel greeting Penelope's 'spotless shade' as it ascended to heaven 'from the dark disk of this terraqueous ball'. The painting, which was engraved as a frontispiece to *Sorrows*, is now in Wolverhampton Art Gallery.[31] Not long afterwards, Flaxman conceived his monument to Agnes Cromwell which, as was shown in the last chapter, initiated the convention of the spotless female shade's ascent to heaven which remained popular throughout the nineteenth-century. During that same century there was also a succession of monuments to children, sleeping, like 'Penelope' upon marble beds. There are several examples of such monuments on the continent,[32] while among English monuments of this type the most notable are those to the daughters of the Rev W. Robinson by Chantrey of 1817; to Constance Methuen by J. C. Lough of *c*. 1830; to Isabella Anne Kemeys by Raffaelle Monti of 1835; and that to Robert and Laura Hanbury by Theed the younger of the late 1860s. At the same time a great many sculptures were carved of this type for a domestic setting: for example, Scoular's portrait of

87. Thomas Banks: Monument to Penelope Boothby, Ashbourne, Derbyshire.

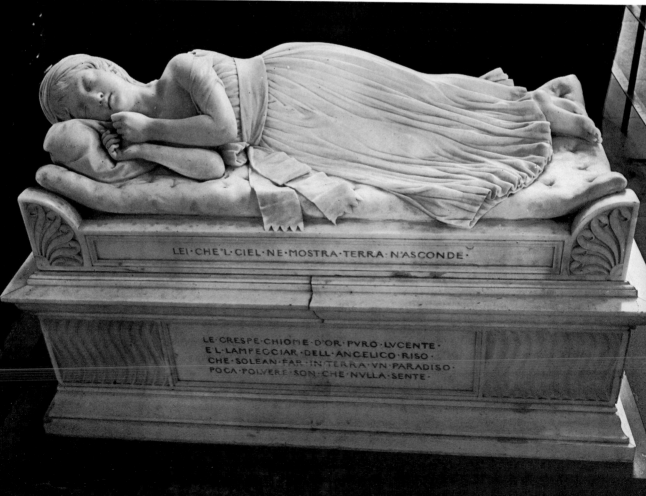

LEI·CHE·L·CIEL·NE·MOSTRA·TERRA·N'ASCONDE·

LE·CRESPE·CHIOME·D'OR·PVRO·LVCENTE·
E·L·LAMPEGGIAR·DELL·ANGELICO·RISO·
CHE·SOLEAN·FAR·IN·TERRA·VN·PARADISO·
POCA·POLVERE·SON·CHE·NVLLA·SENTE·

Elizabeth, daughter of the Duchess of Clarence of 1822, and W. Geef's *Sleeping Children* at Osborne House. Of all these by far the most celebrated was Chantrey's monument in Lichfield Cathedral to the daughters of the Rev W. Robinson—*The Sleeping Children*, as it was called (Plate 88).

This monument was commissioned on 10 August 1815, for £600 by Mrs Robinson who also ordered, at the same time, a monument to her husband for £50.[33] *The Sleeping Children* created a similar sensation, when exhibited at the Royal Academy in 1817, to that caused by Banks's work nearly a quarter of a century before.[34] Here also the detail on the tomb-chest, although there is less of it, is classical. The informality of the children is here, as in Banks's work, which Chantrey certainly knew, suggestive of sleep; and in this case the informality also helps the sculptor to make the figures both visible from one side.[35]

This type of monument is undoubtedly close to the death-bed monuments of the same period, some of which were mentioned in the last chapter, but it is important to note that these children are not shown on their death-bed (even

88. Francis Chantrey: *The Sleeping Children*, Lichfield Cathedral.

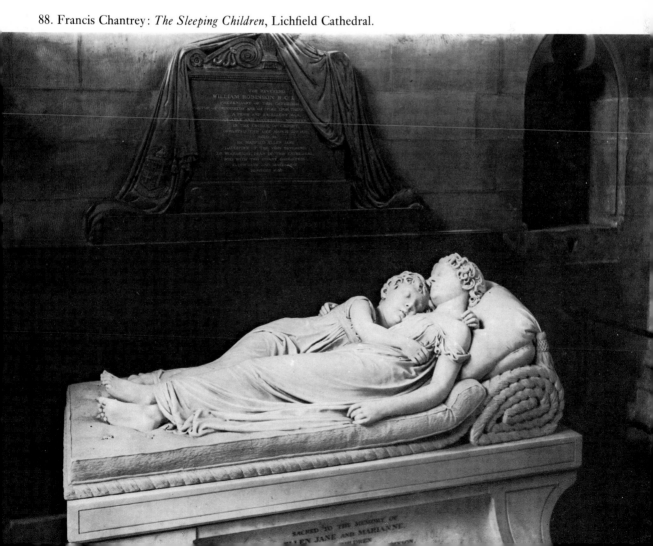

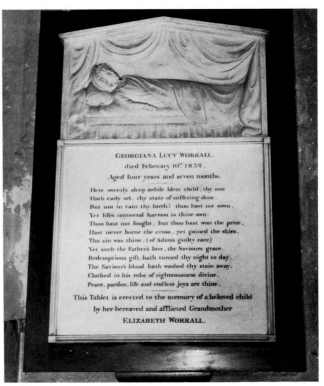

89. J. and T. Tyley:
Monument to Georgina
Worral, Bristol Cathedral.

GEORGIANA LUCY WORRALL,
died February 10th 1852,
Aged four years and seven months.

Here sweetly sleep awhile blest child, thy sun
Hath early set, thy state of suffering done,
But not in vain thy birth! thou hast not sown,
Yet life's immortal harvest is thine own:
Thou hast not fought, but thou hast won the prize,
Hast never borne the cross, yet gained the skies.
Tho' sin was thine, (of Adam's guilty race)
Yet such the Father's love, the Saviour's grace,
Redemptions gift, hath turned thy night to day,
The Saviour's blood hath washed thy stain away.
Clothed in his robe of righteousness divine,
Peace, pardon, life and endless joys are thine.

This Tablet is erected to the memory of a beloved child
by her bereaved and afflicted Grandmother
ELIZABETH WORRALL.

though there is a rush mat of the type upon which corpses were layed, placed, poignantly, below their mattress). The girls did not die either at the same time, or in the same way. E. Hawkins in *Notes and Queries* related how Mrs Robinson, mourning not only her daughters but her husband, discussed the monuments with Chantrey and in doing so 'expatiated upon the characters' of those she had lost, and described how she used to contemplate them 'locked in each others arms asleep', thus giving the sculptor the idea for the monument.[36]

However, the idea of their death could never be far from the beholder's mind: the highly polished white marble is reflected in the equally polished black marble foil of their father's monument behind, and the single misquotation from Milton which serves as an inscription: 'Oh, fairest flowers!—no sooner blown than blasted!', make the scene something far more than a happy memory. As an anonymous Victorian author in an American annual, *The Offering*, remarked of the sculpture, the sleep of the children owes its appeal not only to their helpless innocence, but to 'the uncertainty of the expression at first view, the dim shadowing forth of that sleep from which they cannot be awakened—their hovering, as it were, upon the confines of life, as if they might still be recalled.' There is also a scrap of evidence that children's corpses were laid out with flowers in their hands.[37]

There are many famous passages concerning children in the literature of this period, but there were many more attempts by writers to describe this

marble group of Chantrey's, than there were attempts by sculptors to refer to these passages of prose or verse.[38] Indeed, it seems unlikely that any sculpture before or since in this country has enjoyed such fame. The mixed feelings described precisely by the American critic quoted above were elaborated freely in most poetic reactions to the work, as in this poem by William L'Isle Bowles:

> Look at those sleeping children! softly tread
> Lest thou do mar their dream, and come not nigh
> Till their fond mother, with a kiss, shall cry
> " 'Tis morn! awake! awake!"—Ah! they are dead!
> Yet, folded in each other's arms they lie,
> So still—oh look! so still and smilingly,—
> So breathing and so beautiful they seem
> As if to die in youth were but to dream
> Of Spring and flowers!—of flowers! Yet nearer stand!
> There is a lily in one little hand . . .[39]

It is in fact a snowdrop. Mrs Hemans hit on the idea of giving 'rising' a double-meaning in her poem (suggested, according to the author, by a monument of Chantrey's), *The Child's Last Sleep*:

> Lovely thou sleepest! yet something lies
> Too deep and still on thy soft-sealed eyes,
> Mournful, though sweet, is thy rest to see—
> When will the hour of thy rising be?[40]

It was not necessary to visit Lichfield in order to appreciate this sculpture, for it was engraved and also reproduced in reduced biscuit replicas.[41]

The innocence of children was something for which doctrinal sanction existed—a point made quite clearly in the epitaph on a relief tablet by the Tyleys to Georgiana Worrall in Bristol Cathedral (Plate 89). (However, there was no theological reason why it was almost always the innocent sleep of little girls that the sculptors dwelt upon; any more than there was a theological reason why only female souls were shown ascending to Heaven.) In this period the Biblical story of Christ and the children was also popular as a relief on church monuments.[42] The feeling for childhood and the nostalgia for innocence which are so powerfully felt in English literature from Gray's 'Ode on a Distant Prospect of Eton College' to Hood's 'I Remember, I Remember' was easily accommodated by the Church. The picture should not, however, be over-simplified. This was also a period which saw organized child-labour on a new scale, and the Evangelical wing of the Church of England certainly did not encourage the idea of the innocence of children. They had difficulty with the Prayer-book's clear statement of the doctrine that Man is unconditionally regenerated in infant-baptism and they attempted to interpret the act of baptism as 'a conditional sign of future regeneration'. Controversy on this

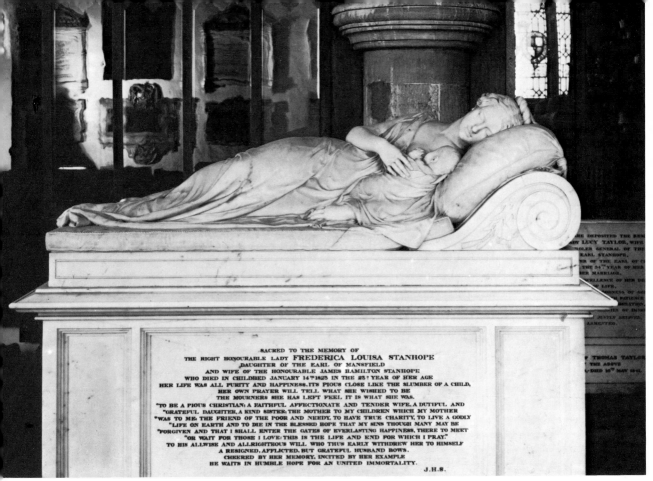

90. Francis Chantrey: Monument to Lady Frederica Stanhope, Chevening, Kent.

matter divided the Church throughout the early nineteenth century and reached a head in the Gorham controversy of the late 1840s.[43] It comes as a shock to realize that for a substantial portion of the population, these sleeping children would have appeared not as an image of innocence, threatened by Death, but certain to be saved; but as particularly tempting prey for the devil.

Chantrey completed other recumbent effigies, and, in particular one to Lady Frederica Stanhope at Chevening, Kent (Plate 90). This monument, which was complete in 1827, seven years after Lady Stanhope's death in childbed, was one with which Chantrey was particularly happy, although he never exhibited it, because of family sensitivity over the widower's suicide.[44] There are other monuments by Chantrey with recumbent effigies to men, one of which will be mentioned in due course, But although he did frequently use gothic ornament on his monuments, and although he apparently sympathized with the style sufficiently to advise the Dean of Westminster Abbey on the restoration of the tomb of Aymer de Valence,[45] there is nothing gothic about his figures on their marble beds. Westmacott, however, is a different matter. His first recumbent effigies are easy to miss because they are surrounded by allegorical figures (the monument in Westminster Abbey to Spencer

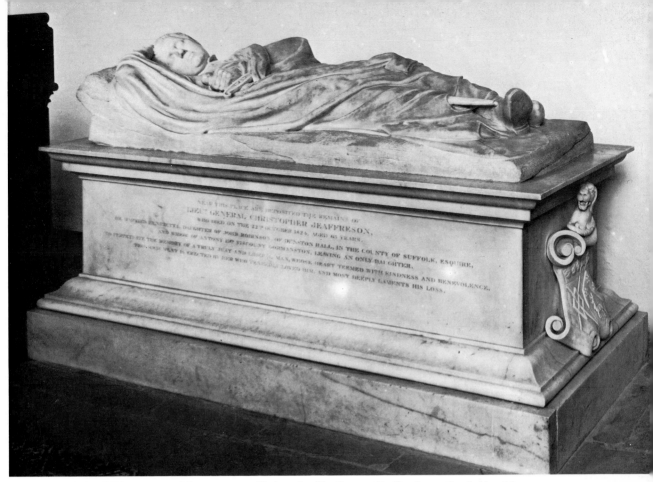

91. Richard Westmacott: Monument to Christopher Jeaffreson, Dullingham, Cambridgeshire.

Perceval, completed in 1816, is a case in point); what concerns us here is his first full-length, free-standing recumbent effigy—the monument to Lieutenant General Christopher Jeaffreson in Dullingham, Cambridgeshire (Plate 91). Jeaffreson died on 22 October 1824, aged sixty-three. The work was commissioned by his wife and since she died on 29 January 1826, it must have been commissioned soon after his death, and can probably be dated in the late 1820s. Westmacott also carved the wall-tablet to the widow, and his father had carved monuments for the same family in the late eighteenth-century (Plate 6).

The general is easily visible on a low tomb-chest. He seems to have died in his bed but here he lies, like Sir John Moore 'with his martial cloak around him,' as if dead on a battlefield, his marble bed roughened to suggest earth into which his left heel has sunk. He wears spurs and has his sword beside him, clasped in one hand whilst his other hand is half-clenched, above his head. Westmacott had studied gothic sculpture with care and this effigy is surely inspired by the cross-legged effigies of knights struggling to draw their swords as they lie on bumpy battlefields, a type of gothic monument of which there are many examples in England, and which were also illustrated by both

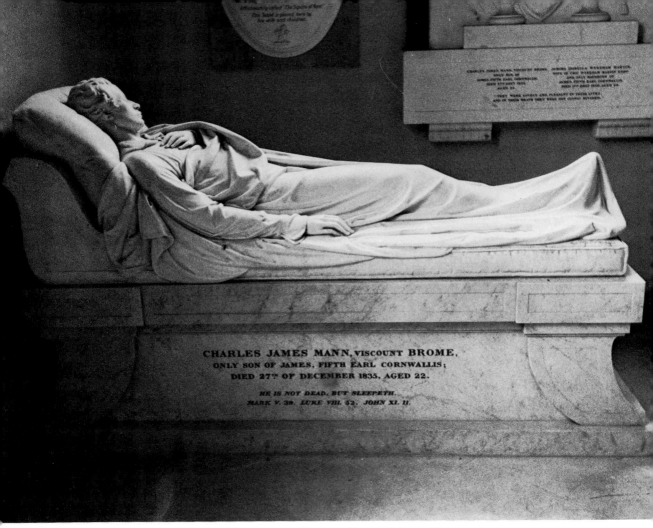

Inscription on monument:

CHARLES JAMES MANN, VISCOUNT BROME,
ONLY SON OF JAMES, FIFTH EARL CORNWALLIS;
DIED 27ᵀᴴ OF DECEMBER 1835, AGED 22.

HE IS NOT DEAD, BUT SLEEPETH.
MARK V. 39. LUKE VIII. 52. JOHN XI. 11.

92. E. H. Baily: Monument to Viscount Brome, Linton, Kent.

Gough and Stothard. This is not to say that there is any gothic ornament on the monument, nor that either the proportions, drapery-style, or costume are gothic.[46]

Other masculine recumbent effigies date from this period. Another by Westmacott is that to the Duc de Montpensier in Henry VII's chapel in Westminster Abbey. This is dated 1830 and was exhibited in the Royal Academy that year. The Duc, whose imprisonment during the revolution, escape, recapture and exile had excited considerable sympathy in England, had died at Twickenham in 1807; but it cannot have been till considerably later that his brother, Louis Philippe, Duc d'Orleans, commissioned the monument. Since 1830 was the year in which Louis Philippe assumed power in France, the work must have been of topical interest. It is quieter than the Dullingham effigy, the head rests upon a plump cushion, and the body is enveloped in a cloak decorated with fleurs-de-lys. The monument may have influenced Ary Scheffer's design for the tomb of the Duc d'Orleans, executed

122

by Pierre Loison, and erected in the mid 1840s in the Chapelle Royale at Dreux. Also similar is Lough's monument to Robert Southey, completed in 1846 and to be seen at Crossthwaite in Westmorland.

Two years after the Duc de Montpensier monument, in 1832, Chantrey signed a male recumbent effigy commemorating Sir Hugh Inglis at Milton Bryan, near Woburn in Bedfordshire.[47] The self-made Scottish director of the East India Company who had died, aged seventy-six, in 1820, is draped in what looks like a very plain dressing-gown. One hand is placed on his chest and the other holds a Bible. Chantrey, however, was not imitating Westmacott, for he had used this same pose in the monument in Winchester Cathedral to the Reverend Frederick Iremonger, who also died in 1820.[48] But much more effective than either of these, or than Westmacott's Duc de Montpensier, is E. H. Baily's monument in Linton Church, Kent, to Charles James Mann, Viscount Brome, who died, aged twenty two, on 27 December 1835, (Plate 92), a work exhibited at the Royal Academy in 1837. the body lies quite flat and against the straight, unadorned mass of the sheet covering it every movement and shadow tells: one hand pressed against the chest; the other, half-bent, resting on the sheet; the lips almost open; one curl pressed between temple and pillow.[49] Viscount Brome, unlike the other males mentioned so far, died as a young man and an only son. The work was commissioned by a distressed father (James, fifth Earl of Cornwallis) so that in a way this is closer to the monuments to sleeping girls, except that here one does not feel that he is asleep, but that he is dead. The plain words 'He is not dead, but sleepeth' are inscribed on the side of the plain Greek sarcophagus, and after them the references to the places in the three gospels where this phrase is used—but the sculptor is not concerned to make any more of this metaphor than did the authors of the Authorized Version. The impact of this work is only equalled, later in the century, by Patrick MacDowell's monument of the mid 1850s to the Earl of Belfast in Belfast Castle where the young man's mother is added, leaning over the bed.[50]

A considerable change of taste is suggested by the monument to Philip Yorke, third Earl of Hardwicke, in Wimpole Church, Cambridgeshire, by Westmacott the younger (Plate 93). This was probably commissioned soon after the Earl's death in 1834, but was only completed a decade later. The crossed legs and the sword may remind one of Westmacott's father's work at Dullingham which the Hardwickes would probably have known; but here there is no battlefield, the sword is ceremonial and we are invited to dwell on tassels, ribbons, medals, garters and badges which tell us that the deceased was a Viscount and a Baron, as well as an Earl, Knight of the Garter, Lord Lieutenant of Ireland, Privy Councillor, High Steward of the University of Cambridge, and Lord Lieutenant of the County. He also carries a Bible. One feels that here is a body lying (a little informally for purposes of visibility) in State, so covered is it with emblems of rank. And this is an impression which can also be given by the richly clad medieval effigies (which certainly did

123

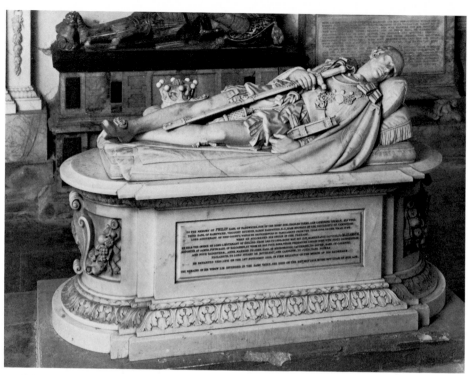

93. Richard Westmacott the Younger: Monument to the third Earl of Hardwicke, Wimpole, Cambridgeshire.

sometimes reflect the style in which the bodies were buried). The Hardwicke monument has, however, nothing gothic about its tomb-chest, which is decorated in the manner of the more corpulent furniture of the 1840s. This is in fact surprising because by 1844, when this work was signed, gothic was established as *the* sacred style, and recumbent effigies were not only becoming common but were usually gothic. This is true of most of the younger Westmacott's own recumbent effigies, including two (at Nether Alderley, Cheshire, and at Ingestre, Staffordshire) which are similar to the Wimpole effigy.

Many changes had taken place in popular attitudes to the gothic. Ruined Abbeys had gradually come to be seen as sacred as well as picturesque. The Reverend J. Evans has a remarkable passage on Valle Crucis Abbey in his *Tour Through Part of North Wales* of 1800. Having carefully assured us that it is not because of any papist associations that he is moved by the ruins, he proceeds to declare that, nevertheless, it was a profoundly religious emotion that they inspired him.[51] Similarly in 1807, Thomas Maurice in *Richmond Hill* deferred briefly to the official view that the monastery at Sheen was erected 'in times when barbarous superstition reigned', but then proceeded to rhapsodize over the richness of gothic ornament and stained glass in religious as well as aesthetic terms.[52] When Sir Arthur and Mr Oldenbuck discourse on the glories of monastic hospitality, scholarship and ceremonial in Walter

124

Scott's *The Antiquary*[53] they are intended as a little comic, but Maurice is in earnest when he laments the destruction of these very qualities by 'bloated Henry'.

Byron in his addition of 1813 to the Preface to *Childe Harold*, protested against the growing sentimentalization of the age of chivalry, but in vain, and the idea of the dark, monkish ages as an age of faith also grew in popularity. 'Once ye were holy, ye are holy still', wrote Wordsworth in his thirty-third Ecclesiastical sonnet, 'Old Abbeys', published in 1822. Cobbett's *History of the Protestant 'Reformation' in England and Ireland* of 1824 and Southey's *Sir Thomas More: Colloquies on the Progress and Prospects of Society* of 1829 reveal that Radicals and Tories could agree that the Reformation had destroyed much of value, and in 1831 Mr Chainmail appeared in Peacock's *Crotchet Castle* expressing his 'high impassioned love of the ages, which some people have the impudence to call dark.'[54] It was the High Church who were to be most highly impassioned of all.

Doubtless some ladies only enjoyed turning over the pages of Nash's popular *Mansions of England in the Olden Time*,[55] with its engravings of yule-logs and hand-spinning, but others commissioned new churches, almshouses and schools in the gothic style; and some of their husbands had great halls built in their houses in order to feast the local squires whilst the peasantry were accommodated in that equally gothic contrivance, the marquee. Among the more serious enthusiasts were many associated either with the Roman Catholics in the circle of the Earl of Shrewsbury, Ambrose Phillips and Pugin, or with the High Church Ecclesiologists of the Cambridge Camden Society, or with the romantic Tory 'Young England' movement led by Disraeli. (These Tories were connected, chiefly through Lord John Manners, with the High Churchmen.)[56] Others quite outside these groups praised the good old days of Feudalism—Carlyle did so in his *Past and Present*, for example—but these groups were the major forces in this movement and they were at the height of their power during the 1840s, when young Lord Vieuxbois in Kingsley's *Yeast* was most busy among 'high art and painted glass, spade farms, and model smell-traps, rubricalities and sanitary reforms.'[57]

The opinions of the new Catholics and of the High Church upon church monuments were fiercely expressed. Nicholas (later Cardinal) Wiseman in 1834 was revolted by the pagan gods and the 'unseemly lack of drapery' in St Paul's and two years later, in 1836, Pugin in his *Contrasts*, discussing bishops' monuments in the Middle Ages, gave an encapsulated account of the history of European monuments. Before the Reformation, according to him, there were dignified recumbent effigies with angelic supporters at the head, and brief but 'Catholic' inscriptions, whilst now there were pompous inscriptions, pagan allegories, pagan nudity and cinerary urns.[58] In the early 1840s this point of view was repeated with great authority by the High Anglican, J. H. Markland, in his highly-influential *Remarks on English Churches, and on the*

125

Expediency of Rendering Sepulchral Memorials Subserviant to Pious and Christian Uses; and also by the Camden Society in their *Handbook of English Ecclesiology* of 1847.[59]

These opinions were soon echoed by others with different religious views, for example, by William Sewell in his long and anonymous review of the second edition of Markland in *The Quarterly Review*.[60] Sewell commends Chantrey for reforming taste by banishing allegory and paganism. But, for the most part, this reappreciation of gothic monuments militated against Chantrey's reputation. Pugin contrasted Chantrey's Malmesbury monument in Salisbury (Plate 62) with a recumbent gothic effigy and two years later, in 1839, Lord Greville noted in his *Memoirs* on a visit to Salisbury that, although the Malmesbury monument was 'very fine', he considered the old 'rude effigies of knights and warriors' more appropriate to our Cathedrals.[61]

Similarly, a critic in the *British Magazine* of April 1842, contrasted Chantrey's monument to Northcote in Exeter Cathedral unfavourably with the gothic monuments which were so much more filled with 'spiritual illumination, reverence and humility'.[62] And even Holland in his *Memorials of Sir Francis Chantrey* quoted with approval a critic who found that Chantrey's monuments were not designed to improve and advance us in the Divine Life, as were gothic monuments, like that to Queen Eleanor.[63]

By the mid-century, when it was almost obligatory for a Bishop to be commemorated in these Cathedrals by a recumbent effigy and a gothic tomb, sentimental monuments to sleeping children were also adapted to the gothic. Westmacott the younger's monument to the fifteen year old Charles Hussey Packe at Prestwold, near Loughborough in Leicestershire, is a good example,[64] but the most interesting example of his work of this sort is the monument to Charlotte Egerton, the only surviving daughter of Wilbraham Egerton of Tatton, who died, aged twenty one, on 10 November 1845. This is in Rostherne Church, Cheshire, between the family chapel and the nave (Plate 94). Here, as in the Packe monument, we find gothic ornament, a facile drapery pattern, the 'repose' but not the stiffness of gothic effigies; but here the figure is turned more to one side and an angel kneels over her as if enraptured at such loveliness, and reluctant to introduce her too abruptly to another life. On the tomb-chest we read the lines:

> Softly she slept—in that last hour
> God's angel hover'd nigh;
> He raised with love that fragile flower
> To wake in bliss on high.

This idea is inspired by the diminutive angels who sometimes support the pillows upon which gothic effigies rest their heads. Such angels were later to be imitated by Victorian sculptors (for instance by John Birnie Philip, in his tombs to Lord Herbert of Lea and the Countess of Pembroke at Wilton), but here the angel is enlarged and turned about and can thus react more

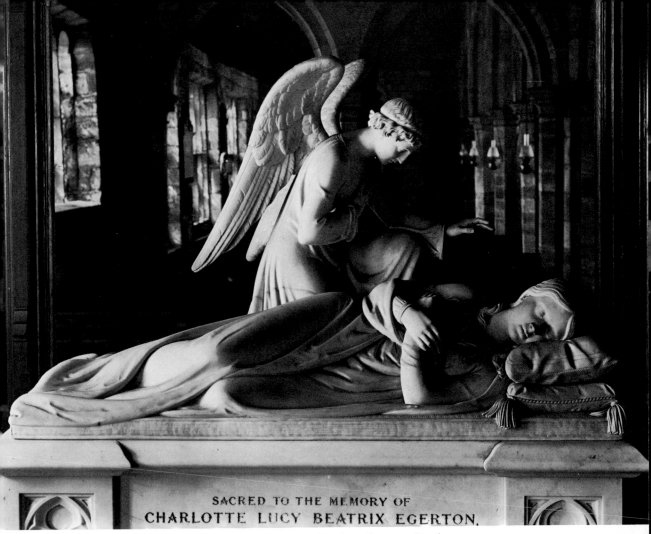

SACRED TO THE MEMORY OF
CHARLOTTE LUCY BEATRIX EGERTON.

94. Richard Westmacott the Younger: Monument to Charlotte Egerton, Rostherne, Cheshire.

dramatically to the figure. Such a desire to add a narrative element to the conventions of gothic sculpture was also characteristic of Flaxman, who, in a drawing in the British Museum, shows a family group that have come out of the gothic niches to either side of the recumbent effigy and mourn him as if by his death-bed. The boy on the right of this drawing carries what may be a pair of skates which suggests that this was an idea for the monument to Matthew Quantock in Chichester Cathedral, for he was killed in a skating accident (Plate 95).[65]

Another free use of gothic ideas is found in the lovely monument in Ledbury, Hereford, to John Hamilton-Martin who died, aged eleven months, in 1851—a sculpture by Thomas Thornycroft and his wife Mary (daughter of Thornycroft's master, John Francis). Here a charmingly interwoven pair of angels form a sort of relief bed-head to the sleeping infant, one of them sad that the child must be disturbed, the other holding a heavenly crown. The relief is contrasted with the figure to suggest different levels of reality, as so

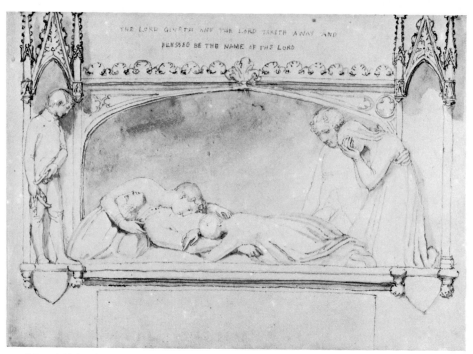

The Lord giveth and the Lord taketh away and
blessed be the name of the Lord

95. (above) John Flaxman: Design for a Monument, British Museum.
96. (right) Thomas and Mary Thornycroft: Monument to John Hamilton-Martin,
Ledbury, Herefordshire.

often in the mid nineteenth century (Plate 96). The double monument, such
as Carlini's at Milton Abbas, also provided opportunities for an additional
narrative interest, but these are rare, doubtless because it was then rare to
erect a monument, even half a monument, to oneself in one's own lifetime.[66]

The influence of the gothic revival on English church monuments during
the 1840s can best be demonstrated by reference to sculpture by artists in
whom gothic leanings come as rather a surprise. Bacon the younger must be
our first example. He had continued working in his father's tradition, using
his father's models for reliefs of ladies adorning urns with garlands, until 1824
when he retired to Devon with a small fortune. His daughter, Christina,
married the Rev John Medley who was vicar of St Thomas's Church, Exeter,
between 1838 and 1845, and later the first Bishop of Fredericton, New
Brunswick. At her request he carved the gothic reredos of St Thomas's
(which was destroyed with the east window during the Second World War)
and when she died in 1842 he erected a monument to her in a niche to the
north of the altar and continuous in design with the gothic panelling
surrounding the reredos (Plate 97).[67] The monument must have been
complete by November of that year when it was very highly praised by the
dogmatic organ of the Cambridge Camden Society, *The Ecclesiologist*, which
claimed that the effigy displayed 'all the sweetness and composure distinctive

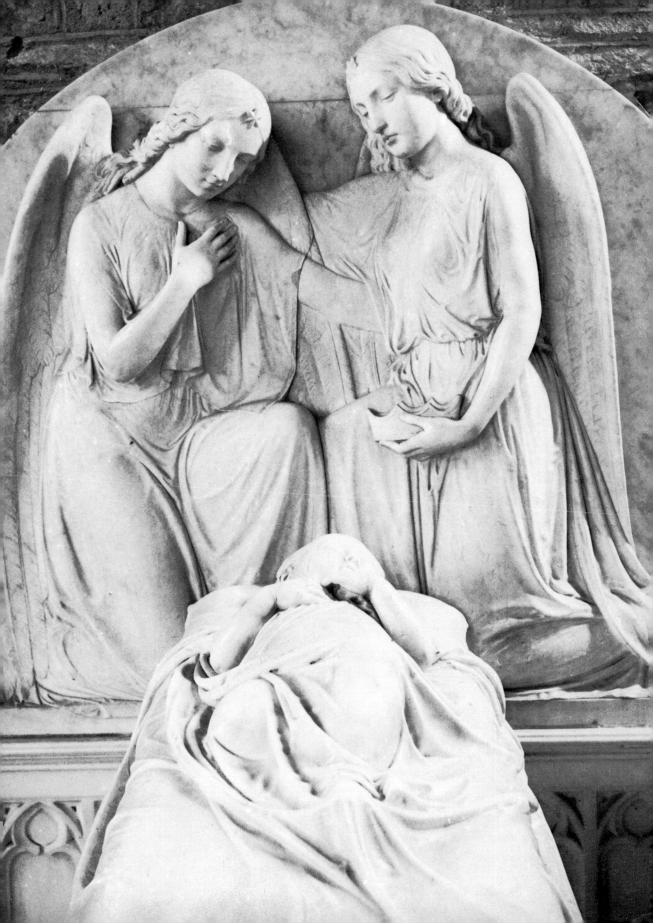

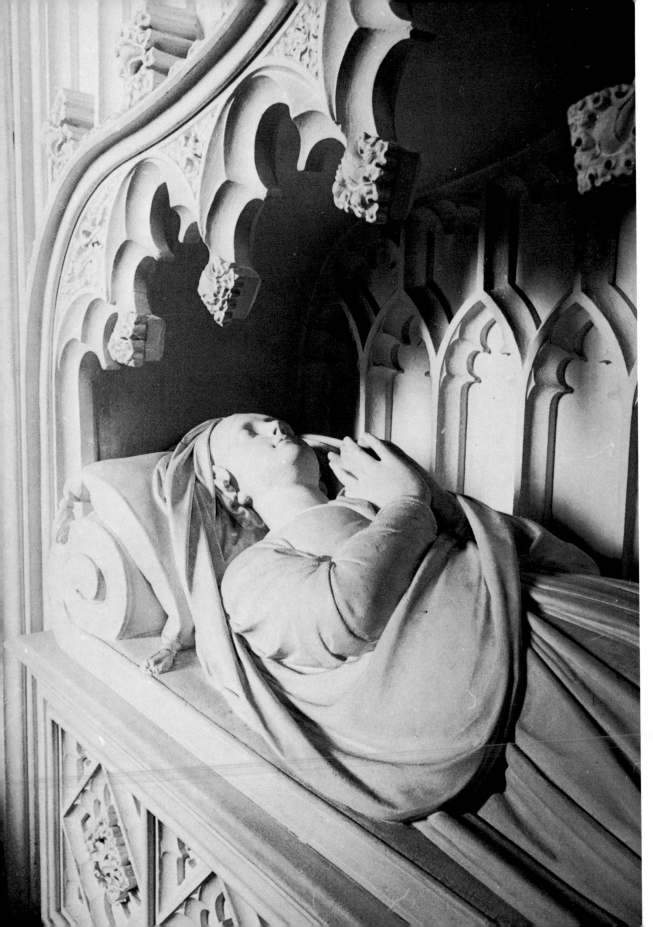

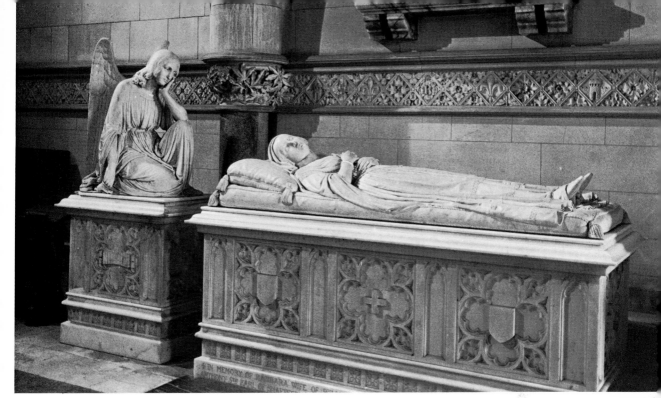

97. (left) John Bacon the Younger: Detail of Monument to Christina Medley, St Thomas's, Exeter.
98. (above) Raffaelle Monti: Monument to Lady de Mauley, Hatherop, Gloucestershire.

of Catholic times'.[68] The Exeter Diocesan Architectural Society, which Bacon addressed in 1842,[69] and in which his son-in-law was a leading light, was a provincial sister to the Camden Society in the High Church movement, which perhaps explains the prompt notice of the monument. *The Ecclesiologist* may also have known that Bacon's father had been an admirer of the Calvinistic Methodist, George Whitefield, and thus have considered themselves as congratulating a convert.[70] However, the work merits their praise: it is well designed, with the drapery gracefully uniting head and arms, But one is disappointed to discover that it is executed in composition or, possibly, free-stone, and whitewashed.

For another case of a gothic monument by a sculptor whom one is rather surprised to find working in this style, one must visit Hatherop Church, Gloucestershire. Clutton who also worked on the neighbouring Castle re-built this Church during the 1850s. Its most remarkable feature is a splendid mortuary chapel to the south of the chancel. A large section of the raised floor is wooden and is clearly a covering to the vaults below. These vaults were evidently partly filled with the occupants of other vaults, for a number of early nineteenth-century tablets to Webbs and Bessboroughs are to be found attached to the chapel wall.[71] But the motive for building this chapel was not primarily dynastic. Like the mausolea discussed in the third chapter of this book, this is a shrine to a beloved wife—Barbara, the daughter of the fifth Earl of Shaftesbury, the grand-daughter of Sir John Webb. She was the wife of the

first Baron de Mauley (who was the third son of the Earl of Bessborough). Her husband's title derived from an old Barony, once in her family, but the 'de' is a Gothic Revival touch.

Lady de Mauley died in 1844 and is portrayed here by Raffaelle Monti peacefully at rest upon a low gothic tomb-chest, wearing braided hair (similar to Queen Victoria's on William Wyon's gothic crown and florin of 1849), and very medieval Victorian dress; and holding a crucifix and what can only be a rosary (Plate 98). The detail repays attention and not only for the virtuosity it reveals. For instance, her bracelet is a serpent consuming its tail—an emblem of eternity. The detail is certainly typical of Italian sculpture of the mid-century and may be compared with the wall relief at Ingestre, Staffordshire, to Lady Victoria Susan Talbot who died in 1856 in Naples and which is executed by the Neapolitan, Ernesto Cali, with every lace fringe of the peacefully dead woman rendered with delicate care. But the gothic element is not Italian. At Lady de Mauley's feet, but separate, an angel kneels looking to heaven for solace, her hands joined in prayer (Plate 99). In small letters on the gothic pedestal we read:

> I have put my trust in Thee
> O Lord my Strength and my Redeemer

At her head there is another kneeling angel who looks down more in mourning than in prayer, and we read:

> The fashion of this world passeth away

In the emotionalism of the angel who looks up and in the small folds of the drapery and hyper-refined attention to textures we may recognize this as the work of a pupil of the great Milanese sculptor, Pompeo Marchesi; but when we compare this with Monti's other works of the 1840s[72] we will appreciate how much he here restrained his tendency to baroque flamboyance—and he did so in order to create a gothic monument.

Behind the effigy is a frieze connecting the capitals of the stumpy gothic columns from which the bold ribs of the low vault spring. We know that Burgess was at work on the church in 1855[73] and the rich and vigorous carving here is surely his work—and it perhaps fulfills as much as any other carving of that period the qualities which Ruskin wished to see in such work. It is adorned with Bs for Barbara, Castles (the emblem of her name-saint), Butterflies (emblems of the soul), and representations of a stupendous range of English flowers and leaves, intended to be seen in relation to Monti's sculpture.

The rosary held by Lady de Mauley may well have been a mistake by an Italian sculptor ignorant of Anglican devotional practices. But there can be no doubt that the de Mauleys were very High Church. Lord de Mauley's nephew, the honourable Walter Ponsonby (later the seventh Earl of Bessborough) was rector of Canford in the 1840s and 1850s, where he greatly

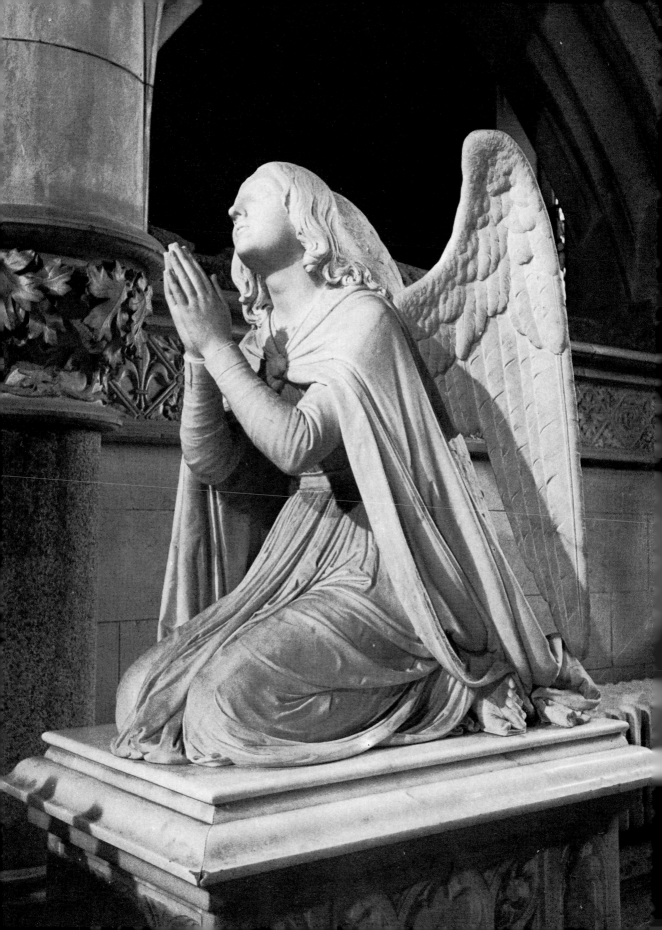

distressed Lady Charlotte Guest by his 'Puseyite' formalism, his intonements, crucifix, candlesticks and muffled bells on Good Friday. Lady de Mauley was originally buried at Canford and the offending crucifix placed in the very place where the monument was to have been erected. Lady Charlotte went as far as to object about Ponsonby to the Archbishop of Canterbury in 1850 and perhaps it was for this reason that the de Mauley's soon afterwards moved their dead to Hatherop.[74]

To *The Ecclesiologist* such works as Monti's monument to Lady de Mauley or Bacon's monument to his daughter were novel: two amongst a handful of modern works worthy of praise. The continuity with the past is now more evident.[75] And, more importantly, the concern, evident in both works to present both a touching image of a beloved wife or daughter asleep, or in the sleep of death, and at the same time in a devotional attitude, was not a new one, but one which may be traced through the preceding half-century.

The Hatherop chapel is a family chapel and it is important to ask what difference the gothic revival made to the practices outlined in chapter three. The replacing or thorough restoration of old churches often involved the removal of old monuments. At least ten large family monuments had been destroyed when Porden rebuilt the Eccleston Church in Cheshire for the Grosvenors in 1815.[76] But on the whole the Victorians took remarkable care of old monuments, even though they detested the style in which they were carved. Thus the great collections of eighteenth-century monuments were preserved when the churches at Rockingham, Northamptonshire, and at Eastnor, Herefordshire, were rebuilt, and when the new church at Bowdon in Cheshire was erected, in 1858–60, by W. H. Brakspear, a separate mortuary chapel for the Lords of Dunham Massey was retained with all the old hatchments and huge georgian memorials.[77] Even in the Rolle mortuary chapel at Bicton, Devonshire, built by Pugin in 1849–50, a seventeenth-century tomb was placed beside Pugin's new gothic monument. Such conservation demonstrates that dynastic pride was in no way incompatible with the gothic revival. A good deal of such pride is evident at Hatherop, although that is primarily a shrine to a beloved wife. A more blatant case is Scott's church of St Mark's, Worsley, Lancashire, an estate church erected for Francis Egerton, heir of the 'Canal Duke', in 1846—the year in which he was made Earl of Ellesmere. It includes a large family chapel and vault to the south of the chancel, adorned with arms on the exterior, with coronets and monograms in the wrought iron screen inside, and with a prominent tomb upon which Scott, John Birnie Philip and Matthew Noble collaborated. By this time, however, church burial was becoming rarer.

The Hoares moved out into the churchyard at Stourton, Wiltshire, early in the nineteenth century. From the mid-century onwards the Leghs preferred the churchyard at Disley, Cheshire, to their old vaults at Winwick, Lancashire. The estate church Scott built for the Duke of Devonshire at Edensor, Derbyshire, in 1867 contains no family vaults or tombs, save for the

huge seventeenth-century Cavendish tomb, a relic of the former church there, and the sixth Duke was commemorated by a cross in the churchyard. Although there are late nineteenth-century churches which do incorporate the monument of the founder,[78] it is remarkable that new churches specifically built to commemorate someone should contain no monuments. A good example is the lavish gothic church of All Hallows, Allerton, Lancashire, built between 1872 and 1876 by C. E. Grayson for John Bibby, a Liverpool iron and copper merchant, 'to the glory of God and in memory of his beloved wife Fanny', daughter of Jesse Hartley, the dock engineer. Bibby moved his family's dead from Walton-on-the-Hill to a vault not in the church, but in the churchyard, at Allerton.[79] Similarly, there is no tomb in the gleaming white limestone church of Bodelwyddan in Flintshire, the gothic church, erected in 1856–60 by John Gibson for Lady Willoughby de Broke as a memorial to her husband.

In an earlier chapter the quarrel during the late 1820s over the mortuary chapel at Little Gaddesden, and the conflict of interest between the needs of the congregation and the space required for a monument was discussed. Such a quarrel, and such a conflict would have been far less likely to occur in the second half of the century.

6. Good Deeds

AMONG the new concerns displayed in English church monuments during the late eighteenth century was a desire to illustrate the virtues of the deceased, not by means of allegorical figures placed in niches around the tomb-chest, as in the late Middle Ages and the Renaissance, nor by means of the more activated allegories of the Baroque; but by means of narrative reliefs. And these were designed less to flatter the family of the deceased than to stir the public to go and do likewise. Death-bed scenes taught the congregation how a Christian should meet his end. Conjugal duty was commended by innumerable marble widows inconsolably lamenting the ashes of their husbands. But most moral of all were the monuments to preachers, teachers, philanthropists and charitable women of the type which will be traced in this chapter. The prevalence of these monuments during the first half of the nineteenth century testifies to the immense influence of Flaxman, but he did not invent this type of monument, and we must look first at earlier examples, and at the convention of using the Good Samaritan story in monuments which seems to have originated in the mid-eighteenth century.

Bronze reliefs of Christ raising the paralyzed and of the Good Samaritan were made by Scheemakers for the base of his bronze statue of Thomas Guy erected in the main court of Guy's hospital in London in 1734;[1] one of Scheemakers's students, Prince Hoare, carved a relief of the Samaritan on the sarcophagus of his monument in Worcester Cathedral to Bishop Maddox, who died in 1759;[2] and a very striking relief of the same subject appears in the unsigned monument in Bath Abbey commemorating Jacob Bosanquet—a philanthropist, 'not more industrious in acquiring a fortune than generous in dispensing it', who died in 1767 (Plate 100). The convention then grew in popularity: the elder Bacon exhibited a relief of the Good Samaritan at the Royal Academy in 1770 and used the theme at least twice, even if on a small scale, in his monuments,[3] whilst Banks placed a medallion relief of this

Go and do thou
likewife,
So halt thou die
the death of the
righteous and thy
last end be like his.

100. Detail of Monument to Jacob Bosanquet, Bath Abbey.

subject on the base of the sarcophagus in his monument to Dr Markham, exhibited at the Royal Academy in 1788.[4] Thereafter the convention can be said to have become truly popular. There are examples by Flaxman, by the younger Bacon and by Muschamp, by the elder and younger Kirk in Ireland, by a host of minor sculptors such as 'Grimsley of Oxford' and 'Samuel Ruddock of Pimlico',[5] and there are unsigned examples, such as the monument in Bath Abbey to Fletcher Partis, who died in 1820, having founded an 'asylum' for 'decayed gentlewomen' (Plate 101) and the monument to Dauntsey Hulme of Salford who died 27 April 1828 which is in the Collegiate Church, Manchester (now the Cathedral) (Plate 102).[6]

All the monuments show the Samaritan either pouring balm or bandaging the traveller's wounds. The only emphasis on a different part of the story

137

101. Monument to Fletcher Partis, Bath Abbey.

102. Monument to Dauntsey Hulme, Manchester Cathedral.

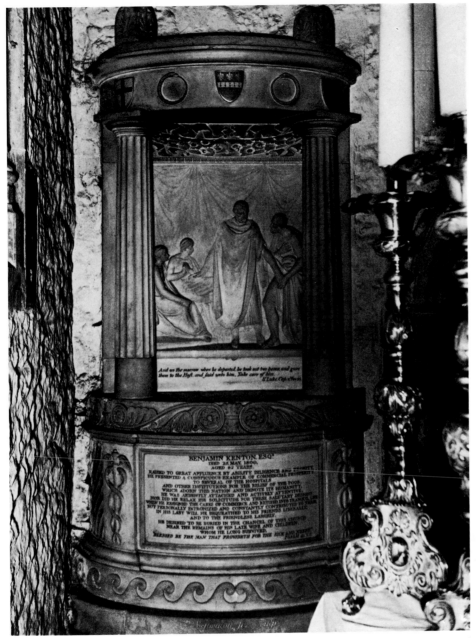

103. Richard Westmacott: Monument to Benjamin Kenton, Stepney Parish Church, London.

comes in Westmacott's monument to Benjamin Kenton (the inventor of a bottled ale that could be exported to India)—a sort of Doric tabernacle in the Parish Church of Stepney, London which includes a relief exhibited at the Royal Academy in 1803 (three years after Kenton's death) showing the Good Samaritan charging the hostel-keeper to tend the wounded traveller well (Plate 103). Kenton was a benefactor of his own charity school and of St Bartholomew's Hospital, but was not himself directly concerned with the care of the sick: hence the emphasis on this part of the story was deliberate.

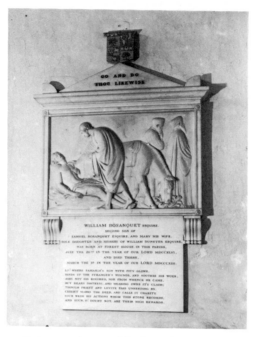

The relief shows the parable of the Good Samaritan, with the inscription above reading "GO AND DO THOU LIKEWISE" and the epitaph tablet below beginning "WILLIAM BOSANQUET ESQUIRE".

104. (left) John Flaxman: Monument to William Bosanquet, Leyton, Essex.
105. (right) John Bacon: Monument to Thomas Guy, Guy's Hospital Chapel, London.

It is worth considering the extent to which changes in style accompanied the adoption of this convention and the degree to which it perhaps assisted or impeded the didactic intention of the convention. The clearest contrast may be made between the monument to Jacob Bosanquet in Bath Abbey and Flaxman's monument at Leyton in Essex, to another Bosanquet, William, who died in 1813 (Plate 104).[7] The sculptor of the earlier work—probably Thomas Carter the younger[8]—portrays the horse arrested in a restless movement and staring with fierce intelligence at the Samaritan's first-aid. Similar movement pervades the entire relief, and the landscape is full of idiosyncratic detail and is bold and muscular in its rhythms. Flaxman, on the other hand, banishes this welter of naturalistic detail and purges the forms of this vitality. There is no landscape and no pictorial space. The contours are simplified to a degree unprecedented in English sculpture. The Samaritan's back is a segmental curve; the back of the donkey and the line made by the priest's cloak are virtually straight. The intention (surely not, in this instance, successful) is to reduce the narrative to its barest essentials and concentrate its dramatic impact. Whereas the early relief is only part of a monument, and is surrounded by busy ornament and rich, coloured marbles, Flaxman's relief *is* the monument, and its meaning is spelt out by the epitaph.

We will have occasion later to observe how Flaxman's familiarity with this convention may have encouraged his use of other, less specific, but related conventions; but first we must see how this was the case with Bacon the elder.

In the late 1770s Bacon was commissioned by the governors of Guy's Hospital to execute a monument to Guy for the west wall of their recently completed chapel (Plate 105). The model was approved by the Governors on

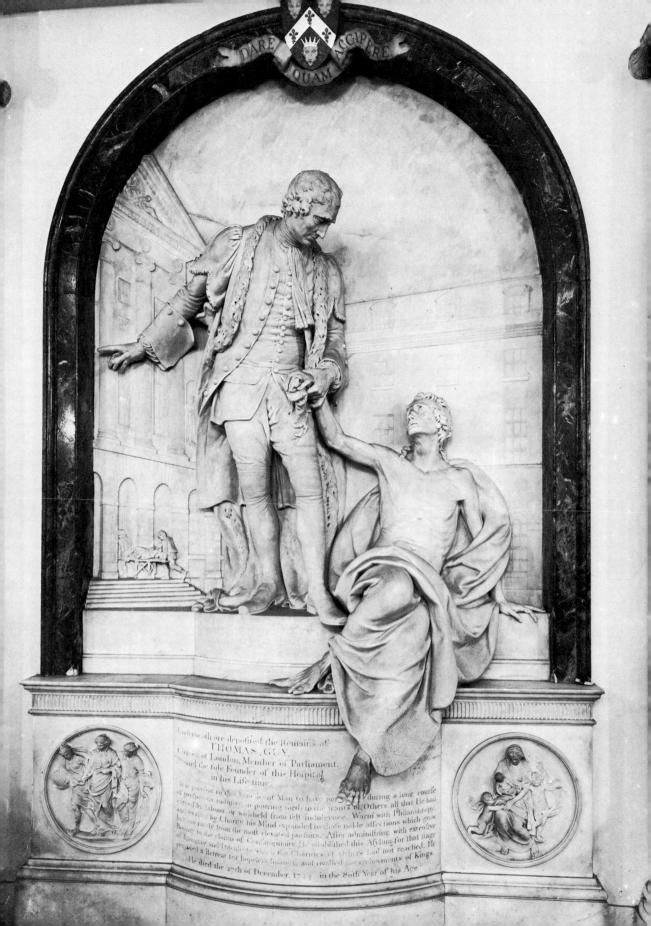

6 November 1776, and the marble was completed in 1779, costing £1,760.10s. (which was £160.10s. more than the hospital had agreed).[9] Guy is shown tenderly assisting a sick man to rise and enter his hospital (founded to shelter incurables and those who could not be accommodated by nearby St Thomas's). The philanthropist's dress corresponds closely to that in Scheemakers's bronze statue outside, and at the same time the monument recalls both of Scheemakers's bronze reliefs on the base. What is new is that now the deceased and not the Good Samaritan, or Christ, is made part of the narrative. In the background the court outside the chapel is represented brick by brick (Bacon's own recent decorations included); equally remarkable is the microscopic wrinkling of the flesh. In medallions below the principle relief, Bacon alludes with miniature allegories to Guy's charity (Caritas is shown in the right-hand medallion) and to his Industry, his Temperance and his Prudence (in the left-hand medallion a lady with a bee-hive walks with a lady with a snake and mirror and a lady with a halter).[10]

In the second half of the following decade the idea of erecting a monument to John Howard ('the man of Benevolence', as his contemporaries sometimes termed him) was first raised. A public subscription was opened in 1786, when Howard was inspecting the prisons of Eastern Europe; and Nichols, who was a leading member of the Committee, published *The Triumph of Benevolence*, a poem by Samuel Jackson Pratt which included the lines:

> Ev'n now perchance, he bears some Victim food,
> Or leads him to the beams of long-lost day,
> Or from the air where putrid vapours brood
> Chases the *Spirit of the Pest* away.[11]

Howard's own opposition to the idea of the monument, forcefully expressed in letters from Venice and Vienna,[12] caused the collected money to be diverted into a fund for alleviating the conditions of prisoners, and into a scheme for casting a gold medal in Howard's honour. Among documented ideas for Howard's monument at this period is one by Charles Atkinson the younger who wrote to the 'Howardian Committee' on 23 March 1787, proposing a Doric column decorated with an enormous inscription.[13] Mr Hedger wished to name his projected crescent at St George's Fields after Howard and proposed that a pillar to him be placed in front of this.[14] Dance the younger's design for this crescent was published in *The Gentleman's Magazine*, as was an idea for a pyramid adorned by four high-relief tablets, by Bacon, Banks, Nollekens and Flaxman, representing the scenes visited by Howard in different countries. It would have been topped by a 'permanent light'.[15] Public monuments to non-royal heroes became popular all over Europe after the Napoleonic War, but there were very few precedents for the idea in the eighteenth century.

At Howard's death in 1790, plans were resumed and permission soon granted for the erection of a monument in St Paul's Cathedral. It was to be the

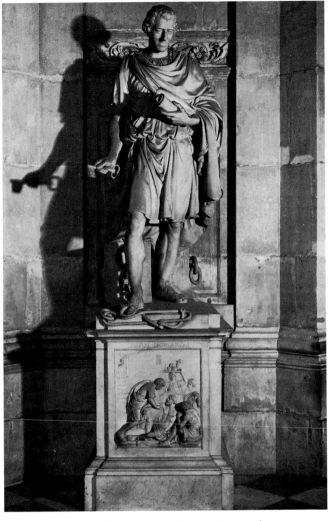

106. John Bacon:
Monument to John
Howard, St Paul's
Cathedral.

first monument in the building and was thus extremely prestigious. Bacon, whose friendship with the King had secured him the equally prestigious Chatham monument in Westminster Abbey in 1779, now obtained this one also. The reputation of the Guy monument must have helped him. Nichols seems to have admired Bacon's work, because he had earlier puffed it in *The Gentleman's Magazine*.[16] In addition, Bacon's own religious beliefs were close to those of the dissenting Howard, and would not have been offensive to Howard's friend and Bedfordshire neighbour, Samuel Whitbread, the son of a dissenter, the champion of dissenter's rights, author of Howard's epitaph, and an increasingly prominent member of the 'Howardian Committee'.

It was resolved on 23 May 1790, that the monument should consist of Howard relieving a prisoner, a group seven feet high surmounting a seven foot pedestal adorned with 'proper emblems and inscriptions', and should cost not more than 1,800 guineas.[17] A model was approved on 6 June 1791.

143

This has not survived; however, one can imagine that it resembled the Guy monument, but with the figures now free-standing. It was never carried out because on 29 July 1791, only two days after the sculptor had drawn his first £500, the 'Committee for Superintending the Erection of Monuments in the Cathedral of Saint Paul'—a quarrelsome bunch of Royal Academicians which preceded the 'Committee of Taste'—met in the Cathedral to consider the site and unanimously regretted Bacon's idea of having two figures. This was ostensibly because a group would not match the single statue of Dr Johnson, also by Bacon, and also to be erected in the Cathedral; and because 'simplicity' was to be preferred. It is hard not to suspect an element of professional jealousy here, for the academicians were piqued that the Chatham commission, and probably this as well, had been given without their consultation. But this veto also, perhaps, reveals the novelty of Bacon's didactic idea for the monument. We read in the Official Minutes of the 'Howardian Committee' the following passage:

> The objections of Mr Bacon that he could not well delineate the character of Mr Howard without a secondary figure appeared to them (the Royal Academicians) of no weight and it was justly observed by one of the Committee (Mr West) that public characters require no embellishments . . .[18]

Bacon had to change his plans to a single statue, for which he received 500 guineas less than was originally agreed; but there is something restless about the figure and he appears as if he is looking around for a prisoner to free with the key he holds (Plate 106).[19] Something of Bacon's original idea is also, surely, preserved in the relief on the base of the monument in which the great philanthropist stoops to assist a victim (Plate 107). Compared with the Guy monument this is much more neo-classical: Roman dress is substituted for modern; only the knot of the prisoner's clothes is not contained by the frame; there is much less contrast between high and low relief; there is less minute detail (although Bacon could not resist the keystone head above the prison door); the main figures are arranged more or less on the same plane. Many of these differences may be accounted for by the relatively low position, the lack of light and the much smaller scale of the Howard relief; but others seem, like the unfortunate heroic character of the Dr Johnson statue, to have been made in response to the changing taste and perhaps, in particular, in deference to Sir Joshua Reynolds's *Discourses*. The composition is well calculated; there is no confusion in the entangled legs and the long, tense curve of the central prisoner's body is continued in the figure standing behind and answers the line of Howard's cloak. The suppliant on the right is particularly moving, whilst a note of suspense is introduced by the assistant carrying clothing, turning as he advances, attention in his finger-tips.

We have seen how Bacon's familiarity with Good Samaritan reliefs may have prepared him for this new type of monument that he created in the

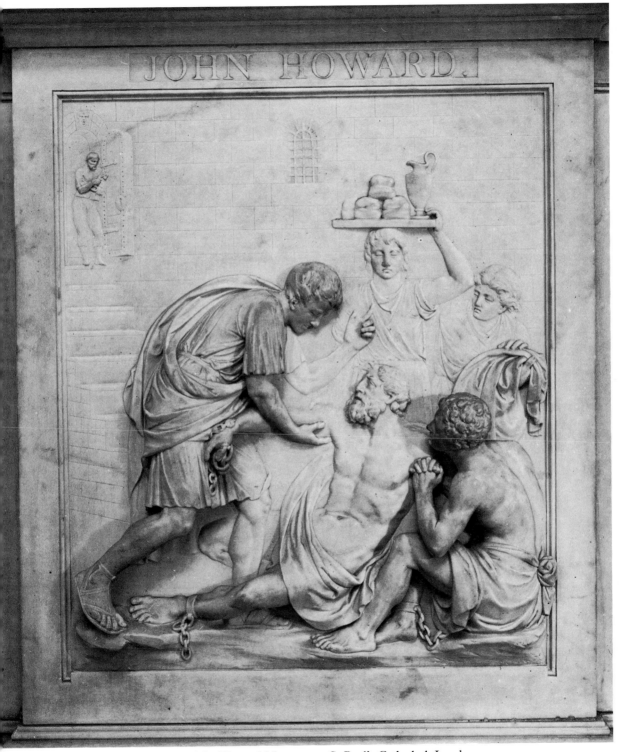

107. John Bacon: Relief on the base of the Howard Monument, St Paul's Cathedral, London.

narrative reliefs commemorating Guy and Howard.[20] With Flaxman, the connection is clearer. Having observed others employ the Good Samaritan story, he utilized other episodes of the New Testament on monuments. A relief of the raising of Jairus's Daughter served as the monument to the daughter of a modern plutocrat, Sir Joseph Mawbey, at Chertsey in Surrey, in the early 1820s; and earlier, in a monument in St Cuthbert's, Edinburgh completed in 1804, to the three infant children of Francis Redfearn, he used a relief of Christ blessing the children.[21] The theme of Christ blessing the children was also employed by Richard Westmacott in his monument to Georgina Holland, erected in 1821, in Millbrook, Bedfordshire (Plate 108). But more often Flaxman illustrates a Christian precept. These are not Biblical narratives, but they can be seen as modern dress versions of those narratives. There are so many Flaxman monuments of this type that I shall concentrate on five only. The first of these is a monument to Sir William Jones in University College, Oxford, and it is of particular interest because it may be contrasted with a work by Bacon.

When Sir William Jones, the poet, lawyer, linguist and oriental scholar, died in 1794, in Calcutta, where he was High Court Judge, the directors of the East India Company voted money for a monument to him and permission was obtained for this to be erected in St Paul's Cathedral. Perhaps hoping to match the Howard and Johnson statues, then the only other monuments in the Cathedral, the commission was given to Bacon,[22] who completed it in

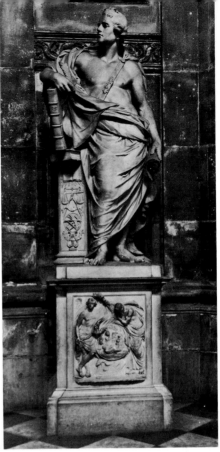

109. John Bacon: Monument to Sir William Jones, St Paul's Cathedral.

1799, having sent another statue of Jones to Calcutta three years earlier. The relief on the base of Bacon's statue in St Paul's is not a narrative, like that on his Howard monument, but an allegory which must refer to Jones's pioneer work of comparative mythology, the brilliant essay *On the Gods of Greece, Italy and India* of 1784, and also to his essay *On the Antiquity of the Indian Zodiac*,[23] but which is very obscure and has never been fully elucidated (Plate 109). The point which should be emphasized here is that Bacon was very original in making moral narrative monuments for philanthropists, but for men who were not obviously philanthropists it did not seem to him necessary to erect this type of monument. Flaxman, on the other hand, did manage to celebrate Jones's good works in a monument which he was commissioned to make by Jones's widow. Similarly, when he was commissioned, in 1798, to carve a monument to William Benson Earle, musician, scholar and philanthropist (erected in 1799 in Salisbury Cathedral) Flaxman showed a draped lady unveiling a relief of the Good Samaritan. A book, a myrtle spray and a lyre also appear, but are subordinate—what is most emphasized is the man's good works.

Flaxman's ideas for his monument to Jones were publicized in advance by his close friend, William Hayley, who, in his *Elegy on the Death of the Honourable Sir William Jones* in 1795, praised the sculptor's 'chaste design ... That best may sooth the pangs of widow'd love.'[24] But more important than soothing such pangs was the clear and instructive presentation of Jones's

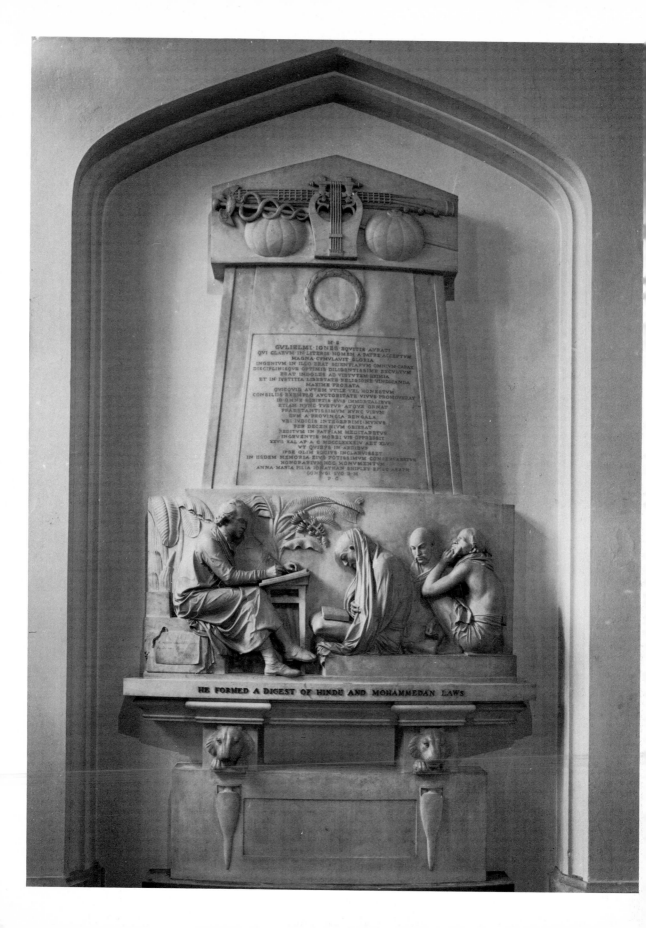

HE FORMED A DIGEST OF HINDŪ AND MOHAMMEDAN LAWS

moral activity. Thus Flaxman (Plate 110) chose to show Jones humbly collecting information from the pundits for his projected *Digest of Hindu and Mohammedan Laws*:

> So justly social, and benignly sage,
> He searched what INDIAN wisdom could produce;
> So hoards of knowledge from the lips of Age
> He drew, and fashioned for the public use.[25]

The poem was in fact published in 1795, before Flaxman was officially given the commission.[26] The top of the monument in which there is an Indian instrument, a Grecian lyre, and a caduceus was a late change, made at Lady Jones's behest, and it refers to Jones's translations of poems in the 'Asiatic languages'.[27]

Just as we have seen that Flaxman went out of his way to illustrate that aspect of Sir William Jones's life which was most morally instructive; so, when he was confronted with a commission for a monument to the family of Thomas Yarborough to be erected at Campsall Church in the West Riding of Yorkshire, he produced a relief which is in no obvious way related to Thomas Yarborough, who died in 1772, but showed instead the 'Piety, extensive Charities and unbounded Benevolence' of his two youngest daughters, Anne and Elizabeth (Plate 111). These ladies, who died in 1793 and 1801, respectively, had ordered the monument to be raised by their executors. Flaxman received the commission in 1803 and the work was erected early in 1806. The sculptor charged £500.[28] The two daughters had intended to commemorate their parents and their sisters, not themselves, but Flaxman, or the executors, or both, made the decision to create something that would not only stir fond memories, but inspire good deeds. Above the relief and below the pediment (decorated with the Cross and with the Anchor of Hope) is the text: 'Blessed are they that consider the Poor'. From a slightly raised platform, one sister dispenses dole from a purse which the other holds. A preparatory drawing for the relief, now in the British Museum Print Room,[29] shows a similar group, but in reverse, and includes a crippled boy (Plate 112). Perhaps that was felt to be too painful a detail and in the relief the only form of disability not due to old age is blindness—for I think we must assume that the wild-haired man on the left who stares upwards rather than at his benefactor is blind; this means that the family is without a breadwinner.

There are eight figures here—if one includes the child on the mother's back—and there is also a dog. This makes it a particularly dense composition for Flaxman. Nowhere else, perhaps, does he allow the frame of the relief to be overlapped, as it is here, slightly, by the cloak of the man on the left; and nowhere else does he show figures virtually four deep with such complete assurance, nor attempt such varied characterization. According to Allan Cunningham, the sculptor considered this relief (with the Abraham Balme

149

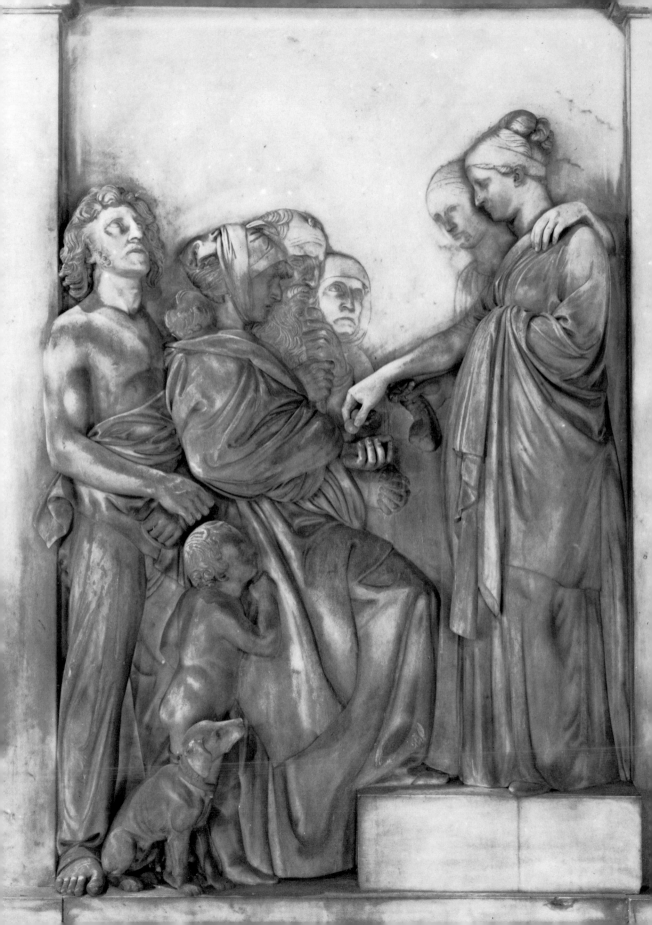

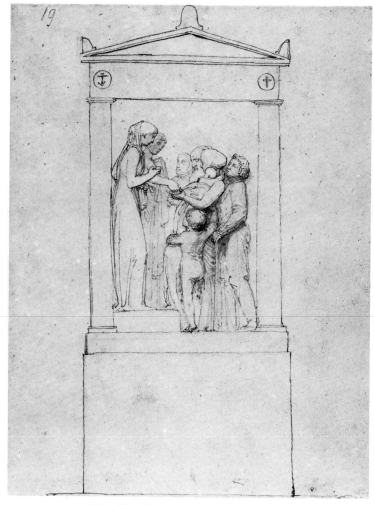

111. (far left) John Flaxman: Monument to the Yarborough Family, Campsall, Yorkshire.
112. (left) John Flaxman: Design for the Yarborough Monument, British Museum.

monument at Bradford) as one of his finest works.[30] Today it is almost black with dirt.

There are only two earlier examples of alms-giving portrayed on a British church monument that I know of. The first is the unsigned monument in the chancel of Boxgrove Priory, Sussex to Mary, Countess of Derby, who died aged eighty-four in 1752 and endowed, a decade before her death, a hospital for twelve old women and a school for six boys and six girls. She is portrayed seated below an oak tree relieving poor travellers whom she directs to a refuge behind her.[31] The second is a very small relief incorporated in the vast monument to Elizabeth, Duchess of Northumberland, which was erected in Westminster Abbey in 1782, six years after her death[32] (Plate 113). This monument, which also serves as an entrance to the Northumberland vault, was designed by Robert Adam and carved by Roubiliac's pupil, Nicholas Read. If we are to believe the Duchess's obsequious obituarists the reference to her charity was fully merited.[33]

151

ESPERANCE : EN : DIEU.

...ABETH PERCY DUCHESS of NORTHUMBERL...
...her own Right...
BARONESS PERCY LUCY POYNINGS FITZ-PAYNE
BRYAN & LATIMER
Sole Heiress of ALGERNON DUKE of SOMERSET
...of the ancient EARLS of NORTHUMBERLAND
She inherited all their great & noble Qualities
With every amiable & benevolent Virtue

Adam's design for this monument in the Soane Museum which is dated 10 July 1778, showed a relief of figures at once antique in dress and attitude. Read, perhaps in order to emphasize what she had actually done, carved a far more naturalistic group.[34] Her ministration to the needy seems relatively comfortable. Seated on a sofa whilst a steward records the sums donated and a servant holds a basket of money bags, she is much less actively charitable than the Yarborough sisters, who seem to have ventured forth to find the poor.

Philanthropists had been commemorated by other conventions during the eighteenth-century. James Hanway, for example, who died in 1786 having done much for orphans and prostitutes, and having founded the Marine Society to educate poor boys for the Navy, is commemorated in Westminster Abbey by J. F. Moore with a monument showing not him but Britannia giving clothes to a kneeling urchin, whilst another, behind, supplicates, and a third stands proudly clad in uniform, with a rudder[35] (Plate 114). In the rather crude monument by T. Cooke at Frome, Somerset Richard Stephens who died in 1776 stands beside an urn and in front of a relief of the asylum he founded. A praying boy and girl from that institution appear, but are quite

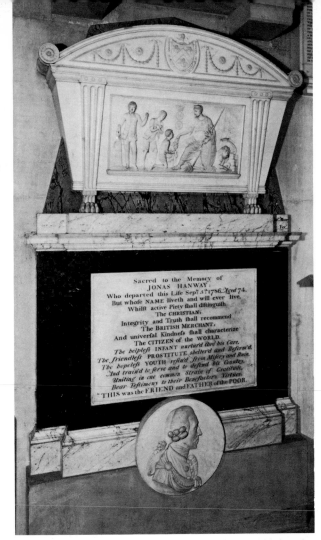

113. (left) Nicholas Read:
Detail of the Monument to
the Duchess of
Northumberland,
Westminster Abbey.
114. (right) John Francis
Moore: Monument to James
Hanway, Westminster
Abbey.

Sacred to the Memory of
JONAS HANWAY
Who departed this Life Sep.ʳ 5ᵗʰ 1786. Aged 74.
But whose NAME liveth and will ever live,
Whilst active Piety shall distinguish
The CHRISTIAN;
Integrity and Truth shall recommend
The BRITISH MERCHANT;
And universal Kindness shall characterize
The CITIZEN of the WORLD.
The helpless INFANT nurtur'd thro' his Care.
The friendless PROSTITUTE shelter'd and Reform'd.
The hopeless YOUTH rescu'd from Misery and Ruin.
And train'd to serve and to defend his Country,
Uniting in one common Strain of Gratitude,
Bear Testimony to their Benefactors Virtues
"THIS was the FRIEND and FATHER of the POOR.

unconnected with him. In the Cliffe Pypard monument, discussed in the
second chapter of this book, Spackman is portrayed as a benevolent spectator,
not as someone actively engaged in a charitable act. It is true that neither
Hanway, nor Stephens, nor Spackman were directly concerned in
administering the charities which they endowed, Nevertheless, it was the
act—the good deed—that Flaxman chose, on all possible occasions, to
illustrate. Perhaps his greatest innovation was to create a type of monument
for scholars which showed the act of teaching as a good deed.

In 1801, two years before he received the Yarborough commission, but for
the same price, Flaxman received a commission from Robert Blake,
representing a committee of 'Wykehamists', for a monument to be erected in
Winchester Cathedral, to Joseph Warton, the poet and headmaster of
Winchester College, who had died in 1800 (Plates 115 and 116). Flaxman
perhaps obtained the commission on account of his monument to William
Collins, a close friend of Warton, but more probably on account of the Hare-
Naylors, important patrons of Flaxman in Rome, who had many commissions
with Winchester and whose sons served as models for the four boys in the

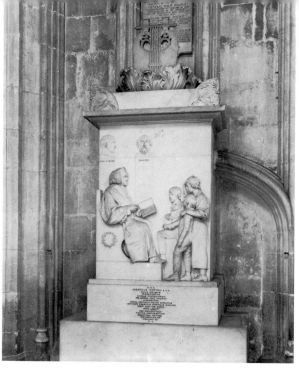

115. (right) John Flaxman: Monument to Joseph Warton, Winchester Cathedral.
116. (far right) John Flaxman: Detail of Monument to Joseph Warton, Winchester Cathedral

relief here (whilst Reynolds's portrait was used for Warton). The model seems to have been ready in the spring of 1801 and the monument was erected in November 1804.[36]

Sometime before the spring of 1801 Flaxman must have produced the two preparatory drawings in the Victoria and Albert and the British Museums.[37] These are for shallow reliefs, not for the block that was eventually decided on, and are flanked by tripods which do not appear in the sculpture. The wreathed medallions in both these drawings do occur in the sculpture, but on the side of the block and not attached separately to the wall, and containing the heads of Pope and Dryden, rather than Homer, Horace or Virgil (as proposed in the drawings). Homer, however, is not forgotten, and appears as a herm portrait, in the centre of the executed relief. There is also a herm portrait of Aristotle (as proposed in the British Museum drawing), but in profile. Another change is the promotion of the poet's lyre from being a small pediment ornament to a large free-standing object arising from a cup of acanthus leaves.[38] The most important change, however, is that the Doctor wears classical costume in the drawings, but contemporary dress in the sculpture, as do the boys, one of whom wears a scholar's gown.

It is obvious that the patrons gave great thought to exactly what achievements and qualities of Warton's they wanted commemorated and what priority should be given to them. They decided (one imagines after some debate) that he should be portrayed as they remembered him and not in idealized antique garb. On the other hand, they were happy to emphasize metaphorically, by means of herm portraits, that he was a critic of the tradition of Aristotle, and devoted to the most sublime of antique epic poets. In subordinate areas of the monument his 'extra-curricular' activities as a lyric poet (the lyre) and as the editor of Pope and Dryden (the side

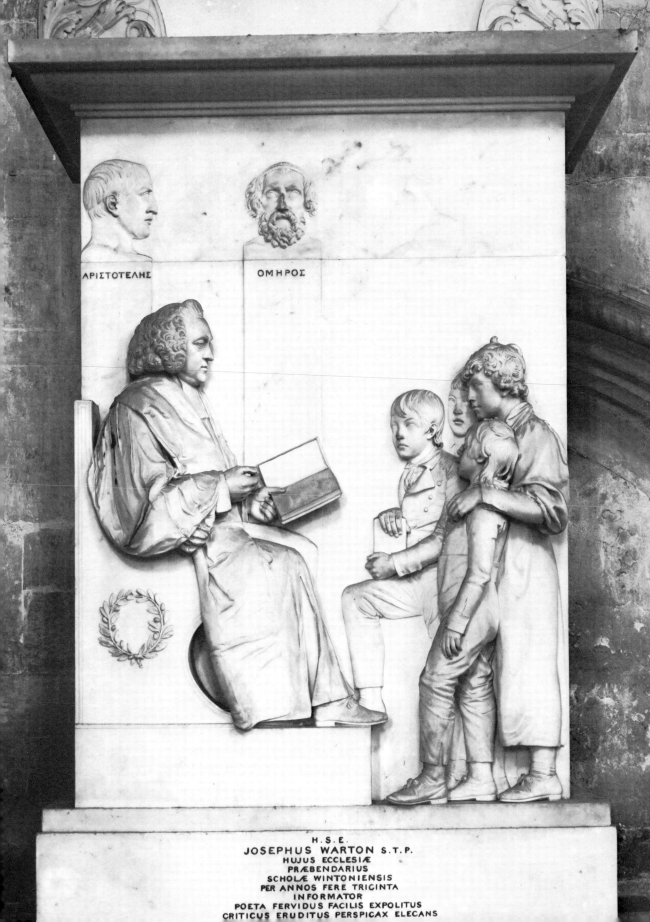

ΑΡΙΣΤΟΤΕΛΗΣ

ΟΜΗΡΟΣ

H.S.E.
JOSEPHUS WARTON S.T.P.
HUJUS ECCLESIÆ
PRÆBENDARIUS
SCHOLÆ WINTONIENSIS
PER ANNOS FERE TRIGINTA
INFORMATOR
POETA FERVIDUS FACILIS EXPOLITUS
CRITICUS ERUDITUS PERSPICAX ELECANS

medallions) are recorded. But Flaxman must also claim responsibility for the decision to stress firstly the Doctor's good deeds to others in a narrative relief, and only secondly his poetic gifts; for he did exactly the same in his Jones monument, where the lyre is also placed above. One wonders whether Warton really was so patient and affectionate a pedagogue. Although greatly loved by some of his pupils, others mutinied against him on three separate occasions, the last insurrection being of such seriousness that he resigned after he had suppressed it.[39]

Before this monument, and some others also by Flaxman (above all, that to Abraham Balme in Bradford Cathedral), there are few schoolmasters portrayed on an English church monument in the act of teaching. There is a pencil sketch for a monument to a clergyman which includes a school scene by Bacon the elder in the Victoria and Albert Museum. Also, Nicholas Stone's early seventeenth-century monument to Thomas Sutton in the Charterhouse Chapel, London, shows the master of the Charterhouse addressing his scholars. However, Stone's monument is not to the schoolmaster, but to Sutton, the school's founder. Schoolmasters had tended to be portrayed surrounded by books, not boys, as scholars not teachers. The only previous occasions when teaching was emphasized in a similar way to Flaxman's reliefs were in late medieval monuments to professors in North Italy, and, in particular, Bologna, and in some Roman sarcophagi showing philosophers surrounded by their disciples.[40]

Flaxman's monument to a man who was both preacher and teacher, the Reverend John Clowes, was commissioned in 1818,[41] not at Clowes's death, but to commemorate his fiftieth year as incumbent of St John's Church, Manchester. The work was erected in 1819, and was reported as yellowing shortly afterwards.[42] It was transferred to St Matthew's Campfield when St John's was demolished, and was lost in 1951 when St Matthew's was in its turn demolished; but two plaster models, one a sketch for the whole, the other, more detailed for the narrative relief (Plate 117), survive in University College, London,[43] and show Clowes instructing a group of children, accompanied by their parents, and one grandparent (just visible on the left), intended to 'denote the three generations who had attended his ministry'.[44] The emphasis is placed, however, on the younger generation and it is interesting to note that Clowes was one of the pioneer supporters of the Sunday School system as early as 1783,[45] and was also very active in fighting for better treatment of children—his name heading the Manchester petition in support of ending child labour (a fact said to have particularly impressed Sir Robert Peel).[46] He was certainly an extremely popular figure, for commemorative earthenware busts of him are still common in antique shops.[47]

Behind Clowes 'a guardian angel is figured, bearing a palm branch, indicating the Divine Protection'. We do not, perhaps, find this noteworthy— such angels, after all, became commonplace in Victorian sculpture—but it is

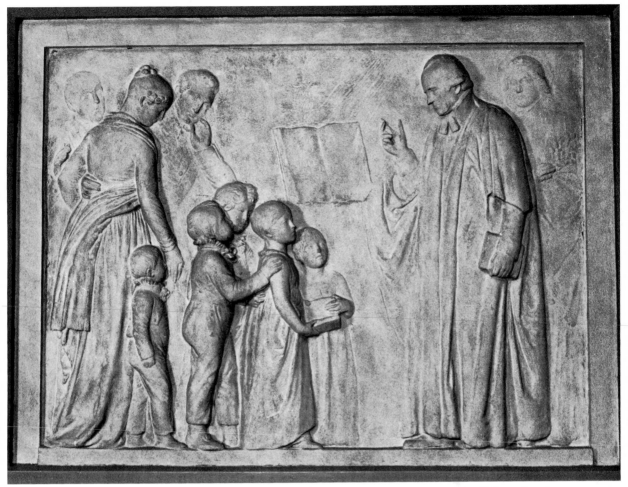

117. John Flaxman: Plaster Model for Relief on the Monument to John Clowes, University College, London.

important that Clowes's followers believed that they conversed with angels, and Clowes firmly held that 'particular angels' were appointed to minister to 'particular persons and societies'.[48] This belief had been revived by Swedenborg and his disciples. Clowes was one of the principle early translators of the Swedish mystic in this country and played a leading part in the Swedenborgian meetings held annually from 1806 onwards at an inn at Hawkstone Park, the seat of Sir Richard Hill, in Shropshire. But, unlike many of his fellow disciples, he believed that he could remain part of the established church. Flaxman took an interest in Swedenborg and assisted Charles Augustus Tulk in founding the 'London Society for publishing Swedenborg's Works' in 1810.[49] Tulk, who was Member of Parliament for Sudbury and Poole at different times, and who was active as a reformer, particularly concerned with child-labour and the conditions of prisons and lunatic-asylums, was closely connected with the Hawkstone meetings, and

157

was also a close friend of Clowes.[50] It was through Tulk that Flaxman received the commission for Clowes's monument. Replying to Tulk in a letter dated 23 July 1818, the sculptor requested a sketch of the proposed site with an indication of lighting and also 'some general idea of the inscription intended for the tablet, the topics or subjects of which will suggest the symbols or appropriate decorations'.[51] The letter then concludes with assurances from Flaxman that he will endeavour to advise for the best both for 'the beauty of design and economy of expence'. He charged £150.[52]

The letter makes it obvious that Flaxman regarded this as a special commission. Certainly, the relief treated a favourite theme of his; and the tenderly observed group of children, touchingly attentive to instruction, must have been as successful in the lost original as, say, in the Warton monument. In his lecture *On Composition*, Flaxman pointed out that 'Parental affection and Domestic charities' are cherished much more powerfully in the Christian Dispensation than in the Grecian codes, and that there are no equivalents in antique art to the Holy Families and the charity groups of the Renaissance.[53] But love of children in Flaxman's work is seldom separable from instruction. His Caritas holds a book — literally so in his monument to Harriet Susan, wife of James, Viscount Fitzharris, second Earl of Malmesbury, who died in 1815, aged thirty-one (Plate 118). She was buried at Salisbury, but the monument was erected in Christchurch Priory where she was most remembered. The figures are carved from the same huge block and the curves of the figures are controlled by one's awareness of the original cubic boundary, stressed by the steps of the pedestal. The closely-knit domestic unit is a charity group dignified by children anxious for learning, rather than scrambling for the breast. Indeed it is a sort of feminine equivalent to the Warton monument. Here also the Greek is mingled with the modern, for the boy's dress and Lady Fitzharris's hair-style are obviously contemporary, whilst the Klismos chair is Greek (or at least Greek revival). The two models for this monument which was completed in 1817, a year after the commission, are in relief with the group reversed.[54] One of them shows a gothic frame with quatrefoil tracery and angel corbels suited to the Priory architecture. This was not felt to be incompatible with the Klismos. Indeed, gothic was perhaps felt to be more appropriate to a theme which has few precedents in antique art. I know of only two earlier treatments of this theme in British sculpture: the miniature oval relief in the monument by Thomas Scheemakers at Powick, Worcestershire, to Mrs Russell, who died in 1786, and the relief of a mother reading to her children signed by Banks in 1791 and erected in the Rowley mausoleum, Summerhill, Laracor, near Dublin. Banks's relief has been destroyed, but it could easily have influenced Flaxman.[55]

Demonstrating the influence of these works of Flaxman's is not difficult. The Clowes monument was matched by a very similar relief by Richard Westmacott, erected in St John's when Clowes died in 1831. Flaxman himself imitated his Warton monument in his monument at St Mary's, Harrow, to

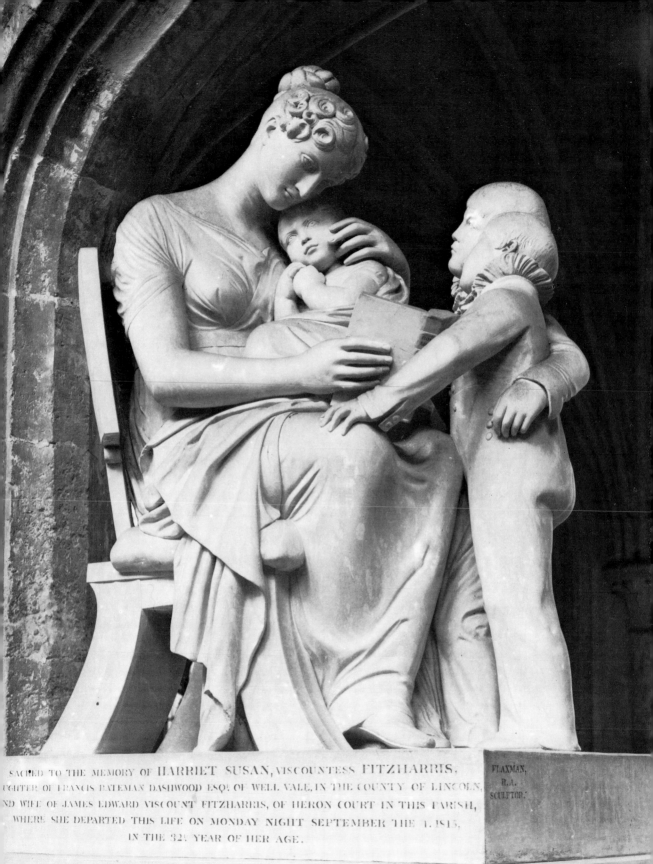

SACRED TO THE MEMORY OF HARRIET SUSAN, VISCOUNTESS FITZHARRIS,
UGHTER OF FRANCIS BATEMAN DASHWOOD ESQ! OF WELL VALE, IN THE COUNTY OF LINCOLN,
ND WIFE OF JAMES EDWARD VISCOUNT FITZHARRIS, OF HERON COURT IN THIS PARISH,
WHERE SHE DEPARTED THIS LIFE ON MONDAY NIGHT SEPTEMBER THE 4, 1815,
IN THE 32! YEAR OF HER AGE.

FLAXMAN,
R.A.
SCULPTOR.

BY NATURE WITH UNCOMMON BEAUTY OF PERSON AND COUNTENANCE.
POSSESSING MANNERS EQUALLY DIGNIFIED AND ENGAGING.
LOWED HERSELF TO BE INFLUENCED BY THE

JAMES HOWARD HARRIS, BO
JOHN BO

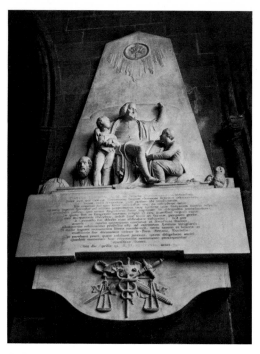

119. (left) John Bacon the Younger:
Monument to Charles Lawson,
Manchester Cathedral.
120. (right) William Behnes:
Monument to Andrew Bell,
Westminster Abbey.

John Lyon, the school's founder.[56] And James Sherwood of Derby in his monument in Derby Cathedral to Thomas Swanwick who died in 1814 used a rather similar idea.[57] The theme of the Warton monument was also adapted by Bacon the younger for his monument in the Collegiate Church, Manchester commemorating Charles Lawson, who died 19 April 1807, at the age of seventy-nine, having been High Master at Manchester Grammar School for nearly fifty years (Plate 119).

Lawson is shown seated with two boys, one of whom rests his hand on a bust of Homer, whilst the other presents his master with an open book. For the benefit of the latter pupil, Lawson points upward to the glory in the obelisk behind him where we see both a cross and a serpent biting its tail (an emblem of Eternity). Decorative allegorical attributes of the type the Bacons so enjoyed also appear, rather redundantly, beside the figures: to the left, the bee-hive of Industry, on the right, the owl of Minerva. A caduceus, sword, crozier and scales of Justice are arranged in a separate relief compartment; a reminder that Lawson urged his students not to live 'in shade and retirement', but to play an active part in public life—'in Foru, Senatu, Ecclesia'.[58]

Chantrey also imitated Flaxman's Warton monument in his monument in Rugby Chapel to Dr James, and Flaxman's Jones monument in his monument to Sir George Staunton in Westminster Abbey.[59] But Flaxman's influence, considered in broader terms, was far more extensive. Neither Chantrey's relief of Heber blessing the natives (Plate 56), nor Lough's monument to Bishop Middleton of 1832, also in St Paul's,[60] nor the younger

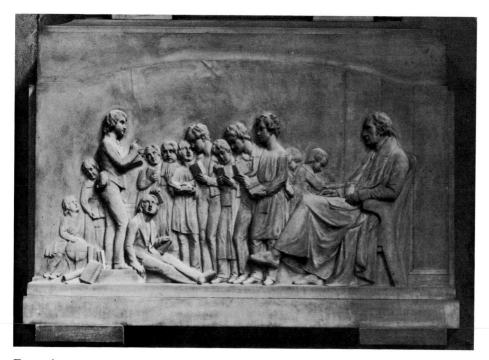

Bacon's monument to the Archbishop of Dublin in Westminster Abbey,
nor Weekes's statue of Bishop Corrie of Madras laying his hand on a native
boy's shoulder, of 1843,[61] could claim to show any direct influence of
Flaxman; yet there were, before Flaxman's Clowes monument and similar
works of his commemorating Indian missionaries, no important English
church monuments which showed the clergy actually performing their
pastoral duties. Similarly, Behnes's relief monument of 1832 to Dr Andrew
Bell in Westminster Abbey is not obviously related to Flaxman's Warton
monument—indeed, Bell (whose idea of 'Mutual Education', worked out in a
Madras orphanage, was then applied in hundreds of Anglican Church
Schools during the first half of the nineteenth-century) is portrayed as a
benevolent spectator whilst the children teach one another (Plate 120).
Nevertheless, as has already been mentioned, Flaxman provided the first
notable English church monuments to teachers which showed them teaching.

Biographical narratives by no means entirely replaced other ways of
commemorating virtues, for the Samaritan reliefs continued in popularity, as
did allegorical personifications of the deceased's virtues.[62] Nevertheless there
was a strong reaction against the elaborate allegories and the 'epigrammatical
conceits' of the eighteenth century. Instead of Religion leaning on an urn
whilst a putto weeps over a mitre we will be more likely to see a Bishop
kneeling at prayer or blessing natives. Reliefs of the ascending soul replace
medallion portraits tied to the pyramid of eternity. Allegories are not at all
uncommon in the monuments to war heroes in St Paul's, but they are far less
extravagant and obscure than had been the case with the heroic machines

161

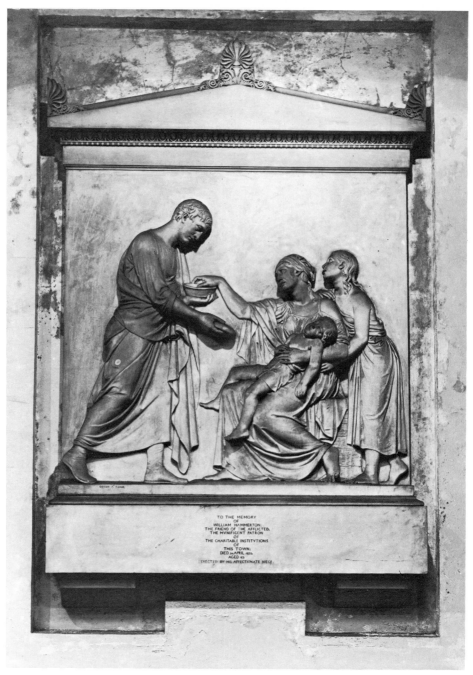

121. John Gibson: Monument to William Hammerton, St James the Less, Liverpool.

erected in Westminster Abbey by Roubiliac and Nollekens. Flaxman, in particular, made the meaning of his monuments easily intelligible,[63] and Chantrey's contributions, and one or two of Westmacott's, struck a new note of naturalism.[64] Chantrey was, throughout his life, a vigorous polemicist against allegory of all kinds. In a letter to Gally Knight on the question of how best to commemorate Wilberforce, he recommended a portrait statue which would express Wilberforce's greatness of mind. He added that there might also be a 'bas-relief upon his pedestal representing his giving freedom to the negroes.'[65] This is the view of a sculptor who was primarily a portraitist and who was little attracted by narrative. It describes the type of the Heber monument, but this was not a type which was favoured by all: Bacon only adopted it reluctantly in his Howard monument. Nevertheless Chantrey did speak for his time when he called for sculpture to be free of erudite allusion and open to the 'plain man's' understanding. Such an attitude must be expected from artists who erected monuments to the virtuous which were intended to edify the public.

The most explicitly edifying monuments were those erected to commemorate charitable men and women, and here it is clear that Flaxman established, with his Yarborough relief, a model for a succession of works throughout the nineteenth century. One of the most interesting of these is Gibson's monument in the cemetary chapel of St James-the-Less in Liverpool to William Hammerton who died in 1832 (Plate 121). This 'munificent patron of the Charitable Institutions of Liverpool' strides forward in Roman costume carrying a loaf and a bowl—sustenance for a widow supported by a daughter and supporting a sleeping child. This movement is awkward and stiff. Also, as is often the case with Gibson's relief figures, Hammerton seems painfully squeezed against the ground, with his further limbs disconnected. But the hard contour of the woman and children certainly contributes to their pathetic appeal, and one must prefer this to Gibson's much earlier treatment of the theme of charity in his wall monument to the Catholic Henry Blundell in Sefton Church, Lancashire—a work dated 1813, and signed by the Liverpool firm of Francey's for which Gibson was then working (Plate 122). Blundell, in antique costume, enthroned in a niche carved out of a pyramid (a motif derived from Bacon) at once supports a youth surrounded by bits of sculpture, a mallet and a pallet and gives a coin to a suppliant woman with two children. The idea is to refer equally to the charities and to the antiquarianism of Blundell and thus illustrate the point of the epitaph apparently written by Roscoe, Blundell's friend, who almost certainly procured this commission for the young Gibson.[66] But it is an over-ambitious idea and the modelling, even though in plaster,[67] is incompetent.

The Hammerton monument is clearly related to Flaxman's Yarborough monument, but one need not assume that Gibson had studied the relief in Campsall Church or even the model in Flaxman's studio, although he could

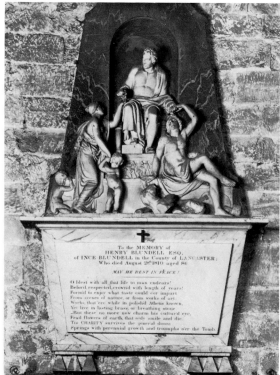

122. (left) John Gibson:
Monument to Henry Blundell,
Sefton, Lancashire.
123. (right) Pietro Tenerani:
Monument to the Marchioness of
Northampton, Castle Ashby,
Northamptonshire.

easily have done so. Pietro Tenerani's monument to Margaret, the second
Marchioness of Northampton at Castle Ashby in Northamptonshire, a work
carved in Rome in 1836, is equally clearly related to the Hammerton relief
which Tenerani was very likely to have had first-hand knowledge of in Rome
(Plate 123). The differences, however, are also obvious: Tenerani's modelling
being far softer and his draperies far more fluent. The choice of Tenerani is
not surprising, for the Northamptons had lived in Italy for ten years when the
Marchioness died there in 1830. The same family also later patronized Baron
Marochetti. Tenerani's figures are much more idealized than Flaxman's; less
rural and less obviously in need of help. The veiled Marchioness has taken
some heavy coins from her embroidered purse which she gives to the seated
woman with a sleeping child on her lap. A boy stands between the two women
in an unlikely attitude of devotion intended to recall Raphael's *Holy Families*.
There is more imaginative sculpture above, where Tenerani has a cup of
acanthus out of which there rises something that is half-shell and half one of
those pleated, segmental canopies portrayed in antique ceiling decorations, in
front of which there is a bust of the deceased, looking Sybilline and holding a
book. This is probably a reference to her poetic attainments.[68] Tenerani must
have been thinking of the portraits set in shell niches in Roman sarcophagi,
but the idea is remarkably similar to Flaxman's in his Warton and Jones
monuments, for there too poetry is referred to at the top of a monument
primarily dedicated to recording good deeds.

164

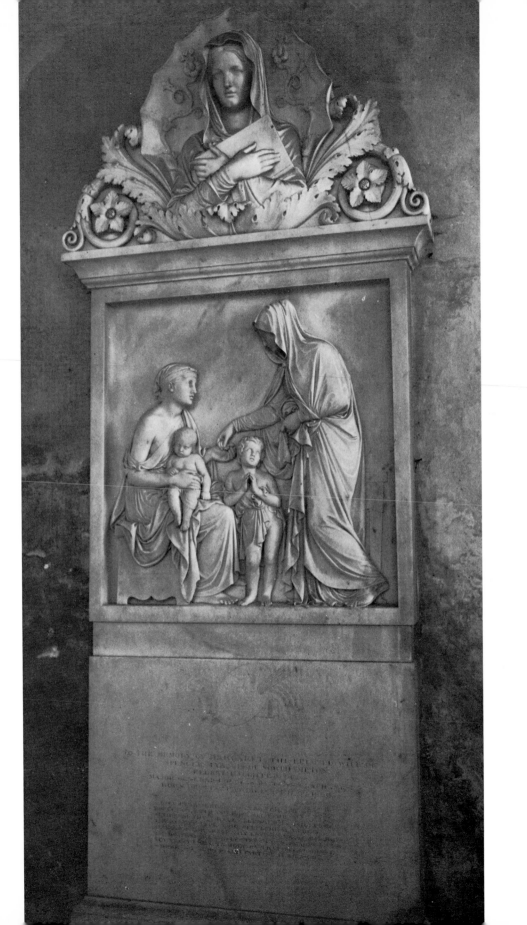

TO THE MEMORY OF MARGARET, THE ELDEST WIFE OF
SPENCER PERCEVAL, SOUTHAMPTON

124. (right) Richard Westmacott the Younger: Monument to Lady Anne Fitz-Patrick, Grafton Underwood Northamptonshire.
125. (far right) F. J. Williamson: Monument to Princess Charlotte, St. George's, Esher, Surrey.

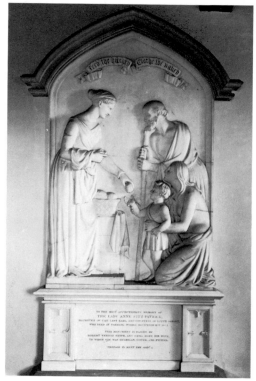

Also in Northamptonshire and for relatives of the Northamptons, there is a monument by Richard Westmacott the younger to Lady Anne Fitz-Patrick, daughter of the Earl and Countess of Upper Ossory, who died in 1841 (Plate 124). This relief, erected in a dark corner of the Church of Grafton Underwood by Robert Vernon (later Baron Lyvedon) and his wife, who were virtually the adopted children of Lady Fitz-Patrick, is slightly gothic in character with an archaic, wriggling scroll upon which we read: 'Feed the Hungry. Clothe the Naked.' Lady Fitz-Patrick hands a boulder-like roll to a little boy, supported by a partly clad mother. The scene is pondered over by a bent grandfather (the boy's father is absent, no doubt dead, so the family is 'deserving'). The figures, which echo the frame, are at once stiff and boneless with cylindrical limbs and vapid faces, and make a telling contrast with Sir Richard Westmacott's figures (Plate 8).[69]

There are a number of other Victorian monuments which continue this theme.[70] One of the finest is also one of the latest: the central relief panel of the tryptich commemorating Princess Charlotte which Queen Victoria commissioned from F. J. Williamson in 1880 (Plate 125). Here we have the good man with his faithful hound looking on with approval as 'the prudent partner of his blood' gives a coin to a modest little boy who is presented by his reverend grandfather, whilst his sister, less brave than her brother, runs to her mother's lap. Here again the children's absent father is no doubt dead and thus the family is 'deserving'. The style of this work is quite dissimilar to

IN MEMORIAM
CHARLOTTE

anything which we have examined in this chapter, but the detailed treatment of the slightly medieval costume may remind us of Monti's Lady de Mauley and the faint relief of the angel may remind us of the reliefs by Farrell and Boehm mentioned in the fourth chapter. Williamson's work, although now in St George's, Esher, Surrey, was designed for Claremont House, not for a church.

Charity was, throughout the nineteenth century, the subject of much thought. As a Christian duty it qualified the belief that the poor should be left alone because their poverty was often their own fault and because hard conditions stimulated the worthy amongst them to help themselves by hard work. The idea that Charity benefited the soul of the donor as much as the bodies of the poor was subjected to subtle elaboration, as when Wordsworth justified Cumberland beggars for the good they did to those who gave them alms. During the 1840s Charity received political as well as religious support in the romantic Tory attempt to revive feudal responsibility in the upper classes. High Church patrons of the gothic revival monuments discussed at the end of the last chapter did not tend to erect monuments showing charitable acts, but they made their charitable institutions commemorative. One of the founder members of the Cambridge Camden Society, Alexander Beresford Hope, conceived the idea of a mortuary chapel to his mother, which was to be part of a rural community including a 'hospice' for the clergy, almshouses, a model estate village and a reformatory-*cum*-farm.[71] This was not simply an escape into the Middle Ages: it offered a retreat for the exhausted urban clergy and a cure for the urban delinquent. The reclamation of bog and moor was also envisaged and this would certainly have involved modern technology. It is to the Industrial Revolution and the improved farming that we must turn in the next chapter.

Some people did resent the patronising assumptions of reformers, such as Beresford Hope: Kingsley's stout-hearted Cornish gamekeeper in *Yeast* was quite clear that charities were a means of 'keeping the people down, and telling them they must stay down, and not help themselves', but wait for what they were given. This is now the orthodox view, and what was once the duty of the privileged individual with a conscience is now a service provided by the State.

Just as Charity complemented the harsh laws of *Laisser-faire*, so it was also most commonly shown as an act performed by ladies and may be recognized as part of the compensatory social role played by the wives and daughters of the wealthy. In accordance with the edicts of economic 'law' the man may have felt obliged to give his labourers starvation wages. The wife and daughter kept them alive in accordance with the edicts of the Gospels.

7. Industry and Agriculture

THE unprecedented mercantile and industrial expansion, and the consequent urban growth and commercial prosperity, of early nineteenth-century Britain was gradually prepared for during the eighteenth century and was unaccompanied by the sort of conflicts between the old upper class and the new middle class which were often characteristic of equivalent continental developments. Not only were the ranks of the English upper classes far less closed than they contrived to pretend, but the nobility lost little time in encouraging the exploitation of iron, lead, copper, coal and slate found on their land, and in developing their urban estates to meet the needs of the expanding population—some of them even contributed personally to 'progress' by inventing methods of coal-tar extraction (the Earl of Dundonald), or a new printing-press (Earl Stanhope), or by pioneering canals (the Duke of Bridgewater). It is true that the tradesmen of Chester found that they were not welcome in the new City Library founded in 1791 for the gentry, but the merchants of Liverpool, at the same date, hunted with the county gentlemen on the Wirral, and it was not considered remarkable in 1792 that one of the founder partners of the Sheffield and Rotherham Bank should be a member of a *nouveau-riche*, non-conformist family of ironmasters whilst the other was one of the long-established landowning Tory, Catholic gentry.[1] Perhaps it is partly because of this lack of any absolute social division that the Industrial Revolution made no sudden or dislocating impact on art— or at least 'high' art—in Britain.

If, as does seem probable, there was a lack of cultural self-confidence in many of the men who made new fortunes in the early nineteenth century, it is hard to detect in the public buildings of Bristol, Liverpool, Manchester or Leeds; and the taste of rampant ornament and cluttered drawing-rooms in the mid-nineteenth century, often viewed as the 'bad' taste of a new middle class, is first found in the aristocratic *Palazzi* of St James's during the 1830s.[2]

169

JOHN WILKINSON,
IRON MASTER,
WHO DIED XIV JULY, MDCCCVIII,
AGED LXXX YEARS;
HIS DIFFERENT WORKS
IN VARIOUS PARTS OF THE
KINGDOM,
ARE LASTING TESTIMONIES
OF HIS UNCEASING
LABOURS;
HIS LIFE WAS SPENT IN
ACTION
FOR THE BENEFIT
OF MAN;
AND, AS HE PRESUMED
HUMBLY TO HOPE,
TO THE
GLORY OF GOD.

LABORE ET HONORE.

No obvious class distinctions are reflected in the church monuments of this period, and we will see that the available conventions for commemorating soldiers, priests, teachers, lawyers and politicians also accommodated those who derived their wealth from oriental trade, insurance, buttons, copper, ceramics and canals. James Barry had made commerce one of the principal subjects of his allegories in the Royal Society of Arts, and sculptors were no more shy than he was of the subject. The allegorical vocabulary inherited from antiquity, via Renaissance Italy, already included the cornucopia for Prosperity, the caduceus for Trade, and the beehive for Industry; and the Virtues or the putti who held the scales of Justice had long ago been persuaded to lean on ships' rudders, or to hold a Bishop's mitre, so that they would not have been startled when asked to hold a cog-wheel, however incongruous that may seem to us. Ripa's *Iconologia* had included an allegory of the Physical Sciences as early as 1603.

In the churchyard at Lindale in Lancashire there is a monument to John Wilkinson who died in 1808. With his father he had established and managed iron furnaces and forges at Bilston, at Broseley and at several sites in Denbighshire. He had collaborated with Abraham Darby in building the iron bridge over the Severn in 1777-9. He was also a collaborator with Boulton and Watt and brother-in-law of Joseph Priestley. With his brother he had pioneered the production of cast-iron building parts and he was said to have built an iron chapel for his Methodist workers at Bradley.[3] Even his own coffin was of cast iron. The Lindale monument is of course also of this material (Plate 126). One might consider this as a bold assertion of a new industrial aesthetic. It was certainly bold to employ iron (perhaps rash for it has rusted and cracked), but the monument takes the form of an obelisk and aspires to emulate the memorials set up by the nobility in their landscaped parks throughout the eighteenth century—it was itself originally in the park of Castlehead, the Wilkinson house. Moreover, there is a classical profile medallion and a classical tag attached to it: 'Labore et Honore'.

As an example of a very different, much less independent 'Captain of Industry' we may take Benjamin Wyatt, the brother of the architects James and Samuel, who was the agent of the Penrhyn estate in North Wales and the right hand of Lord Penrhyn in his development of the slate industry of that area. His most important personal contribution was perhaps the design of a new type of track for the horse-drawn railway he built from the mountain quarries to the quay.[4] Not long after his death in 1818 his family erected a large slate pyramid to his memory in Llandegai churchyard (Plate 127). This was a splendid exhibition of the quality and size of Penrhyn slate, just as the Lindale obelisk was a splendid exhibition of cast iron, but it was also, like the Lindale obelisk, an entirely neo-classical idea. No less neo-classical was the 'permanent light' found on the tomb, in the Père Lachaise Cemetery, Paris, of Frederick Albert Winsor, one of the inventors and frustrated capitalists behind the introduction of gas lighting in England and in France. Even

171

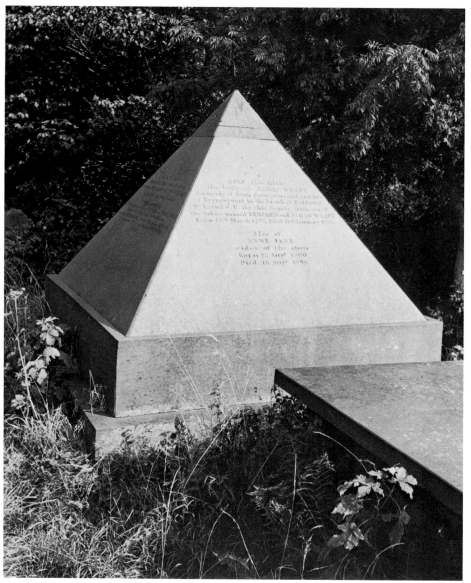

127. Pyramid tomb of Benjamin Wyatt and family, Llandegai churchyard, near Bangor, North Wales.

Winsor's projects, incidentally, could be sanctioned by Holy Writ, for his cenotaph in Kensal Green Cemetery, London was inscribed with a line from Zacharias 14:7 'At Evening Time it shall be Light'.[5]

The great poet of the early Industrial Revolution, Erasmus Darwin, had no quarrel with the classical imagery which had served Alexander Pope. He used antique mythology when he projected a monument for the great canal engineer Brindley, who, he pointed out in a footnote, 'ought to have a monument in the Cathedral Church at Lichfield':

172

—NYMPHS! who erewhile round BRINDLEY's early bier
On snow-white bosoms shower'd the incessant tear,
Adorn his tomb!—Oh, raise the marble bust,
Proclaim his honours, and protect his dust!
With urns inverted, round the sacred shrine
Their ozier wreaths let weeping Naiads twine;
While on the top MECHANIC GENIUS stands,
Counts the fleet waves, and balances the lands.[6]

Darwin intended this as a serious hint for a sculptor, but in 1791 few English sculptors would have been pleased to undertake so ambitiously allegorical a conceit—although presentation silver was produced with similar programmes up to the mid-nineteenth century.[7]

Darwin was a keen admirer of Roubiliac, and Nicholas Read, Roubiliac's pupil, would perhaps have been the ideal artist to carry out his plans. Read's monument of 1766 at Brightlingsea, Essex, to Nicholas Magens (Plate 1)—a merchant of Holstein who realized a fortune in London and retired to Essex, purchasing the Brightlingsea estate in 1763 for £29,300 and dying there on 14 August 1764—can be interpreted with the assistance of a contemporary account.[8] It portrays the Resurrection and the pyramid is about to crumble, for 'all shall dissolve'. A female angel displays an inscription recording Magens's virtues and stands beside the emblems of his trade—ships, bales of merchandise, and anchor and a globe. There is also 'an Angel-child, sitting on the Horn of Plenty pointing to the Globe showing Trade is no more', and at the same time 'the emblems of Prudence, Justice and Honour which he (Magens) traded with' are placed at the top of the pyramid where we see another 'Angel-child sounding the Trumpet intermix't with a Choir of Cherubs in Clouds'.

A monument very different in style, but with no less complicated an allegorical conceit, is that by J. F. Moore to the city merchant, William Baker, in Bath Abbey. Moore's employment on this work is not surprising if we consider that he had erected the statue of Lord Mayor Beckford for the City of London, and that Baker, when he died on 23 January 1770, had been an Alderman for more than twenty years. Moore had also worked for Lord Mayor Beckford at Fonthill 'Splendens' which is not far from Bath. The monument is not dated, but it must have been erected by 4 February 1783, when it is included in a list of monuments in Bath Abbey given in *The Gentleman's Magazine*.[9] Above the sarcophagus of Siena marble (which is topped by crisply carved, flat, scaled volutes uncurling into eagle-heads) is a relief filled with Moore's typically elongated figures (Plate 2). This relief shows, from left to right, a ship's masts and an anchor; Justice with her scales with a boy reading a book; a ram beside a female murally-crowned, holding a cornucopia (perhaps the City of London). Next we have a horse and a cow evidently startled by a suppliant native boy with an eager beaver (perhaps an

128. John Bacon: Monument to Charles Roe,
Christ Church, Macclesfield, Cheshire.

emblem of Industry, perhaps an allusion to the fur-trade). Finally there is an
ivory tusk and a lamp-bearing oriental leading a camel. Below are the
three words 'ORBIS.TERRARUM.FELICITAS'. The whole does convey the idea of
international commercial goodwill; but one would like a more specific
interpretation and seeks for one in vain in the peculiar latin of the epitaph.

Bacon the elder although fond of allegory seldom employed it in a very
obscure way (although the base of the monument to Sir William Jones in St
Paul's referred to in the last chapter, is an exception to this), and there is no
problem in interpreting his monument in Macclesfield to Charles Roe who
died 3 May 1781, (Plate 128). An allegorical female supporting a type of cog-
wheel and holding a medallion portrait of Roe in her other hand along with an
olive-branch (emblem of the peaceful Arts) sits on top of three reliefs. Two of
these show Roe's Industrial concerns. The mill on the left must be for thread
or silk, and the furnaces on the right for copper, because as is made clear by
the epitaph, Roe began the Macclesfield button and twist manufacture (in
1744), introduced silk-throwing (in 1758), and also established a manufactory

174

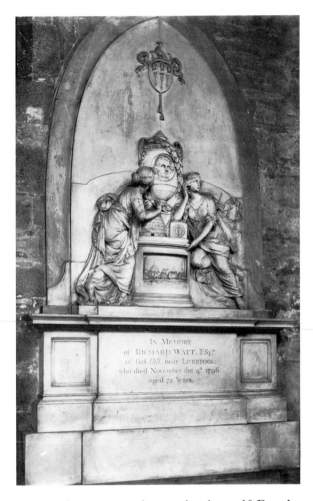

129. John Bacon the younger: Monument to Richard Watt, Standish, Lancashire.

to process ore from the Parys mountain copper-mine on Anglesey.[10] But the central relief of the three shows Christ Church, Macclesfield, 'the elegant structure which encloses this monument', erected by Roe, in the gothic style, 'in the space of seven months'.

A larger monument by Bacon the younger at Standish in Lancashire was erected in 1806 to Richard Watt, 'an eminent West India Merchant' who 'from an obscure station, had realized property to the amount of half a million by unremitting assiduity and attention to business.'[11] Watt died 4 November 1796, 'a martyr to the gout', at his seat of Oak Hill, near Liverpool. Here again we have the medallion portrait—in this case together with an urn. Here also is the olive. But instead of one allegorical female there are two: Industry with her beehive and navigation with her compass and ships behind her. Below, as in the Roe monument, there is a topographical low-relief—here a port-scene indicated by Navigation (Plate 129). Bacon the younger's monument to Stephen Stonestreet in St Stephen's, Walbrook, London, is another contribution to this type, commemorating not

175

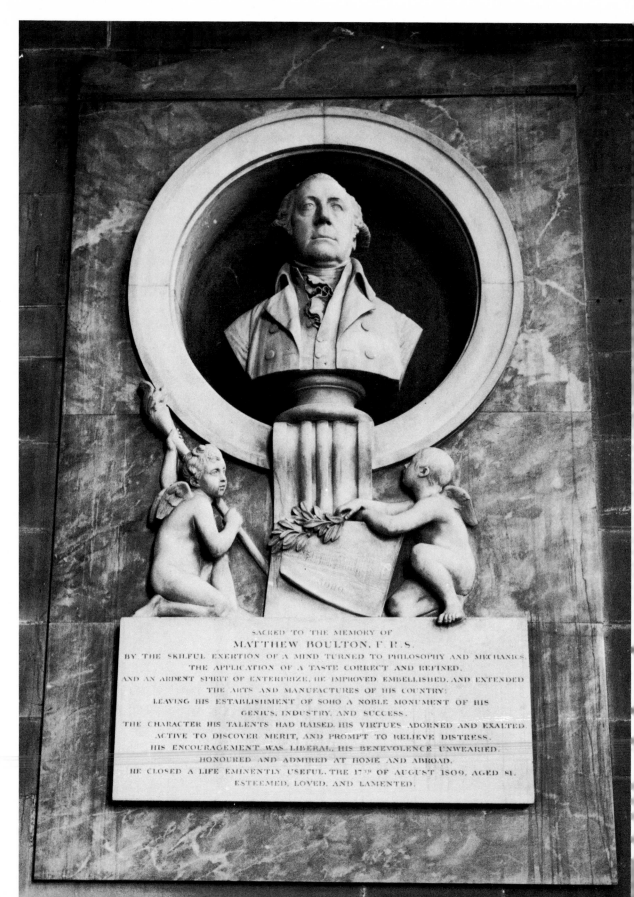

SACRED TO THE MEMORY OF
MATTHEW BOULTON, F.R.S.
BY THE SKILFUL EXERTION OF A MIND TURNED TO PHILOSOPHY AND MECHANICS,
THE APPLICATION OF A TASTE CORRECT AND REFINED,
AND AN ARDENT SPIRIT OF ENTERPRIZE, HE IMPROVED, EMBELLISHED, AND EXTENDED
THE ARTS AND MANUFACTURES OF HIS COUNTRY:
LEAVING HIS ESTABLISHMENT OF SOHO A NOBLE MONUMENT OF HIS
GENIUS, INDUSTRY, AND SUCCESS.
THE CHARACTER HIS TALENTS HAD RAISED HIS VIRTUES ADORNED AND EXALTED.
ACTIVE TO DISCOVER MERIT, AND PROMPT TO RELIEVE DISTRESS.
HIS ENCOURAGEMENT WAS LIBERAL, HIS BENEVOLENCE UNWEARIED.
HONOURED AND ADMIRED AT HOME AND ABROAD.
HE CLOSED A LIFE EMINENTLY USEFUL, THE 17TH OF AUGUST 1809, AGED 81.
ESTEEMED, LOVED, AND LAMENTED.

an Industrialist, but a man who developed the Phoenix Assurance Company to cater for the new requirements of the growing metropolis. As its name suggests, this company was concerned with fire insurance and provided fire-engines for the property of policy-holders, hence the small relief here beneath the allegorical female shows an engine of that period.[12]

Flaxman was less inclined than Bacon towards pretty detail. His allegories also tend to be simpler; but they are recognizably of the same kind. Matthew Boulton, for example, in Handsworth, Birmingham, is commemorated by Flaxman with a superb bust in a tondo, below which one baby angel holds a lighted torch (an emblem of his immortality) and another holds a drawing of Boulton's handsome factory nearby at Soho (then one of the wonders of the world) together with a branch of olive (Plate 130). Flaxman's earlier monument to Josiah Wedgwood who died in 1795 which was erected in 1803 at Stoke on Trent again has a simple bust portrait in a roundel, but only two vases perched on the inscription below. He was not paid nearly as much for this as for the Boulton monument;[13] and as a result, although both Wedgwood and Boulton may have claimed (in the words of Boulton's epitaph) to have 'embellished and extended the arts and manufactures of his country' through 'the application of a taste correct and refined and an ardent spirit of enterprize', Boulton's monument is by far the more distinguished. Boulton died on 17 August 1809, and the monument was commissioned by Robert Boulton in the following February. Flaxman charged 300 guineas, and this was all paid by 1813.[14] After that date I have not found monuments with allegorical putti or ladies, olive branches and medallion portraits, to people of the type so far considered. The topographical low relief, on the other hand, which played an important part in both Bacon and Flaxman's monuments, did continue to be used. Such topographical reliefs had incidentally also been popular on eighteenth-century naval monuments.

A tablet to Joseph Priestley, an engineer (not the chemist of that name) who died 14 August 1817, is in Bradford Cathedral. William Pistill, the sculptor of this work, provided an elegant neo-classical frame and a neat assembly of globe, dividers, quill, compass, ruler, and set-square in the pediment and also a rather surprisingly naïve pictorial relief of an engineer supervising two navvies working in a canal tunnel (Plate 131). The monument was erected by 'the Company of Proprietors of the Canal Navigation from Leeds to Liverpool . . . as a mark of regard for his able, zealous, and assiduous attention to the interests of that great and important undertaking.' Priestley had apparently always rejected tempting offers to work elsewhere.

A similar work to this is at Tyringham, Buckinghamshire, and commemorates William Praed who died 9 October 1833, and who, as M.P. for St Ives, and later Banbury, and as a senior partner in a banking house in London and in both Truro and Falmouth, 'was ever alive to projects of Local Improvement or of great National Importance', and, in particular, 'obtained and carried into effect the Act of Parliament for making and maintaining the

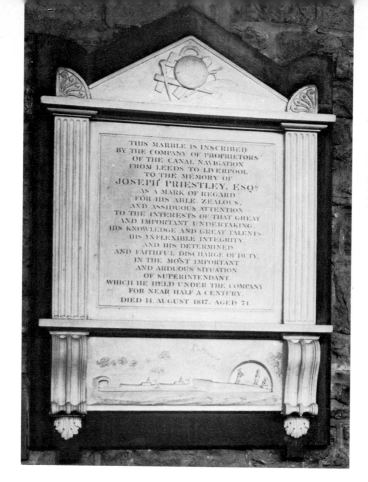

Grand Junction Canal.' Here the relief is in a lunette and shows a canal lock
with a barge in it (Plate 132). Praed, in addition to what he gained from his
banks and his involvement with this canal, had acquired a fortune by his
marriage with Miss Backwell of Tyringham—'the sole heiress of a very
opulent family'—and yet this monument, although by Behnes, a better
known sculptor than Pistill, is hardly larger than the tablet to Priestley. This
may be partly accounted for by the fact that Praed did not die at Tyringham,
but in his Cornish seat of Trevethow, and was buried at Lelant, Cornwall, in a
'massive' Portland stone tomb.[15] Thus this tablet is a sort of second
monument to him.

The only works comparable in scale to Bacon's monument to Watt and to
Read's earlier monument to Magens which were erected in churches to
commemorate merchants or industrialists in the early nineteenth century,
were Chantrey's statue of James Watt and Westmacott's monument to Lord
Penrhyn, both of which, as we shall see, introduced a new note of naturalism.
Even if Praed's monument had been grander it would have been unlikely at
that date to have featured allegorical ladies with cornucopias or compasses.
Erasmus Darwin, whose idea for a monument to Brindley has already been
noticed, also planned one for Arkwright exhibiting 'the Pyramids of Egypt, a
Sphinx, a Mummy and a Spinning Machine'. It is significant that

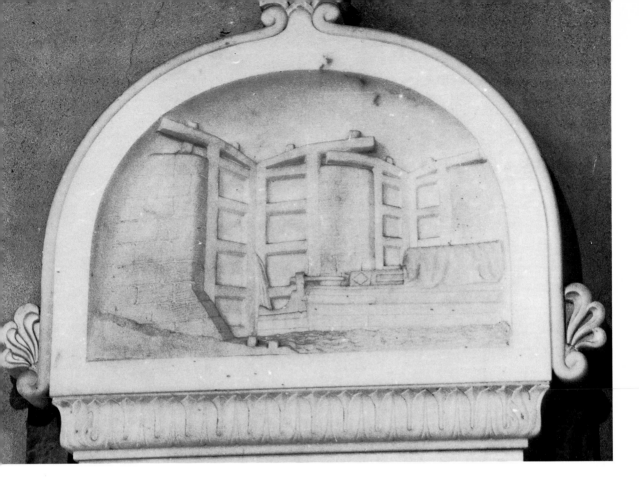

Cunningham, in 1830, ridiculed this as too obscure, complex and literary for sculpture.[16]

Perhaps the really significant fact about monuments which reflect the Industrial Revolution is the fact that there are so few of them. Elaborate conceits of the type used by Moore or Read declined in favour in monuments (although they remained popular for silver centre-pieces, and for the pediments of Exchanges, Banks and Insurance Offices). In the previous chapter the increasing desire for monuments to show morally edifying narratives was stressed; but whereas bishops could be portrayed blessing natives and teachers instructing youth, it was far harder for the merchant, manufacturer, entrepreneur or inventor to be cast in any obviously edifying role, however beneficial to the public his work might have been. Thomas Spackman was in no way ashamed of his trade as a carpenter, but it is chiefly his charity which his monument commemorates; members of the East India Company chose to be portrayed as kindly administrators concerned to abolish suttee, rather than as men making money out of shawls or tusks or spices; and Benjamin Kenton was commemorated for his philanthropy, not for his bottled ale.

In addition to this, it must be remembered that the noblemen who benefited from mineral finds on their estates, whether the Marquis of

Londonderry or Lord Byron, were not likely to take any special pride in this source of revenue, even when, like the fourth and fifth Earls Fitzwilliam they took a very close interest in it. Their agents might have done so, but their agents, in spite of their increasing importance and status, 'knew their place'— which was unlikely to extend much beyond a modest wall tablet, or possibly a grand tomb in the churchyard, like the Wyatt pyramid. Also, many men who had made a fortune in trade or finance invested their fortune in land. And some of these—although not Nicholas Magens—were commemorated as country gentlemen.[17]

William Denison, an 'opulent Leeds clothier ... after realizing an immense fortune, a considerable portion of which he is reputed to have gained by one ship's cargo, which opportunely arrived at Lisbon immediately after the great earthquake in 1755',[18] purchased the manor of Ossington in Nottinghamshire from the four co-heiresses of the Cartwright family in 1768. He died in June 1782 and left his estates to his younger brother, Robert, 'one of the greatest merchants in the woolen manufactory in the north of England',[19] who, however, died in 1785. William's will, drawn up on 18 July 1778, reveals that he was contemplating erecting a monument, for he bequeathed 40 shillings per annum 'for the cleaning and keeping in good condition of any monument which I may ... erect or direct to be erected to my memory in the parish church at Ossington.' But in the winter of 1783 Robert made a will which referred to a mausoleum 'now erecting'. This is not a mausoleum in the sense used in this book but an estate church, rebuilt, with a strong dynastic emphasis, on the site of the old, and still standing deep in landscaped grounds beside the site of the house. It is by Carr of York, who also planned a two-staged doric temple for the brothers.[20] Robert's will mentions 'a monumental statue at full length to the memory of my said late brother agreeable to his directions' and sets aside £1000 for a similar monument for himself. These are the two life-size statues by Nollekens placed in niches to right and left of the west entrance of Carr's church (Plates 133 and 44).

These statues were intended to overlook a succession of Denisons from the manor house. The dynasty, however, proved rather tenuous. Robert, being childless, left his fortune and his property to his cousin, John Wilkinson, a London merchant, on condition that he changed his name to Denison. This he did, and he was living at Ossington by the summer of 1794 when his first wife and child died there. However, by his second marriage, he supplied Victorian England with one of its most zealous churchmen (Edward Denison, Bishop of Salisbury), one of its most respected politicians (John Denison, Viscount Ossington), and one of its ablest colonial administrators (Sir William Thomas Denison).

In a relief on the base of William Denison's statue Nollekens portrayed a flock of sheep on one side, a ship at anchor in the middle, and, on the other side, men unloading bales and barrels (according to one source, at Lisbon).

133. Joseph Nollekens: Monument to William Denison, Ossington, Nottinghamshire.

WILLIAM DENISON, Esq.
Died 11ᵗʰ April 1782, Aged 68.

Whether or not Denison actually owned flocks, as some clothiers did, he must have been closely involved with those who did so, and it was quite legitimate for him to strike this rural note. By the purchase of Ossington he had become a country gentleman with extensive agricultural responsibilities and it is as such and not as a manufacturer that he is portrayed by Nollekens, leaning on a stump, and holding a copy of Pope's *The Universal Prayer*, written as a sort of appendix to *The Essay on Man* and addressed to the

> Father of All! in ev'ry Age
> In ev'ry Clime ador'd
> By Hermit, by Savage, and by Sage,
> Jehovah, Jove, or Lord!

His brother is portrayed leaning on his books, cross-legged, without his wig— a far more animated and articulate figure, but evidently less concerned to appear as a country gentleman. One scrap of evidence suggests that William had not been accepted by all the county as a gentleman—a desperate letter from his agent tells of Lord George Sutton removing his traps and saying Denison 'was no gentleman' or he would not 'destroy ye foxes'.[21] It is also noteworthy from their wills that neither brother wished the inheritor of Ossington to sever links with the wool trade.

The Fletchers who owned a large paper mill at Prestolee, Lancashire, would have been unlikely to have had any desire to conceal the source of their

wealth, but Matthew Fletcher who died in 1808 is commemorated at Ringley, Lancashire by an allegory of Justice with sword and scales—that is not as a manufacturer but as a just man, and as a Justice of the Peace, and, therefore, a landowner. Ellis Fletcher, in the same Church, is wept over by an idealized widow. And this convention, unrelated to profession or rank, was also employed in the monuments to other manufacturers: Josiah Spode the younger at Stoke on Trent and George Brettle at Belper, Derbyshire, for example.

But the 'neutral' convention that was perhaps most popular was the bust portrait, and occasionally one can say that the style of these is distinctly suited to a 'Captain of Industry'. One would not, I think, feel this to be true of Chantrey's bust in Handsworth Church of William Murdock, the friend and associate of Boulton and Watt, pioneer of coal gas-lighting, the inventor of an air-bell, an iron-cement and many improvements and variants on the steam-engine, who died in 1839;[22] but one may feel that this is true of Chantrey's posthumous bust of the Shropshire ironmaster, John Simpson, who died 15 June 1815, and which was perhaps erected by Telford in its special niche by Carline in St Chad's, Shrewsbury (Plate 134). Simpson played an important part in the construction of a great many iron bridges, also the Pontcysylte and Chirk aqueducts, and locks and basins of the Caledonian canal; and in addition he superintended the construction of Steuart's great church in which his bust is to be seen. It is true that the herm-type of bust was a fashionable neo-classical type, but surely Chantrey chose it here to underline the tough and practical energy of this bull-necked man.[23]

A final point to be made about the men associated with the Industrial revolution is that many of them were non-conformists. Magens's huge monument adorns the chancel of Brightlingsea Church, but to judge from his will, with its lavish bequests to the elders of the Lutheran Church in Trinity Lane in London, he was no Anglican. Josiah Wedgwood's monument is in an Anglican church, and so is the monument at Chiswick to his partner Thomas Bentley—carved by the younger Scheemakers to the design of Stuart—but Bentley was a founder of the Octagon Chapel in Liverpool and Wedgwood supported the 'rational devotions' of that institution. Charles Roe, whose monument in Macclesfield we have noticed, was certainly an Anglican, but it is noteworthy that his church-building enterprise was part of his fight against Methodism, encroaching not only on the town but on his own family.[24]

An extraordinary number of men associated with the Industrial Revolution were Quakers. It may be said that the Quakers were behind almost all the important developments in the eighteenth-century iron industry. The Darby's of Coalbrookdale not only replaced charcoal with coke in the smelting process but found entirely new markets for cast iron. Other Quaker families such as Reynolds, Rawlinson and Lloyd, formed a network of iron manufactures throughout Britain. In addition it was one of the many Quaker

134. Francis Chantrey: Bust of
John Simpson, St Chad's,
Shrewsbury.

clock and instrument makers, Huntsman, who first devised a satisfactory method of casting steel. The first man to make zinc in Britain—also an important manufacturer of brass and copper and pottery—was a Quaker, William Champion. The smelting of lead ores by means of coal pioneered by the Quaker, Dr Edward Wright, led to the formation of the immensely powerful Quaker lead company. By the end of the eighteenth century great Quaker banking concerns had arisen partly out of the goldsmith banks, partly as a convenient by-product of domestic industries. The Gurneys and Overends became the first great bill-brokers of the nineteenth century. Barclays and Lloyds are still household names. In addition to this, Quakers controlled about ten per cent of the Corn Trade at the time of the Napoleonic Wars. The Brights of Rochdale, with their carpet works and cotton mills, were Quakers. There were great Quaker brewers and pharmacists and many who established themselves in grocery, tea-dealing, cocoa and chocolate manufacture, and, later in the nineteenth century, in biscuits and in safety-matches. The Quaker, Edward Pease, whose family was involved in iron, coal, banking and in the dyeing and weaving of cloth, founded the Stockton and Darlington railway, and it is impossible to study the growth of the railways without noticing the part played by eminent Quakers, such as Ellis, Sturge, Rowntree and Fry. It is worth briefly surveying this roll-call of names because none of them were permitted the smallest sculptured commemoration. Even statues are rare. One was erected in Darlington in 1875 to

Edward Pease's son, the railway magnate and first Quaker M.P., but this was posthumous and was not erected by his family or by his religious society.[25]

Also, a great many men associated with the Industrial Revolution were Unitarians—for example, we may list in this category many of the great families in Liverpool in this period: the Tates, the Heywoods, the Roscoes, the Rathbones, and the Booths (sugar-merchants, bankers, cotton-importers, corn-merchants and railway-projectors). Unitarians were not entirely opposed to monuments, for there was a bust of Roscoe and a monument to Rathbone, by Foley, in the Renshaw Street Chapel in Liverpool (later moved to the Unitarian Church in Sefton Park) and in 1840 there were mural monuments by Chantrey in the Mosley Street Chapel, Manchester; but Unitarians did tend to favour simple tablets. Jedediah Strutt, Arkwright's partner who revolutionized the stocking-frame and old methods of cotton-spinning is only commemorated by a tablet erected by his family in the mid-nineteenth century in the Unitarian Chapel at Belper, Derbyshire. Samuel Courtauld, the silk and crêpe manufacturer whose fortune depended on mourning habits, although a Unitarian, had a family vault in the Parish Church at Gosfield (Catholic families also sometimes retained their old vaults in what became Anglican Churches), but he had no monuments there.[26] At Styal, Cheshire, in 1823, Samuel Greg the second erected a chapel for workers in his silk-mill. He moved, at about the same date, from the house beside the mill to a neo-Elizabethan mansion in a park behind the village. The chapel thus became a sort of Unitarian estate church. Its walls are studded with tablets to the Gregs—but there is nothing at all ambitious.

It is easy to set rural and industrial England in opposition during the romantic period. On at least one major political issue (the Corn Laws) farmer and squire were united against mill-owner and labourer. In general, too, the farmer and the squire were more likely to be Tory, and also attached to 'Old England'. But Styal is a useful place to remind oneself of the interdependence of the industrial and the rural. The original mill, like the Soho factory, must have resembled a country house. Earl Fitzwilliam's colliers were then employed in harvesting during slack periods, and the pits were propped with estate timber.[27] Improvements in the tempering of cast iron made great improvements in plough shares possible, whilst cow dung was required for calico printing, and livestock was transported by canals. The mind of a man like Erasmus Darwin dwelt equally on the possibilities of improving harvests and mineral findings, reclaiming land and making canals, whilst the agents of the landowning nobility were engaged as much in bargains with railway projectors as in quarrels over broken fences.

But however false the opposition between agriculture and industry the very strength of the idea that they are opposed is important. Farming is an ancient profession and, however industrialized, it can still avail itself of a pastoral mythology. I have already pointed out that industrialists had difficulty in casting themselves in the obviously benevolent roles such as were

available for preachers and teachers; but the landed aristocracy and the gentleman farmer, although using steam-powered threshers and moving cattle by canal, could be commemorated as belonging to the most venerable of vocations—the word 'husbandry' and the image of harvesters having Biblical as well as pastoral resonance; the plough commonly employed as an ornament on rustic china, surrounded by moral tags, and sometimes set up in the parish church. In the monuments to men concerned with farming and agriculture which will be examined here, the use of this 'loaded' imagery will be quite clear. The interdependence of agriculture and industry will also emerge in the activities of many of the men commemorated.

John Westcar who died 24 April 1835, at the age of eighty-four had been a gentleman farmer all his life. He was, more specifically, 'a celebrated grazier' and occupied 'Creslow Pastures' near Whitchurch, Buckinghamshire, in which church, above his family pew, Gibson's large relief monument to him is to be seen. It portrays him leaning on a staff in front of one of those fat cattle for which between 1799 and 1821 he received no less than forty two prizes at Smithfield[28] (Plate 135). According to Robert Gibbs, the sculptor could not have known much about 'the points' of fat cattle, and the little bunch of sheep included in the bottom right hand corner are certainly perfunctory—perhaps the Roman campagna did not supply the sculptor with suitable models. However, Gibbs may not have looked very closely at the work, for he thought that Westcar was wearing a 'classic garment'.[29] In fact, he is wearing contemporary clothes beneath his cloak. One's first impression is, admittedly, of a neo-classical version of the most static moment in the procession of sacrificial animals on the Parthenon frieze; but on a second view, the work has just as much in common with that minor and provincial tradition in English art of painstaking profile portraits of prize-winning animals—which is not to deny that the figure of Westcar has a certain dignified ease. Just as the Denisons, although manufacturers, had more concern with farming than one might at first have supposed, so also Westcar was not oblivious to the advantages given to farming by the Industrial Revolution, for he was one of the first graziers in his part of England to convey his fat cattle to the London markets by canal.[30]

The convention to which the Westcar monument belongs has more to do with painting than with sculpture, and it is an exceptional work in this period. Another exceptional work is the monument erected in 1850 in the Pro-Cathedral, Dublin, to Peter Purcell, the founder of the Agricultural Society of Ireland, by the Irish sculptor, Hogan—like Gibson a Roman resident for much of his life. The deceased is shown resting after his labours, leaning against a stump with a plough and a few sheep behind him. An angel descends with emblems of death (a sickle) and of heavenly reward (a palm-branch).[31] Here we have an explicit use of Biblical metaphors.

If there can be said to have been a convention for monuments to men engaged in rural 'improvement' then it will be found in the work of a single

135. (left) John Gibson: Monument to John Westcar, Whitchurch, Buckinghamshire.
136. (right) Richard Westmacott: Harvesters (detail of Statue of the fifth Duke of Bedford, Russell Square, London).

sculptor, Richard Westmacott, and to trace it we must begin by looking at a public statue rather than a church monument—indeed, Westmacott's first commission for a statue in bronze.

The fifth Duke of Bedford died in 1802 and Westmacott's statue of him was erected in 1809 on the south side of Russell Square—a prominent part of the newly developed Bedford Estate. A tall stone pedestal ensures that the bronze figure of the Duke is contrasted against the sky and is not dwarfed by the trees planted here in accordance with the plans of Repton.[32] The Duke looks down Bedford Place to where the statue, also by Westmacott, of his friend and political mentor, Fox, was to be erected a few years later. The Duke is shown leaning on a ploughshare and holding a sheaf of corn, and is thus commemorated as an agricultural improver. He had indeed, with Salmon, his Clerk of Works, introduced new threshing, milling and winnowing machinery. The plough is a 'Rotherham'—the new model plough introduced in England in the eighteenth century.

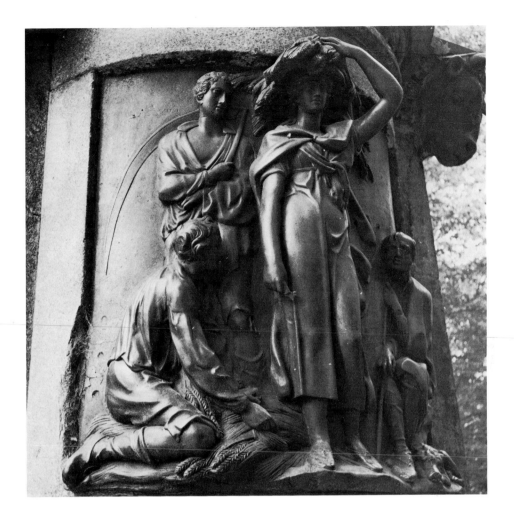

Around the Duke the seasons revolve: a putto with a festoon of flowers is followed by one with a cornucopia, by one with a butterfly, and then by a very small boy huddled in a cloak. (The sequence is thus, Summer, Autumn, Spring, Winter, which one would like to think was due to inept restoration.)[33] Massive bulls' heads adorn the corners of the pedestal and are joined by a narrow frieze of horses, sheep, deer and cattle, reminding us that the Duke was a keen sheep-breeder and the first president of the Smithfield Club. On either side of the pedestal are two large, convex, bronze reliefs. One (Plate 136) shows a group of harvesters dominated by a superb woman with a sheaf on her head and a sickle (now broken). The other shows herdsmen, less happily grouped, with two figures clumsily placed back to back, drinking and blowing. The more pensive figures are appropriately elegiac in mood. The Duke's labourers may not have been so heroic, yet the pride which they took in their work was probably enhanced by the shearing and ploughing competitions held at the model farms at Woburn.

187

A detailed and objective account of what was achieved on the Duke's 3,637 acres is given in the *Farmer's Magazine* which also published an elegy to the man whom they considered to be 'unquestionably the first or greatest farmer in Britain', in whose day 'the plough its honoured rank resumed' and who will be revered by posterity when

> The swains, enraptur'd as they roam, shall say,—
> 'These wastes to bloom, the noble BEDFORD gave'.[34]

The subscribers who erected this statue, some of them Whigs who shared the Duke's political principals and some of them Tories who shared his agricultural enthusiasms, did not decide on any inscription, but there seems to have been some idea of supplying one in the early 1830s. Sydney Smith wrote to Lord Holland about this in April 1832, observing in a postscript that it was hard to compose an inscription because 'the Statue was erected by the Tories who tilled the ground—and by Whigs who cared nothing about tilling the ground.'[35] From this we may infer that it was then regarded as odd for a great agriculturalist to be a radical Whig and 'friend of the people' as the Duke of Bedford had been, but in fact this was also true of Thomas Coke of Norfolk, a great friend of the Duke and, like him, an ardent admirer of Fox, and also true of Viscount Anson, Coke's son-in-law.

When Coke inherited Holkham from his great aunt, the area around it was a 'wilderness'. With indefatigable energy he reclaimed 700 acres from the sea; pioneered new systems of irrigation, fertilization, marl and clay application and crop rotation; planted thousands of trees; bullied the county into adopting drill husbandry; replaced a few patches of poor rye with acres of best wheat; substituted herds of North Devon cattle for degenerate Norfolks, and 4000 Southdowns for 200 local sheep; and, like his friend the Duke of Bedford, he helped promote all these reforms by the competitions and demonstrations held at his annual sheep-shearings—'Coke's Clippings', as they were called—the ancestor of the modern Agricultural Show—which were attended by up to 7000 visitors.

Coke was buried at Longford in Derbyshire where there is a huge gothic tomb on the north side of the chancel carved by Hall of Derby to the design of Henry Stevens which makes no reference whatsoever to Coke's agricultural achievements in its imagery.[36] On the other hand the silver vase presented to him by the 'Farmers of Norfolk' on 23 July 1804, included among its ornaments a Devon cow and a Southdown sheep and a representation of drill cultivation, and the column erected between 1845 and 1850, in his memory, in the park at Holkham is capped by a wheatsheaf and adorned at the base by a plough, a drill, a pair of Southdowns and a Devon ox. There are also reliefs by Henning the younger showing Coke demonstrating an improved breed of sheep at a shearing (Plate 137), supervising land drainage, and presenting a free lease to the grandson of a worthy tenant farmer.[37] Such works as this obviously share many of the conventions found in Westmacott's statue of the

137. John Henning the Younger: Detail of the Monument to Thomas Coke of Norfolk, Holkham, Norfolk.

Duke of Bedford.[38] One aspect of Westmacott's statue, however—the elegiac reliefs of farm labourers—was taken up and developed by him in a number of church monuments which deserve special attention.

In 1808, a year before the statue of the Duke of Bedford was erected, Richard Pennant, first Baron Penrhyn, died at the age of seventy. John Pennant, his father, had inherited extensive Jamaican plantations from his wife's family and from both his father and from his brother, Sir Samuel Pennant, a Lord Mayor of London. By a judicious marriage and by the wealth deriving from these plantations, Richard Pennant was enabled to re-unite a large estate near Bangor in North Wales which had been divided earlier in the century. When he decided to 'improve' this estate in the early 1780s, he had plenty of experience in dealing at a distance with the Jamaican estates and was also used to public life (he was Whig member of parliament for Petersfield from 1761 until 1767 and then for Liverpool until 1780, also chairman of the West India Committee and of its special anti-abolitionist sub-committee). But the extent of his improvements could not have been foretold. After 1790, when he gave up politics, he devoted all his energy to acquiring, and defending by vigorous litigation, the leases which he required; to modernizing the methods of slate quarrying; and to finding new markets for the material. When he had built the first carriage-road over the Nant Francon valley and tramways from the mountains to a quay at Port Penrhyn he had established

the first great European 'Slate Empire', and in this, as was mentioned earlier, he was assisted by Benjamin Wyatt.

Lord Penrhyn was certainly a great Industrialist, but he is considered here in order to emphasize that his quarrymen, like farm-labourers, worked out of doors (underground workings were developed later, most extensively at Blaenau) and lived in cottages (barracks, again, were a later development). Their wives may have worked at cottage industries (spinning and making wooden frames for school slates) and they certainly kept a few animals. Also, the slate industry was only a part of a wider campaign of rural 'improvement'. Lord Penrhyn was also a great agricultural reformer. He introduced stock-breeding into Caernarvonshire, improved farm-buildings and planted an annual average of 35,000 trees. For his workers he founded a contributory Benefit Club, and he provided model cottages with ample gardens and rustic porches in the estate village of Llandegai.[39]

The childless dowager Lady Penrhyn died on 1 January 1816 and in her will, proved on 15 May 1816 she bequeathed lavish sums to her servants, her horses and her dogs, and £2000 to be expended on beautifying and enlarging Llandegai Church, providing it with a school room and bells. She declared it her wish to be buried in this church 'in a handsome manner', and she set aside another £2000 to be expended.

> as soon as conveniently may be after my decease in the Church of Llandegai aforesaid a monument to the memory of the late Lord Penrhyn and myself the inscription on which I leave to the discretion of my executors but direct that such Inscription shall state the said monument to have been erected at my expense.[40]

The monument by Westmacott was probably erected in 1821, the year in which parts of it were shown at the Royal Academy.[41] The credit for the design must go to the sculptor or to Lady Penrhyn's executors. Lady Penrhyn herself, like so many patrons of commemorative sculpture, seems to have been more concerned with the words than with the imagery.

A sarcophagus, draped with the heavy robes of Lord Penrhyn's Irish peerage, is supported by a base adorned by miniature scenes of putti illustrating the progress of Lord Penrhyn's estates from a 'wild pastoral state' (a piping putto with goats) to Industry (putti hammering), Morality and learning (village putti reading in front of a Village Church) and improved agriculture (dancing putti, dangerously equipped with sickles) (Plates 138 and 139). There is an industrial element in this frieze, but it is more than balanced by an agricultural one.

A miniature relief frieze of putti, showing the 'Progress of Navigation', had been carved by Westmacott between 1813 and 1817 for the Collingwood monument in St Paul's, and there is another, very similar to this on a chimney piece at Woburn. In style these reliefs are no more neo-classical than, say, many late eighteenth-century Coade stone plaques of similar subjects. The

138. Richard Westmacott: Monument to Lord and Lady Penrhyn, Llandegai, near Bangor, North Wales.

function which the putti perform here is, however, quite different from any of the allegorical conceits used by sculptors like Moore or Bacon in the late eighteenth century. There are precedents for such putti, in Roman sarcophagi (showing children with actor's masks or racing chariots) and in early eighteenth-century monuments such as that by William Townsend in St Mary's, Oxford, where three putti play with astronomical instruments on the console which supports the bust of David Gregory.[42] However, this allegorical element in the Penrhyn monument is only a detail in a work which is above all characterized by a new type of naturalistic narrative.

Almost fifty years before the Penrhyn monument, Vangelder in his monument to the Duchess of Montague at Warkton, Northamptonshire, portrayed 'poor orphan babes and widows' mourning by the ashes and the abandoned coronet of their patroness.[43] Here Westmacott shows a young slate worker, mournfully pondering the robes and tomb of his late Lord, leaning on a crow-bar, clad in a leather apron and holding a hatchet. The crow-bar may still be used to prise large slabs out of the rock-face, but the hatchet was soon replaced by the 'drafel' or slate chisel for reducing the 'rude stones' to shape and size.[44] The slate worker is paired by a peasant girl of great beauty, a distaff by her bare feet, who is seated on a rock admiring the putti. The oak garland in her hair may be taken to allude to Lord Penrhyn's plantations. Oak is also, in Ripa's *Iconologia*, emblematic of utility. Complementary in pose and mood, one dwelling on the individual's death and the other, less mournfully, contemplating his achievements and the future that he made possible, the pair of figures correspond (no less than do Monti's angels at Hatherop) to the paradox of classical elegy: 'he is dead, yet he liveth'. They also represent the mixed society—half-rural, half-industrial—fostered by the deceased, but abandoned by subsequent narrow-minded slate magnates.

It seems likely that Westmacott's idea for this monument—its *tableau vivant* quality—was worked out simultaneously in a monument erected in Calcutta to Alexander Colvin, a senior partner in the firm of Colvin, Bazell and Co. of London and Calcutta. The *Hindoo Girl* which Westmacott exhibited

139. Detail of the Monument to Lord and Lady Penrhyn, Llandegai, North Wales.

at the Royal Academy in 1821, apparently played a similar role in the completed Colvin monument as the peasant girl plays in the Llandegai monument.[45] Something of the same idea may perhaps also be reflected in the figures of a seated Mussalman and a Brahmin Pundit below Westmacott's statue of Warren Hastings erected on top of the steps under the south portico of the Town Hall, Calcutta in 1830, but now in the Victoria Memorial.[46]

However, the work which perhaps reflects the influence of the Penrhyn monument most interestingly, is Westmacott's monument to Mrs Warren. She was the widow of the Bishop of Bangor who had died in 1800, and whose monument in Westminster Abbey, signed 'Westmacott junior', must be one of Westmacott's earliest works. Mrs Warren died in 1816 at the age of eighty-three and Westmacott's monument to her was exhibited at the Royal Academy in 1822. This took the form of a poor woman dressed in homespun, with loose hair, bare feet and a bundle (Plate 140). Widows and the fatherless and 'necessitous travellers' (those forced to migrate due to 'seasonal fluctuations in the job-market') were the particular objects of Mrs Warren's charity.[47] The idea of a seated, scantily-clad, rural woman bereft of her protector might well have derived from the Penrhyn monument. And in both works there is great emphasis on textural contrasts in the carving.[48] The Bishop of Bangor, interestingly, had been a neighbour of Lord Penrhyn, but not, it seems, a friendly one.[49]

This is a monument which commemorates 'Good Deeds', but it does so in a different way from any of the monuments examined in the last chapter. The dead woman is not shown giving alms to the *Distressed Mother* or the *Houseless Traveller* as this statue was called, but the poor creature is simply presented alone, so as to solicit us to do for her what the dead woman can no longer do. It was immensely popular. Like Chantrey's monuments to Mrs Digby and to the Robinson girls it was engraved in the *Illustrations of Modern Sculpture* of 1832 and thought of as suitable for a sculpture gallery as well as for a church. Indeed, when the marble was shown at the Royal Academy in 1822 it so impressed the Marquis of Lansdowne that he purchased it for Bowood, and when Passavant saw it there he thought it was a 'Hagar in the Desert with the expiring Ishmael on her lap'.[50] Westmacott, of course, had to secure the consent of Mrs Warren's sister, Lady Eyre, who had commissioned the work before he agreed to sell it, and a replica was then produced for the monument in Westminster Abbey.

Another replica was ordered by Mrs Ferguson of Raith and sent to Beal, her Scottish seat.[51] One is reminded of the impact which Gainsborough had made half a century earlier with his appealing scenes of rural poverty. Westmacott tried unsuccessfully to repeat his success by a *Happy Mother* which he exhibited at the Academy in 1825, but this was still not sold by 1832.[52] In 1832 he also exhibited a *Gipsy and Child*. Other sculptors attempted works in this genre. In 1830 the *Athenaeum* critic complained of the popularity of this theme: '*The Deserted Mother* is a lady in desperate

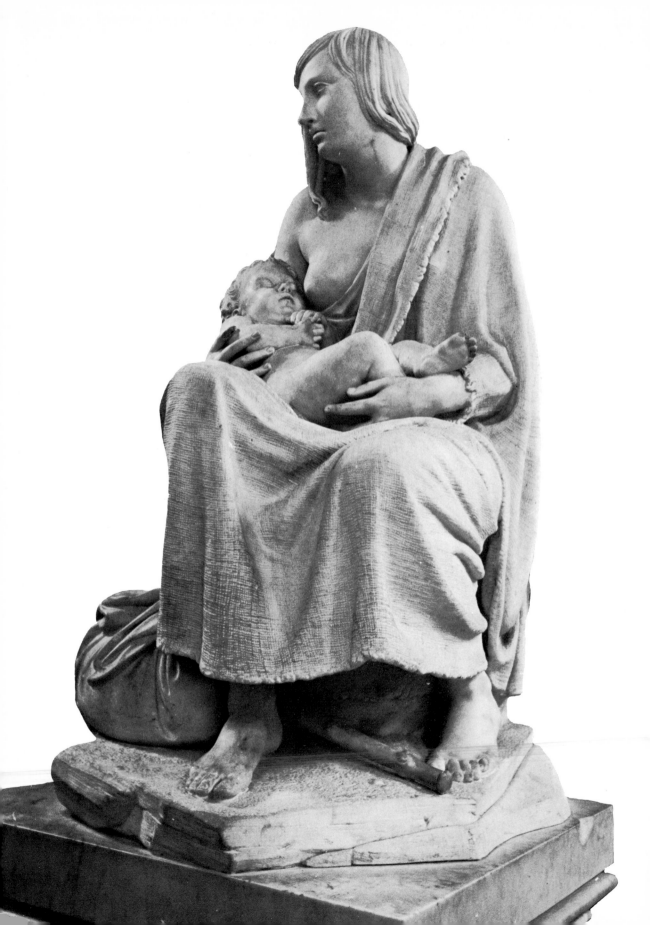

affliction suckling ... *The Forsaken* is another sufferer drooping over an unclothed infant.'[53] Weekes's statue *The Suppliant* shown at the Academy in 1850 and engraved by *The Art Journal* in 1853 was still clearly inspired by Westmacott's work which was, by then, being reproduced in parian ware.[54] Also, and as with Chantrey's *Sleeping Children*, Westmacott's sculpture was much dwelt upon in poetry or poetic prose. *The Lady's Magazine* was exercised as to whether or not the woman had seen 'better days, and brighter scenes'—meaning whether or not she had begun life in a 'higher station'— almost as 'interesting' a question as whether the 'Sleeping Children' were asleep or 'asleep'.[55]

I am concerned here with monuments which commemorate 'rural improvement' rather than direct charity, but Westmacott's *Distressed Mother* is closely connected in its theme not only with Westmacott's Penrhyn monument, but also with his monument to the seventh Earl of Bridgewater who died in 1823, which is at Little Gaddesden in Hertfordshire, and his monument to the eleventh Earl of Pembroke who died in 1827, which is at Wilton. In both these monuments Westmacott showed a group of pensive peasants sadly reflecting on the death of their Lord, just as the *Distressed Mother*, also a rural figure, reflects on the death of her patroness.

The Little Gaddesden monument is of such high quality that it is hard to believe that Westmacott would not have exhibited it at the Royal Academy, and it is surely to be identified with the *Afflicted Peasants*, an 'alto-relievo' which he exhibited in 1825.[56] Perfectly lit in a small chapel designed by Wyattville, and for which it serves almost as an altarpiece, the monument shows a peasant family at rest, their unity as a family emphasized by the tondo shape. Without the shaggy dog and the agricultural implements we might at first mistake the work for an Italian Renaissance Holy Family resting on the Flight; but on closer acquaintance the work belongs clearly to both the age of sensibility and the age of neo-classicism. Yearningly, the young man turns his Greek profile to gaze on his child, deeply asleep and holding his Mother's nipple, the only one among this family to be unconscious of their patron's death (Plate 141).

By showing peasants here Westmacott emphasized the most rural and agricultural side of the estate improvements in which the Earl had in fact engaged. He had given a great deal of employment in the neighbourhood, but chiefly on account of the building of Ashridge House, the repair and opening of roads and the rebuilding of churches. He also insisted upon hygenic cottages,[57] and, according to his epitaph, 'in dispensing the aids of judicious benevolence, and in improving the morals of the poor, he gained both affection and respect'. More perhaps of the latter than the former. Nearby, Cobbett, in the autumn of 1829, noted that male paupers were still shut up in pounds.[58]

Less memorable than the Little Gaddesden monument as a composition, but almost equal in quality, is Westmacott's large relief monument to the Earl

141. Richard Westmacott: Monument to the seventh Earl of Bridgewater, Little Gaddesden, Hertfordshire.

of Pembroke, now lost in the dim interior of the neo-Romanesque church which replaced the old church at Wilton for which this monument was designed. The Earl is said to have trebled his rent-roll by 'improvements'.[59] Whether or not he was ever especially concerned with the plight of his labourers, he was commemorated as a 'father to the poor' (the inscription quotes Job 29:16) and the relief shows a group of them—another seated woman with a sleeping child and her husband leaning on a staff whilst an older man relates how the tree, shown beside him, was blasted. Above, there is a bust of the Earl in a circular niche, with drapery looped on one side, and a heavy swag of oakleaves on the other (Plate 7). 1830 would seem a probable date for this monument since that is when Westmacott signed a replica of this same bust now in Wilton House.[60] Westmacott used the same figures in at least one smaller monument of inferior quality at about the same date.[61]

This type of monument, displaying the beneficial consequences of 'improvement', was not imitated by other sculptors, with the exception of Westmacott's brother Henry in his monuments in the church of St John the Evangelist, Black River, Jamaica.[62] But Westmacott's Penrhyn, Bridgewater and Pembroke monuments need not be considered in isolation. They should be related to the growing desire amongst the landed classes to reconcile picturesque and philanthropic improvements, following the precepts of Uvedale Price and the practice of Nash. The estate cottages at Blaise Hamlet, Ilam, Penshurst and Eccleston are the triumphs of nineteenth-century landscape architecture, whilst the temples of Rousham, Stowe and Stourhead had been the equivalent triumphs of the eighteenth century.[63] The village, which had been uprooted to make way for the park (as at Nuneham Courtenay or Shugborough), or at best appreciated as a charming distance (as at Stourhead), was now in the foreground of attention, and a recreation of classical arcadia with lead statues of shepherds gave way to a recreation of 'olde England', with genuine deferential labourers and with a church school added, like the one described by Bowles:

> Witness that schoolhouse, mantled with festoon
> Of various plants, which fancifully wreath
> Its window-mullions, and that rustic porch,
> Whence the low hum of infant voices blend
> With airs of Spring, without . . .[64]

Here perhaps we might think of Westmacott's putti reading outside the church in the Llandegai frieze.

We certainly should not consider Westmacott's monuments as reliable documents of the condition of the 'peasantry', and we should not read Bowles without reflecting that, in spite of certain charming villages and much genuine benevolence, rural 'improvements' did not, in general, improve the lot of the poor. Indeed, the farm labourer's situation was made more precarious by the introduction of farm machinery; enclosures deprived villagers of ancient rights; the game laws were harshly imposed; and starvation and cholera, rick burning and the Captain Swing riots, were recorded in the newspapers read by the same families that read Bowles's poems. The poet was in fact aware of social evils. He blamed the evangelicals, the poor laws and 'vomitories huge of smoke'—each 'a steam-engine of crime, polluting far and wide'.

If Bowles considered the steam engine as a metaphor for moral pollution perhaps the majority of his cultured contemporaries were excited by it, and by the 'March of Mind' in general. Nor was it impossible to reconcile a belief in material progress with a faith in the values of paternalistic rural England. Many early steam engines were named after King Arthur's knights. In the Prologue to his *Princess* of 1847, Tennyson, remembering what he had seen at Park House, the Lushington's seat, near Maidstone, described a fête given by

Sir Walter Vivian. We read of the classic house and the gothic ruin in the park, the suits of armour and the ancestor's tombs, the smiling farm-land and the happy cricket-playing tenantry; but we also read of the activities of the local Mechanic's Institute of which Sir Walter is patron: fire balloons, a toy telegraph and model steam engines.[65]

If Westmacott's monuments to Lord Penrhyn, to the Earl of Bridgewater and to the Earl of Pembroke successfully embody the ideal of paternalistic rural England, where can we find a church monument which embodies, with equal success, the 'March of Mind'? One monument at least does so; Chantrey's statue of James Watt at Handsworth, Birmingham—a work which stands in much the same relation to the early nineteenth century as Roubiliac's Newton stands in relation to the early eighteenth.

Chantrey was not only the greatest portrait sculptor of his day and so a natural choice for anyone wishing for a statue of Watt, but he had made a much admired bust of Watt which he could use as a starting point.[66] The Handsworth commission was given to him by Watts's son in 1820, 'pursuant upon approved sketch in clay'. He charged £2000 and this was all paid by May 1824. The statue was exhibited at the Royal Academy in that year and it was erected at Handsworth in the following.[67] Another statue was commissioned for Glasgow (now in the Hunterian gallery) which was completed in 1833 for half the price. A colossal version for Westminster Abbey was completed for three times the cost of the original, its size reflecting the success of the subscription for the work opened at a public meeting on 18 June 1824 with speeches by Brougham, Peel, Lord Liverpool and Huskisson.[68] There was also a marble statue completed in 1835 for Greenock and one in bronze for Glasgow paid for in 1832.[69] And Theed's bronze statue of Watt, erected in Piccadilly Gardens, Manchester in 1857 is closely modelled on Chantrey's work.

At Handsworth Watt is portrayed seated, with a paper spread over his knees (Plates 142 and 143). There is a diagram of an engine on the paper and he holds dividers (which have been broken) in his right hand. Dr Whinney pointed out how 'the device of the paper enables the sculptor to use the large, simple forms he loved, for it ties the legs together, and the coat, which might otherwise have been needed for this purpose, can fall back in straight folds on either side of the chair'.[70] As a portrait the statue is far less particularized than the bust, and we may turn to Chantrey's own words as reported by Macready for an explanation of this:

> He observed that to satisfy relations or friends it was desirable that the likeness of a bust should be as exact as possible, but that in the case of a person of genius we must have something to engage the attention and respect of those who could never be able to judge of a likeness.[71]

The figure can be seen from a number of angles, but from directly in front it appears too narrow owing to the high base. It is best viewed either from

142. Francis Chantrey: Monument to James Watt, Handsworth, Birmingham.

slightly to one side and from quite close to, where one can concentrate on the face, or from the side, framed by the chapel entrance, when one is most struck by the idea of 'a genius left alone with his ideas', as Pevsner phrases it.[72] The chapel which houses the work was specially designed by Rickman. It is Gothic, as is the ornament on the base of Chantrey's work, and painted grey, which would be too cold were it not for the gilding of the architectural members.[73] Watt's crest, a club of Hercules crossed with a caduceus of Mercury (emblems of power and of commerce and ingenuity), appears on the base of the statue and on the hatchment which still hangs high up on the

199

entrance wall of the chapel. It serves to remind us of the allegorical imagery which Read certainly, Bacon probably and Flaxman possibly, would have employed in commemorating this man.

The power, both of Watt's mind and of the machinery upon which he broods which was conveyed by this still, silent image was well expressed by Haydon, who wrote of his rail-journey to London, having seen the statue, that 'the booming rattle of the train seemed like the spirit of Watt still animating inert matter'.[74] Today perhaps it is more striking how the moral solidity and profoundly earnest thoughtfulness of Chantrey's Watt is common also to his Bishop Heber.

143. Francis Chantrey: Monument to James Watt, Handsworth, Birmingham.

Conclusion

THE subject matter of this book could easily have been divided differently. There is of course also a mass of material which, if included, could not have been accommodated tidily under the present arrangement. Nevertheless, the general conclusions arrived at here are such as would, I believe, be endorsed by an investigator who approached and selected the material in another way. Monuments in this period were seldom erected by men for themselves, and at the end of this period there was a reaction against church monuments altogether, connected with a decline in church burial. The style of these monuments was, broadly speaking, neo-classical, with an element of naturalism which it is important to distinguish; but in the 1840s we witness the coming of age of the gothic revival, partly, at first, as a reflection of the High Church movement. Monuments throughout this period tended to make their appeal more to sentiment than to family pride than had formerly been the case; and more of the notable monuments than before were erected to women and to children. There was a distinct change of convention for portraying the future state, with only the spirits of women shown ascending to heaven, and a new concern to show the deceased in a devotional attitude is evident. Portraiture of men is more common than of women who tend to be idealized and are often interchangeable with and easily mistaken for personifications of virtue. More monuments than ever before were designed to stir or to instruct a wide public—and this applies to small tablets with simple emblems of broken flowers and resting pilgrims as much as to more ambitious reliefs of the deeds of great philanthropists and charitable women. There was a reaction against complex allegory and 'witty' and erudite references (and, outside the universities, latin was less commonly employed on inscriptions).

My practice has generally been to begin with the monuments and then to ask historical questions of them; but since, in the final chapter, I did to some

extent, begin with the history, I am anxious here to dispel any impression that these monuments are chiefly of value as grist for the mills of social history. Flaxman's monument to Matthew Boulton, Westmacott's relief at Little Gaddesden and Chantrey's statue of Watt, for example, are among the finest works of art created in any medium anywhere in the early nineteenth century. If the quality of such works is not widely recognized it is surely because they are so often to be found either in remote rural churches or in locked urban and suburban ones. Inconvenient though this is, it does make for the excitement of the pilgrimage, rare now that great art tends to be concentrated in great collections. More important, it means that we see this sculpture in its original context, and it should therefore be less easy to forget its intended function and meaning than is the case with an altarpiece or a family portrait elevated to the status of national 'treasure' in a public gallery, or (alas) to private treasure in an art-investor's safe.

Notes

Notes to Chapter 1

1. In Oct. 1799 Rossi told Farington that it cost three guineas a square foot whereas he remembered it at 18s.6d. Farington, p. 1640. There is an important volume of marked catalogues of marble sales of the 1760s, 1770s and 1780s, originally collected by the sculptor Richard Hayward, and now in the library of the British Museum Print Room (A-5-9). Marble was sold in veneers, slips, slabs, scantlings, nosings, lumps and blocks. None of these terms indicated a standard size, and additional cubic or square measurements, or simply lengths, were often given. During the 1760s and 1770s marble seems to have been cheaper than Rossi remembered.

2. The collection of marbles made by Faustino Corsi in the early nineteenth century and housed today in Oxford Museum provides invaluable evidence of what was available to sculptors in the period studied here. The samples in the Sedgwick Museum, Cambridge are also helpful, as is the catalogue for that collection by J. Watson, A. H. Lee's *Marble and Marble Workers* (London 1888), and G. H. Blagrove's *Marble Decoration* (London 1888).

3. Potterton, p. 49. See also K. Esdaile 'Christopher Hewetson and his monument to Dr. Baldwin' *Journal of the Royal Society of Arts in Ireland* lxxvii (1947) p. 134.

4. 'A rare sized slab of lumatella [sic] antica', $4\frac{1}{2}$ ft. × $2\frac{1}{2}$ ft., was sold for two guineas at the auction of Edward Bird's stock, 18 March 1771 (given in the collection cited in note 1). Porphyry fetched the same sort of price, whilst a similar sized slab of dove or Siena cost from two to four shillings. For the identification of antique marbles, and for a full account of the glamour they once possessed, R. Gnoli *Marmora Romana* (Rome 1971) is indispensable. One should also study the samples in the Corsi collection.

5. This monument to Hester Hoare (d. 1785) is described by Hoare himself in his *History of Modern Wiltshire*, i (London 1822) p. 59. For west-country granites see the Rev R. Polwhele *History of Devonshire*, i (London 1797) p. 642.

6. 'Pitt Statue Commemoration Book', Cambridge University Archives, Misc. Coll. 24. Papers relating to the monuments to Fox, British Library, Add. Ms 514722, f. 113. There was also a project for Chantrey to carve out of Scottish granite, a colossal bust of George IV which would rival the British Museum's head of Memnon. *The Journal of Mrs Arbuthnot, 1820–1832* i (London 1950) p. 171.

7. Hutchins and Pennant are quoted by A. H. Lee, *op. cit.*, pp. 27, 29. For Bullock, see Gunnis, p. 69.

8. A. H. Lee, *op. cit.*, p. 22. The Rev R. Polwhele, *op. cit.*, mentions only one quarry at which chimneypieces were made. The Rev T. Moore in his *History of Derbyshire* i (London 1829) p. 375, mentions two. Nevertheless 'Plymouth marbles' were sometimes sold in the eighteenth century as we know from the catalogues cited in note 1.

9. The growth of the Derbyshire marble industry can be charted by comparing J. Farey *General View of the Agriculture of Derbyshire* i (London 1811), with S. Glover *History of the County of Derby* (Derby 1829), and Glover with S. Bagshaw *History Gazetteer and Directory of Derbyshire* (Sheffield 1848).

10. A flour-spar urn is included in the very peculiar gothic monument devised by the Fynney family at Cheddleton, Staffs. as a memorial to their ancestors in *c.* 1785.

11. The most splendid of the Bakewell tablets are those in the chancel to Thomas and Mary Bagshaw (erected 1741), to Nicholas Twigge (*c.* 1760) and to John Twigge (d. 1798). But there are also smaller examples, one signed by the firm of Watson.

12. Mr Hall's steam-powered mill in Derby was a tourist attraction. The enthusiasm of the chief quarry-owner, the Duke of Devonshire, was most important. So too was the geological enterprise of White Watson, author of *The Delineation of the Strata of Derbyshire.*

13. The major part of Coade's business was in the relief panels, keystones, capitals etc. for façades. Garden vases and sundials were also popular. A full account of the factory's methods was given after Croggan had purchased the business, in *The Somerset House Gazette*, xxiv (1824) p. 381. A good brief history of the business is given by Christopher Hussey's *English Country Houses: mid Georgian* (London 1956), p. 27.

14. For the practice of 'piecing' see Smith, i, p. 261. It had always been most important for out-flung limbs which neo-classical sculptors anyway avoided. Improvement in the quality of marble is easily observed in Westminster Abbey.

15. An idea of the equipment required—laymen, scaffolding, jacks, bankers, pullies, breast-drills, crowbars, clay, plaster, etc.—may be obtained from the sale of Roubiliac's stock in 1762, or the retirement sale of Peter Scheemakers in 1771, or the sale of the stock of the bankrupt Emanuel Williams in 1779—all included in the collection cited in note 1. The sculptor's expenses are commented on in the *Edinburgh Review* xliii (1826) p. 508.

16. See the entries on these artists in Gunnis; also Gahagan's letter of 23 Sept. 1813 to Samuel Whitbread, Whitbread Papers, Beds. County Record Office, W1/2946. Of the men listed only Fisher of York seems to have been imprisoned. See the letter by John Carr to Benjamin Hall of 12 Feb. 1792 in the Wentworth Woodhouse Muniments, City Archives, Sheffield, Steward's Papers 6 (iv). Subsequent letters by Carr in the same collection show that he was soon back in business, but never recovered his reputation.

17. Gunnis, pp. 326ff.

18. A hard-headed man would not have guaranteed Ugo Foscolo's credit. E. R. Vincent *Ugo Foscolo: an Italian in Regency England* (Cambridge 1953) pp. 172ff. For the sums spent on public monuments see *Parliamentary Papers and Accounts* xxvi (1837–8) p. 47.

19. Farington, pp. 3222, 6917.

20. G. Acloque and J. Cornforth 'The Eternal Gothic of Eaton' *Country Life* (1971) p. 306. Gunnis, p. 327.

21. Memoirs of Thomas Worthington, the Manchester architect (in private possession).

22. Weekes entered Chantrey's studio aged twenty in 1827, having studied under Behnes; he was given a separate studio and a private room; he was also left £1000 in Chantrey's will. See the biographical sketch attached to his *Lectures on Art* (London 1880). For his part in Chantrey's work, see an undated letter to Cunningham (Fitzwilliam Museum Ms 24-1949), and for the way Chantrey passed bust commissions on to him see Chantrey's letter of 28 Nov. 1838 to John Lewis (*Ibid.*, Ms 23-1949).

23. In addition to the entries on these artists in Gunnis, see the exhibition catalogue by T. Friedman and T. Stevens *Joseph Gott* (Leeds and Liverpool 1972); also T. S. R. Boase 'John Graham Lough: a transitional sculptor' *Journal of the Warburg and Courtauld Institutes* xxiii (1960) pp. 277–90; and, for Carew, see Lord Egremont's letter to Lord Holland (British Library, Add. Ms 51725, f. 128).

24. David Udy directed my attention to the indentures (Guildhall, Joiners Company Registers: Apprentice Bindings, vii, p. 125) and to his discovery, from Robert Vardy's will, that this Vardy, and not as has long been thought, the architect, was Sir Richard's maternal grandfather.

25. Gunnis, p. 388ff.

26. See Penny (2) for some details. Farington frequently refers to the way that the Wyatt 'party' backed Westmacott in Academy elections (pp. 188, 1807, 3329, 4461). Typical of the early monuments with possible Wyatt connections is that to Sir George Warren (d. 1801) erected in St Mary's, Stockport, Cheshire, by Warren's daughter, wife of Lord Bulkeley, for whom Samuel Wyatt built Baron Hill, Anglesey. There are, also, tablets by Westmacott commemorating the wife of John Eveleigh (in St Mary's, Oxford) and Eveleigh's predecessor as Provost of Oriel (in Oriel Chapel), both erected by Eveleigh who commissioned Wyatt to build his college library.

27. For an account of the gothic house and the Roman baths at Penrhyn built by 'the ingenious Mr Wyatt' see the Rev J. Evans *A Tour through part of North Wales* (London 1806) pp. 234ff.

That this was Samuel is suggested by Ms 1835 in the Penrhyn Castle Papers, University college library, Bangor. *Ibid.*, Ms 2034 is an agreement between Lord Penrhyn and a group of Liverpool merchants, revealing that James and Samuel Wyatt had a special supply of slate from the Penrhyn quarries. This perhaps accounts for Samuel's interesting experiments with this material at Shugborough, Staffs.

28. For Rossi and Smirke see Farington, pp. 188, 3209, 6826, 7075. Chambers shared a bank account with Thomas Collins, the plasterer, who was Wilton's cousin. G. Beard *Decorative Plasterwork in Great Britain* (London 1975) p. 75. For Nicholl see Gunnis, p. 271.

29. Rundells did some bronze casting both of small pieces (Baily's statuette of George IV on horseback in the Royal Collection) and large (the replica of the Warwick Vase at Windsor).

30. Chantrey's practice of selling plasters is evident from his ledger. Nollekens had certainly also done so. T. Kenworthy-Browne 'Taken from the Marble' *Country Life* (1975) pp. 1509ff. Plasters however made it easier for busts to be pirated in Italy, in Bartolini's workshop, according to H. Matthews *The Diary of an Invalid* (London 1820) p. 59, and later by 'Bazzanti fils' also of Florence. The copyright act of 21 June 1798 was 36 Geo.iii c. 71. Garrard hoped to prosper by the protection it promised, as did Sebastian Gagahan. But see the letter cited in note 16, and also W1/2969 and 2989 in the same collection. For the failure of John Henning the elder's small plaster replicas of the Parthenon and Phigaleian friezes and his miniature reliefs after Raphael's cartoons, see Gunnis, p. 197. One would like to know much more of the mysterious F. Hardenberg who signs the beautiful lamp-bearing plaster figures at Heaton Hall, Lancs. and who was perhaps the author of similar figures at Dodington, Wilts.

31. Nollekens's activities are described in Smith. For more on the world of restorers and dealers in the Rome of the 1760s and 1770s see Seymour Howard, 'An Antiquarian Handlist and the Beginnings of the Pio-Clementino', *Eighteenth-century Studies*, vii (1973–4), pp. 40ff. Deare mentions the *cavas* he was involved in in a letter to George Cumberland, British Library, Add. Ms 36497, f. 288. Westmacott operated in collaboration with C. H. Tatham as an agent for the Prince of Wales's architect Henry Holland. With Canova's help he purchased some fragments from Piranesi's collection. Tatham Papers, Victoria and Albert Museum, D1479/1889/5; see also Penny (2), p. 120.

32. For Flaxman's poverty see Sarah Symmons 'The Spirit of Despair: Patronage, Primitivism and the Art of John Flaxman', *Burlington Magazine* cxviii (1975) pp. 644–50.

33. Guelfi and Rysbrack worked to Gibbs's designs; Scheemakers to Stuart's designs; Read, Carlini and Rysbrack to Adam's designs; Wilton to Chambers's designs; the elder Westmacott to James Wyatt's designs. Sir Richard Westmacott's relationship with the Wyatts was quite different. Rossi, however, still worked to Smirke's designs (for instance at Prestwold, Leics. in his monument to Major Packe), and to Cockerell's (see D. Watkin, *C. R. Cockerell* (London 1974), p. 254). And see also Whinney (1), p. 279, note 26. The architect's importance revived in the mid-nineteenth century when gothic monuments of an architectural character were revived.

34. Ettore Camesasca *L'Opera Completa di Ingres* (Milan 1968) p. 116.

35. Haydon, in jest, suggested that neither Westmacott nor Chantrey ever cut the stone. W. Homer (ed.) *Letters* iii, pp. 522, 646. For James Milne's machine for cutting stone and marble see *London's Gardener's Magazine* viii (1832) p. 92. For earlier patents for stone cutters see *The Repository of Arts* vi, n.s. (1805) pp. 163–7; viii, n.s. (1806) pp. 11ff; i, 3rd series (1825) p. 352.

36. Wollston's invention was employed by Chantrey. H. Weekes *Lectures on Art* (London 1880) pp. 219ff. By the 1860s photo-sculpture had been developed by M. Willème and was causing a stir in Paris. *The Art Student* i (1864) pp. 31–3.

37. Aaron Scharf *Art and Industry* (Open University Humanities Foundation Course), (Bletchley 1971) pp. 81–5. We should beware of reading only the optimistic publicity for these machines; A. H. Lee, a marble merchant, writing in his *Marble and Marble Workers* (London 1888) p. 141, was not impressed by their performance. However, a competent gothic monument to Thomas and Jane Bennion (d. 1803 and 1840) at Overton, Denbigh., is signed 'London Marble Works by Patent Machinery'.

38. R. Brilliant describes how sarcophagi, complete save for portraits of the deceased, have been discovered in shipwrecks. *Roman Art from the Republic to Constantine* (London 1974) p. 100. For the French monuments see the anonymous article 'Tomb-stone Warehouse, or Magasin des Modes Monumentales at Paris, 1819' *The London Magazine* i, n.s. (1820) pp. 31–4.

39. An untitled set of etchings published 1777–9 shows approximately the same range of products

as is described in *A Descriptive Catalogue of Coade's Artificial Stone Manufactory at King's Arms Stairs, Narrow Wall, Lambeth* (London 1784). The gallery was established in the Westminster Bridge Road during the 1790s and its contents then described in *A Description of Ornamental Stone in the Gallery of Coade and Sealy* (London 1799).

40. Cecil, pp. 7–10.

41. Thus if we inspect Westmacott's three huge monuments to Prime Ministers in Westminster Abbey we find that three figures far surpass all others in quality—the group of Truth and Temperance in the Percival monument and the slave in the Fox monument—and these were the only figures exhibited at the Academy.

Notes to Chapter 2

1. Compare Spackman's pose to that of Christ in Germain Pilon's resurrection group, Panofsky, Plate 359.

2. In 1784 Deval was made master of the Mason's Company. Another John Deval, possibly this Deval's grandfather or uncle, was Sergeant Plumber. He died in 1769. One of his sons had married the daughter of Mr Mist, the royal paviour and foundation digger in 1738. Another Deval, Peter who died in 1763 was accomptant-general to the Chancery.

3. The codicil was added in July 1786. The will was proved at the Perogative court of Canterbury 26 Oct 1786. Here as elsewhere I have consulted the copy in the National Record Office.

4. Roses, corn, convolvulus and so on in these cartouches do not appear to have had any specific meanings such as the elegists (most obviously Milton in *Lycidas*) gave to the flowers they strewed. But the olive and the palm-branch did have a meaning, of course, and the vine could be an emblem of Resurrection.

5. Joseph Evans of Derby also signs a tablet at Dingley, Northants. to Thomas Peach (d. 1770). Another Evans, Eneas, assisted Joseph Hall of Derby in carving the alabaster columns for Kedlestone (the Hall family subsequently owned an important marble, alabaster and flour-spar works in Derby).

6. Mavis Batey 'Nuneham Park, Oxfordshire', Part 2, *Country Life* (12 September 1968) pp. 640–3. See also Sir E. Bryges (ed.) *Collins' Peerage of England* iv (1812) pp. 449–52, and W. G. Lewis

(ed.), *Horace Walpole's Correspondence*, xxix (New Haven 1955), pp. 348ff. and p. 427ff.

7. The will was proved at the Perogative Court of Canterbury 15 May 1809.

8. The other monument is an architectural tablet with cherub-head consoles supporting veined marble columns and with putti reposing on the pediment. It commemorates Lord de Grey's maternal aunt, the dowager Countess de Grey who died in 1832. For Wrest Park see the second of two articles by Simon Houfe in *Country Life* (2 July 1970) pp. 18–21.

9. W. W. Rouse Ball and T. A. Venn *Admissions to Trinity College, Cambridge* iii (London 1911) p. 196. For more on Hawkins see F. W. Steer (ed.) *I am, My Dear Sir . . . A Selection of Letters written mainly to and by John Hawkins* (Chichester 1959) p. 36.

10. Columbia Ms, p. 100.

11. Letter of 20 February 1823. British Library, Add. Ms 39781, f. 187.

12. Original letter in the Hawkins papers in the West Sussex Record Office, Chichester. A transcript made by Maria Denman, in the Spring of 1843 is in the British Library, Add. Ms 39790, f. 9.

13. *Ibid.*, f. 191.

14. In a letter of 31 March 1823 Flaxman mentioned that the small model was complete and asked for £50—a third of the total cost (*ibid.*, f. 10). On 3 November he was starting the carving and asked for the promised olive branch and the Latin epitaph (*ibid.*, f. 10v). He acknowledged receipt of the folio on 21 November (*ibid.*, f. 11). Final payment was made in 1827 (Columbia Ms, p. 19).

15. One of the papers which Hawkins compiled from the notes of the botanist, John Sibthorp, was entitled 'On the Olives and Vines of Zante—on the Corn cultivated in that Island, and in Parts of Ancient Boetia—the Produce of Corn in Some Districts of Greece.' The Rev Robert Walpole (ed.) *Memoirs Relating to European and Asiatic Turkey* (London 1818) pp. 288–98.

16. His *Flora Oxoniensis* appeared in 1794, his *Flora Graecae Prodromus* was published posthumously in two volumes (1806 and 1813), and his *Flora Graeca Sibthorpiana* with nearly a thousand plates engraved by Sowerby came out in ten volumes between 1806 and 1840. He bequeathed his freehold estate at Sutton to Oxford University to subsidize these publications, and his notes, drawings and dried flowers to assist his editors.

17. Fitzwilliam Museum, G.R. 20-1865. This

was in the Cambridge University Library in 1814, as we know from E. D. Clarke *Travels in Various Countries* ii (London 1817) pp. 494 and 528. But it was not there in 1800, so there is little likelihood of any direct influence. In fact the only Attic relief which Flaxman seems certain to have been influenced by is the Orpheus relief in Naples which he adapted for his celebrated Theocritus Cup.

18. Sibthorp's father who died in 1797 is commemorated by a tablet at Inslow in Devon, signed T. Kendall of Exeter and dated 1801 in which this plant plays an important part, curling up around the inscription.

19. The watchmaker was George Rowledge who died in 1802 and his tombstone is at Lydford, Devonshire. The engine-driver's elegy appears first on a grave-stone at Bromsgrove, Worcs. to Thomas Scaife who was killed in 1840 in an explosion on the Birmingham and Gloucester line. It was repeated on a stone in the porch of the Church of Newton-le-Willows, Lancs., which commemorates Peers Naylor, who died in 1842. Another elegy with similar metaphors appears on the tomb to William Pickering and Richard Edgar (both d. 24 December 1845) in the South porch of Ely Cathedral. This was drawn to my attention by Mary Alexander.

20. The monument only cost 50 guineas. Croft-Murray p. 64.

21. For the Ottoman Club see R. Twedell *The Remains of John Twedell* (2nd. ed., London 1816) p. 337n.

22. For details of the collection of pictures housed by Hawkins in his neat neo-classical box at Bignor Park see J. Dallaway and E. Cartwright *The Parochial Topography of the Rape of Arundel* ii (London 1832) p. 246n.

23. For Hawkins's help to Flaxman in Rome see The Rev J. Romney *Memoirs of George Romney* (London 1830) p. 204; also British Library, Add. Ms 39782, f. 257, a note from Hawkins to Maria Denman of 4 January 1829. Flaxman added wax additions to the repoussé bronze relief and to the bronze Hermes now in the British Museum, then in Hawkins's collection. John Hawkins, 'On the site of Dodona' in Rev R. Walpole (ed.) *Travels in Various Countries in the East* (London 1820) pp. 473–88. Also Adolf Michaelis *Ancient Marbles in Great Britain* (Cambridge 1882) pp. 212ff. For Hayley, see the Flaxman Correspondence 1784–1826 in the Fitzwilliam Museum, Cambridge, pp. 23, 31 and 34. In addition the Hawkins papers at Chichester show that Flaxman designed a tombstone for a relative of Hawkins. Through Hawkins he also secured a commission to execute a bust of Colonel Sibthorp. And the poet Klopstock seems to have made contact with Flaxman through Hawkins.

24. He signs a tablet with this motif to J. A. Newton (d. 1823) which is in St Mary's, Stockport.

25. Sometimes it might have another meaning as an emblem of the ephemerality of mundane glory. A putto holding a tail-biting snake-emblem of eternity—points to a broken column in Rysbrack's monument of 1753 at Addington, Bucks. to Thomas Busby, perhaps with this meaning in mind.

26. The work is chipped and only the letters 'KIN' survive. A broken column, along with a tree stump, had made a far less obtrusive appearance in the gable of the dainty tablet in Westminster Abbey carved by Richard Hayward and erected in 1776 by the sisters of John Roberts to the memory of their brother—the secretary to Henry Pelham—who had died without issue. At Llanelltwyd, Merioneth, the antiquarian Sir Robert Howel Vaughan who died in 1792 is commemorated by a tablet showing a column which is tottering rather than by one which has already fallen.

27. Close in date to the Belton monument are Westmacott's monuments to Edward Atkyns at Kitteringham, Norfolk, signed 1807, and that to Philip Yorke, (d. 1804) which is at Marchwiel in Denbighshire. Later monuments by him which continue with the theme are at South Ormsby, Lincolnshire and at Prestwold, Leicestershire commemorating Charles Massingbread (d. 1835) and Charles James Packe and his sister (d. 1837).

28. Other late examples are a tablet by Ternouth to Frances Popham (d. 1839) at Chilton Foliat, and an unsigned one to Mrs Rees in the Unitarian Chapel, Belper. At Llanrhystud, Cardinganshire there is a relief of a rose and bud on a broken stem—for Mrs Hughes and her new-born child who died in January 1834—signed by Wallace and Whyte of Edinburgh.

29. A monument by Van Nost the younger at Moyglare, Co. Meath to Robert Shields and his son (d. 1772) shows a woman with a scythe and a cut rose branch (Potterton, p. 86). A boy angel with a sickle and a cut lily appeared in the tondo relief on the sarcophagus of Banks's monument to Anne Martha Hand (d. 5 July 1784). This monument was destroyed when St Giles's, Cripplegate was bombed. A design for it was exhibited at the Royal Academy in 1785, No. 500. At South Thoresby, Lincs., there is an unsigned

tablet to Willoughby Wood who died aged 18 in 1786. It has a relief of a rosebush from which one rose has fallen.

30. The earliest seems to be the tablet at Great Badminton, Glos, in memory of Caroline Somerset who died, aged three, 19 August 1800. A broken rose and a broken lily appear in relief panels at the bottom of his monument at Frome, Somerset, to Louisa and Lucy, the daughters of the Countess of Cork and Orrery who died in 1826 and 1827. There is also a broken flower in the pediment of the monument to Mrs Chichester (d. 4 April 1830) in Derby Cathedral. Westmacott the younger took up the theme in his monument to Sacharissa Hibbert in Exeter Cathedral.

31. See for example *An Elegy on the Death of an Only Son, aged Ten years and Six Months, by a late Minister* (London 1795) p. 12 or Coleridge's 'Epitaph on an Infant'.

32. He used this in the monuments at Colwich, Staffs. to Thomas Anson (d. 1818), at Orsett, Essex to Richard Baker (d. 1827), and at Loughborough, Leicestershire to the Tate family (c. 1830).

33. Other examples are at Ockbrook, Derbys. to Thomas Parks (d. 1824), at Honington, Warwicks. to Gore Townsend (d. 1826), at Farnham, Hants to Sir Nelson Rycroft (d. 1827).

34. Westmacott the younger used a related motif in his monument to Henry George Monck Browne at Crossboyne, Co. Mayo. Browne died aged nineteen in 1843 from an accident with his gun and is shown by the sculptor in front of a tree with a broken bough. Potterton, p. 87. Wordsworth's 'Essay on Epitaphs' was first published in Coleridge's *The Friend* xxv (February 1810) pp. 407–8. It was later appended to book five of *The Excursion* as a long note.

35. *The Poetical Works of William Lisle Bowles* ii (London 1855) p. 326.

36. *Ibid.*, ii, p. 247.

37. A good example is the account of the funeral of John Munby, brother of the diarist. Derek Hudson *Munby: Man of Two Worlds* (London 1972) p. 313.

38. Buckle's seventh chapter contains what is still the best compact account of the rise of English scepticism and the decline of church authority. *History of Civilization* i (London 1857) pp. 335–47. Joseph Priestley's *Memoirs* make it quite clear that disbelief was far more common among the French Intelligentsia.

39. See the entry in the *D.N.B.*, i, p. 1283 by H. R. Tedder. Charles Saumarez-Smith drew my attention to Baskerville.

40. See N. B. Penny 'Dead Dogs and Englishman', *Connoisseur* (August 1976) pp. 298–303. William Beckford, who died in 1844, wished to be buried beside his dog in the grounds of Lansdown Tower. Jon Millington *Beckford's Tower, Lansdown, Bath* (Bath 1973) p. 3.

41. See Egremont's letter to Lord Holland written on 7 March 1833 reminiscing on his youth. Holland House Papers, British Library, Add. Ms 51725, f. 123. Fox died a non-believer and the Hollands were well known to be sceptics. L. Strachey and R. Fulford (eds.), *The Greville Memoirs* iv (London 1938), p. 115 and v (1938), pp. 87 and 240.

42. *Ibid.*, f. 13, f. 25, f. 33.

43. *Ibid.*, f. 59.

44. *Ibid.*, f. 39.

45. This is well discussed by Hugh Honour in *Neo-Classicism* (Harmondsworth 1968) pp. 152ff.

Notes to Chapter 3

1. J. Weever *Funeral Monuments of Great Britain . . .* (London 1632) pp. 11ff.

2. George Sherburn (ed.) *The Correspondence of Alexander Pope* ii (Oxford 1956) pp. 27, 300 and 306ff.

3. The column and the obelisk were to be raised in Ashridge Park. He also left money for the embellishment and maintenance of the inscription on Lord Chancellor Egerton's tomb. Ashridge House Mss, Herts. County Record Office, AH/2495.

4. The monument was of course much smaller than was originally intended. The column was erected, but not the obelisk which Lady Bridgewater considered 'a specimen of very bad taste'. *Ibid.*, AH 2568, 2578, 2582, 2589, 2600, 2641–2, 2648, 2656, 2668.

5. Anon. *A Sketch of the Life and Character of the late John Duke of Bedford* (Woburn 1839) pp. 9f.

6. Brinsley Ford 'The Earl Bishop' *Apollo* xcix (June 1974) p. 434.

7. An instance is recalled in Dame Ethel Smyth's *Impressions that Remain* (London 1919).

8. Derek Linstrum *Sir Jeffry Wyattville* (Oxford 1972) p. 230. Two views of the chapel were exhibited at the Royal Academy in 1816. The base of Canova's monument is decorated with floral reliefs of the type used by Richard Westmacott in his monument to Mrs Wilmot discussed in chapter two. This suggests that Westmacott supervised the erection of the statue.

9. Quatremère de Quincy *The Destination of Works of Art* (trans. Henry Thomson) (London 1821) p. 81.

10. The term 'dormitory' (so suggestive of absolute confidence in the Resurrection) was used more frequently than the *O.E.D.* suggests. The Bishop of Lincoln used it in granting the Earl of Kent permission to extend the De Grey Chapel at Flitton in 1704. Gibbs's Turner Chapel at Kirkleathan in the North Riding of Yorkshire which is connected to the Church only by a corridor is the closest a mortuary chapel can come to being a mausoleum as I define it.

11. This means that I exclude the pyramid-topped sandstone box at Chiddingstone, Kent, erected for Henry Streatfield in the 1730s; also the Gothic canopy over Henry Colt Hoare's neo-classical tomb at Stourton, Wilts and the odd piece of stone Gothic furniture put up by Walter Barton May at Hadlow, Kent. There are a remarkable number of these large tombs, as I prefer to call them, in Ireland. See Maurice Craig 'Mausoleums in Ireland' *Studies: an Irish Quarterly Review* (Winter 1975) pp. 410–23.

12. For a survey of mausolea in this period see Charles Saumarez-Smith's B.A. thesis (Cambridge University 1976)—the prelude to an exhaustive investigation which he hopes to undertake before long. Sir John Soane's fascination with the theme of death was the subject of a lecture delivered by Sir John Summerson in Cambridge, Spring 1974, part of which has been published as 'Le Tombeau de Sir John Soane' *Revue de L'Art* xxx (1976) pp. 51–4.

13. The Bishop of Rochester had granted permission for a vault to be constructed below the chancel of Cobham Church in 1721, and this was not entirely filled until 1893. Darnley Mss, Kent County Archives, U565/F1/2 and 3, and Add. F65. The second Earl was buried there in 1781, but his body was surely intended for the mausoleum (U565/F2). Carpenters were paid to board up the building in November 1815. A good deal of work was done to it in the following year (U565/A34a and A35a).

14. *Royal Commission on Ancient and Historical Monuments in Wales and Monmouthshire* ii (London 1960) p. 188. The Newborough family papers in the Caernarvonshire Archives are not yet available to the public.

15. The sarcophagus to the first Earl of Lansdowne at Bowood was carved by Carlini. The mausoleum also contains a monument erected in 1862. The mausoleum at Farningham was completed in 1785—it may have been the earliest

work of John Nash, nephew of Sir Thomas Nash, for whom it was built.

16. Roubiliac's monument to Sir Thomas Molyneux was shipped to Castle Dillon, the seat of Sir Capel Molyneux in Co. Armagh, only to be placed in a provisional hut, and then stored in the cellars of the house until it was moved in the 1840s to Armagh Cathedral. Carter's monument to William Conolly at Celbridge, Co. Kildare, was erected in a barn! Potterton, pp. 75 and 39.

17. The *Hibernian Journal* is quoted by Rupert Gunnis in 'Some Irish Memorials' *Bulletin of the Irish Georgian Society* (1961) pp. 12ff. There is a photograph of the building in Maurice Craig and the Knight of Glin *Ireland Observed* (Cork 1970) p. 38. The Dawsons built a vault at Stoke Poges, Buckinghamshire in 1802, according to Hakewill's *History of Windsor* (London 1813) p. 270.

18. Victoria and Albert Museum, E.500–1965.

19. John Kenworthy-Browne suggests that this was the 'bust of a lady' exhibited by Nollekens at the Royal Academy in 1777.

20. Smith, i, p. 13.

21. See, for example, the text appended to the first plate of the 28th Cahier of J. G. Grohmann's *Recueil d'Idees Nouvelles pour la Decoration des Jardins* iii (Leipzig 1799). Also Comte Alexandre de Laborde, *Descriptions des Nouveaux Jardins de la France* (Paris 1808).

22. There is an excellent discussion of Foscolo's attitude to England in this poem by E. R. Vincent in his *The Commemoration of the Dead: a study of the Romantic Element in the 'Sepolchri' of Ugo Foscolo* (Cambridge 1936). For Legouvé see his *Oeuvres*, ii (Paris 1826) p. 166.

23. See N. B. Penny 'The Commercial Garden Necropolis of the Early Nineteenth Century and its Critics' *Garden History* ii (Summer 1974) pp. 61–76.

24. T. Espin, *A Description of the Mausoleum in Brocklesby Park, Lincolnshire* (Boston, Lincs. 1812). Wyatt's drawings for the building were exhibited at the Royal Academy in 1795. Espin's date is confirmed by account books for the mausoleum which John Kenworthy-Browne has examined. There is one later entry, for May 1798, when the skylight was painted.

25. *Ibid.*, p. 7.

26. Quoted by Linstrum, *op. cit.*, p. 231. The sum is not confirmed by the account book which records payment of £8,884 (exclusive of sculpture).

27. Espin says that the 'colossian female' seated on Sir William's sarcophagus holds a stork 'the

emblem of filial piety'. If 'filial' is very loosely interpreted it could allude to Pelham's respect to this ancestor. The soul's prospects are symbolized by a tail-biting snake with a butterfly walking around it held by a putto on the Anderson monument, whilst on the third monument a personification of learning, leaning on heavy folios, cradles a medallion portrait of Charles Pelham. Christopher Hussey asserted, with no evidence, that these monuments were made in Italy, *Country Life* lxxv (1934) pp. 218–24.

28. The connection between the two figures is confirmed by one of Nollekens's terra-cotta 'pensieri' in the Victoria and Albert Museum, A8-1944, which is half-way between the two works.

29. A. M. W. Stirling *Coke of Norfolk and his Friends* i (London 1908) p. 448. See Smith, ii, p. 22.

30. This does not only apply to the mouldings. The iron scroll-work of the door is based on that at Sempringham, Lincs.

31. Benjamin Dean Wyatt introduced this style into the London homes of the Dukes of Wellington and York. Its association with Tory patrons suggests that it was related to the Tory attempt at turning the political clock back by reinstating the Bourbons in France. However it was also used for Crockford's, and was soon widely adopted.

32. The date for the sculpture comes in a letter written by Wyatt on 28 January 1826. Wyatt Family Papers, R.I.B.A. Drawings collection, WY 3/1/28. The dates for the building are given in the Rev I. Eller *History of Belvoir Castle* (London 1841) pp. 349ff.

33. These are the four cardinal virtues: two on either side of the three theological virtues.

34. Wyatt's major commissions were the Nelson monument in Liverpool, the Princess Charlotte monument at Windsor, the equestrian George III in Cockspur St, and the equestrian Duke of Wellington which stood, for a time, on the Hyde Park Corner arch. Although awarded a silver medal by the Academy on 10 December 1802 (Farington, p. 2116) Wyatt did not usually exhibit there. He was particularly praised for his part in the 'effect of spectacle' at the Spitalfield's Ball of 1807 (R.I.B.A. papers WY 3/1/43), and there was a proposal that he should design a triumphal car for the coronation of George IV (*ibid.*, WY 3/1/26). Wyatt's talents were varied. We find him petitioning Sir Robert Peel to accept his scheme for lighting Dublin with gas. The Peel Mss., British Library, Add. Ms 40252, f. 371–2. Typical of him was his painting, in 1817, of the

sensational nocturnal attack on the Exeter mail coach by an escaped lion. *Annals of the Fine Arts* ii (1817) pp. 282–5. This was exhibited in his studio, as was the Princess Charlotte monument and his polychrome marble statue of Lord Dudley's dog, Bashaw.

35. Drummond of Cadland Mss B6/78/0/1. Letter from the Duke of Rutland to his son dated Good Friday 1826. I am grateful to Maldwin Drummond for sending me a photocopy of this.

36. Strachey and Fulford (eds.) *The Greville Memoirs*, i (London 1938) p. 164.

37. Charles Saumarez-Smith directed my attention to this case, which is fully explored in N. Higson 'The Building of the Mausoleum at Halsham' *Transactions of the East Yorkshire Georgian Society* (1961–3).

38. Derek Linstrum *Catalogue of the Drawings Collection of the Royal Institute of British Architects: the Wyatt Family* (London 1974) fig. 60, p. 41.

39. Chantrey Ledger, p. 291.

40. O. Millar *English Paintings in the Royal Collection* i (London 1969) p. 130.

41. Whinney and Gunnis, p. 29, Plate 3a.

42. She was 'represented as mounting through parting clouds to Heaven, her long fair hair glittering in the light, bearing in her arms the three infants, who, even in death were not divided from their mother', according to the author of 'A Walk through the studios of Rome' *Art Journal* vi, n.s. (1854) p. 186. The various paintings of the Apotheosis of Princess Charlotte discussed in Penny (1) are also relevant in this connection.

43. See the entry on Wale in the *D.N.B.*, Malcolm's *Londinium Redivivum*, 4 vols (London 1802–7), gives a good idea of the number of them in London churches. For Manchester, see Joseph Aston *A Picture of Manchester* (Manchester 1816).

44. N. Pevsner *Wiltshire* (Harmondsworth 1963) p. 516.

45. Wentworth Woodhouse Muniments, Sheffield City Library, MP, 13a–e. Obelisks were appropriate since 'Athenian' Stuart's treatise *De Obeliseo Caesaris Augusti* (Rome 1751) was dedicated to Lord Rockingham.

46. *Ibid.* A1332 (a special account book). For the obelisks see Carr's letter to Benjamin Hall, the Wentworth steward, 25 September 1792 in *ibid.*, Steward's Papers, 6 (iv).

47. Between 1785 and 1792 he was paid at least £84 per annum. The sum is entered under 'Artificers & Sundries' in the Household Accounts.

48. Carr's nephew was vice-president of the York

Rockingham Club. See also Carr's letter to Lord Fitzwilliam of 8 March 1784. *Ibid.*, Fitzwilliam Correspondence, F34/59. Also his letter to Benjamin Hall of 20 April 1795. *Ibid.*, Steward's Papers, 6 (v).

49. Letter from Carr in London to Benjamin Hall of 28 April 1788 requesting for Nollekens the exact height of the main chamber of the mausoleum. *Ibid.*, Steward's Papers, 6 (iii).

50. The position of these statues in Rockingham's house is given in an inventory made in 1782 for Lord Rockingham's executors. *Ibid.*, A1204.

51. On 26 January 1794 Carr reported to Hall that he had seen Fisher but had not then discussed the 'Basoo Relievo of Lord Rockingham'. *Ibid.*, Steward's Papers, 6 (iv). On 6 February 1795 he wrote 'I am afraid Fisher will never get your little monument done. I most sincerely wish you had applied to Nollekens just to have done the head, the rest might have been done here, all Fisher's best men have left him, they cannot get their wages of him . . .' A postscript mentions this relief monument again and refers to 'Burke's epitaph' (*by* Burke, and not as Gunnis assumed, *to* him). On 20 April he mentions that Fisher has still made no progress. *Ibid.*, 6(v). On 8 September 1798 Ely Crabtree of York wrote to Hall that he had seen Fisher and 'something', but 'not a great deal' had been done. *Ibid.*, 6(vi). I am grateful to the staff of the archive division of Sheffield City Library for help in my research and to Lord Fitzwilliam, the Trustees of the Wentworth Woodhouse estate, and the director of Sheffield City Library for permission to quote from these papers.

52. For the Woburn temple see N. B. Penny 'The Whig Cult of Fox' *Past and Present* lxx (February 1976) pp. 94–105.

53. Letter of 'Monday' (almost certainly 1 July 1782) from Fox to 'my dearest Fitz' (Lord Fitzwilliam). Wentworth Woodhouse Muniments, Sheffield City Library, Fitzwilliam Correspondence, F63. See acknowledgement at end of note 51.

54. For a comprehensive study of Fitzwilliam's political attitudes and his awareness of the heritage of his uncle's role, see E. A. Smith *Whig Principles and Party Politics* (Manchester 1975) p. 289.

Notes to Chapter 4

1. A terracotta model by Guelfi is in the Soane Museum. The drawing by Gibbs is in the Victoria and Albert Museum (E.3641-1913). It is reproduced and discussed by Physick, p. 69. For Pope's part in this see G. Sherburn (ed.) *The Correspondence of Alexander Pope* ii (Oxford 1956) pp. 217n, 242–3, 246, 266, 457, 484. There is a much earlier instance of the crossed legs in English sculpture: the monument to Sir William Slingsby, who died in 1634, possibly by Epiphanius Evesham at Knaresborough, Yorks.

2. Such a double commemoration is not common. Philip Yorke, second Earl of Hardwick, married Jemima, Marchioness Grey. Their daughter married the second Baron Grantham whose son, the third Baron, succeeded as Earl de Grey and Baron Lucas in 1833 and commissioned the monument to his Countess by Farrell which is mentioned later in this chapter. The Flitton mourner is modelled on a figure on a giant antique keystone in the Capitoline museum. Hayward used the same figure (Plate 5) and it was a popular prop in Pompeo Batoni's portraits.

3. The confusion was not modern. The same female mourning figure by Banks is called both Fidelity and Filial Piety. Bell, pp. 112ff. The Rev. G. N. Wright, in his *Historic Guide to Bath* (Bath 1864) p. 193, says of the lady leaning on an urn in the unsigned monument to Henshaw that she was 'possibly meant for his widow'.

4. Commissioned by Lord de la Warre in 1828 and completed in May 1831 at a cost of £829. Chantrey Ledger, p. 208.

5. Commissioned in 1830 and paid for by December 1832; it cost £600. *Ibid.*, p. 233. The figure has 'Sarah' inscribed below, so the deceased is perhaps here intended.

6. Wright, *op. cit.*, p. 205. Commissioned in April 1833, over a year after the Admiral's death, dated 1834, and paid for July 1835, it cost £500 with £26.16s.0d. expenses for cartage and the cost of erecting it. Chantrey Ledger, p. 255.

7. The work was commissioned by Earl St Vincent in June 1816. He had earlier commissioned a bust from Chantrey. The monument cost £852 in all. *Ibid.*, p. 45.

8. The monument to Frances Cooke at Owston near Doncaster is only different in that Mrs Cooke has a dimple in her chin and no coronet. One could easily mistake Mrs Cooke for her daughter or an allegorical female mourner. In fact Hunter in his *South Yorkshire*, quoted in Holland, describes her as Veneration. The monument was paid for early in 1823, and was commissioned early in 1818. Chantrey Ledger, p. 86. Chantrey's monument to Lady Charlotte Finch (d. 1820) at

Burley-on-the-Hill, Rutland differs from this model only in that the hands are raised higher. There are also a number of high-relief monuments by Chantrey using this theme, at Epsom and Weybridge in Surrey, and at North Cray in Kent.

9. Charlotte Bulkeley died in 1829. The monument is clearly indebted to Canova's kneeling Magdalene as well as to Chantrey. Westmacott's monuments commemorate Anne Lee Warner who died in 1835 (Little Walsingham, Norfolk) and Lord and Lady Farnborough who died in 1837 and 1838 (Wormley, Herts.).

10. Gerard Hubert *La Sculpture dans L'Italie Napoleonienne* (Paris 1964) Plate 204.

11. Marble replicas are in the Tosio gallery, Brescia and in the Palazzo Bianco in Genoa.

12. Jennifer Montagu *Bronzes* (London 1963) p. 89.

13. Allworthy's habit is mentioned in chapter 3. It was apparently common for children to kneel to receive their parents' blessing. Wickham Legg, p. 196.

14. Daniel Defoe *A Tour through the Whole Island of Great Britain* (ed. G. D. H. Cole) i (London 1927) p. 307. Communion, however, was not then a frequent act, even with the pious. In 1779 Johnson resolved to communicate thrice a year instead of at Easter only. Queen Anne communicated once a month. The people are shown kneeling in Wheatley's *The Communion* of 1792.

15. *The Diary and Letters of Madame D'Arblay* iii (London 1842) p. 269. My attention was directed to this by Wickham Legg. Byron's views on the cushion are expressed in several letters. Leslie A. Marchand (ed.), *Wedlock's the Devil* (London 1975), pp. 239, 249 and 252.

16. J. E. Austen-Leigh *A Memoir of Jane Austen*, (2nd Ed. London 1871) p. 13.

17. Shelford was born in 1837, so one may assume that the second two decades of the century are referred to. Leonard E. Shelford (ed.) *A Memorial of the Rev. William Cadman* (London 1899) p. 7. My attention was directed to this by Professor Chadwick.

18. Chadwick, p. 165.

19. Westmacott portrayed Generals Packenham and Walsh, in his monument erected in St Paul's in 1823, just as Reynolds would have painted them. Chantrey's bronze, standing, Pitt or his seated Robert Dundas (in Hanover Sq, London and in the Edinburgh Parliament House) are not much more public in feeling than are his church monuments to the Duke of Sutherland and to

James Watt (at Trentham and at Handsworth).

20. The monument was ordered on 13 November 1837 and paid for January 1838. It cost £1500. Chantrey Ledger, p. 283. However, it was exhibited at the Royal Academy in 1841 (*Catalogue* no. 1251) and erected shortly before Chantrey's death.

21. Chadwick, p. 134. The committee which commissioned the Bathurst monument perhaps insisted on this wig, for Chantrey very much disliked carving them. Holland, p. 287n. Archbishop Stuart in Armagh, however, also retains his. Potterton, p. 36.

22. The monument in St George's Chapel, Madras, engraved as a frontispiece to Amelia Heber's *Life of Reginald Heber* (London 1830), was commissioned in March 1827, completed by 1830, when it was exhibited at the Royal Academy, and cost £1500. Chantrey Ledger, p. 198. The St John's monument was ordered in March 1827 and was not complete until 1835 owing to a 'misapprehension' (Chantrey expected 2000 guineas, not £2000). The St Paul's monument, ordered in September 1828, was also completed in June 1835, but cost £3000. *Ibid.*, pp. 199, 215.

23. For the Ryder monument see Chantrey Ledger, p. 284. It was no. 1218 in the Royal Academy *Catalogue*. The statue of Bathurst was also shown that year so the comparison was intended. A profile relief monument by Chantrey similar to the Heber is that in Durham Cathedral commemorating Bishop Shute Barrington who died 25 March 1826. It was commissioned in 1832 and paid for in January 1834. It cost £1,260. *Ibid.*, p. 247.

24. Whinney (2) pp. 152f.

25. The straight, stiff, upward-pointing praying hands of gothic effigies were seldom imitated even in gothic revival monuments. The hands of the effigy of the ninth Lord Cobham, at Cobham, Kent were restored to a clasped position in 1840 or 1865.

26. English examples are the statue of Anne Rushout exhibited by Lough at the Royal Academy in 1856 as *Prayer* and erected as a monument in Blockley Church, Oxford, Watts's intense portrait of Sir Thomas Owen at prayer at Condover, Salop., a work of 1866–7, and the monument to Frederick George Lindley Meynell (d. 1910) at Hoar Cross, Staffs. carved by Bridgeman and Son to the design of Cecil Hare. An interesting French example is Cartellier's statue of Josephine, erected in 1825, at Reuil. L. Normand aîné *Monuments funeraires choisis dans*

les cimitières de Paris i (Paris 1863). See also the monuments to the Marquis de Juigné and to Mons. Sibour which may be glimpsed in the dim apsidal chapels of Notre Dame, Paris. In addition to Clement XIII there was Canova's Pius VI, now in St Peter's, upon which Canova was at work when Chantrey visited him in 1819.

27. The works listed before the Flaxman are by Roubiliac, Hewetson, Nollekens, Bacon and Banks respectively. See Penny (1), p. 316. For Flaxman's Shuckburgh-Evelyn Monument, see Whinney and Gunnis, p. 20 and Plate 3b.

28. Johnes also commissioned from Chantrey a bust of himself and eight plaster replicas of antique busts for his library. They were commissioned in 1811, as was the monument. Chantrey charged £3,265 for the monument and he was still being paid for it in 1835. Chantrey Ledger, p. 20.

29. The Taylor monument was commissioned by his sister in June 1817; it was complete in 1822, but the last payment was not made until January 1825. It cost £2,100. *Ibid.*, p. 71. For the monuments to women who died in childbed see Penny (1).

30. The busts were of George IV, the Marquis of Londonderry, Wellington, Pitt and Nelson. Chantrey Ledger, p. 152. The tombstone cost £500. *Ibid.*, p. 64. Mr Russell purchased Ilam shortly before his marriage in 1811 as we learn from Farington, p. 5703.

31. Chantrey Ledger, p. 64. The date of 1826, given on the inscription, is earlier than that given in the ledger.

32. *The Gentleman's Magazine* lxxxvi (1816), part 2, pp. 192–4. The panegyric is by 'A.H.', a friend of the deceased. Watts is now best remembered as a maternal uncle of Constable and as a patron and supporter of that artist. He was an important patron of modern British painting (one of the subscribers who purchased West's *Christ in the Temple* for the British Institution, for example).

33. *Ibid.*, p. 192.

34. H. Venn *The Complete Duty of Man* (Derby 1823) p. 236.

35. Published in three parts from 1818 to 1847.

36. Whinney (1), p. 219.

37. Chantrey Ledger, p. 137. See also British Library, Egerton Mss 1911, p. 124.

38. One example is the monument to Lord Farnham at Cavan, commissioned by the Countess of Farnham January 1824, completed July 1827. Chantrey Ledger, p. 164. More important is the monument to Thomas Kinnersley at Ashley, Staffs., erected in 1826. This was commissioned a little later than the Malmesbury monument. The figure sits up more positively which is an improvement, but the addition of a medallion portrait of Kinnersley's wife who died in June 1825 ruins the work—as well as making it more expensive. (*Ibid.*, p. 136).

39. Gott's monument to Benjamin Gott in St Bartholomew's, Armley, erected soon after 1840 survives, but the monument to Jonathon Akroyd, formerly in the mortuary chapel of All Souls, Akroyd in the West Riding of Yorkshire has been destroyed. T. Friedman and T. Stevens *Joseph Gott* (Leeds and Liverpool, Exhibition Catalogue, 1972) pp. 18–19, 39.

40. Gunnis, Plate xxvii.

41. T. K. Hervey (ed.) *Illustrations of Modern Sculpture* (London 1832).

42. Chantrey Ledger, p. 151.

43. *Ibid.*, p. 228.

44. The book consists of a series of dialogues between the author, who was a parson, and various of his parishioners. The parson endeavours to convert the infidel, or non-conformist, to give hope to the wretched, to tease repentance from sinners, and to deflate the zeal of Evangelical extremists. The dialogues are based closely on genuine experience, and are highly convincing as documentary accounts fictionalized only for the purpose of coherence.

45. A good case is the death of Mrs Atkinson: 'The scene was very striking, and interesting. The daughters surrounded the sick bed . . .' one in tears, the other composed, the mother 'perfectly tranquil and placid, patience and resignation beaming forth . . .' 'The Late Rev. John Warton' *Deathbed Scenes and Pastoral Conversations* i (London 1827) p. 151. Warton was the pseudonym of William Wood, Vicar of Fulham.

46. *Ibid.*, (2nd Ed. London 1828) p. iv.

47. Holland, pp. 319, 348ff.

48. The date is given in the *Art Journal* n.s., ii (1851) p. 45. Hollins attempted to make a reputation in the metropolis during the 1830s. The lack of space and light in the small greenbaize room set aside for the display of sculpture at the Royal Academy was then much complained of, and, like Macdonald, Lough and M. C. Wyatt Hollins held studio exhibitions. *The Spectator* iv (14 May 1831) p. 478, and vii (21 June 1834) p. 569; *The Athenaeum* (1831) p. 331.

49. Penny (1), p. 319. The monument is not described by William White in his *History, Gazetteer and Directory of Nottinghamshire* (Sheffield 1832).

50. *The Spectator* vii (29 March 1834) p. 302.

51. The relief was copied or adapted from one which Flaxman exhibited at the Royal Academy in 1797. See Flaxman's letter to Hayley of 29 June 1798. British Library, Add. Ms 39780, f. 70 (verso). We know that Flaxman was still awaiting Mr Cromwell's instructions from his letter to Hayley of 27 November 1799. Fitzwilliam Museum, Flaxman Correspondence 1793–1801, f. 10. For preliminary sketches see Whinney and Gunnis, p. 55 and Plate 22.

52. Other British examples are Westmacott's monument in Brighton Parish Church to Frances Crosbie (d. 1830), Chantrey's monument at Whittlebury, Northants., to Charlotte Bradshaw (d. 1820) and Gibson's monument at Badger, Salop., to Harriet Pigot (d. 1852). At Chiseldon, Wilts., the monument to Elizabeth Calley (d. 1832) by W. Pugh of Bristol is an accurate copy of the Cromwell monument. At Chiseldon also is Randolph Rogers's monument to Anne Nicolson (d. 1875), a late example of this convention. A very late example is J. W. McBean's monument at North Cray, Kent in the late 1890s. A continental example is Thorwaldsen's monument to Baroness Chandrey. Eugène Plon *Thorvaldsen: his Life and Works* (trans. Mrs C. Hoey) (London 1874).

53. For Read's monument and Flaxman's Mrs Morley monument see Penny (2), p. 324. For Roubiliac's Petre monument, which was of stucco, see N. B. Penny, 'The Macabre Garden at Denbies and its monument', *Garden History* Summer 1975, pp. 58–61. There is a drawing for the Bray monument in pen and wash, the same design essentially but with a different frame, and endorsed 'To Mr Chri.Cass to be left at the George Inn; in Woodstock, Oxfordshire.' Victoria and Albert Museum 3436–424, Physick, pp. 67–8. The eight year old Jane Bray 'Dyed of the Small Pox at her aunt CATCHMAY's in Gloucester' on 21 May 1711, and the fifteen year old Edward died of the same disease on Christmas-day, 1720 at the Academy at Angers in France. The epitaph also supplies several dense paragraphs of etymological information. Another notable resurrection monument is that by Henry Scheemakers to John Bradbury (d. 1731) at Wicken Bonhunt, Essex.

54. For Bernini's monuments see R. Wittkower *Gian Lorenzo Bernini* (London 1966) pp. 210–12. The idea probably derived from the use of medallions carried by virtues and skeletons against a background of *panni lugubri* in the ephemeral funeral decorations pioneered by the Medici court from the mid-sixteenth century onwards in San Lorenzo, and which were subsequently adopted by all who could afford such pomp. Early examples of the carried medallion in Britain are the gigantic unsigned monument to Mrs Anne Nanney (d. 1729) at Llanfacreth, Merioneth, and the monument (also unsigned) to Elizabeth Cary (d. 1723) in St Mary's, Oxford.

55. Nollekens was the last notable British sculptor to use the convention of a putto weeping over a medallion and either draping it or pulling the drapery aside to permit us one last glimpse of the deceased. Rossi in his monument of 1802 in St Paul's, to Captains Mosse and Riou has Victories carrying medallions of the dead heroes.

56. The areas in highest relief such as the head of the kneeling lady on the left now have the texture of old tennis balls. Farrell was a pupil of Thomas Kirk. Both men were employed on ideal statues by Earl de Grey who had been Lord Lieutenant in Ireland.

57. T. M. Neale *The Unseen World* (London 1853) p. 201.

58. *The poetical Works of Mrs Hemans* (Boston, Mass., no date) pp. 374–5.

59. Emile Mâle *L'Art Religieux après le Concile de Trente* (Paris 1932) pp. 300–9.

60. See, for instance, the *Elegy to Dr Kenn* quoted by Wickham Legg, p. 334. Also, *The Spectator*, Paper 204 (24 October 1711) and Dr Johnson's prayer (*Boswell's Life of Johnson* (ed. T. G. Birkbeck Hill) i (Oxford 1887) p. 235).

61. No. 764 in the Academy *Catalogue*. For the price see Croft-Murray, p. 81; also Whinney and Gunnis, pp. 58–9, and Plate 23b for models.

62. *Poems Upon various subjects, Latin and English, by the late Isaac Hawkins Browne* (London 1768). This edition includes Soame Jenyns's translation of *De Animi*. Another translation by John Lettice was published in Cambridge in 1795.

63. No. 1264 in the Academy *Catalogue*.

64. According to Farington (quoted by Whinney and Gunnis, p. 59) Mr Simeon, a fellow of King's College, objected to the absence of wings on Flaxman's angels.

65. This is a year before Canova's graces arrived at Woburn. But Westmacott must surely have seen a sketch of Canova's work when the two sculptors were together at Woburn in 1816 discussing the temple which would accommodate the group. See Penny (2). Alternatively, the famous antique group of Cupid and Psyche embracing was perhaps a common source.

66. Those at Woburn, Beds. to Charlotte Seymour (d. 1824), at Stradsett, Norfolk to Grace

Bagge (d. 1834), in St Asaph's Cathedral to Sir John Williams, signed 1835.

67. Evident, for example, in his drawing in a private collection, Album (B), p. 163, and also in his set of moral engravings, *The Fight of Freewille* (London 1839) in which a guardian angel constantly shadows a young man in his endeavours to be virtuous.

68. See his monument at Old Alresford, Hants, to Esther North (d. 1823) and in St Peter's, Stoke on Trent, to John Bourne (d. 1833). These works established a type which was to be much imitated in Victorian cemeteries.

69. Samuel Rogers *Human Life, a Poem* (London 1819) p. 65.

70. Charles Dickens *David Copperfield* (London 1850) p. 620.

71. Samuel Rogers, *op. cit.*, p. 33.

Notes to Chapter 5

1. Quoted in a letter from C.H. to *The Times* (28 October 1842) when the problem of overcrowded church walls was a matter of great concern.

2. John Webster *The Duchess of Malfi*, Act IV, Scene 2, lines 156–62.

3. Panofsky, p. 82.

4. See, for example the double tomb by Nicholas Stone to Sir Moyle Finch and Elizabeth, Countess of Winchelsea, now in the Victoria and Albert Museum, A186-1969. John Physick 'Five Monuments from Eastwell' *The Victoria and Albert Museum Yearbook*, ii (1970) pp. 125–44, Plates 7 and 8.

5. Whinney (1), p. 64 and Plate 48.

6. One of the few is Cheere's monument to the Earl of Kildare in Christ Church, Dublin. Gunnis discovered that the Earl, who died in 1743, ordered in his will that his body be left unburied for as long as possible. 'Some Irish Memorials', *Bulletin of the Irish Georgian Society*, iv (1961) p. 5. This is repeated by Potterton (p. 40) who agrees with Gunnis in considering it as an explanation of the recumbent posture. It was in fact a common precaution reflecting the fear of being buried before one was dead.

7. Quoted by A. P. Stanley *Historical Memorials of Westminster Abbey* (London 1869) pp. 848ff.

8. There is a drawing for the tomb chest signed by Robert Adam. There is also a drawing of the figures, arranged more or less as carved, except that there is a coronet on Lady Milton's head, and

they both rest on a couch with an urn, like a chamber pot, below it—a note on this second drawing orders the removal of the coronet. The drawings are nos 62 and 63 in Vol. XIX of the Adam drawings in the Soane Museum.

9. J. Newman and N. Pevsner *Dorset* (Harmondsworth 1972) p. 292.

10. A cabinet, about $1\frac{1}{2}$ ft × 1 ft made for Ellen Devis to commemorate her parents, Arthur, the painter, and Elizabeth, probably in 1787 when the former died. The door is modelled on the gothic window of the church where the couple were married. Inside there is an urn and an inscription. The urn opens to reveal a wedding ring on a platform of the parent's interwoven hair and, inside the lid, there is a drawing of a tomb and a weeping willow.

11. Horace Walpole *Letters* (ed. P. Toynbee) v (Oxford 1905) pp. 95–6.

12. For Mason's letter to Walpole on the Dealtry monument and Walpole's reply see W. S. Lewis (ed.) *Horace Walpole's Correspondence* xxviii (New Haven 1955), pp. 97ff. A drawing in pen and wash for the Mann monument is in the collection of W. S. Lewis of Farmington, Connecticut. John Harris *A Catalogue of British Drawings for Architecture etc.* Upple Saddle River 1971) p. 21. See also W. S. Lewis (ed.) *op. cit.*, xxi (New Haven 1948) p. 157. There are other half-gothic monuments erected in the late eighteenth century by antiquarians—those at Great Wilbraham, Cambridgeshire commemorating the Wards for example.

13. Quantock was drowned whilst skating on 11 December 1812. The monument was completed in 1814. For the model see Whinney and Gunnis, p. 37. There is at least one notebook of Flaxman drawings after English gothic effigies, corbels, bosses and so on. Fitzwilliam Museum, Flaxman Mss 832/6. Marchant thought Flaxman affected for mingling the Gothic and Greek. Farington, p. 3209. When, during the peace of 1802, Flaxman expressed admiration for the sculpture on Amiens Cathedral, Opie and Fuseli replied that they found it 'absurd and childish' and 'entitled only to the admiration of the Antiquary'. *Ibid.*, pp. 8110–11.

14. R. Gough *The Sepulchral Monuments in Great Britain* i (London 1786) p. cxxv.

15. This was the Whig view, see Uvedale Price *Essays on the Picturesque* ii (London 1810) p. 264; also Roscoe's *Mount Pleasant*, a descriptive poem of 1777 reprinted in G. Chandler, *William Roscoe of Liverpool* (London 1953) p. 339.

16. H. Buxton Forman (ed.) *The Poetical Works*

of John Keats (Oxford 1915) p. 212.

17. R. Gough, *op. cit.* For the Musée des Monuments Francais see Francis Haskell 'The Manufacture of the Past in 19th Century Painting' *Past and Present* liii (November 1971) pp. 114–5.

18. C. A. Stothard *Monumental Effigies of Great Britain*, (ed. Alfred Kempe) (London 1832).

19. *Ibid.*, p. 22.

20. Edward Blore *The Monumental Remains of Noble and Eminent Persons* (London 1826).

21. N. Pevsner *Bedfordshire, Huntingdon and Peterborough* (Harmondsworth 1968) p. 215n.

22. *The New Monthly Magazine* (1817) p. 563.

23. L. Normand aîné *Monuments Funeraires choisis dans les cimitières de Paris* i (Paris 1863) Plate 62.

24. Bell, pp. 95ff.

25. The effigy of a boy on top of the Prometheus sarcophagus in the Capitoline Museum or the young man with a snake by his side in the courtyard of the Terme Museum are examples; and there were also some at Palmyra. Robert Wood *The Ruins of Palmyra* (London 1753) Plates LVI and LVIII.

26. Quoted by 'Sympathia' *The Gentleman's Magazine* lxxvi (1806) pp. 816ff.

27. 'I was not in safety, neither had I rest, and the trouble came' is the English inscription, and below it brief details of Penelope's parents, then the words—'She was in form and intellect most exquisite. The unfortunate parents ventured their all on this frail bark, and the wreck was total.' At Penelope's head is a Latin line 'Omnia tecum una perierunt gaudia nostra' and below it some lines recalling Tacitus's 'Tu vero felix, Agricola etc.'— 'Tu vero felix et beata Penelope mea, quae tot tantisque miseriis una morte perfuncta es.' At her feet we read: 'Beauté! C'est donc ici ton dernier azile', followed by 'son cercueil ne la contient pas toute entière. Il attend le reste de sa proie. Il ne l'attendra pas long temps.' The principle side, towards which the effigy is turned, is inscribed in Italian: 'Lei che'l ciel ne mostra terra n'asconde' and has these lines below:

> Le crespe chiome d'or puro lucente
> E'l lampecciar dell'angelico riso
> Che solean far in terra un paradiso
> Poca polvere son che nulla sente.

28. See Elizabeth Mavor *The Ladies of Llangollen* (Harmondsworth 1973) for an interesting example of this.

29. Sir Brooke Boothby *Sorrows* (London 1796). The poems are adorned with vignettes of Ashbourne House and Church, a shattered tree and a butterfly breaking out of a cocoon.

30. Mrs Lavinia Forster is quoted to this effect by Allan Cunningham *The Builder* xxi (3 January 1863) p. 4.

31. Benedict Read traced the painting for me. It was engraved by M. Benedetti and is bound in some volumes of *Sorrows*. V. Griffiths and D. Rodgers, *A Catalogue of Oil Paintings* (Wolverhampton Art gallery and Museums 1974), p. 20. The subject of this picture was anticipated by West's *Apotheosis of Prince Octavius* of 1784 mentioned in Chapter 3, and by the paintings of the Rev M. W. Peters, above all his *Angel carrying the Spirit of a Child to Paradise*, a great success at the Academy of 1783.

32. Schadow carved a sleeping child on the Graf Alexander von der Mark tomb, erected in 1791 in the Dorotheenstadtische Kirche, Berlin. Rauch's recumbent effigy of the six year old Princess Elizabeth at Charlottenburg was executed in the late 1820s. Pradier's Princesse Francoise d'Orleans (d. 1818) in the Chapelle Royale at Dreux is a French example of the same period.

33. Chantrey Ledger, p. 43.

34. No. 1029 in R. A. Catalogue. Whinney (1), p. 219 and p. 279.

35. Stothard is alleged to have assisted the sculptor in the design. *Ibid.*, see also *op. cit.* in note 30, and Holland, pp. 271–5. Chantrey must have known Banks's work since it was in his native county. He presented Soane with the 'best of Banks'—that is the relief of the release of Peter and the cast of Penelope now in the Soane Museum. Arthur T. Bolton *The Portrait of Sir John Soane R.A.* (London 1927) pp. 462ff.

36. E. Hawkins *Notes and Queries* (11 July 1850) pp. 94ff.

37. The annual is quoted by Mrs Hemans as an epigraph for her poem 'The Sculptured Children'. *The Poetical Works of Mrs Hemans* (Boston, Mass., undated) pp. 472ff. See the end of Chapter 23 of Mrs Sherwood's *The Fairchild Family* (Part 2, 1842) for an account of how a child's body was laid out.

38. Papworth projected a statue inscribed 'Nell: No marvel at the Silence Now'. Edgar George Papworth *Original Sculptural Designs* (London 1840) Plate 17.

39. The Rev George Gilfillan (ed.) *The Poetical Works of William Lisle Bowles* i (Edinburgh 1855) p. 288.

40. *Op. cit.* in note 37, p. 433.

41. There was an interesting example, possibly Rockingham ware, in the collection of the late Dr. A. N. L. Munby to which Professor Michael Jaffé

kindly directed my attention. The figures here are less intimately nestled together, perhaps out of prudery.

42. Monuments by Flaxman and by Westmacott with this theme are mentioned in chapter 6.

43. Chadwick, pp. 251–71.

44. Penny (1), p. 318.

45. Blore, *op. cit.* in note 20, p. 13.

46. But Westmacott was gothic in all these ways in the sculpture which he executed for Ashridge Park at the same date.

47. Inglis's monument was commissioned on 27 February 1826 and erected in September 1832. Chantrey charged £700, exclusive of the cost of carriage and erection. Chantrey Ledger, p. 178.

48. The Iremonger was commissioned 17 February 1823 and erected 10 June 1827. Chantrey charged £650. The work was of Roche Abbey stone, not marble. Chantrey Ledger, p. 155.

49. The effigy brings to mind some shrouded effigies of the early seventeenth century; that to Sir William Curle at Hatfield, Herts., and that to Henry Buller at Bassingbourn, Cambs.

50. Potterton, p. 58.

51. The Rev J. Evans *A Tour through Part of North Wales* (London 1800) pp. 322–5. The author reveals the strength of the taboo against monkish superstition which usually inhibited full-hearted appreciation of the gothic.

52. 'Full on the altar flam'd the fervid ray,/ And ope'd a gleam of Heaven's eternal day'. Thomas Maurice *Richmond Hill* (London 1807) pp. 66–76.

53. Walter Scott *The Antiquary* chapter xvii.

54. Thomas Love Peacock *Crotchet Castle* (London 1831).

55. Joseph Nash *The Mansions of England in the Olden Time* (London 1839–49).

56. David Watkin has argued for a link between the 'Young England' movement and the Italianate style (*Thomas Hope and the New Classical Idea* (London 1968) pp. 187ff.), but his examples do not come from Disraeli's most political novels in which the gothic is clearly connected with the author's political programme. The Abbey in *Sybil* is an emblem of the England which the hero and heroine hope to restore and in *Coningsby* both Eustace Lyle and to a lesser extent Millbanke promote Christian architecture, whilst the villainous Rigby has a neo-classical villa and considers the pagoda style to be suited for new churches.

57. Charles Kingsley *Yeast* (London 1851, but published in parts in 1849) p. 102.

58. A. W. N. Pugin *Contrasts* (London 1836) pp. 11ff.

59. J. H. Markland *Remarks on English Churches and on the Expediency of Rendering Sepulchral Memorials subservient to Pious and Christian Uses* (3rd and enlarged ed. Oxford 1843). Anon. *A Handbook of English Ecclesiology* (Cambridge 1847).

60. *Quarterly Review* lxx (1842) pp. 417ff: Sewell was a friend of Pusey, Keble and Newman, but he was alienated by Tract 90. He is identified in the *Wellesley Index to Victorian Periodicals 1824–1900*, (ed. Walter E. Houghton) (Toronto 1966) p. 724.

61. Strachey and Fulford (eds.) *The Greville Memoirs* iv (London 1938) p. 187.

62. Quoted in J. H. Markland, *op. cit.*, pp. 71ff.

63. Holland, p. 350.

64. Packe died at Eton aged fifteen of a 'malignant fever' on 28 October 1842. Westmacott admired Gothic sculpture but did not approve of other artists's attempts to imitate its attenuation and stiffness, and thought that the revival of gothic script was a folly. His views are given both in *A Lecture on Sculpture delivered in the Town Hall, Cambridge* (Cambridge 1863) p. 28, and in his *Handbook of Sculpture Ancient and Modern* (Edinburgh 1864), pp. 34ff.

65. See note 13.

66. One example is Boehm's tomb at Deene, Northants. commemorating the seventh Earl of Cardagan and his Countess. This was erected in 1869 by the Countess who lived for another forty-six years. He is stiffly recumbent with his hands folded over his ceremonial sword, but her figure informally arranged, as if she had turned towards him in a disturbed sleep. The tomb is illustrated in *Country Life* (April 1976), p. 811. Although Marochetti carved effigies of both Albert and Victoria for Frogmore, the Queen's effigy was not placed beside Albert's on the massive granite tombchest until she died.

67. Caroline Fox *Journals* (1882), entry for 12 October 1847.

68. *The Ecclesiologist* ii (November 1842) p. 58; see also, iv (January 1845) p. 19.

69. *Transactions of the Exeter Diocesan Architectural Society* i, pp. 117–26. A cutting from this is to be found amongst the Gunnis papers in the Conway Library.

70. Cecil, p. 42.

71. Many must have been removed from Canford. Canford Magna, rebuilt for Lord de Mauley between 1825 and 1836, was sold to Sir John Guest, ironmaster, in 1846 when the de Mauley's moved to Hatherop. Lady de Mauley was first buried at Canford according to *The*

Complete Peerage of England Scotland and Great Britain iv (new ed. London 1916) p. 176.

72. Anthony Radcliffe *Monti's Allegory of the Risorgimento* (London 1970).

73. David Verey *Gloucestershire: the Cotswolds* (Harmondsworth 1970) pp. 270ff.

74. The Earl of Bessborough (ed.) *The Diaries of Lady Charlotte Guest* (London 1950) pp. 234–9. Pugin made designs for stained glass and metalwork for Canford (according to Mrs Stanton, reported by J. Newman and N. Pevsner, *Dorset* (Harmondsworth 1972) p. 128n). Surely this was not for the very protestant Guests, but for the de Mauley's projected mortuary chapel.

75. The lamb at the feet of the effigy is as close to the animals on Bacon's father's monuments of the late eighteenth century (the beaver in General Hope's monument, for example) as it is to any medieval beast.

76. The destroyed monuments are described and their inscriptions recorded by G. Ormerod in *The History of the County Palatine and City of Chester* ii (London 1882) pp. 828–30.

77. *Ibid.*, i (London 1882) p. 514.

78. Good late examples are Bodley's churches at Hoar Cross, Staffs. and at Eccleston, Cheshire (replacing Porden's building) in both of which there are tombs to the right of the chancel.

79. The sculpture of the ascending soul by Fabiani of Genoa originally marked the Bibby burial place, but in 1899 when the marble began to deteriorate a faculty was obtained to move it inside. R. Stewart-Brown *A History of the Manor and Township of Allerton* (Liverpool 1911) pp. 457–8.

Notes to Chapter 6

1. Scheemaker's model was approved a little less than three years before the statue's erection on 17 February 1734. It cost £500. S. Wilks and G. T. Bettany *A Biographical History of Guy's Hospital* (London 1892) pp. 94ff. Hogarth took the Good Samaritan as one of his subjects for his paintings at St Bartholomew's in 1735.

2. Maddox was a great benefactor of the London hospitals and was also co-founder of the Worcester Infirmary. He had himself been educated at a charity school and was famous for his charity sermons. Gunnis gives 1743 as the date upon which this monument was erected, but this might be a mistake.

3. The relief appears held by Benevolence in Bacon's monument to James Marwood at Widworthy, Devon, in 1781, and also beneath the urn commemorating Elizabeth Strode (d. 1790) at Warboys, Hunts. There is also a design for a monument to a doctor (with a staff of Aesculapius) in the book of Bacon's designs in the Victoria and Albert Museum (E1571-1931). Also possibly by Bacon is a Good Samaritan relief in Coade stone included in an untitled set of engravings of 1777–9, p. 21. This relief was advertised as costing five guineas in *A Descriptive Catalogue of Coade's Artificial Stone* (London 1784) No. 253, p. 10.

4. This was erected in St Mary's, Whitechapel in the same year. It is still there but a charred ruin from a nineteenth century fire (Bell, p. 72).

5. The younger Bacon signs the monument with a Samaritan relief to John Little Hales, a doctor, in Winchester Cathedral; Muschamp signs one to the Rev David Simpson (d. 1799) in Christ Church, Macclesfield; the Kirks sign monuments of this sort usually to country doctors, in Limerick Cathedral, Ballinrobe (Co. Mayo), Cumber (Co. Down), Roscarbery (Co. Cork), and the Pro-Cathedral, Dublin; Grimsley signs the Samaritan relief monument at Witney, Oxfordshire, to Edward Batt (d. 1853); and by Ruddock is the large tomb to Rebecca Waterlow (d. 1869) in the churchyard of St Mary's, Reigate, Surrey, which incorporates a relief of this subject.

6. The monument is not in its original position. Everett's *Manchester Guide* (Manchester 1840) p. 73, gives it to 'Westmacott junior'. Due to over-enthusiastic use of an abrasive cleaner the blacking has been removed from the epitaph. Hulme dispensed his 'ample fortune' with a 'liberal hand'. He endowed Salford Infirmary with £20,000.

7. This was commissioned on 1 June 1813 by Bernard Bosanquet, and was erected 23 March 1815; it cost 200 guineas (Columbia Ms, p. 54).

8. According to the Rev G. N. Wright *Historic Guide to Bath* (Bath 1864) p. 183, this work is 'from the design and chisel of W. Carter'. There is no record of a W. Carter, but a Carter was doubtless responsible, and Thomas the younger (son-in-law and nephew of the elder Thomas) is the best candidate. An interesting comparison can be made between this relief and the relief on the Townshend monument of *c.* 1860 in Westminster Abbey—part of a monument by Thomas Carter, but executed by J. Eckstein.

9. Wilks and Bettany, *op. cit.*, p. 95.

10. Bacon's bust of 'Sickness', presented in 1778

to the Royal Academy as his diploma work, is based on the sick man in this monument. Anthony Radcliffe 'Acquisitions of Sculpture by the Royal Academy during its first Century' *Apollo* lxxxvi (January 1969) pp. 406–15, Plate 6.

11. British Library, Add. Ms 26055, f. 27.

12. *Ibid.*, f. 25 and Add. Ms 5418, f. 2.

13. *Ibid.*, Add. Ms 26055, f. 40.

14. *The Gentleman's Magazine* lvi (1786) p. 628.

15. *Ibid.*, p. 727.

16. *Ibid.*, p. 480 and lvii (1787) p. 660.

17. British Library, Add. Ms 26055, f. 62 (verso).

18. *Ibid.*, f. 64 and f. 75.

19. Since he held a key and was dressed in antique garb he was thought by some to represent St Peter. Bacon's statue of Dr Johnson was similarly mistaken for St Paul. Anon [Allan Cunningham] *Quarterly Review* xxiv (1826) p. 126. A prototype for Bacon's small narrative relief is Roubiliac's statue (now in Armagh Cathedral) of Sir Thomas Molyneux, physician general to the Irish army. He is shown tending the sick on the base, but in a very different style of relief.

20. Flaxman—or perhaps his father—along with 'Mr Hickey and Mr Sanders', 'testified a great desire of being favoured with the instructions of any of the friends of Mr Howard, intimately acquainted with his features, in order to furnish the Committee with a likeness of him.' *The Gentleman's Magazine* lvi (1786) p. 632.

21. Croft-Murray, p. 77.

22. According to Farington (Grieg's edition, i, p. 258), the King told James Wyatt that Bacon had tried to persuade him that since he had been responsible for the first three monuments in St Paul's, he should be granted a monopoly on future ones for the sake of consistent standard and style. But Wyatt was not above a little hyperbole.

23. Sir William Jones (with W. Chambers Esq., W. Hastings Esq., et al.), *Dissertations and Miscellaneous Pieces relating to the History and Antiquities, the Arts, Sciences and Literature of Asia* i (London 1792) pp. 1ff. and pp. 369ff.

24. William Hayley *Elegy on the Death of the Honourable Sir William Jones* (London 1795) Stanza lx.

25. *Ibid.*, Stanza lxii.

26. The Commission was officially given on 17 February 1796.

27. *Poems consisting chiefly of Translations from the Asiatic Languages* (Oxford 1772). One of Flaxman's notebooks contains sketches of Indians seated in a similar fashion to that adopted by the pundits in the relief and also copies made after Moghul miniatures (Fitzwilliam Museum, Flax-man Sketchbook 8932/3, Unpaginated). On the same pages there is a reference to a Mr Devis—surely Arthur William Devis, shipwrecked on the *Antelope* voyage, who made his way back to Britain via India where he was patronized by Sir William Jones. Did Devis provide Flaxman with information about Indian instruments?

28. Croft-Murray, p. 80.

29. British Museum, 1888–5–3–51. There is another preparatory study, still including the limping boy, but no longer reversed. Robert R. Wark *Drawings by John Flaxman in the Huntingdon Collection* (San Marino, California, 1970) p. 54.

30. Cunningham, p. 325.

31. I am grateful to Professor Francis Haskell for bringing this work to my attention. The endowment is described by T. W. Horsfield in *The History, Antiquities and Topography of the County of Sussex* ii (Lewes 1835) p. 60.

32. *The Gentleman's Magazine* lii (1782) p. 287.

33. E. B. de Fonblanque *Annals of the House of Percy* (London 1887) p. 531. Henry Lucas, *The Teares of Alnwick, a Pastoral Elegy* (London 1777) p. 9. The Rev T. Maurice, 'A Monody sacred to the Memory of Elizabeth, Duchess of Northumberland', in *Poems and Miscellaneous Pieces* (London 1779) pp. 137–46.

34. Soane Museum, Adam Drawings, xix (no. 19), but now kept in box 4.

35. There are drawings for this monument in the Victoria and Albert Museum, 4910–20 and 4910–22. Physick, pp. 130ff.

36. Full details of the commission are given in an invaluable article by J. M. G. Blakiston in *The Winchester Cathedral Record* (1973) pp. 23–39.

37. The Victoria and Albert Museum 7345 and British Museum 1888–5–3–45.

38. This motif was perhaps suggested by the tops of Greek stele. c.f. the giant marble palmette rising out of acanthus leaves, loaned by Trinity College, Cambridge, to the Fitzwilliam Museum.

39. T. F. Kirby *Annals of Winchester College* (London 1892) pp. 404ff. H. C. Adams *Wyke-hamica* (Oxford 1878) pp. 134–53.

40. Bacon's design is Victoria and Albert Museum E1577-1931. For Stone's monument see Whinney (1), Plate 18a. For the Bolognese professors and Roman sarcophagi see Panofsky, p. 70.

41. Columbia Ms, p. 106, dates the first payment of £50 to 23 April 1819. The final payment was made over a year later. However, T. Compton *Life and Correspondence of the Reverend John Clowes* (London 1874) p. 230, gives 1818 as the

date of the commission and letters confirm this (see note 51).

42. *Ibid.*, p. 230.

43. Whinney and Gunnis, pp. 30, 37. In tracing the melancholy fate of the marble I was assisted by Miss Schofield, secretary to the Bishop of Manchester, and by the rector of St Ann, Manchester, the Rev Canon Eric Saxon.

44. T. Compton, *op. cit.*, p. 189.

45. *Ibid.*, p. 34. Sunday schools were introduced in Bath in 1787. J. H. Adeane, *The Girlhood of Maria Josepha Holroyd* (London 1896) p. 17.

46. T. Compton, *op. cit.*, p. 191.

47. These were made by Barker, Sutton and Till of Burslem who operated between 1834 and 1843. Geoffrey A. Godden *An Illustrated Encyclopaedia of British Pottery and Porcelain* (London 1966) Plate 35. Clowes was prominent amongst the Tory Mancunians who signed an address of thanks to the Regent for his desertion of the Whigs in April 1812. So too was Dauntsey Hulme (see note 6). Clowes was also the author of little tracts for younger members of his flock, some of which are appended in the Rev J. Henn's *Memoir of Richard Hanby* (Manchester 1886).

48. T. Compton, *op. cit.*, pp. 37, 117.

49. One of Flaxman's earliest known letters to Hayley, dated 10 February 1784, makes it clear that he has lent some of Swedenborg's writings to his friend. British Library, Add. Ms 39780, f. 33 (quoted by Morchard Bishop in *Blake's Hayley* (London 1951), p. 78).

50. Mary C. Hume *A Brief Sketch of the Life, Character and Religious Opinions of the late Charles Augustus Tulk* (Boston 1850).

51. Fitzwilliam Museum Mss, Flaxman Correspondence 1784–1826, p. 50.

52. Columbia Ms, p. 106.

53. Flaxman Lectures, p. 160.

54. Whinney and Gunnis, pp. 26ff. Columbia Ms, p. 86.

55. Bell, p. 84. A sketch was known to Cunningham. Cunningham, p. 111.

56. Westmacott's monument was lost along with Flaxman's relief. T. Compton, *op. cit.*, p. 252. The Harrow relief was executed in 1816, 220 years after Lyon's death using Dr George Butler, headmaster from 1805 to 1829 as a model. Butler paid £300 for the work. Columbia Ms, p. 91.

57. A schoolboy with a pile of books and a globe is here shown being instructed not by Swanwick but a schoolmistress, or a female allegory of learning.

58. This was an important theme in Lawson's public address on becoming High Master, quoted by R.F.I. Burn 'The Development of the School to 1849' in Graham and Phythian (eds.) *The Manchester Grammar School, 1515–1965* (Manchester 1965) p. 25.

59. The Rugby monument was erected in 1824. The Staunton monument was erected in the same year. British Library, Egerton Ms 1911, p. 70. Staunton is seated in profile below a palm tree conferring with crouching natives; but he is not learning from the pundits, he is treating with Tippu Sultan in 1783–4 as representative of his friend, George McCartney, then Governor of Madras.

60. The plaster model for this was exhibited in the Egyptian Hall on 15 May 1830. *The Athenaeum* (1830) p. 300.

61. This was sent to India in the Spring of 1843. *The Illustrated London News* ii (supplement) (18 March 1843) p. 196.

62. Westmacott sometimes used allegories of Charity—for instance, in his monument to the Duke of Ancaster at Swinstead, Lincs.—and one of the finest sculptures of this period, the monument of 1817 by Theed to Thomas Westfaling at Ross-on-Wye, Herefordshire, has a relief panel reminiscent of the Lady Fitzharris group, but representing Charity.

63. This point is made very well by Whinney and Gunnis, p. 6. A remarkable exception was his design for the Abercromby monument described by his wife, in a letter to the Rev William Gunn on 5 January 1802, as involving crocodiles, sphinxes, a Victory with laurel crowns, the genius of France, and antique trophies (Maria Denman's transcript of 1835 is British Library, Add. Ms 39790, f. 17).

64. For Chantrey, see Whinney (1), p. 202. He claimed to have substituted a female Victory for an English soldier in one of his models for a monument in St Paul's 'for a freak' to see if the Committee of Taste preferred it—which they did. W. Toynbee (ed.), *The Diaries of William Charles Macready* i (London 1912) pp. 99ff, diary entry for 6 February 1834. The Westmacott's that I have in mind are the monuments to Packenham and Gibbs and to Abercromby—the latter a complete contrast to Flaxman's idea mentioned in note 63. These are illustrated and discussed in Penny (2). But usually Flaxman's ideas were simpler than Westmacott's.

65. The letter to Gally Knight is quoted in Macready's *Diaries, loc. cit.* See also the important letter Chantrey wrote to H. Corbould on 12 March 1823 announcing his ambition 'to embody nature so that it might be intelligible to natural

minds', but adding that such work would not be properly esteemed 'till the present generation of classic patrons are removed to a better world'. Fitzwilliam Museum Ms 17-1949.

66. 'Genius', a part of this group, was exhibited in 1812 in the third exhibition of the Liverpool Academy. Trevor Fawcett *The Rise of English Provincial Art* (Oxford 1974) p. 63. For Roscoe's patronage of the young Gibson, see Lady Eastlake *Life of John Gibson* (London 1870) pp. 30ff. There are two preparatory drawings for this monument in the Victoria and Albert Museum, D1321-98 and D1322-98. The latter shows lion's heads on the legs of Blundell's throne, for which cf. the small antique statue of a seated philosopher purchased by Blundell in 1777. B. Ashmole *A Catalogue of the Ancient Marbles at Ince* (Oxford 1929) p. 33. The relief below Blundell in the monument is a copy of part of a then celebrated sarcophagus front in Blundell's collection. It is discussed and illustrated in A. Michaelis *Ancient Marbles in Great Britain* (Cambridge 1882) pp. 375ff. The arrangement of the main figures, and the pose of the suppliant in particular, is inspired by Blundell's mosaic of Thetis before Zeus. The torso is the Torso Belvedere and the head perhaps the Holkham Aphrodite. The youth is a feeble exercise in the manner of the Sistine *ignudi* and the boys are derived from Nollekens.

67. Information from Timothy Stevens of the Walker Art Gallery, Liverpool.

68. For an idea of how highly this work was esteemed, see A. R. Willard's *History of Modern Italian Art* (London 1900) p. 108. Some of the Marchioness's poems were edited posthumously by her husband in an anthology entitled *The Tribute: a Collection of Miscellaneous Unpublished Poems* (London 1837). They are bad.

69. Westmacott the younger may have been given the commission on the strength of his father's work, for there is a good monument in the same church by Sir Richard, commemorating, among others, John, the second and last Earl of Upper Ossory, Lady Fitz-Patrick's father.

70. For instance, the monument by Gaffin to Mrs Pye (d. 1847) which is at Swinhope, Lincs., and the unsigned monument at Illogan in Cornwall to Frances, Baroness Basset (d. 1855).

71. J. Newman *West Kent and the Weald* (Harmondsworth 1969) p. 340n. For more details see H. W. and I. Law *The Book of the Beresford Hopes* (London 1925) pp. 182-4 which quotes from Beresford-Hope's letter to Webb on the subject. It was first proposed to carry out this plan in the woods near Frith.

Notes to Chapter 7

1. The prominent founders were Vincent Ayre, a landowner in his own right, and also steward of the Duke of Norfolk, and the Walker family of ironmasters. *The Three Banks Review* lxxiii (March 1967). For hunting in the Wirral see H. K. Aspinall *Birkenhead and its Surroundings* (Liverpool 1903), for the Chester library see *The Chester Guide* (Chester 1818)—a less exclusive library was established in Fletcher's building, Bridge Street in 1817.

2. The first record of the cluttered style of decor known to me comes in Passavant's *Tour of a German Artist in England* i (London 1936) pp. 139ff. What I would chiefly contest is the point of view expressed in Pevsner's 'Victorian Prolegomena' in *Victorian Architecture* (ed. Peter Ferriday) (London 1963) p. 35.

3. W. H. Chaloner 'Notes on Wilkinson' *Architectural Review* cvi (1949) p. 333; also, Turpin Bannister 'The First Iron-framed Buildings' *Architectural Review* cvii (1950) p. 245. For his patents see *The Repository of Arts and Manufactures* xvi (1802) p. 92; i (1794) p. 370; xii (n.s. 1808) p. 347.

4. For the patent on this type of track see *ibid.*, iii (n.s. 1803) pp. 284-7. Benjamin was succeeded as agent by his son, James. For details of Wyatt's agency see Cheshire County Records Office, DMD/F/1, a letter from Benjamin and Arthur Wyatt to Daniel Vawdrey concerning James Wyatt's request to Lord Penrhyn's heir, G. H. D. Pennant, to reconsider the terms of his employment. See also Penrhyn Castle Papers, University College Library, Bangor, Mss 1849 and 1850 (letters from Benjamin Wyatt to Lord Penrhyn of 20 and 27 November 1803).

5. This inscription is given by T. S. [T. Seccombe] in *D.N.B.* lxii, p. 206.

6. Erasmus Darwin *The Botanic Garden* (London 1791) p. 140n, p. 141.

7. See, for example, the silver centrepiece, now in Bristol City Art Gallery and Museum made by E. J. Barnard in 1854-5 for presentation to Robert Bright when port dues were abolished in Bristol.

8. The account, which must have come from the patron or the artist, appeared in *The Ipswich Journal*, 8 November 1766. My attention was directed to this by a note which Mr B. Butte contributed to Pevsner's *Essex* (Revised ed. Harmondsworth 1965) p. 103.

9. *The Gentleman's Magazine* liii (1783) p. 213.

10. One half of the Parys mountain was owned by Sir Nicholas Bayley of Plas Newydd. Roe was

entrusted with the exploitation of this in the 1760s. The other half was inherited by the curate of Trefdraeth and his wife and was to be developed far more systematically.

11. *The Gentleman's Magazine* lxvi (1796) p. 970. The monument was perhaps begun by Bacon senior.

12. For London fire-engines, see R. J. Mitchell and M. D. R. Leys *A History of London Life* (Harmondsworth 1963) p. 225.

13. He was paid £86.12s.2d., which included the costs of erecting the work. Croft-Murray, pp. 79ff.

14. Columbia Ms, p. 12. The monument is related to the anonymous medal of Boulton, mentioned in J. K. Whiting *Commemorative Medals* (Newton Abbot 1974) p. 164.

15. Davies Gilbert *The Parochial History of Cornwall* iii (London 1838) pp. 9ff.

16. Cunningham, p. 75.

17. Graham Mee *Aristocratic Enterprise* (Glasgow 1975), gives evidence for the close interest taken by the Fitzwilliams in their mines. It is hard to assess how frequently families wished to sever links with the source of their original wealth. The banking Hoares did this at Stourhead, on the other hand the brewing Whitbreads who purchased Southill from Lord Torrington in 1795, did not. F. M. L. Thompson in his *English Landed Society in the Nineteenth Century* (London 1963) pp. 129ff suggests that it usually took two generations for a new family to withdraw from the scenes of its commercial success.

18. Cornelius Brow *Worthies and Celebrities of Nottinghamshire* (London 1882) p. 366n. Connections with Portugal are suggested by the fact that Robert Wilkinson, a cousin of the Denisons, died at Lisbon, aged twenty one, in 1789.

19. *The Gentleman's Magazine* lv (1785) p. 237.

20. Carr's plans for this temple are preserved in the Denison papers, Nottingham University Library, De-B/35-9.

21. *Ibid.*, Miscellaneous Collection of papers. Letter of 2 August 1772.

22. Chantrey Ledger, p. 168. The bust was ordered on 31 March 1824 and completed on 23 December 1828 when it was presented to Mr Watt. There is no evidence that it was designed for a monument.

23. A bust of 'the late Mr Simson' was commissioned by Thomas Telford, Civil Engineer, in 1816. The order was confirmed by Johnstone (Simpson's son-in-law) in 1819. The bust was completed 12 February 1820 and cost £106. *Ibid.*, p. 22. There is a companion bust also in a niche by Carline, commemorating another

Shropshire ironmaster, William Hazledine (d. 1840). Hazledine commissioned this in 1837. *Ibid.*, p. 230.

24. C. Stella Davis (ed.) *A History of Macclesfield* (Manchester 1961) pp. 113–20.

25. Arthur Raistrick *Quakers in Science and Industry* (Newton Abbot 1968). See also, Paul H. Emden *Quakers in Commerce* (London 1939).

26. Courtauld refused to pay Church Rate between 1834 and 1853, but he paid for it at Gosfield because of his family vault there.

27. For the Fitzwilliam colliers see Graham Mee *Aristocratic Enterprise* (Glasgow 1975). For the Soho factory, built 1761–2 to designs by Benjamin Wyatt (father of James and Samuel and Benjamin the Penrhyn agent) see James Bisset *A Poetic Survey Around Birmingham* (Birmingham 1800).

28. Robert Gibbs *Worthies of Buckinghamshire and Men of Note in that County* (Aylesbury 1888) p. 399.

29. *Ibid., loc. cit.*

30. *Ibid., loc. cit.*

31. Potterton, p. 51 and Plate 63.

32. J. C. Loudon (ed.) *The Landscape Gardening and Landscape Architecture of the late Humphrey Repton* (London 1840) p. 343.

33. N. B. Penny 'Monuments to Early Reformers' *Country Life* (7 March 1974) pp. 492–3.

34. *The Farmer's Magazine* iii (1802) pp. 272–5 and 398–402; v (1804) pp. 444–7.

35. Charles Nowell Smith (ed.) *The Letters of Sydney Smith* ii (Oxford 1953) p. 555. The letter is undated but 'April 1832' is pencilled on it.

36. For the Longford monument see *The Builder* ii (1844) pp. 554ff. For Coke in general see A. M. W. Stirling *Coke of Norfolk and his Friends* (2 vols. London 1908); also Edward Rigby *Holkham, its Agriculture* (2nd Ed. Norfolk 1817), and *The British Farmer's Magazine* i (February 1827) pp. 178–81.

37. For the circumstances of the column's foundation, see *The Illustrated London News* vii (16 August 1845) pp. 111ff.

38. Presentation silver of this period frequently abounds in pastoral imagery. A fine example is the candelabra presented in 1840 to the Marquis of Bristol by his tenants, now in the dining room at Ickworth, Suffolk.

39. A. H. Dodd *History of Caernarvonshire* (Denbigh 1968) pp. 246–9, 301.

40. A slightly inaccurate account of the will is given in *By-gones relating to Wales and the Border Counties* v (August 1908) p. 99.

41. Nos 1179 and 1238 in R. A. *Catalogue*.

42. Penny *op. cit.* in note 33 also cites Rysbrack's

Newton monument of 1731 in Westminster Abbey, where putti play with prism and telescope, weigh the planets and work the mint, in brief allusion to the diverse achievements of the deceased.

43. The figures do not appear to be at all impoverished, but they are clearly identified by H. Lyte's elegy in the inscription. Mary, Duchess of Montague, died in May 1775, aged sixty-three. Adam designed the monument, but the degree to which the figures are his invention is open to doubt.

44. The Rev J. Evans, *A Tour through part of North Wales* (London 1806), p. 233.

45. No. 1085 in R. A. *Catalogue*. Colvin was born 11 April 1756 and died 15 December 1818. The monument is described in *Bengal Past and Present* xiv (1917) p. 70 and scraps of information about Colvin and his family may be obtained from *ibid.*, xxviii (1924) p. 65.

46. The two figures were exhibited at the Royal Academy in 1829 (catalogue nos. 1196 and 1201). The group was due to be moved in 1912 when Wilmot Corfield published his invaluable list of the British Monuments in Calcutta, *Notes and Queries*, 11th series, vi (1912).

47. No. 989 in R.A. *Catalogue*. It is described as 'A distressed mother and her infant, in place of the accustomed hospitality she had sought, finds the tomb of her benefactress.' Did Westmacott originally intend to place an urn beside her?

48. It seems possible that in creating his *Homeless Traveller* Westmacott had Canova's *Magdalene* in mind; the contrast between rough earth, crude homespun and smooth flesh, also the loose hair and weary shoulders, are similar.

49. They quarrelled over the Llandegai tithes and over the conditions of the leases bought by Lord Penrhyn. Mss cited at the end of note 4.

50. J. D. Passavant *Tour of a German Artist in England* i (London 1936) p. 313. Lansdowne apparently gave 500 guineas for the statue which was delivered on 1 October 1823 according to the *Memoirs, Journal and Correspondence of Thomas Moore* (ed. Lord John Russell) iv (1853) p. 133. The statue was no. 989 in the R.A. *Catalogue*.

51. T. K. Hervey *Illustrations of Modern Sculpture* (London 1832).

52. Westmacott's own description of the *Happy Mother* appears in Hervey, *op. cit.* It was no. 1065 in the R.A. *Catalogue* for 1825 when, however, it was described as a *Madonna and Child*. Did the sculptor change the title to attract protestant buyers?

53. *The Athenaeum* (12 June 1830) p. 364.

54. Weekes's work was executed in 1851 and on account of it he was elected A.R.A., H. Weekes *Lectures on Art* (London 1880) p. 6. The statue is illustrated by the *Art Journal* v (n.s. 1853) p. 103.

55. *The Lady's Magazine* xxxiv (1823) p. 50.

56. No. 1043 in R.A. *Catalogue*.

57. H. J. Todd *The History of the College of Bonhommes at Ashridge* (London 1823) p. 85.

58. William Cobbett *Rural Rides* (ed. Edward Thomas) ii (London 1912) p. 215.

59. See the entry by H. Manners Chichester in *D.N.B.*

60. Westmacott stayed at Wilton in 1813 and told Farington of its 'baronial hospitality' in 1819. Farington, pp. 6290 and 7641. He was involved in arranging the sculpture gallery there, very tastefully, according to Passavant, *op. cit.*, i, p. 299.

61. The monument at Ledbury, Herefordshire, to Daniel Ellis Saunders (d. 16 July 1825), erected by Clarence, his widow.

62. These commemorate Henry Munro and Caleb Dickenson and were erected in 1828. Lesley Lewis 'English Commemorative Sculpture in Jamaica' *Commemorative Art* (January 1967) pp. 17–18.

63. The most recent survey of nineteenth-century picturesque villages is Gillian Darley *Villages of Vision* (London 1975).

64. G. Gilfillan (ed.) *The Poetical Works of William Lisle Bowles* i (Edinburgh 1855) pp. 142ff.

65. Christopher Ricks (ed.) *The Poems of Tennyson* (London 1969) pp. 743–6.

66. The bust was made in 1814, repeated twice in 1816, and then again in 1817 and 1822. Chantrey Ledger, pp. 36 and 136.

67. No. 1010 in R.A. *Catalogue*. Chantrey Ledger, p. 124.

68. The statue was removed from the Abbey to the Railway Museum, formerly at Clapham, and it is hoped that it will soon be erected in the crypt at St Paul's. The meeting was held in the Freemason's Hall. See *Leigh Hunt's London Journal* ii (30 June 1824) p. 205 and *The Penny Magazine* xxvi (31 July 1824) p. 209.

69. Chantrey Ledger, pp. 192–5.

70. Whinney, p. 221.

71. William Toynbee (ed.) *The Diaries of William Charles Macready* i (London 1912) p. 84.

72. N. Pevsner and A. Wedgwood, *Warwickshire* (Harmondsworth 1966) p. 180.

73. I suspect that this colour scheme is not true to the architect's original intentions.

74. Quoted by Whinney (1), p. 222.

Select Bibliography

All the works listed below are abbreviated in the footnotes.

Bell: C. F. Bell *The Annals of Thomas Banks* (Cambridge 1938).

Cecil: The Rev Richard Cecil *Memoirs of the late John Bacon* (London 1811).

Chadwick: Owen Chadwick *The Victorian Church*, Part I (3rd Edition, London 1971).

Chantrey Ledger: Ms ledger of the sculptor in the library of the Royal Academy of Arts, London.

Columbia Ms: Ms account-book of John Flaxman in the Montgomery Library, Columbia University, New York.

Croft-Murray: Edward Croft-Murray 'An Account-Book of John Flaxman' *Walpole Society* xxviii (1939–40) pp. 51–101. A transcription of British Library, Add. Ms 39784, with valuable annotations.

Cunningham: Allan Cunningham *Lives of the Eminent British Painters, Sculptors and Architects* iii (London 1830).

Farington: The Farington Diaries. The typewritten transcript of the complete Ms, deposited in the Print-room of the British Museum by permission of Her Majesty the Queen is normally referred to.

Flaxman *Lectures*: John Flaxman *Lectures on Sculpture* (2nd Edition, London 1838).

Gunnis: Rupert Gunnis *A Dictionary of British Sculptors, 1660–1851* (New Edition, London 1964).

Holland: T. Holland *Memorials of Sir Francis Chantrey* (Sheffield 1851).

Jones: George Jones *Recollections of the Life, Practice and Opinions of Sir Francis Chantrey* (London 1849).

Panofsky: Erwin Panofsky *Tomb Sculpture* (London 1964).

Penny (1): N. B. Penny 'English Church Monuments to Women who Died in Childbed' *Journal of the Warburg and Courtauld Institutes* xxxviii (1975) pp. 314–332.

Penny (2): N. B. Penny 'The Sculpture of Sir Richard Westmacott' *Apollo* cii (August 1975).

Physick: John Physick *Designs for English Sculpture 1680–1860* (London 1969).

Potterton: Homan Potterton *Irish Church Monuments, 1570–1880* (Ulster Architectural Heritage Society 1975).

Smith: J. T. Smith *Nollekens and his Times* (ed. W. Whitten), 2 Vols. (London 1920).

Wickham Legg: T. Wickham Legg *English Church Life* (London 1914).

Whinney (1): Margaret Whinney *Sculpture in Britain, 1530–1830* (Harmondsworth 1964).

Whinney (2): Margaret Whinney *English Sculpture, 1720–1830* (London 1971).

Whinney and Gunnis: Margaret Whinney and Rupert Gunnis *The Collection of Models by John Flaxman R.A. at University College, London* (London 1967).

Index